WORLD OF ART

WHITNEY CHADWICK

Women, Art, and Society

243 illustrations, 50 in color

THAMES AND HUDSON

For Moira

This book is heavily indebted to the many feminist
scholars whose work has charted this new art
historical territory and to my students in the
Women and Art course at San Francisco State
University whose questions helped me shape and
refine the material. Linda Nochlin, Moira Roth,
and Lisa Tickner have read the manuscript and
made many helpful suggestions. Jo Ann Bernstein,
Cristelle Baskins, Susie Sutch, Pat Ferrero,
Josephine Withers, Janet Kaplan, and Mira Schor
offered valuable critical commentary on specific
chapters. Darrell Garrison and George Levounis
spent many hours checking bibliography and
references. I am especially indebted to Nikos
Stangos and the staff at Thames and Hudson who
enthusiastically undertook this book and who have
cheerfully coped with my hesitations and doubts as
the manuscript expanded far beyond our original
projections.

First published in the United States in 1990 by
Thames and Hudson Inc., 500 Fifth Avenue,
New York, New York 10110

Library of Congress Catalog Card Number
89-50634

Set in Monophoto Bembo
Printed and bound in Singapore

Contents

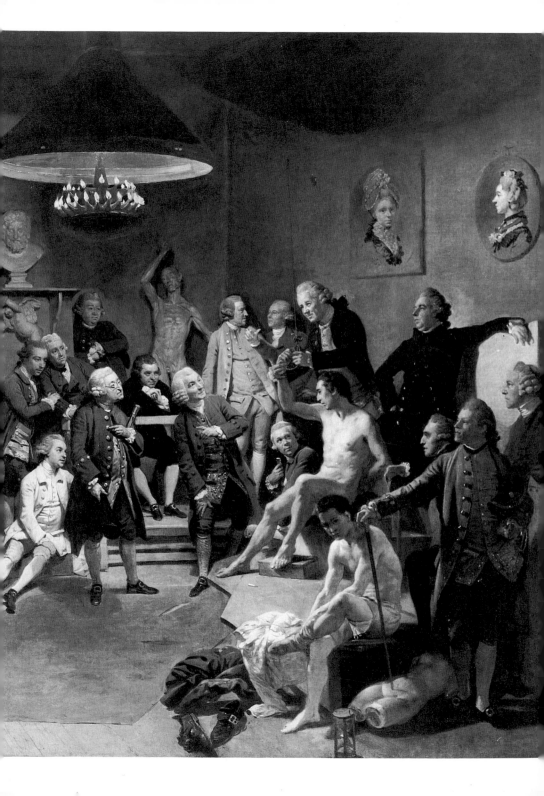

Preface

Among the founding members of the British Royal Academy in 1768 were two women, Angelica Kauffmann and Mary Moser. The fact that both were the daughters of foreigners, and that both were active in the group of male painters instrumental in forming the Royal Academy, no doubt facilitated their membership. Kauffmann, elected to the prestigious Academy of Saint Luke in Rome in 1765, was hailed as the successor to Van Dyke on her arrival in London in 1766. The foremost painter associated with the decorative and romantic strain of classicism, she was largely responsible for the spread of the Abbé Winckelmann's aesthetic theories in England and was credited, along with Gavin Hamilton and Benjamin West, with popularizing Neoclassicism there. Moser, whose reputation then rivalled Kauffmann's, was the daughter of George Moser, a Swiss enameller who was the first Keeper of the Royal Academy. A fashionable flower painter patronized by Queen Charlotte, she was one of only two floral painters accepted into the Academy. Yet when Johann Zoffany's group portrait celebrating the newly founded Royal Academy, *The Academicians of the Royal Academy* (1771–72) 1 appeared, Kauffmann and Moser were not among the artists casually grouped around the male models. There is no place for the two female academicians in the discussion about art which is taking place here. Women were barred from the study of the nude model which formed the basis for academic training and representation from the sixteenth to the nineteenth centuries. After Kauffmann and Moser, they were barred from membership in the Royal Academy itself, until Annie Louise Swynnerton became an Associate Member in 1922 and Laura Knight was elected to full membership in 1936. Zoffany, whose painting is as much about the ideal of the academic artist as it is about the Royal Academicians, has included painted busts of the two women on the wall behind the model's platform. Kauffmann and Moser have become the objects of art rather than its producers; their place is with the bas-reliefs and plaster casts that are the objects of contemplation and inspiration for the male artists. They have become

7

representations, a term used today to denote not just painting and sculpture, but a wide range of imagery drawn from popular culture, media and photography, as well as the so-called fine arts.

Zoffany's painting, like many other works of art, conforms to widely held cultural assumptions about women which have sub-sumed women's interests under those of men and structured women's access to education and public life according to beliefs about what is "natural." It reiterates the marginal role traditionally ascribed to women artists in the history of painting and sculpture and affirms the female image as an object of male contemplation in a history of art commonly traced through "Old Masters" and "masterpieces."

The striking paradox of Zoffany's painting focuses attention on the dissimilar positioning of men and women in art history. In the early 1970s, feminist artists, critics, and historians began to question the assumptions which lay behind the masculinist claim for the universal values of a history of heroic art which happened to be produced by men and which had so systematically, it appeared, excluded women's productions from its mainstream, and so powerfully transformed the image of woman into one of possession and consumption. The resulting reexamination of women's lives as artists proceeded amidst debates about the relationship between gender, culture, and creat-ivity. Why had art historians chosen to ignore the work of almost all women artists? Were successful women artists exceptional (perhaps to the point of deviance) or merely the tip of a hidden iceberg, submerged by the demand of patriarchal culture that women produce children, not art, and confine their activities to the domestic, not the public, sphere? Could, and should, women artists lay claim to "essential" gender differences that might be linked to the production of certain kinds of imagery? Could the creative process, and its results, be viewed as androgynous or genderless? Finally, what was the relationship between the "craft" and "fine" art traditions for women?

Feminism in the arts grew out of the contemporary women's movement; its first investigations relied heavily on sociological and political methodology. Early feminist analyses focused new attention on the work of remarkable women artists and on unequalled traditions of domestic and utilitarian production by women. They also revealed the way that women and their productions have been presented in a negative relation to creativity and high culture. They showed how the binary oppositions of Western thought—man/woman, nature/culture, analytic/intuitive—have been replicated within art history and used to reinforce sexual difference as a basis for

8

aesthetic valuations. Qualities associated with "femininity," such as "decorative," "precious," "miniature," "sentimental," "amateur," etc., have provided a set of negative characteristics against which to measure "high art."

A belief in a female nature or feminine essence, which could be revealed by stripping away layers of patriarchal culture and conditioning, dominated American feminist investigations during the early 1970s. The desire to reclaim women's histories, and to resituate women within the history of cultural production, led to an important focus on female creativity. It also directed attention to the categories—"art" and "artist"—through which the discipline of art history has structured knowledge. Originating in the description and classification of objects, and the identifying of a class of individuals known as "artists," art history has emphasized style, attribution, dating, authenticity, and the rediscovery of forgotten artists. Revering the individual artist as hero, it has maintained a conception of art as individual expression or as a reflection of preexistent social realities, often divorced from history and from the social conditions of production and circulation.

Art history concerns itself with the analysis of works of art; sexual difference has been shown to be inscribed in both the objects of its inquiry and the terms in which they are interpreted and discussed. If, as Lisa Tickner and others have recently argued, the production of meaning is inseparable from the production of power, "then feminism (a political ideology addressed to relations of power) and art history (or any discourse productive of knowledge) are more intimately connected than is popularly supposed." Early feminist investigations challenged art history's constructed categories of human production and its reverence for the individual (male) artist as hero. And they raised important questions about the categories within which cultural objects are arranged.

As some feminist art historians began to question the ahistoricity of writing about women artists as if gender were a more binding point of connection between women than class, race, and historical context, others found the isolation in which many women artists have worked, and their exclusion from the major movements through which traditional art history has plotted the course of Western art, insurmountable barriers to their reinscription in art history as it is conventionally understood. Again and again attempts to reevaluate the work of women artists, and to reassess the actual historical conditions under which they worked, have come in conflict with art

history's identification of art with the wealth, power, and privilege of the individuals and groups who commissioned or purchased it, and the men who wrote about it and identified with it.

After almost two decades of feminist writing about women in the arts, there remains a relatively small body of work in the history of Western art since the Middle Ages that can, with any certainty, be firmly identified with specific women artists. When women artists like Berthe Morisot, Georgia O'Keeffe, and Frida Kahlo have been admitted to the art historical canon, it has been under a banner of "greatness," and as exceptions. "Greatness," however, remains tied to specific forms of artistic lineage; isolated from the centers of artistic theory and from roles as teachers, few women have been able to directly bequeath their talent and experience to subsequent generations. Problems relating to attribution, the determination of authorship, and oeuvre, or its size and significance, remain unresolved for many women artists. Attempts to juggle domestic responsibilities with artistic production have often resulted in smaller bodies of work and smaller works than those produced by male contemporaries. Yet art history continues to prefer prodigious output and monumental scale or conception to the selective and the intimate. Finally, the historical and critical evaluation of women's art has proved to be inseparable from ideologies which define her place in Western culture generally.

As the inadequacies of methodologies based on the ideological and political conviction that women were more unified by the fact of being female, than divided by race, class, and history, were exposed, many feminist scholars turned to structuralism, psychoanalysis, and semiology for theoretical models. During the 1980s, scholars in these disciplines have challenged the humanist notion of a unified, rational and autonomous subject which has dominated study in the arts and humanities since the Renaissance. They have also emphasized that since the "real" nature of male and female cannot be determined, we are left with representations of gender. Since the category "woman" has been shown to be a fiction, feminist efforts have been increasingly directed toward dismantling this fiction and analyzing the ways that images produce meanings which are constantly circulated within the social formation.

The body of writings now referred to as postmodern or poststructural draws on the structural linguistics of Ferdinand de Saussure and Emile Benveniste, the analysis of Marx and Louis Althusser, the psychoanalytic theory of Freud and Jacques Lacan, the

theories of discourse and power associated with Michel Foucault, and Jacques Derrida's critique of metaphysics. All forms of poststructuralism assume that meaning is constituted within language and is not the guaranteed expression of the subject who speaks it, and that there is no biologically determined set of emotional and psychological characteristics which are "essentially" masculine or feminine. Poststructuralist texts expose the role of language in deferring meaning and in constructing a subjectivity which is not fixed but is constantly negotiated through a whole range of forces—economic, social and political. They have undermined long cherished views of the writer or artist as a unique individual creating in the image of divine creation (in an unbroken chain that links father and son as in Michelangelo's God reaching toward Adam in the Sistine Chapel frescoes), and the work of art as reducible to a single "true" meaning. And they have demonstrated that one way that patriarchal power is structured is through men's control over the power of seeing women. As a result, new attitudes toward the relation between artist and work have begun to emerge, many of which have important implications for feminist analysis. Now artistic intention can be seen more clearly as just one of many often overlapping strands—ideological, economic, social, political—that make up the work of art, whether literary text, painting, or sculpture.

One result has been changes in the ways many feminist art historians think about art history itself. As an academic discipline, art history has structured its study of cultural artifacts within particular categories, privileging some forms of production over others and continually returning the focus to certain kinds of objects and the individuals who have produced them. The terms of its analysis are neither "neutral" nor "universal;" instead they reinforce widely held social values and beliefs and they inform a wide range of activities from teaching to publishing and the buying and selling of works of art.

The connection between meaning and power has occupied recent thinkers from Foucault to Frederick Jameson. Foucault's analysis of the way that power is exercised, not through open coercion, but through its investment in particular institutions and discourses, and the forms of knowledge that they produce, has raised many questions about the function of visual culture as a defining and regulating practice, and the place of women in it. His distinction between "total" and "general" history in his *Archeology of Knowledge* (1972) allows for a "general" history which does not focus on a single meaning. The

reliance of "general" history on "series, segmentations, limits, difference of level, time-lags, anachronistic survivals, possible types of relation," seems applicable to the feminist problematic of formulating a history which is responsive to women's specific experiences without positing a parallel history uniquely feminine and existing outside the dominant culture.

European, particularly French, psychoanalysts have written about women, not as producers of culture, but as signifiers of male privilege and power. Lacan's rereading of Freud stresses the linguistic structure of the unconscious and the acquisition of subjectivity at the point of the entry of the individual as a speaking subject into the symbolic order of language, laws, social processes, and institutions. The writings of Lacan and his followers have been concerned with a psychoanalytic explanation about how the subject is constructed in language and, by extension, in representation. The place assigned woman by Lacan is one of absence, of "otherness." Lacking the penis which signifies phallic power in patriarchal society and provides a speaking position for the male child, woman also lacks access to the symbolic order which structures language and meaning. In Lacan's view, she is destined "to be spoken" rather than to speak. This position of otherness in relation to language and power poses serious challenges to the woman artist who wishes to assume the role of speaking subject rather than accept that of object. Yet Lacan's views have proved to be important for those feminists who are interested in clarifying the positioning of woman in relation to dominant discourses (or differing ways that social institutions and processes are organized to give meaning to the world) and have provided the theoretical base for the work of a number of contemporary women artists, several of whom are discussed in the last chapter of this book. Moreover, the psychoanalytically oriented writings of Luce Irigaray, Hélène Cixous, Julia Kristeva, and others, have posed the issue of woman's "otherness" from radically different bodily perspectives.

As a result of these and other theoretical developments, much recent scholarly writing has shifted attention away from the categories "art" and "artist" to broader issues concerning ideologies of gender, sexuality, and power. There can be no simple category defined as "feminist art history." There are only what Griselda Pollock has identified as "feminist interventions in the histories of art." Feminism cannot be integrated into the existing structures of art history because they leave intact the categories which have excluded

women from cultural significance. It can only be reformulated as a problematic within the contested field of art history.

Within feminism itself, there are now multiple approaches to these issues. Some feminists remain committed to identifying the ways that femininity is shown in representation, and others have replaced the search for an ahistorical and unchanging feminine "essence" with an analysis of gender as a socially constructed set of beliefs about masculinity and femininity. Still others have concentrated on psychoanalytic explanations which view femininity as the consequence of processes of sexual differentiation.

The implications of new ways of thinking about gender and representation have yet to be fully articulated and understood. The recent emphasis on dismantling all forms of knowledge sometimes appears to hold little promise for changing the realities of women's lives and the institutions which represent them. Julia Kristeva's argument that, "A woman cannot be; it is something which does not even belong in the order of being" and "it follows that a feminist practice can only be negative, at odds with what already exists so that we may say 'that's not it' and 'that's still not it,'" corresponds to a theoretical position held by many, but fails to resituate women in history.

The gradual integration of women's historical production with recent theoretical developments can be achieved only through a reexamination of the woman artist's relationship to dominant modes of production and representation in the light of a growing literature concerned with the production and intersection of gender, class, race, and representation. Issues of women's desire and sexual pleasure, and the situating of the feminine as mythic and historically specific, are being explored, as is the very important area of a female pleasure which does not rest exclusively on spectatorship.

This book provides a general introduction to the history of women's involvement in the visual arts. Focusing on women who have chosen to work professionally in painting, sculpture, or related media, and on the ideologies which have shaped production and representation for women, it seeks to identify major issues and new directions in research which might enrich the historical study of women artists, and to summarize the work which has been done to date. It concentrates on the intersection between women as producers of art and woman in representation because it is here that we can begin to unravel the discourses that construct and naturalize ideas about women and femininity at specific historical moments. It is also at the

intersection of production and representation that we can become most aware of what is not represented or spoken, the omissions and silences that reveal the power of cultural ideology.

The limitations of art history as a discipline have been articulated by other feminist art historians. Nevertheless, after almost two decades of feminist art historical writing, it is clear that critical issues of women's historical production remain unanswered. While many women artists have rejected feminism, and others have worked in media other than painting and sculpture, none has worked outside history. Although I am aware of the difficulty of organizing a book such as this in a way that avoids positing an alternative canon of "great" women artists based on assumptions and values which many of us have come to distrust, we must keep in mind the fact that it is the discipline of art history which has structured our access to women's contributions in specific ways.

As an introductory text, this book provides neither new biographical nor archival facts about women artists. Instead, it is entirely dependent on the research of others and seeks primarily to "reframe" the many issues raised by feminist research in the arts. Although the format of the World of Art Series does not allow individual footnotes, sources are acknowledged in the topical notes at the end of the text. Among the many problems confronting such a study is the question of how to "name" women artists. Although many writers have chosen to designate women by their given names rather than their patronyms, the use of familiar names has also been used to diminish women artists in relation to their male contemporaries. Thus I have adopted the more historically common form of address by patronym. The fathers of artist daughters are identified by full name while the daughters are most often referred to by family name; for example, Gentileschi refers to Artemisia Gentileschi, her father is called Orazio Gentileschi. The problem of naming is only the first of a complex set of issues having to do with women and language, and is explored in the next chapter on the writing of art history and women artists.

Art History and the Woman Artist

The origins of art history's focus on the personalities and work of exceptional individuals can be traced back to the early Renaissance desire to celebrate Italian cities and their achievements by focusing on their more remarkable male citizens. The first formulation of the new ideal of the artist as a learned man, and the work of art as the unique expression of a gifted individual, appears in Leon Battista Alberti's treatise, *On Painting*, first published in 1435. Modern art historical scholarship, beginning in the late eighteenth century and profoundly influenced by Idealist philosophy with its emphasis on the autonomy of the art object, has closely identified with this view of the artist as a solitary genius, his creativity mapped and given value in monographs and catalogues. Since the nineteenth century, art history has also been closely aligned with the establishing of authorship, which forms the basis of the economic valuing of works of Western art. Our language and our expectations about art have tended to rank art produced by women below that by men in "quality," and thus their work is often of lesser monetary value. This has profoundly influenced our knowledge and understanding of the contributions made by women to painting and sculpture. The number of women artists, well known in their own day, for whom no work now exists is a tantalizing indication of the vagaries of artistic attribution.

A review of attribution problems in the work of several women artists reveals one reason why any study of women artists must examine how art history is written and the assumptions that underly its hierarchies. Let us consider three paradigmatic cases from three centuries: Marietta Robusti, the sixteenth-century Venetian painter; Judith Leyster, the seventeenth-century Dutch painter; and a group of women artists prominent in the circle of Jacques-Louis David, the eighteenth-century French painter. Their stories not only elucidate the way that art history's emphasis on individual genius has distorted our understanding of workshop procedures and the nature of collaborative artistic production, they also illustrate the extent to which art history's close alliance with art market economics has

affected the attribution of women's art. They offer dramatic examples of the ways that expectations about gender affect the ways we literally see works of art.

Marietta Robusti was the eldest daughter of Jacopo Robusti, the Venetian painter better known as Tintoretto. Her birth, probably in 1560, was followed by those of three brothers and four sisters. Her sister Ottavia became a skilled needlewoman in the Benedictine nunnery of S. Amia di Castello; Robusti and her brothers Domenico and Marco (and possibly Giovanni Battista) entered the Tintoretto workshop as youths. It is known that she worked there more or less full-time for fifteen years and that her fame as a portrait painter spread as far as the courts of Spain and Austria. Her likeness of Jacopo Strada, Emperor Maximilian II's antiquarian, so impressed the emperor that she was invited first to his court as painter and subsequently to the court of Philip II of Spain. Her father refused to allow her to leave and instead found her a husband, Jacopo d'Augusta, the head of the Venetian silversmiths' guild, to whom she was betrothed on condition that she not leave Tintoretto's household in his lifetime. Four years later, at thirty, she died in childbirth.

The model of artistic production in Italy had shifted from that of crafts produced by skilled artisans to that of the work of art inspired by the genius of an individual creator. In sixteenth-century Venice, where the change occurred more slowly than in Florence and Rome, the family was still a unit of production (as well as consumption), and family businesses of all sorts were a common feature. Tintoretto's workshop, organized around the members of his immediate family, would have been classified as a craft under guild regulation. Similar to the dynastic family workshops of Veronese and Bellini in Venice, Pollaiuolo, Rossellino, and della Robbia in Florence, the workshop provides the context within which to examine Robusti's career (or what little we know of it). At the same time, that career is inextricably bound up with Tintoretto's, understood since the sixteenth century as the expression of an individual temperament.

As Tintoretto's daughter, Robusti's social and economic autonomy would have been no greater than those of other women of the artisan class. Nevertheless, remarks by Tintoretto's biographer Carlo Ridolfi about her musical skills and deportment, published in 1648, suggest that she was also part of a changing ideal of femininity that now emphasized musical and artistic skills for women, as well as some education. Other accounts of Tintoretto and his workshop offer a series of paradoxes with regard to a daughter whose hand was

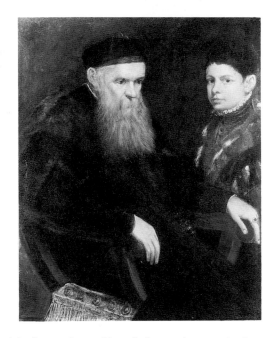

2 Marietta Robusti *Portrait of an Old Man With Boy* c. 1585

apparently indistinguishable from that of her father, whose painting was sufficiently good to be confused with his, and whose fame must have continued after her death since Ridolfi placed her among the most illustrious women of all time.

Robusti, like her brother Domenico (who inherited the workshop on Tintoretto's death and was thus considered the new "master"), learned to paint portraits in her father's style. It is commonly assumed that her achievements were largely due to his influence. This facile assumption, however, is a product of modern scholarship. Sixteenth and seventeenth-century sources point in two directions: Robusti's close ties to her father and his production, and her independent achievement. Although Ridolfi mentions portraits by Robusti of all the members of the silversmiths' guild, Adolfo Venturi is alone among twentieth-century art historians in tentatively identifying a group of paintings in the manner of Tintoretto with her in 1929 on the dubious but all too common grounds that they display a "sentimental femininity, a womanly grace that is strained and resolute." Most modern scholars attribute only a single work to her, the *Portrait of an Old Man With Boy* (c. 1585). Long considered one of Tintoretto's finest portraits, it was only in 1920 that the work was found to be signed with Robusti's monogram. Even so, the attribution has subsequently been questioned.

The workshop's prodigious output, a subject of much comment ever since the humanist Pietro Aretino first commended Tintoretto's "speed in execution accompanied by excellence" in the sixteenth century, has helped to define the artistic genius of its Master. Though many Tintoretto scholars acknowledge the problems of attribution in the workshop, they generally embrace a model of almost superhuman production and use it to build an image of "greatness" for the artist.

Hans Tietze in 1948 proposed a "Tintorettesque style" to encompass the varied hands at work; "The Tintorettesque style is not only an impoverishment but also an enrichment of the style of Tintoretto; it enters into innumerable combinations with the personal style, makes transitions and mixtures possible, increases the master's scope, augments his effectiveness, and affords opportunity for trying out on a larger scale artistic principles which in reality are his own personal property." Thus the collective style called "Tintorettesque" is used to prove the individual genius of the artist Tintoretto, leading inexorably to Tietze's conclusion that, "Works in which pupils certainly had a considerable share—as for instance the two mighty late works in San Giorgio Maggiore—are among his most important and most personal creations." Constructions such as this make it all but impossible to disentangle Robusti from her father. Since women were not credited with artistic genius, an art history committed to proving male genius can only subsume women's contributions under those of men. Although in many extant Tintoretto portraits an "amazing variability of brushstroke" is detected, this has not led to new interpretations of workshop production that differ significantly from conventional views of individual creation.

It is widely assumed that Robusti assisted in the preparation of large altarpieces, as did all workshop assistants. Yet surely we should question Francesco Valcanover's 1985 assertion that in the 1580s, "assistants were largely confined to working on less important areas of the canvas, not only because of the family tie and the submission that could be expected but also because of the imperiousness of the recognized master that Tintoretto had by now become . . . What responsibility they may have been allowed must therefore have been partial and at best modest." It is clear from Robusti's renown by the 1580s that she had achieved considerable status as a painter, although we do not know precisely what that meant. Nor do we know how it related to her continuing participation in the workshop. The model Valcanover assumes for the Tintoretto workshop is more conservative and hierarchical than that in many other sixteenth-century artists'

studios, but we lack the documentary evidence that might revise his view.

The imposition of modern views of originality and artistic individuality on workshop production obscures the actual development of painters like Robusti and her brother Domenico by subsuming them entirely under the name Tintoretto despite contemporary evidence of independent achievement. Although it is clear that as a female member of Tintoretto's household Robusti was subservient and that her short life resulted in limited production, it is modern scholarship which has buried her artistic life under that of her father and brother. Rather than seeing the workshop as a site of varied production, modern scholars have redefined it as a place where lowly assistants painted angels' wings while a "master" artist breathed life into the Madonna's features. Even Ridolfi's remark about the slackening of Tintoretto's "fury for work" upon Robusti's death in 1590, which he and others have attributed solely to a father's grief at the death of a beloved daughter, demands rereading in the light of the loss of so capable an assistant.

By the nineteenth century, interest in Robusti expressed itself primarily by transforming her into a popular subject for Romantic painters. Attracted by the familial bonds and the melancholy of her early death, they recast her as a tubercular heroine passively expiring as she stimulated her father to new creative heights. Léon Cogniet's *Tintoretto Painting His Dead Daughter*, exhibited at the Musée Classique du Bazar Bonne-Nouvelle in 1846, influenced both Karl Girardet and Eleuterio Pagliano to produce works on the same subject. They were followed by Philippe Jeanron's *Tintoretto and His Daughter* of 1857, in which the female painter has become a muse and model for her father. During this period Robusti also figured in a novel by Georges Sand and a play by the painter Luigi Marta, *Tintoretto and His Daughter*. First staged in Milan in 1845, the play includes a deathbed scene in which the dying young woman now inspires Paolo Veronese.

The bizarre but all too common transformation of the woman artist from a producer in her own right into a subject for representation forms a *leitmotif* in the history of art. Confounding subject and object, it undermines the speaking position of the individual woman artist by generalizing her. Denied her individuality, she is displaced from being a producer and becomes instead a sign for male creativity. Zoffany's depictions of Kauffmann and Moser turned them into portrait types in which their individual features are

barely discernible. Robusti's metamorphosis into a dying muse turns her into an ideal of quietly suffering femininity.

The second case concerns the pressure that financial greed exerts on correct attribution. Since the monetary value of works of art is inextricably bound up in their attribution to "named" artists, the work of many women artists has been absorbed into that of their better-known male colleagues. Although not restricted to the work of women, such misattributions have contributed to the perception of diminished production by women. Other women have suffered from the overattribution of inferior work to them. To reassemble the *oeuvre* of the eighteenth-century Venetian painter Giulia Lama, Germaine Greer reported, scholars were forced to borrow from the work of Federico Bencovich, Tiepolo, Domenico Maggiotto, Francesca Capella, Antonio Petrini, Jan Lyss, and even Zurbarán. Thus it comes as no surprise that Judith Leyster, one of the best-known painters of seventeenth-century Holland, was almost completely lost from history from the end of that century until 1893, when Cornelius Hofstede de Groot discovered her monogram on *The Happy Couple* (1630) which he had just sold to the Louvre as a Frans Hals.

Judith Leyster, the daughter of a Flemish brewer, was born in Haarlem in 1609. In 1628 she moved with her family to Vreeland, near Utrecht. Her early work shows the influence of Hendrick Terrbrugghen and the Utrecht Caravaggisti. The family returned to Haarlem in 1629 and it is probably at this time that she entered the studio of Frans Hals. She was admitted to the Guild of St. Luke in Haarlem in 1633 and in 1636 married the genre painter Jan Molenaer, with whom she had three children. Her production appears to have lessened significantly after this. The fact that in 1635 Leyster is recorded as having three male pupils is a good index of her status as an artist, as is her inclusion in Samuel Ampzing's description of Haarlem in 1627; thirty years later she seems to have been completely forgotten.

As early as the eighteenth century, when Sir Luke Schaub acquired *The Happy Couple* as a Hals, her work had already begun to disappear into the oeuvres of Gerard van Honthorst and Molenaer, as well as Hals. Prices for Dutch painting remained painfully low until the latter part of the nineteenth century when the emergence of "modern" art with its painterly surfaces and sketch-like finish, the aesthetic tastes of the British royal family, and the appearance of wealthy private collectors all contributed to a burgeoning demand for Dutch paintings. As late as 1854 the connoisseur Gustav Waager could write

3　Judith Leyster *The Happy Couple* 1630

4　Judith Leyster *The Jolly Toper* 1629

of Hals that, "the value of this painter has not been sufficiently appreciated;" by 1890 demand outpaced supply.

In the early 1890s, when Hals prices were rising dramatically, Leyster's name was known, but no work by her hand had been identified. Hofstede de Groot's discovery that the Louvre's *Happy Couple* belonged to Leyster led to the reattribution of seven paintings to her. In 1875 the Kaiser-Friedrich Museum in Berlin had purchased a Leyster *Jolly Toper* as a Hals; a work sold in Brussels in 1890 bore her monogram crudely altered to read as an interlocking F.H. Another *Jolly Toper*, acquired by Amsterdam's Rijksmuseum in 1897, and one of "Hals's" best-known works, bears her monogram and the date 1629. Her emergence as an artist in her own right, however, was blurred in turn by her close connection to Hals and the many copies after Hals subsequently attributed to her. The attributions in Juliane Harms's series of articles on Leyster published in 1929 have been challenged by de Groot and, more recently, by Frima Fox Hofrichter, author of a forthcoming *catalogue raisonnée*.

Leyster's work, though painted in the manner of Hals, is not the same. Nevertheless, the ease with which her works have been sold as his in a market eager for Hals at any price offers a sober warning to art

4

historians committed to a view of women's productions as obviously inferior to those of men. "Some women artists tend to emulate Frans Hals," noted James Laver in 1964, "but the vigorous brushstrokes of the master were beyond their capability. One has only to look at the work of a painter like Judith Leyster to detect the weakness of the feminine hand." Yet many have looked and not seen; the case of Judith Leyster offers irrefutable evidence of the ways that seeing is qualified by greed, desire, and expectation.

That there is a direct relationship between what we see and what we expect to see is nowhere clearer than in the case of three well-known "David" paintings in American museum collections. The Metropolitan Museum of Art's *Portrait of Mademoiselle Charlotte du Val d'Ognes* (c. 1801) was purchased as a David for $200,000 in 1922 under the terms of a bequest. In 1952, The Frick Collection purchased a *Portrait of Antonio Bruni* (1804) through Knoedler & Co., and in 1943 the Fogg Art Museum at Harvard University acquired a *Portrait of Dublin-Tornelle* (c. 1799) from a bequest. All three were believed to be by David.

Jacques-Louis David, chronicler of the Revolution and painter to Emperor Napoleon, was France's foremost artist from the 1780s until his exile in 1816. As a popular teacher when reforms initiated by the Revolution had opened the Salons to unrestricted participation by women (the number of exhibiting women artists increased dramatically from 28 in 1801 to 67 in 1822), David left his imprint on the work of a number of women artists. Moreover, he encouraged his women pupils to paint both portraits and historical subjects, and to submit them regularly to the Salon. George Wildenstein's publication of a list of all the portraits exhibited at the Salon in Paris between 1800 and 1826 greatly aided attempts to sort out the profusion of portraits executed in the Davidian style. It contributed directly to the reattribution of the *Charlotte du Val d'Ognes* to Constance Marie Charpentier in 1951, the *Portrait of Antonio Bruni* to Césarine Davin-Mirvault in 1962, and that of *Dublin-Tornelle* to Adélaide Labille-Guïard in 1971. All three women were followers or pupils of David and their portraits, like the works by David which inspired them, are characterized by the strong presence of the sitter against simple, often dark backgrounds, clarity of form, academic finish, and candid definitions of character. The existence of three such outstanding examples of late eighteenth-century portraiture should provoke future art historical investigation into David's role as a teacher of women.

22

The finding during reattribution to lesser-known artists that works of art are "simply not up to the high technical standards" of the "Master" is common. The shifting language that often accompanies reattributions where gender is an issue is only one aspect of a larger problem. Art history has never separated the question of artistic style from the inscription of sexual difference in representation. Discussions of style are consistently cast in the terms of masculinity and femininity. Analyses of paintings are replete with references to "virile" handling of form or "feminine" touch. The opposition of "effeminate" and "heroic" runs through classic texts like Walter Friedlaender's *David to Delacroix*, where it is used to emphasize aesthetic differences between the Rococo and Neoclassical styles. Such gendered analogies make it difficult to visualize distinctions of paint handling without thinking in the terms of sexual difference. The case of *Charlotte du Val d'Ognes* is also a revealing example of how expectations about gender color "objective" viewing and its qualitative evaluations.

André Maurois, although not an art historian, had concluded of the Metropolitan's painting that it was "a perfect picture, unforgettable." The museum itself had identified the work as exemplary of "the austere taste of the time." Yet in 1951 Charles Sterling, arguing that the painting was not by David, asserted that the "treatment of the skin and fabric is gentle" and "the articulation lacks correctness." Finally, he stripped the work entirely of its former stature; "Its poetry literary rather than plastic, its very evident charms and cleverly concealed weaknesses, its ensemble made up of a thousand subtle artifices all seem to reveal the feminine spirit." One is forced to wonder not only how such characterizations will hold up in the light of recent allegations that the work is not by Charpentier after all, and may well have been painted by either Gerard or Pierre Jeuffrain, but also how Maurois's characterization so quickly turned to "cleverly concealed weaknesses" in the eyes of the beholder. It is as if Charpentier herself had set out to dupe her audience! Not until 1977, twenty-six years after Sterling's article appeared, did the Metropolitan Museum remove David's name from the label. In 1980 the label was changed again to read "unknown French painter."

The cases of Marietta Robusti, Judith Leyster, and the "Davids" reveal the role played by modern assumptions in the aesthetic evaluation of works of art. The existence of these and other falsely attributed works by women artists in major museum collections continues to challenge easy assumptions about "quality." Using

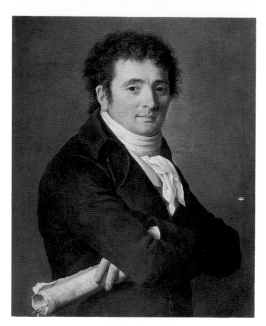

5 Adélaide Labille-Guïard
Portrait of Dublin-Tornelle c. 1799

6 Césarine Davin-Mirvault *Portrait of Antonio Bruni* 1804

examples like that of Charpentier, feminist art historians have continually exposed the gender biases of art historical language. The word "artist" means man unless qualified by the category "woman." Feminizing the term "Old Masters," as Elizabeth Broun and Ann Gabhart did in their 1972 exhibition of women artists at the Walters Art Gallery in Baltimore, collapses an original speaking position of authority into a sexualized pun.

In traditional art history, literary evidence is used to "prove" visual interpretations. Research by feminist art historians has contributed to demonstrating that literary sources themselves have been appropriated to particular ideologies and cannot be uncritically applied to works of art. Roland Barthes and others proposed that we explore the idea of the text as a methodological field in which writer, reader, and observer (critic) function equally in formulating meaning. The historical texts need constant rereading as we attempt to understand better the problematic of femininity and the role of images in the social production of meaning. The brief survey that follows indicates how writing about art has confused the issue of women artists by inscribing social constructions of femininity on them.

24

7 Constance Marie Charpentier (attributed to) *Portrait of Mademoiselle Charlotte du Val d'Ognes* c. 1801

"It is a great marvel that a woman can do so much," noted the German painter Albrecht Dürer in 1520 after purchasing an illuminated miniature of Christ by the eighteen-year-old painter Susan Hornebout for one florin. By the nineteenth century, the polarization of male and female creativity was complete. "So long as a woman remains from unsexing herself, let her dabble in anything," notes one commentator. "The woman of genius does not exist. When she does, she is a man." Quotes such as these reveal an overwhelmingly inconsistent pattern of recognition and denial, constructing and reiterating stereotyped categories for women's productions which have come to be seen as natural, but which are, in fact, ideological and institutional. Dürer is but one of a series of writers who record the names of prominent women artists and celebrate their achievements, but simultaneously emphasize their status as exceptions. Eliding artistic achievement and "feminine" accomplishment, they put the woman artist in a context in which artistic genius, the final measure of achievement, is a male prerogative. The humanist ideals which inform these texts over three centuries continue to dominate the teaching of art history despite current challenges.

The first consistent attempt to document the lives of Italian artists, and the work which set the tone for much subsequent commentary, was Vasari's *Vite de' . . . Pittori Scultori e Architettori . . .*, first published in 1550, revised and expanded by the author in 1568. Vasari saw in his own culture, that of sixteenth-century Florence, a rebirth of the values and ideals of the classical past. He traced the development of Renaissance culture from the thirteenth century to the sixteenth, using artist's biographies to establish the artistic greatness that he considered culminated in Michelangelo's work. Although Vasari distinguishes few artists of his day as inspired by the genius that invokes divinity, and none of them are women, the second edition of his *Vite* mentions at least thirteen women artists. Vasari's work enables us to identify the first prominent women artists of Renaissance Italy, but it draws its vision of the woman artist from multiple discourses on women ranging from medical knowledge and antique sources to medieval literature and contemporary treatises on female deportment. Vasari's praise of women is genuine, but it is qualified. To the woman artist belongs diligence rather than invention, the locus of genius. Should women apply themselves too diligently, notes Vasari in his discussion of the sculptor Properzia de' Rossi, they risk appearing "to wrest from us the palm of supremacy." While men can achieve nobility through their art, women may practice art only

because they are of noble birth and/or deportment. Above all, Vasari's model for the woman artist reflects the growing Renaissance subordination of female learning and intellectual skill to rigid prescriptions about virtue and deportment.

Vasari's model for naming women artists is Pliny the Elder (AD 23/24—79) whose *Historia Naturalis*, in addition to discussing the origins of painting and sculpture in the classical world, mentions the names of six female artists of antiquity. Three are Greek women painters who lived before his time: Timarete, Aristarete, and Olympia, about whom he provides no information, either biographical or historical. Of the remaining three, all Hellenistic artists, two are identified as the daughters of painters. Pliny relates nothing about Kalypso and tells us only that Helen of Egypt was known for painting a *Battle of Issus* which included Darius and Alexander. Iaia of Kyzikos (sometimes identified as Laia or Lala of Cizicus) was famed for her portraits of women, worked with amazing speed and was said to have outranked her male competitors while remaining "perpetua virgo." Content to catalogue briefly, Pliny neither analyzes nor describes works of art. Nor did he concern himself with the daily lives and personalities of the artists.

The first edition of Vasari's *Vite* included the female painters cited by Pliny; the second recorded their descendants—Suor Plautilla, a nun and the daughter of the painter Luca Nelli, who painted a *Last Supper* (now in the refectory of Santa Maria Novella in Florence); Lucretia Quistelli della Mirandola, a pupil of Alessandro Allori; Irene di Spilimbergo, who studied with Titian but who died at eighteen having completed only three paintings; Barbara Longhi, the daughter of the Mannerist Luca Longhi; five female miniaturists; Sofonisba Anguissola, the best-known woman painter of sixteenth-century Italy, and her sisters; and three Bolognese women: Properzia de' Rossi, Lavinia Fontana and Elisabetta Sirani—as proof that Renaissance Italy could claim its own women of learning and achievement.

Not content merely to identify the better-known of these women, as did his classical sources, Vasari also situated them in relation to a vast body of Renaissance treatises on the education and deportment of women which included hundreds of books on the subject produced between 1400 and 1600. Distinguishing intellectual capabilities from deportment, Vasari reports that the sculptor de' Rossi was not only excellent in household matters, but was also very beautiful and played and sang better than any woman in her city, while Lavinia Fontana, the daughter of the Bolognese painter Prospero Fontana, was from a

8 cultured household. De' Rossi's relief, *Joseph and Potiphar's Wife*, is praised for being, "A lovely picture, sculptured with womanly grace and more than admirable." Qualities such as tenderness and sweetness are as desirable in the woman artist as are the "grace, industry, beauty, modesty and excellence of character" that Vasari saw combined with "all the rarest qualities of the mind" in the painter Raphael Sanzio. If women artists lack the spark of genius and are sometimes forced to labor diligently rather than work with facility, they are nevertheless worthy of great praise.

 The noble birth, good education, and deportment that Vasari identifies with women like Sofonisba Anguissola, however, are not merely female traits affirming sexual difference but are signs of class and of the newly elevated social status of the artist. Descriptions such as these reassured Vasari's readers that women artists conformed to the social expectations and duties of noblewomen of the period, removing them from the satiric barbs often directed at middle- and lower-class women. Praise for women's achievements is part of a sexual control in which intellectual and artistic freedoms might be exchanged for rigid adherence to the demands of chastity.

 Humanist treatises on the nature and education of the Renaissance woman, while advocating the education of women, particularly noblewomen, so that they might be better wives and mothers, and more virtuous exemplars of the Christian ideals of chastity and obedience, also set forth significantly different ideals for men. Often they reiterate the biases of medieval Christian tracts which reflected both the doctrinal opposition of Eve and Mary and a long history of misogynist writing about women. The new man's life of action and self-sufficiency represents a clear break with the rigid hierarchies of the feudal world, but women remain locked in a medieval model which still stresses chastity, purity and obedience.

 Boccaccio's *De Claris Mulieribus* (1355–59), a collection of 104
10 biographies of real and mythical women drawn from Greek and Roman sources like Plutarch's *Moralia*, was the first Italian humanist work to concern itself entirely with the improvement of women's minds and the first of many Renaissance treatises that reinforce woman's subordinate position. Plutarch, challenging Thucydides's remark that the best woman is the one about whom there is least to say, had argued that only by placing women's lives beside those of men was it possible to understand the similarities and the differences between the virtues of men and women and had concluded by suggesting that paintings by men and women might very well exhibit

28

8 Properzia de' Rossi *Joseph and Potiphar's Wife* c. 1520

the same characteristics. Boccaccio opened his treatise by recalling these women. "By emulating the deeds of ancient women," he began, "you spur your spirit to loftier things." Among the ancient women proposed as models by Boccaccio are three women painters of antiquity: Thamyris, Irene, and Marcia. "I thought that these achievements were worthy of some praise," he notes, "for art is very much alien to the mind of woman, and these things cannot be accomplished without a great deal of talent, which in women is usually very scarce." Boccaccio departs from his antique model in

articulating a specific set of character traits for the ideal woman. She must be gentle, modest, honest, dignified, elegant in speech, pious, generous in soul, chaste, and skilled in household management. By the time Vasari's *Vite* appeared, Boccaccio's model was well in place in works such as Fra Filippo da Bergamo's *De Claris Selectibus Mulieribus* of 1497, but it had also provoked rebuttals by women writers, the most famous of whom was Christine de Pisan.

In the *Cité des Dames* (1405), Christine de Pisan, a French writer born in Italy and the first professional woman writer in Western history, responded to Boccaccio by constructing an allegorical city in which great and independent women lived safe from the slanders of men. Pisan belonged to the transitional period between the late Middle Ages and the Renaissance. The daughter of an Italian-born doctor and astrologer at the court of King Charles V of France, she took up writing after the death of her husband and became a respected writer on moral questions, education, the art of government, the conduct of war, and the life and times of Charles V. She was also a renowned poet and the author of two major works on the lives and training of women at the end of the Middle Ages. Pisan's attack on Jean de Meun, the author of the second part of the *Roman de la Rose*, that great medieval tribute to courtly love with its vicious denunciation of women and marriage, is remarkable for the age. She cannot understand, she says, why men write so scathingly about women when they owe their very existence to them. And she asks, in a question rephrased throughout history, how can women's lives be known when men write all the books?

Pisan's allegorical city includes female saints and contemporary women, as well as the women of antiquity collected by Boccaccio. She offers evidence of women's great achievements in place of Boccaccio's disdainful references to women's "inherent inferiority" and she includes examples to prove her points. Among those she lists is a contemporary Parisian painter of miniatures named Anastaise, whose work has not yet been identified by modern scholars.

Little more than a hundred years later, Baldassare Castiglione reopened the debate between the medieval view of woman as a defect or mistake of nature and the Renaissance humanist vision of male and female as separate and complementary though not equal. Castiglione's influential work *Il Libro del Cortegiano* contains a fictionalized discussion about the characteristics of the perfect courtier at the court of Urbino in 1528 and devotes considerable space to a discussion of the role of woman in political and social life. On the one hand,

Castiglione's Renaissance lady of the court is presented as the equivalent of the courtier with the same virtues of mind and education. On the other, education and culture are accomplishments only for the noblewoman. Her task is to charm; his is to prove himself in action. Again, it is beauty and moral qualities which constitute perfection for the Renaissance woman.

Vasari's *Vite*, while it was an important model for later chroniclers of art and initiated a tradition in which exceptional women artists did have a place in art history, reflected the multiple discourses shaping an ideal of femininity for the Renaissance woman. Moreover, it initiated a model for "reading" the achievements of women artists which was quickly adapted by subsequent generations of commentators. Women artists appear in Vasari's *Vite* in ways which would come to characterize their relationship to painting and sculpture in the literature of art from the sixteenth to the twentieth centuries: as exceptions; as the authors of works small in scale and modest in conception at historical moments which equated size with profundity, importance, and "authority;" as evidence of the modern world's right to the mantle of antiquity; as signs of talent legitimized for women by combination with other, "feminine" virtues; as defining

9 Christine de Pisan in her study, miniature from *The Works of Christine de Pisan*, early fifteenth century

10 "Thamar" from Boccaccio's *De Claris Mulieribus* 1355–59

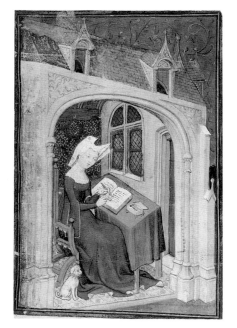

and affirming "essential" differences between men and women in choice of subject and manner of execution; and ultimately, at least implicitly, as the proof of masculine dominance and superiority in the visual arts.

Throughout the sixteenth and seventeenth centuries the literature of art continued to record the presence of exceptional women artists. In Italy, Ridolfi and other seventeenth-century commentators followed Vasari's model, listing the women artists of antiquity before turning to the present. Ridolfi's *Meraviglie dell'Arte*, published in 1648, contains only Spilimbergo and the contemporary painters Fontana, Chiara Varotari, and Giovanna Garzoni, beginning a tradition whereby the names of women artists appear in, and disappear from, the literature with astonishing arbitrariness.

During the sixteenth and seventeenth centuries, Italian writing on art became increasingly partisan as the work of women artists, like that of their male contemporaries, was annexed to the desires of male writers to glorify specific cities and their artists. The achievements of women artists are cited to prove the range of artistic talent in uniquely cultured and creative cities. Thus Count Malvasia, director of the Accademia del Nudo and an influential nobleman and discriminating collector in seventeenth-century Bologna, opened his *Felsina Pittrice* of 1678 with an attack on Vasari and his bias toward Florentine painters; "I will not fight here over the origins of painting, that is over how, when and from whom it was born. I will not record the different learned opinions of ancient writers. I am not writing on art, but on artists, or rather only the artists of my native city." He then took personal credit for the development of the painter Elisabetta Sirani whose fame was used to prove the uniqueness of Bologna. Anguissola, Fontana, and Fede Galizia are isolated at the bottom of a list of male portraitists, but Malvasia's praise of Sirani, which continues the tradition of confounding person and painter, is part of a larger celebration of Bologna's newly won status as a producer of artists who rival those of Rome; "I lived in adoration of that merit, which in her was of extreme quality, and of that virtue, which was far from ordinary, and of that incomparable humility, indescribable modesty, inimitable goodness."

Although northern European commentaries followed the Italian model, they are generally more moderate in tone. The earliest northern European commentary, Karel van Mander's *Het Schilder Boeck* published in 1604, omitted the five Netherlandish women mentioned by Vasari, but the works of subsequent Dutch and Flemish

authors acknowledge the significant numbers of women artists active in the Northern Renaissance. The third edition of Arnold Houbraken's *Groote Schouburgh* (1721) listed eleven women painters. Yet despite a flurry of interest in women artists in seventeenth-century Holland, where the Protestant Reformation had liberalized attitudes toward women, by the eighteenth century commentators had begun to shift the emphasis toward what became a primary aesthetic concern of that age: the identifying and defining of a "feminine sensibility" in the arts. Lairesse, writing on flower painting in his *Het Groot Schilderboeck* (1707), commented that, "it is remarkable that amidst the various choices in art, none is more feminine or proper for a woman than this."

Women were isolated from the theoretical and intellectual debates that dominated the arts because in most cases they were barred from membership of the academies in Rome and Paris, the major centers of art education during the eighteenth century. Excluded from life drawing classes, they were insufficiently trained to work in prestigious genres like history painting. The birth of modern art criticism during this period renewed interest in a hierarchy of genres in which history painting reigned supreme.

The eighteenth century opened with the Rococo period and a courtly, elegant style in which artifice, sentiment, and pleasure dominated the concerns of aristocratic men and women. By the second half of the century, philosophical inquiries into the nature of sexual difference had begun to reshape gender identity. A transition took place from older forms of public life to the modern division between public and private that underlies the formation of the modern family. In parallel, a modern notion of gender was built around the opposition between a public sphere of male activity and a private and female domestic realm.

Although seventeenth-century French writers celebrated "feminine reason," and writers from Corneille to Descartes admired female intelligence and perception, during the eighteenth century a critique of women became the basis for aesthetic judgments. Jean de la Bruyère, following the lead of classical authors like Quintillian who had contrasted "made-up" emasculated rhetoric with the healthy eloquence of the virile orator, drew an analogy between a critique of women and a condemnation of make-up. Carried over to representation, such analogies became the basis for denouncing overly refined brushwork and immoderate pleasure in color. Charles Cochin, writing during the reign of Louis XV, warned artists against applying

color as if they were women putting on make-up. Artists working in the newly fashionable medium of pastel used many of the same ground pigments that found their way onto women's faces. Casting art in the forms of femininity has persisted to the present. Writing about the Rococo style in 1964, Jean Starobinski cautioned that it "could be defined as a flamboyant Baroque in miniature: it crackles and scintillates, making the mythological images of authority childlike and effeminate. It is the perfect illustration of a form of art in which a weakening of underlying meaningful values is combined with an expansion of elegant, ingenuous, facile, smiling forms. . . ."

Aesthetic debates between nature and artifice took place in the context of Enlightenment attempts to apply scientific models to the study of human nature. Central to these was the attempt to determine which characteristics and qualities of human existence stem from nature, and thus from unchanging natural law, and which aspects of our lives result from custom and man-made laws. Voltaire, Antoine Thomas, Montesquieu and others contributed to a natural law theory of equality, but a significant group of other thinkers explicitly denied the equality of men and women on grounds of law or nature. It is Jean-Jacques Rousseau's ideas on the proper place of women in the social and political order which became identified with the new, modern world. His argument is important both because it supported the separation of work-place and home which underlay the development of modern capitalism and because it is consistent with a lengthy Western tradition which has rationalized the separation and oppression of women in patriarchal culture. Rousseau not only believed women to be naturally inferior and submissive, but he also put great emphasis on the notion that the sexes should be separated. Believing that women lacked the intellectual capacities of men, he argued that they had no ability to contribute to art and the work of civilization apart from their domestic roles. The influence of Rousseau lay behind an increasing identification of femininity with nature in the second half of the eighteenth century. Although his position can be seen as a response to the very real political and artistic power held by a number of women earlier in the century, and part of the complex dialogue explored here in Chapter 5, by the end of the century it dominated the popular imagination. In the novel *Emile*, published in 1762, Rousseau presents a lengthy list of feminine qualities which he considers innate, among them shame, modesty, love of embellishment, and the desire to please. "I would have you remember, my dear," Samuel Richardson wrote in a letter to his

34

daughter in 1741, "that as sure as anything intrepid, free, and in a prudent degree bold, becomes a man, so whatever is soft, tender, and modest, renders your sex amiable. In this one instance we do not prefer our own likeness; and the less you resemble us the more you are sure to charm. . . ." The rigid polarizing and "naturalizing" of sexual difference came to dominate discussions of women's role in the arts. Not only was women's work evaluated in terms of what it revealed of its maker's "femininity," it was also consigned to media and subjects now considered appropriate and "natural" to women. "To model well in clay," notes George Paston in his *Little Memoirs of the Eighteenth Century*, "is considered as strong minded and anti-feminine but to model badly in wax or bread is quite a feminine occupation."

As the division between the Man of Reason and the charming but submissive woman widened, women had less access to the public sphere which governed the production of art. The characterization of women's art as biologically determined or as an extension of their domestic and refining role in society reached its apogee in the nineteenth century. It was most clearly expressed in a bourgeois ideology which defined separate spheres for activity by men and women, including the practice of art. John Ruskin's "angel in the house" presided over a world in which class and gender were strictly defined, female labor devalued, and the family increasingly privatized. "Male genius has nothing to fear from female taste," wrote Léon Legrange in the *Gazette des Beaux-Arts* in 1860; "Let men conceive of great architectural projects, monumental sculpture, and the most elevated forms of painting, as well as those forms of the graphic arts which demand a lofty and ideal conception of art. In a word, let men busy themselves with all that has to do with great art. Let women occupy themselves with those types of art which they have always preferred, such as pastels, portraits, and miniatures. Or the painting of flowers, those prodigies of grace and freshness which alone can compete with the grace and freshness of women themselves."

The demand that women artists restrict their activities to what was perceived as naturally feminine intensified during the second half of the century, particularly in England and America. The growing numbers of women pursuing advanced training in art in these countries led many women to negotiate new relationships with prevailing ideologies of femininity. A few, such as Elizabeth Thompson and Rosa Bonheur, were isolated as "exceptional" and freed from the constraints of their femininity, but critics continued to evaluate the work of most women in terms of gender. The novelist

35

and critic J. K. Huysmans located Mary Cassatt's ability to paint children in her womanhood rather than her artistic skill; "Woman alone is capable of painting childhood . . ." he declared. Remarks such as these advance ahistorical and unchanging views of "feminine" nature. And they ignore the commitment, hard work, and sacrifices which many women artists have made in order to contribute to the shaping of visual culture.

It is also to nineteenth-century art history that we must look for the origin of the categories "woman artist" and "female school." The wholesale rewriting of the history of art as separate and distinct lineages for men and women laid the groundwork for twentieth-century accounts in which, once separated, women and their art could easily be omitted altogether. Ruskin's was the dominant voice of the period, but it was Anna Jameson who was the first writer to define herself as a specialist in the history of art. Jameson also believed in the existence of a specific and separate female art, equal to that of men but different from it; "I wish to combat in every way that oft-repeated but most false compliment unthinkingly paid to women, that genius has no sex; there may be equality of power, but in its quality and application there will be and must be, difference and distinction."

Jameson's *Sacred and Legendary Art* (1848) outlined woman's not inconsiderable place within the Christian tradition and its art. Her association of charity and purity with a female point of view and her emphasis on character, emotion, and moral purpose as feminine virtues were quickly adopted by her Victorian audience. A number of books about women soon followed, with most authors declaring themselves in favor of what women had done, often expressing a belief in the inevitability of equality as an historical certainty, and quick to assume and articulate a biologically determined sphere of activity for women. The first of these were Ernst Guhl's *Die Frauen in der Kunstgeschichte* (1858) and Elizabeth Ellet's *Women Artists in All Ages and All Countries* (1859). They were followed by Ellen Clayton's *English Female Artists* (1876), Marius Vachon's *La Femme dans l'Art* (1893), Clara Clement's encyclopedic *Women in the Fine Arts from the 7th Century BC to the 20th Century* (1904), Walter Sparrow's *Women Painters of the World* (1905), and Laura Ragg's *Women Artists of Bologna* (1907). Their arguments serve as a caution that we must look at art historical and critical evaluations of art produced by women with a healthy skepticism, and they reveal why it is that much contemporary feminist art has chosen language as the site of the struggle over content and meaning in art.

The Middle Ages

The contemporary practice of distinguishing between the fine arts and the crafts originated in the reclassifying of painting, sculpture and architecture as liberal arts during the Renaissance. The general exclusion of women from highly professionalized forms of art production like painting and sculpture, and the involvement of large numbers of women in craft production since the Renaissance, have solidified a hierarchical ordering of the visual arts. Feminism in the arts has protested against the distinction between "art" and "craft" grounded in their different materials, technical training, and education (see Chapter 11) and has rejected inscriptions of "feminine" sensibility on craft processes and materials, but it has also pointed out the dangers of sanctifying an artisanal tradition by renaming it "art." A contemporary return to pre-Renaissance values and a feudal division of labor is not possible, but we can look to the Middle Ages for models of artistic production which are not based on modern notions of artistic individuality.

Our knowledge about the daily lives and customs of women in the Middle Ages owes much to representations emphasizing their labor, as in a thirteenth-century manuscript illumination of a woman milking a cow. Similar scenes—carved onto the capitals of Romanesque and Gothic churches, embroidered into tapestries, and painted with jewel-like precision in the borders of manuscripts—offer a diurnal counterpart to the sacred imagery of the Virgin Mary and Child that dominates medieval visual culture. Whether laboring in the service of God or for daily subsistence, the lives of most medieval men and women were organized around work. Although the names of a number of powerful women who were the patrons and benefactors of such representations are known today, we know little of the authors, for few of them signed their names and the preservation of their individual biographies had no role to play in their productions.

The Christian church, as the dominant force in Western medieval life, organized communication and culture, as well as religion and

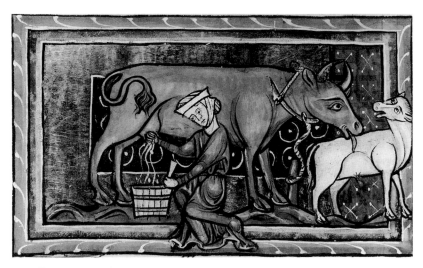

11 Illustration in a Bodleian Library manuscript, Ms 764, f. 41v.

education. Assuming what Foucault called "the privileges of knowledge," the church exercised the religious and moral power which gave shape to human expression; "The need to take a direct part in spiritual life, in the work of salvation, in the truth which lies in the Book—all that was a struggle for a new subjectivity." The church's hierarchical organization reinforced the class distinctions in society; its patriarchal dogma included a full set of theories on the natural inferiority of women which can be traced back to ancient Greece and the Old Testament. While medieval writers and thinkers discussed at length issues concerning women and their proper status in society, Christian representation was focused on the opposition of Eve and Mary, seducer and saint.

Recent careful work by social historians has illuminated the ambiguous situation of women between the fourth and the fourteenth centuries. Scholars have demonstrated significant differences in men's and women's rights to possess and inherit property, in their duties to pay homage and taxes, their civil and legal rights, and their rights to present evidence or serve as judges or priests. The confusion of sovereignty with personal property (the fief) contributed to the emergence of a number of powerful upper-class women at a time when most other women were restricted to the home and economi-

cally dependant on fathers, husbands, brothers, or sovereigns. The rigidity of social divisions, and the gulf which separated upper and lower classes, meant that upper-class women had more in common with the men of their class than with peasant women.

While women's social roles remained circumscribed by a Christian ethic that stressed obedience and chastity, by the demands of maternal and domestic responsibility, and by the feudal legal system organized around the control of property, there is evidence that their lives, as those of men, were also shaped by economic and social forces outside ecclesiastic control, at least during the period of the early Middle Ages. Women's lives do not appear to have been privatized and their social functions subordinated to, or defined by, their sexual capacities. Symbiotic modes of production and reproduction, no clearly defined physical boundaries between domestic life and public and economic activity, and the physical rigors of medieval life, encouraged women to take significant part in the management of family property and in general economic life. And there is evidence that they participated in all forms of cultural production from masonry and building to manuscript illuminating and embroidery.

Most art during this period was produced in monasteries. Access to education and the convent, the center of women's intellectual and artistic life from the sixth to the sixteenth centuries, was often determined by noble birth. Historians of the medieval church divide its history into two periods separated by the late eleventh-century reforms of Pope Gregory VII (1073–85). The division is important: not only did the Gregorian Reform, which coincided with the development of feudal society, lead to a dramatically restricted role for women in the church and to the emergence of a new tradition of female mysticism, it also emphasized an ideology of divine woman-hood which reached its apogee in the twelfth-century cult of the Virgin Mary. As most medieval painter nuns discussed in feminist art histories belong, in fact, to twelfth-century Germany and the particular political and social forces that defined an expanded place for educated women in that culture, it is necessary to distinguish between early and late medieval production.

The origins of female monasticism in Western Europe can be traced to the founding of a convent by Bishop Caesarius of Arles in AD 512 to be headed by the bishop's sister, Caesaria. "Between psalms and fasts, vigils and readings, let the virgins of Christ copy holy books beautifully," wrote Caesarius. The foundation initiated a tradition of learned women as nuns, for within the convent women had access to

learning even though they were prohibited from teaching by St. Paul's caution that "a woman must be a learner, listening quietly and with due submission. I do not permit a woman to be a teacher, nor must a woman domineer over a man; she should be quiet." During the Middle Ages the convent provided an alternative to marriage, offering a haven for noncomformists and female intellectuals. Although women shared equally with men in conversion to the faith and the learning that accompanied it, they were barred from the forms of power by which the Church exercised control: preaching, officiating in church, and becoming priests. Nevertheless, the Rule of Saint Benedict, which shaped early medieval monasticism, sanctioned the founding of double monasteries in which monks and nuns lived communal lives and often worked side by side. Before their abolition by the Second Council of Nice in 787, many of these monasteries were run by abbesses famous for their learning, among them Anstrude of Laon, Gertrude of Nivelle, Bertille of Chelles, and Hilda of Hartlepool.

Although traditional art history has omitted women from discussions of the productions of the double monasteries, there is considerable evidence that by the eighth century powerful and learned abbesses from noble families ran scriptoria in which manuscripts were copied and illuminated. Little evidence remains as to how they were produced and it is impossible to identify whether the authors or scribes were male or female, yet we can assume from the existence of the double monasteries that both monks and nuns were involved in composing, copying, and illuminating manuscripts. Documents from the period reveal impressive lists of women's names attached to manuscripts after AD 800 when the Convent of Chelles, under the direction of Charlemagne's sister Gisela, produced thirteen volumes of manuscripts including a three-volume commentary on the Psalms signed by nine women scribes. Early medieval saints' lives contain references to female illuminators and a letter written in 735 by St. Boniface to Eadberg, the abbess of Minster in Thanet, thanks her for sending him gifts of spiritual books, and requests that she "copy out for me in gold the epistles of my Lord Saint Peter . . ."

Despite the evidence of women active in British and Carolingian scriptoria, the first documented example of an extended cycle of miniatures worked on by a woman is Spanish. The most remarkable visionary manuscripts of the tenth and eleventh centuries depict the Apocalyptic vision of St. John the Divine in the Book of Revelation. They include a group of manuscripts (there are about twenty-four

known copies with illustrations) containing Commentaries on the Apocalypse compiled around 786 by the Spanish monk Beatus of Liebana (c. 730–798). Their paintings are executed in the distinctive Mozarabic style of Spanish illumination produced by Christian artists strongly influenced by the Moslem formal and decorative tradition. The monk Emetrius worked on the so-called Beatus Apocalypse of Gerona. This manuscript was written and illuminated in a monastery in the mountains of León in northwest Spain by a priest called Senior—who may have assisted in the painting—by Emetrius, whose hand has been identified from an earlier manuscript, and by a woman called Ende. Ende titles herself DEPINTRIX (paintress) and DEI AIUTRIX (helper of God), following the custom of noblewomen of the time. She has been identified with a school of illuminators and limners in medieval Spain which also included the poetess Leodegundia.

The Beatus Apocalypse mingles the fierce visionary and fantastic imagery of St. John's vision with pure ornament and a careful attention to naturalistic detail. Most of the illustrations are in the flat 16 decorative style characteristic of Mozarabic illumination with stylized figures set against broad bands of colors. In other places, rich colors and ornamented grounds are set off by delicate tones and subtle plays of line.

Although we shall perhaps never know the precise role played by Ende and her contemporaries in early medieval illuminations, the modern assumption that only monks worked in the scriptoria is clearly erroneous. By the tenth and eleventh centuries the development of feudalism and the effects of church reform had begun to deprive women of powers they had exercised during the earlier Middle Ages. Only in Germany, where the Ottonian Empire fostered an unprecedented flowering of female intellectual and artistic culture, are we able to trace the work of individual women.

Despite the liabilities of feudalism elsewhere, under it women did not lose all legal rights, status, and economic power. Often they managed large estates while men were at war or occupied elsewhere on business; by the thirteenth century the rapid growth of commerce and city life had even produced a class of urban working women.

The decline of the monastery as a place of female culture and learning in the British Isles can be traced directly to the monastic reforms of the tenth and eleventh centuries. Tenth-century reform in England placed the king as guardian of the rule in monasteries and his queen as guardian and protector of the nunneries. No new abbacies for women were created. Instead, prioresses were placed in charge of

smaller and less important priories subordinated to male abbots. The disappearance of the double monastery, often under the rule of a powerful abbess, gradually led to a diminished tradition of learning for women and a subsidiary role for the convent.

The Norman Conquest of 1066 introduced the feudal system into England. The events leading up to the Norman invasion and culminating in the defeat of Harold at the Battle of Hastings are the subject of the Bayeux Tapestry. Produced around 1086, it is not a tapestry at all but a silk on linen embroidery twenty inches high and more than two hundred feet long. The "tapestry" contains a sequence of separate scenes, each of them dominated by a few images organized to be read horizontally and identified by a running text in simple Latin. The frieze-like figures are stiff and simplified, but there is drama and energy in the story of the journey across the sea, the preparations for battle and, finally, Harold's defeat. It is dominated by three figures—Edward the Confessor, Harold who succeeded him, and William Duke of Normandy. The emphasis is on battles, bloodshed and feasting. A wealth of naturalistic detail in the picturing of carts, boats, costumes, armor, and everyday life infuses the work with a convincing energy and has made the tapestry a rich source of information about the military aspects of medieval life.

The only surviving example of Romanesque political embroidery of the eleventh century, the Bayeux Tapestry has been called the "most important monument of secular art of the Middle Ages." Yet its origins remain obscure, and the history of its production has been distorted by modern assumptions that medieval embroidery was an exclusively female occupation. A tradition identifying Queen Mathilda as the work's main embroiderer can be traced at least to the early eighteenth century even though there is absolutely no evidence for identifying her with the tapestry. In the nineteenth century, as Roszika Parker has shown, the legend of Queen Mathilda's labor became the cornerstone of attempts by writers to confer aristocratic status on the art of needlework practiced by thousands of middle-class women. Recasting embroidery as an aristocratic pursuit, they presented Mathilda as a source of inspiration for women isolated in the home by nineteenth-century ideologies of bourgeois femininity. Parker is alone, however, in suggesting that the tapestry was produced in a professional embroidery workshop by male and female labor; most other historians believe that it was made at an estate or nunnery, possibly in Canterbury or Winchester where embroiderers had long enjoyed royal patronage, and probably by women as

12 Ælfgyva and the
Cleric, from *The
Bayeux Tapestry*
c. 1086

contemporary documents include no mention of male needle-workers.

The Bayeux Tapestry's narrative structure is close to that of the *chansons de geste*. Its actors are military heroes, its subtexts concern loyalty, bravery, treachery, and male bonding through oath-taking and military action. Its organization into registers of words and images affirms a consolidation of power, but it is worth noting that the work's structure and language displace women from power. Among the scores of male figures, there are only three women in the central register. One appears as a mourner in the scene of King Edward on his deathbed, another holds a boy by the hand as they flee from a burning house. The third figure represents the only break in the work's narrative. Although the scene of Ælfgyva and the cleric 12 must have been familiar to eleventh-century audiences, its meaning

43

has been lost in the course of centuries of rewriting history so that it details only the exploits of men. The incident depicted was probably scandalous—the presence of a nude male priapic figure in the margin below may indicate a sexual content—but our inability to identify it today and the general lack of female figures situate women outside the medieval discourse of political power under feudalism.

Even as the status of women was beginning to decline in other parts of Europe, and as cultural production was becoming both professionalized and secularized, great convents continued to flourish as places of learning in Germany, the first area in Europe to reestablish a stable government after the death of Charlemagne in 814 and the disintegration of his empire. By the middle of the tenth century, the German kingdom of Otto I was the most secure power in Europe. Otto's marriage to Adelaide of Burgundy strengthened ties between Germany and Italy; her appearance on coins and her signature on diplomas testify to her political power and prestige. She was a staunch protectress of the Abbey of Cluny and commissioned many books for use in her various foundations. There were other powerful women in Ottonian Germany, including Otto's sister Mathilda, the Abbess of Quedlinburg, who ruled in his name during his absences.

In 947 Otto had invested with supreme authority the Abbess of Gandersheim, a house founded in 852 and led by a series of abbesses drawn from the reigning families. She became, in effect, the ruler of a small, autonomous principality with its own courts, army, coinage, and papal protection. The independence of such royal women may have suited the political needs of the Ottonian dynasty; giving unmarried women of royal blood religious power and intellectual authority was one way of lessening the chances that they would marry potential rivals outside the family.

The presence of well endowed convents encouraged large numbers of women to take up religious lives during the twelfth century, and cults of female saints proliferated alongside the cult of the Blessed Virgin. The output of Ottonian scriptoria was voluminous, and the majority of women illuminators of the Middle Ages were active as part of this cultural flowering. Among them is Diemud of the Cloister of Wessobrun in Bavaria. A sixteenth-century text lists forty-five books by her hand which are distinguished by ornate initial letters. Another nun, named Guda, tells us that she wrote and painted a *Homiliary of Saint Bartholomew*. The contributions of these women to the history of the illustrated book are well documented. They range from a richly illuminated astronomical treatise from Alsace, which

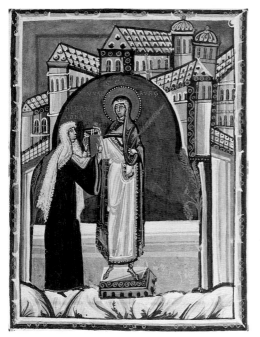

13 *Gospel Book of the Abbess Hitda* showing the Abbess offering her gospel book to the cloister's patron, St. Walburga, c. 1020

14 German psalter from Augsburg, late twelfth century

includes a dedication miniature showing the Virgin flanked by the scribe Guta and the illuminator Sintram, and a representation of the Abbess Hitda offering her Gospel Book to the cloister's patron, St. 13 Walburga (c. 1020), to a charming self-portrait by one Claricia, who dangles with joyous abandon as the tail of the Q in a psalter from 14 Augsburg (c. 1200). Claricia's hand is just one of several in this manuscript, leading Dorothy Miner to conclude on the basis of her dress—uncovered head, braided hair, and a close-fitting tunic under a long-waisted dress with long tapering points hanging from the sleeves—that she was probably a lay student at the convent.

A new type of Christian illuminated encyclopedia emerged during the twelfth century. Lambert's *Liber Floridus*, written in Flanders in 1120 and based on the work of the ancient encyclopedist Isidorus, is one of the earliest examples of the new interest in cosmological, ethical, and eschatological aspects of the world which found its fullest expression in the work of Herrad of Landsberg and Hildegard of

15 Herrad of Landsberg
Hortus Deliciarum fol. 323r,
after 1170

Bingen. Herrad's illustrated encyclopedia, the *Hortus Deliciarum*, or *Garden of Delights*, written between 1160 and 1170, and Hildegard of Bingen's visionary book of knowledge, *The Scivias*, begun in 1142 and completed ten years later, are two of the most remarkable religious compilations by women in Western history. Although neither book was necessarily illustrated by its author, and questions remain as to the specifics of production in both cases, the illustrations and texts are so closely integrated that the works' visual contents cannot be separated from their authors' conceptions. Pioneers of visual autobiography, both women were part of the twelfth-century move toward a more personal spirituality. Yet both were also able administrators and active in the political and social life of their day.

In 1167 Herrad was elected Abbess of Hohenburg near Strasbourg. The *Hortus Deliciarum*, a massive folio of 324 sheets of parchment, had 636 miniatures which were probably executed in a professional workshop in Strasbourg shortly after her death in 1195. Both an anthology and a religious encyclopedia, it includes nearly 1200 texts by various authors, as well as several poems which appear to be in Herrad's hand. In addition to her literary and editorial work, she almost certainly supervised the scheme of the illustrations and she may have contributed to the outline drawings. The manuscript remained in the Abbey of Hohenburg throughout the Middle Ages. Tragically, the bombing of Strasbourg in 1870 destroyed the original and we are left with only a small number of illustrations reproduced in engravings during the nineteenth century and a few fragments with pictures later acquired by the British Museum.

The fullest description of the work comes to us from Engelhardt, a nineteenth-century commentator who remarked on the brilliant smoothness and finish of the original manuscript. The style of the miniatures rests between the conventions of Byzantine illumination and the greater realism of Gothic art, and Engelhardt also pointed out the similarity between certain images and those of Greek ninth-century manuscripts.

Herrad dedicated the *Hortus Deliciarum* to the nuns of her convent: "Herrad, who through the grace of God is abbess of the church on the Hohenburg, here addresses the sweet maidens of Christ. . . . I was thinking of your happiness when like a bee guided by the inspiring God I drew from many flowers of sacred and philosophic writing this book called the *Garden of Delights*; and I have put it together to the praise of Christ and the Church, and to your enjoyment, as though into a sweet honeycomb. . . ." The work opens with a miniature showing six rows of female heads and includes the name of each nun 15 and novice. Among them are the names of the area's landed gentry, suggesting that Hohenburg, like most medieval convents, drew its members from the upper class. Herrad intended the *Hortus Deliciarum* as a compendium of desirable knowledge in religious and secular subjects for the education of the young girls in the convent. Her inclusion on the last page of Relindis, her teacher and predecessor as abbess, offers tangible evidence of the transmission of learning between women in medieval Germany.

The *Hortus Deliciarum* includes a comprehensive history of humankind, as well as a natural history of the world quoted from the variety of authors mentioned in the introduction. Its illuminations

number monumental representations of figures like Philosophy, wearing the garland characteristic of the seven Liberal Arts, narrative pictures from the Old Testament, Gospels, and Acts, scenes from Judgment Day, and allegories of the Virtues and Vices, as well as gardening hints, and scenes from contemporary life. The miniatures which illustrate the Creation are introduced by diagrams and digressions on astronomy and geography.

The subjects of the *Hortus Deliciarum* come from a long tradition in Western and Byzantine art, but their fresh and spontaneous treatment, and the author's close attention to the costumes, life, and manners of her age, have made the work a unique and valuable source for our understanding of life at the time. Herrad's decision to add to each picture the name of every person or implement in Latin or German, or sometimes both, has greatly assisted modern research into medieval terms and their usage.

Late eleventh-century church reform had focused new attention on prohibitions against clerical marriage. Increasing restrictions against ecclesiastical women, including cloistering as a form of social control, had accompanied the rigid imposition of rules of clerical celibacy. During the same period medieval scholars, particularly Thomas Aquinas, were rediscovering Aristotelian thought, as well as that of Hippocrates and Galen with their insistence on the natural inferiority of women. Women made no contribution to the scholastic philosophy and dominant theology which grew out of these debates. They were excluded from the intellectual life of cathedral schools and universities in which students were legally clerics, a rank not open to women. Instead, they turned increasingly to mysticism and, through vivid imagery and inspired commentaries, were influential in an alternative discourse, though one certainly not unique to women.

Hildegard of Bingen left a body of work unparalleled in its range. The texts in which she describes her religious experiences form only a small fraction of her literary output, but they are of particular interest to art historians because of their visionary imagery. Although scholars have noted strong similarities in the drawing in Hildegard's prayerbook and Herrad's *Hortus Deliciarum*, it is not sufficient to consider Hildegard as simply part of a female tradition, for she exerted a profound influence as one of many voices raised in support of the Gregorian Reform.

A great contemplative nun, as well as a politically active woman who corresponded with Henry II of England, Queen Eleanor, the Greek Emperor and Empress, Bernard of Clairvaux, and others,

Hildegard was born in 1098 to well-to-do parents in a Rhineland village. Her father was a knight attached to the court of the Count of Spanheim. Hildegard's childhood visions of shimmering lights and circling stars may have influenced her family's decision to enroll her as a novice in the convent at Disibodenberg at the age of seven or eight. The four-hundred-year-old Benedictine Abbey there had only recently added a community of women under the rule of Jutta, the Count of Spanheim's sister, who took charge of the education of the young Hildegard, training her in scripture, Latin, and music. Hildegard took the vows of a Benedictine nun in 1117 and was elected abbess in 1136.

Hildegard confided the existence of her troubling visions to Bernard of Clairvaux, whose desire to raise the church above worldly concerns through renewed faith and deep mystical contemplation set the moral tone for the period. Recognizing in her a new ally for his efforts to rejuvenate spiritual life, he urged the pope that he, "should not suffer so obvious a light to be obscured by silence, but should confirm it by authority." Papal recognition established Hildegard's reputation as a prophetic voice within the church. In addition to the *Scivias* (begun 1142), *The Divine Works of a Simple Man* (begun 1163), and the *Meritorious Life* (1158), Hildegard wrote sixty-three hymns, a miracle play, and a long treatise of nine books on the different natures of trees, plants, animals, birds, fishes, minerals, metals, and other substances. Her visions encompass much of the scientific and religious knowledge of her time and she has the distinction of being the only woman who has a volume of the church "fathers'" official *Patriologia Latina* devoted entirely to her works.

The *Scivias (Know the Ways of the Lord)* consists of thirty-five visions relating and illustrating the history of salvation. The earliest 17–19 copy, made before her death in 1179, apparently under her direction, though probably not by the nuns of her cloister, has been missing from the Wiesbaden library since World War II. The book opens with the words: "And behold! In my forty-third year I had a heavenly vision. . . . I saw a great light from which a heavenly voice said to me: 'O puny creature, ashes of ashes and dust of dust, tell and write what you see and hear.'" The persona adopted by Hildegard for the expression of her visionary theology is, like those of many other twelfth-century mystics, that of a weak person, a passive vessel into which is poured the word of God. She herself claimed to be nothing more than a receptor, "a feather on the breath of God." A gift from God to a weak but chosen woman, the vision circumvents the

16 Illustration from *The Beatus Apocalypse of Gerona* 975

17 Hildegard of Bingen *Scivias* 1142–52

18 Hildegard of
Bingen *Scivias* f. 1r,
1142–52

medieval Church's denial of power or authority to women. It disrupts
masculine control over knowledge by separating the body of woman
from thought. Conservative by temperament, background, and
upbringing, Hildegard did not challenge the Church's views on the
subjection of women. Her conception of the religious role of woman
derived from a strong sense of female otherness from male authority
and a vision of woman as complementary to man.

 Hildegard's *Scivias* appears to be the first medieval manuscript,
apart from the Beatus Apocalypse, in which the artist uses line and
color to reveal the images of a supernatural contemplation. The
paintings, while stylistically remote from other contemporary
northern European manuscript illuminations, have a freshness and
energy despite their almost naive drawing. They are characterized by
a highly individualized sensibility, and it is reasonable to assume
Hildegard's close supervision in their making. The first miniature
depicts Hildegard and the monk Volmar in the monastery at Bingen
to which Hildegard had moved her nuns in 1147. Two small rooms
with red cupolas and gilded dormer windows frame a larger room.

52

Hildegard wears a cowl clasped at the waist and a veil, which the artist has given the look of a black wool shawl, the dress of courtly women of the time. As the vision descends in a great flash of light from heaven, piercing Hildegard's eyes and head, both she and Volmar prepare to record it on a wax tablet.

The illustrations for the *Scivias* range from representations of the church in human form, or as a city, to fallen angels, the Antichrist, the struggles of the soul, and the battles of the Virtues and Vices. In her excellent study of Hildegard of Bingen, Barbara Newman identifies her as the first Christian thinker to deal seriously and positively with the idea of the feminine, shown as Eve, Mary, and Ecclesia, or Mother Church. At the heart of her spiritual world are the images of Sapientia and Caritas, visionary and female forms of Holy Widsom and Love Divine, and she is the first of the female theologians to personify love as a consummately beautiful woman.

Churchmen who wrote about female mystics tended to emphasize their inspiration and minimize their education. Vincent of Beauvais confirmed that Hildegard had dictated her visions in Latin, but claimed that she had done so in a dream as she was otherwise illiterate. More recently, scholars have pointed out that, although expressed in terms of vision and revelation, her ideas unmistakably indicate her familiarity with the works of St. Augustine and Boethius as well as contemporary scientific writers and Neoplatonic thinkers.

19　Hildegard of Bingen *Scivias* f. 5, 1142–52

20 The Syon Cope, late thirteenth/
early fourteenth century

Hildegard's place in the art and spiritual life of the twelfth century is gradually being clarified. Although in 1928 Charles Singer advanced the view that her visions were nothing more than the auras of chronic migraine, others have pointed out that such glib views fail to distinguish between the pathological basis of the visions and their intellectual content and spiritual import. Barbara Newman has placed her firmly within a school of Christian thought that centers on the discovery and adoration of divine wisdom in the works of creation and redemption expressed through images of the feminine aspect of God, Church, and Cosmos.

In an age ripe for prophetic literature, Hildegard's writings not only seemed to anticipate events later associated with the Protestant revolt, but her appeal to free the church from corruption and worldliness had a profound impact on the feminine religious movement of the thirteenth century known as the Beguines. As a

prophetic voice chosen by God, she was able to assume many sacerdotal functions which the church saw as male prerogatives. This aspect of female mysticism—with its imagery of confused consciousness, loss of subjecthood, and divine flames that transform the soul into a fluid stream dissolving all notions of difference—has led contemporary theorists like Irigaray, one of a group of French women who broke away from Lacan's teaching, to view mysticism as the one important break with the medieval polarities that placed women in a subordinate position. Irigaray has argued that in patriarchal cultures, which deny "subjectivity" to women, the mystical experience is the one experience that dissolves the subject/object opposition, and the one area of high spiritual endeavor in which women have excelled. Thus it has become an important area of inquiry in feminist attempts to explore the positions from which women have spoken and interrupted male control over language and institutional life.

The growth of towns during the thirteenth century created a new class of women—urban working women whose managerial skills were in great demand due to a high degree of mobility among men. Deep-seated changes in the social position of women—their acquisition of the right of inheritance and the feudal privileges normally associated with it—integrated them more firmly into the economic structure of the later Middle Ages. Henry Kraus has convincingly related the newly humanized image of the Virgin Mary that culminates in Gothic art to social changes which had to take account of the new status of women active in trade, particularly the *femmes soles*, or unmarried and widowed women.

The importance of women for the medieval economy won them a place in the guilds, despite restrictions, and the right to carry on family businesses after the death of a husband or father. The woman merchant, as the Wife of Bath tells us in Chaucer's *Canterbury Tales*, had full civic status. Women are shown working at several occupations in the sculptural series called the "Active Life" on the North porch of Chartres Cathedral, and Etienne Boileau's *Book of Trades*, written in the thirteenth century, lists a hundred occupations in Paris, six of which were governed solely by female guilds. Eighty other occupations, from cloth production to dairying, included women. The margins of Gothic manuscripts often show images of women holding distaffs and spindles, and women were active in the textile industries in Flanders, northern France, Champagne, and Normandy. It is important once again to recognize that few trades were exclusively practised by either men or women. The division of labor according to sex is a modern invention, often manifested in attempts to identify female sexuality with activities like needlework. Throughout much of the Middle Ages, although noblewomen did indeed embroider in their homes and castles, and other women spun, combed, carded, and wove the cloth for the family's clothes, both women and men worked side by side in guild workshops and in workshops attached to noble households, monasteries, and convents.

In England, an expanding international market for the kind of ecclesiastical embroidery known as *Opus Anglicanum* led to a shift from domestic production, often by women widely scattered around the country, to tightly organized, male controlled, guild workshop in London. The Syon Cope is a late thirteenth- or early fourteenth-century example of this highly developed medieval art which equalled painting and sculpture in status. Technically intricate and

20

wonderfully expressive, *Opus Anglicanum* incorporated silk and metal threads, pearls, jewels, and beaten gold on a ground of linen or velvet, working the materials into shimmering scenes of everyday life and Biblical events. As the demand for *Opus Anglicanum* spread throughout Europe, letters from Pope Innocent IV to the abbots of England requested large quantities. The richly worked vestments of *Opus Anglicanum* identified the riches of earthly power, signified by precious materials and superb craftsmanship, with divine rule as the movement of the body under the cope transformed its surface into a transcendent blaze of light. After the middle of the thirteenth century, women seem to disappear from professional production and modern accounts identifying this form of needlework with individual feminine achievement have greatly obscured the means of its production.

The thirteenth century also witnessed the rise of secular scriptoria as the production and illustration of books moved outside the monastery. Book making, now a luxury industry, was carried out close to urban centers of money and power. The term *imagier* which appears in the tax rolls of Paris may refer to a painter, illuminator, sculptor, or even architect, making it difficult to determine specific activities of women. Nevertheless, analysis of the tax rolls of Paris between 1292 and 1313 reveals that the percentage of women in these trades is considerably lower than in other fields. Robert Branner, investigating manuscript makers in mid-thirteenth-century Paris, discovered the records of a parchmenter named Martha who worked with her husband; Françoise Baron, in an examination of tax records in various parishes of Paris from the later thirteenth and early fourteenth centuries, found references to eight female illuminators though we have no examples of their work. We know that Maître Honoré, the founder of the great Parisian school of illuminators at the end of the thirteenth century, was assisted by his daughter and her husband, but the work was executed anonymously, within the strict conventions of a style, and nothing survives that can be firmly identified with her hand. Millard Meiss has attributed a number of the finest miniatures in the collection of the Duc de Berry to Bourgot, the most famous of the professional female illuminators of the fourteenth century, and her father, Jean le Noir. Shortly after the marriage of Yolande de Flandre in 1353 the pair executed a delicate Book of Hours which combines 21 the elegant style of the illuminator Pucelle with a sturdier expressionism, but here again individual hands cannot, and should not, be identified.

21 Bourgot and
le Noir *Book of
Hours* c. 1353

These examples indicate the impossibility of fitting medieval visual productions in many media into art historical categories that stress individual creativity and assume that the artist is a man. Recent studies by social historians have provided rich material that deserves careful scrutiny by art historians interested in tracing the changing circumstances of men's and women's participation in medieval cultural life. Further research is necessary into the nature of medieval collaborations and into the role of visual representation in structuring women's relationship to "the privileges of knowledge."

The Renaissance Ideal

Jacob Burckhardt, the foremost European Renaissance historian of his day, asserted unequivocally in *The Civilization of the Renaissance in Italy* (1860) that, "To understand the higher forms of social intercourse in this period, we must keep before our minds the fact that women stood on a footing of perfect equality with men." Burckhardt's assumption that equality of the sexes followed the humanist rediscovery of the "freedom and dignity of man" dominated historical accounts of the Renaissance until it began to be repudiated by feminist scholars in the 1970s. In "Why Have There Been No Great Women Artists?" (1971), the essay which inaugurated feminist challenges to the prevailing view of Renaissance art as a naturalistic reflection of reality rather than a set of constructed and gendered myths, Linda Nochlin explored artistic talent and the institutions which have traditionally nurtured it. A few years later, the historian Joan Kelly-Gadol elaborated the relationship between literary ideals of female equality and changing property relations, forms of institutional control, and cultural ideology as they affected women. Although her conclusion—that the very developments that opened up new possibilities for Renaissance men, particularly the consolidation of the state and the development of capitalism, adversely affected women in leaving them with less actual power than they had enjoyed under feudalism—must be qualified by more recent studies of the many exceptional women active during this period, her essay has proved an important source of revisionist thinking. These and other studies can help us understand why the history of art contains no female equivalents of Leonardo da Vinci, Michelangelo, Raphael, and other "master" artists of the period, but they stop short of exploring women's relationship to the new Renaissance ideals of pictorial representation.

The development of capitalism and the emergence of the modern state transformed economic, social, and familial relationships in Renaissance Italy. Art historians continue to look to fifteenth-century Florence for the sources of the new ideals of artistic genius and

individuality that distinguish the modern world from that of the Middle Ages. It is here that we find the origins of modern capitalism and the privatization of the family, as well as the beginning of the redefinition of painting and sculpture as liberal arts rather than crafts. And it is in Renaissance Florence that linear perspective developed— a mathematical system which organized pictorial space illusionistically and defined the viewer's relationship to the picture surface in ways that dominated Western painting until the end of the nineteenth century.

The absence of women's names from the lists of artists responsible for the "renaissance" of Western culture in fifteenth century Florence deserves careful scrutiny. It is in the cultural ideology that supported women's exclusion from the arts of painting and sculpture that we find the roots of the subsequent shift of woman's role in visual culture from one of production to one of being represented. As the wealthiest, and perhaps most conservative of the Italian city-states, Florence is in some ways an extreme model to adopt. Yet Florence was also where individual power was relocated in the public rather than the private sphere. Looking at early Renaissance Florence helps to explain why the first well-known woman artist of the Renaissance, Sofonisba Anguissola, is found in the sixteenth rather than the fifteenth century, is associated with the provincial city of Cremona rather than with the artistic centers of Florence and Rome, and with the court patronage of Spain rather than the civic and papal patronage of Italy.

The dialogue between past and present—between the ideals of classical antiquity and the realities of late medieval Italy—ushered in the Renaissance. Central to that debate, as revealed in the works of Boccaccio, Christine de Pisan, and others, were discussions about the lives and comportment of women. The intensity and complexity of these debates complicated later attempts to understand the relationship between prescriptive literature and historical fact, and between idealized depictions and lived realities.

A tradition of educated and skilled women in religious orders persisted in fourteenth- and fifteenth-century Italy despite an increasingly secularized society. The only women artists whose names have come down to us from fifteenth-century Florence were nuns like Maria Ormani, who included her self-portrait in a breviary of 1453; the painter Paolo Uccello's daughter, Antonia, the painting nun of the Carmelite Order in Florence, none of whose works have survived; and the miniaturist Francesca da Firenze. The few works

22

22　Maria Ormani *Breviarium cum Calendrium* 1453

that remain indicate that while convent life still made it possible for some women to paint, church reform and the isolation of most convents from the major cities in which the guilds were assuming control over artistic production meant more insularity for religious women. It is to the cities and their guilds that we must look.

Florence grew rich from the silk and wool industries, and from banking in the thirteenth and fourteenth centuries. Moralists then might argue about whether education was a good thing for girls, but a literate wife was becoming essential to the mercantile families that formed the new Florentine middle class. The chronicler Giovanni Villani reported that by 1338 eight to ten thousand Florentine children, male and female, were attending elementary school to learn their letters; yet by the fifteenth century, women's roles in general economic life had become more circumscribed.

By the middle of the fourteenth century the Guild of Linen Manufacturers was flourishing as one of the Seven Great Guilds which regulated cloth production. Noblewomen, as well as many regular workers in linen thread, took up the art of lace-making. Nuns were considered particularly proficient teachers of a skill practiced across class lines by both amateurs and professionals. The revision of guild regulations in 1340 reaffirmed women's right to be admitted to full

privileges and duties in the guild. At the same time, however, as revised statutes restricted membership to active entrepreneurs, women and less skilled workers were left almost entirely without rights. Most of the highly skilled artisans were now men; women were relegated to areas which required fewer skills, or skills of a kind which could be easily transferred to new households upon marriage.

Social historians have shown that as long as Florence produced a small quantity of simple woolen cloths alongside the more elaborate woolens and silks for which the city became famous, a small number of women appear in the account books of the Florentine wool manufacturers as weavers of the plainer and coarser wools. None, however, worked as weavers in the silk industry which was entirely devoted to luxury cloths and required a high degree of skill. With the evolution of a new constitution for the city in the fourteenth and early fifteenth century the guilds became agencies of communal authority rather than corporate interest groups. Women's relationship to the guilds became inseparable from their broader social role—a role which was being radically transformed by the city's new wealth and political power, and by the new opposition of public and private.

Women were relegated to unskilled activities in the guilds at an historical moment when the demand was growing for "designers" who could plan patterns for figured cloths and style the finished pieces. These skills were inseparable from the skills of artists who, still considered artisans, worked at a variety of tasks that ranged from painting altarpieces to decorating furniture and designing banners for heraldic events. As the social status of Florentine painters gradually improved during the fourteenth century, they broke away from the Guild of Doctors and Apothecaries and, in 1349, formed the Confraternity of Saint Luke, also known as the Confraternity of Painters. Generally drawn from the artisan class, painters worked to the demands of their patrons in workshops in which they had served at least four-year apprenticeships. A master's signature on a work of art meant that the work met the standards of the workshop, not that it represented an individual production.

A statute of 1354 provided that, "those who inscribed themselves on the Roll of Membership—whether men or women—should be contrite and should confess their sins. . . ." Yet guild records of the second half of the fourteenth century reveal virtually no women's names, though it is possible that husbands signed for wives as their legal representatives. Women's names are also missing from the employment rosters of construction projects in Florence, a sharp

departure from evidence of their participation in medieval building trades.

By the early decades of the fifteenth century, art was acquiring a bourgeois and secular character in an increasingly prosperous society. Many of its patrons were now mercantile and professional men, acting as members of confraternities or as individuals. Peasants, women, and the urban poor had almost no part to play in a cultural renaissance oriented toward the growth and embellishment of the city as a matter of civic pride, and stressing a model of production in which man's creations paralleled those of God and carried with them the same implicit power over objects that wealth conferred.

Fifteenth-century writers viewed artistic activity as a public affirmation of the artist's role as citizen and the new republic's stature. Wealthy individuals became private patrons of a magnificent public, civic art. Rucellai suggested that art (patronage) gave him contentment and pleasure, "because they [objects] serve the glory of God, the honor of the city, and the commemoration of myself." Leonardo Bruni and other "civic" humanists stressed that men must set aside their private concerns in order to assume public roles. But citizenship in fifteenth-century Florence was restricted to a small elite group of wealthy men who were set apart from women, even those of wealth and privilege. "Everyone seeks me out, honors me . . .," Bruni wrote of the city's adulation of him; "And not only the first citizens, but even the women of the highest rank." For Bruni, the central motif of Florentine history is the creation of a public space; the symbolic focal points of ecclesiastical and political power in the city soon became the great public assembly spaces of the Duomo and Baptistry, and the Palazzo della Signoria, as well as the private palaces of wealthy Florentine families like the Medici, Strozzi, and Rucellai.

The division between public and private in Florence at that time restructured art as a public, primarily male, activity. This ideology was strengthened as the Republic and later the Medici princes organized Renaissance society as a culture in which male privilege and male lines of property and succession were strongly valued. The Florentine kinship system stressed patrilineal descent and patrilocal residence. Women's loyalty was often suspect; it was believed, for example, that the technical secrets of the Della Robbia family workshop were divulged by a disgruntled female relative.

Although Leon Battista Alberti's treatise, *On the Family* (1435), is often cited as exemplary of the new humanist ideal, it is in fact the major Renaissance statement on the bourgeois domestication of

women and an important indication of male anxiety in response to social change. Reworking Xenophon's *Economics*, Alberti transformed his source into a rigid prescription for women's lives. Women's virtues are chastity and motherhood; her domain is the private world of the family. Cautioning men not to confide affairs of business to women, but to look to their wives for family and comfort, Alberti, himself a life-long bachelor, advances the humanist model of modesty, purity, passivity, physical attractiveness, chastity before marriage and fidelity ever after. "It would hardly win us respect," he cautions, "if our wife busied herself among the men in the marketplace, out in the public eye."

Prescriptive literature contributed to shaping women's lives and participation in general economic and public life. Our view of the fifteenth century in Italy is being constantly revised as research brings new documents to light. We now know of a small group of women humanists, most of them from wealthy and prominent northern Italian families, whose writings specifically addressed the situation of women. They were extravagantly praised by male humanists, as were women artists in the following century, but were also urged to chastity and limited expectations. Often forced to choose between marriage and learning, a significant number of them entered cloisters or otherwise secluded themselves. It appears that the same attitudes worked to keep other women out of occupations that required mobility and public exposure, like the arts. And although modern historians have documented far more complex marriage patterns than those prescribed by Alberti, his ideal reinforces the polarization of Florentine society along strict gender lines.

When the architect Filippo Brunelleschi was commissioned to make a maquette for the construction of the dome for Florence Cathedral in 1418, he and his collaborator, the sculptor Ghiberti, inaugurated a new artistic model. Brunelleschi was the first of a new type of architect, one who had not served an apprenticeship in a mason's lodge; instead he had received a liberal education as the son of a well-to-do Florentine notary. As humanist ideas with their stress on nature and the Antique began to influence the visual arts, education and erudition became prized qualities for artists, as well as scholars and poets. Filippo Villani's *De Origine Florentiae et de eiusdem famosis civibus*, written at the end of the fourteenth or beginning of the fifteenth century, includes an account of the principal Florentine artists of the day. Characterizing them individually, he points particularly to Giotto, whom he describes as a man of education and

learning, for returning art to the study of nature and to the fundamental principles of antiquity. That the first artists separated from the mass of craftsmen active during this period are those—such as Masaccio, Donatello, Uccello, and Ghiberti—whose interests lay mainly in scientific and theoretical knowledge reveals the close links between humanist thought, science, and art at the time. Mathematics, and its teaching, was the connection, and mathematical training was now organized by gender.

Although humanist thinkers advocated a certain equality of education for the daughters and sons of wealthy burghers and patricians, by the fifteenth century the practice of sending girls to public schools had apparently been discontinued. Girls received their education, which concentrated on Christian virtues and moral teachings, primarily at home or in the convent. Boys progressed from schooling at home to public education organized around the affairs of the community; girls were trained for marriage or the cloister. Public education consisted of reading, writing, and arithmetic, with mathematics taking precedence because of the business orientation of Florentine society. Skill in mathematics and an ability to draw were now required of the artisan-engineer. Commercial mathematics, adapted to the needs of a growing merchant class, used skills which were also deeply ingrained in the principles of representation underlying fifteenth-century painting.

The first fully developed adaptation of linear perspective to problems of artistic composition occurred in Masaccio's fresco, the *Trinity* (1425), at Santa Maria Novella in Florence. The treatment of the architectural setting gives the illusion that we are looking through an arch into a tunnel-vaulted chapel in the style of Brunelleschi. The vanishing point of the fictive architecture, which allows the viewer to experience the two-dimensional surface as if it were a three-dimensional space, is exactly five feet nine inches off the floor, the height of the ideal male Florentine viewer. Alberti, in his treatise on painting (1435–36) which stresses the mathematical sciences as a means of controlling visible reality, relates the system of representation to the proportions of the male body; the Florentine unit of measurement, called a *braccio*, measured twenty-three inches, or the length of a male arm. An understanding of the principle of gauging (a way of establishing spatial relationships and measurements based on the regular dimensions of common objects like cisterns, columns, and paving stones), educated the spectator in seeing and understanding the spatial relationships in the new illusionistic painting.

23

The close connections between the concerns of merchant and artist in fifteenth-century Florence can be seen in Piero della Francesca's treatises on geometric bodies and perspective, and in his mathematical handbook on the abacus for merchants with its rules for assessing the cubic capacity of barrels and similar objects. The practice of illusionism, through which the fifteenth-century viewer understood pictorial space, elides artist and viewer through the act of seeing—by organizing the pictorial surface so that the viewer takes up a position identical to that originally occupied by the painter. It recreates the spaces of public life, the piazza and the marketplace, and assumes a spectator used to measuring and quantifying space. The new ideal of the artistic masterpiece was based on Alberti's association of the antique use of perspective with *istoria*, a term which included monumentality and dramatic content and which gradually provided new criteria against which to measure the male artist's ambitions.

It would be simplistic to suggest that women were unable to understand the new painting, but it is true that as pictorial seeing established itself along learned and scientific principles taught only to men, it was increasingly organized according to male expectations

and conventions. Painting became one of a growing list of activities in which women had intuitive, but not learned, knowledge and to whose laws they remained outsiders. The humanist encouragement of education for women did not include mathematics, rhetoric, or the sciences. Bruni specifically cautioned against the study of rhetoric, the one discipline with which a woman might participate publicly in intellectual debate: "To her neither the intricacies of debate nor the oratorial artifices of action and delivery are of the least practical use, if indeed they are not positively unbecoming. Rhetoric (and mathematics) in all its forms . . . lies absolutely outside the province of women." When Bruni and other humanists advanced their view of Florence as a microcosm of divine order and proportion or explained, as did Nicolaus Cusanus in his *Idiota* (c. 1450), that the ability to measure is God's greatest gift to man and therefore the root of all wisdom, they were reinforcing woman's removal to a place on the edge of the dominant discourses of Renaissance Florence.

Woman's position on the fringes of the new system of representation mirrored her place in society generally. Not only was public space associated with the arts of painting, sculpture and architecture, it also became the site of vision, of the looking and the visual contemplation associated with aesthetic experience. Scholars have traced the path by which the gaze became a metaphor for the worldliness and virility associated with public man and women became its object. While the display of material wealth through the lavish dresses worn by wealthy Florentine women provoked the archbishop of Florence in 1450 to inveigh against the "gratuitously elaborate costume" as "one of the things which do not serve to arouse devotion but laugher and vain thoughts," some women sought escape from the imbrication of vision and materiality. The Dominican Clare Gambacorta (d. 1419) hoped to avoid scrutiny by establishing a convent "beyond the gaze of men and free from worldly distraction."

It is not surprising that it was at precisely this moment that the "male" art of painting was elevated above the "female" art of embroidery. Under guild regulation painters did not distinguish between the designs produced for altarpieces, tapestries, banners, chests, etc. The painters Neri De Bicci, Sandro Botticelli, and Squarcione, as well as Antonio Pollaiuolo, all produced designs for professional embroiderers. Although Parker has shown how the technique called *or nué*, in which gold threads are laid horizontally and shaded by colored silk in couching stitches, enabled embroiderers to achieve the same perspectival effects as painters, and was used by

painters like Pollaiuolo in his embroidery *The Birth of John the Baptist*, it was during this period that embroidery became the province of the woman amateur. Redefined as a domestic art requiring manual labor and collective activity rather than individual genius, mathematical reasoning, and divine inspiration, embroidery and needlework came to signify domesticity and "femininity."

Although much of the art of fifteenth-century Florence remained religious in content and patronage, there was also a shift from the representation of secular figures as mere adjuncts to religious scenes to the emergence of the individual portrait. The appearance of the profile portrait in the middle of the century conflated subject and patron in images which described worldly position, identity, wealth, and social standing, and refocused attention on women's costume, demeanor, and material embellishment.

The transfer of property and the social realignments that accompanied marriage in Renaissance Florence isolate this as the key moment in the life of a young girl; one in which free choice and physical attractiveness played little or no part. The profile portrait, with its emphasis on linear design and two-dimensionality, and on "mapping" the surfaces of body and garments rather than realizing the figure volumetrically, results in an image that is closer to a schematic rendering of reality than a naturalistic portrayal. Its sources show that it was an affirmation of material reality. Influenced by the profile paintings of Gothic Italy, it originated around 1440 in cast medals by Pisanello which recall the coins of the Roman emperors but which now commemorated individuals of high achievement and/or patrician rank who wished to immortalize themselves. Art historians have generally examined profile portraits in relation to their stylistic sources, but these new representations of secular men and women became in the 1980s an important source for analyses of gender in the early Renaissance.

Patricia Simons has convincingly demonstrated how female profile portraits by Pisanello, Piero della Francesca, Ghirlandaio, and others produce a version of femininity, wealth, and lineage through a careful cataloguing of the objects of the wealthy Florentine household: meticulously delineated gold and seed jewelry, brocades and silks, emblems and family crests. Through marriage and family alliances, women became signs for the honor and wealth which defined social prestige for Florentine citizens. Alberti himself suggested a careful visual inspection of the female goods which would bear the husband's inheritance, advising future grooms to act "as do wise heads of

families before they acquire some property—they like to look it over several times before they actually sign a contract." At the same time, he urged men to seek moral and spiritual qualities in a bride; "a man must first seek beauty of mind, that is, good conduct and virtue." In these idealized portraits, material and spiritual qualities are elided, as if wealth were legitimized in the eyes of God through the spirituality conveyed by the remote gazes and severe poses of the female sitters. Their demeanor one of virtue, piety, and submission to the authority of husband, church, and state, these female figures do not look; they are turned away and presented as surfaces to be gazed upon. The same convention holds for male profile portraits, but it is surely significant that by mid-century the profile view was largely abandoned in representations of male figures in favor of three-quarter views. Not until the 1470s do portraits of women follow this example.

Ghirlandaio's *Giovanna Tornabuoni née Albizzi* (1488) emphasizes 24 Giovanna's role as a chaste, decorous piece of her husband's lineage. His initial L appears on her shoulder and his family's triangular emblem is embroidered onto her garment. The inscription behind the

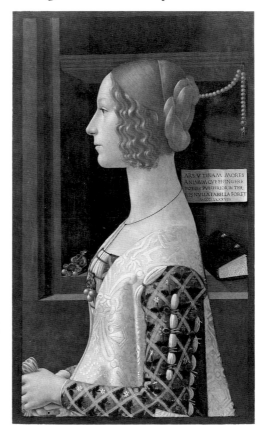

24 Domenico Ghirlandaio
 Giovanna Tornabuoni
 née Albizzi 1488

figure ("O art, if thou were able to depict the conduct and soul, no lovelier painting would exist on earth") commends virtuous conduct and spiritual quality. The portrait is commemorative for Tornabuoni died in 1488 during her pregnancy. Framed in front of a window, she appears as a beautiful object of contemplation at a time when women were banned from displaying themselves at windows and when sumptuary laws barred ornate and lavish dress.

Not until the sixteenth century did a few women manage to turn the new Renaissance emphasis on virtue and gentility into positive attributes for the woman artist. Their careers were made possible by birth into artist families and the training that accompanied it, or into the upper class where the spread of Renaissance ideas about the desirability of education opened new possibilities for women. Many of them benefited from the Counter Reformation's emphasis on piety and accomplishment; for all of them, their social and professional accomplishments were conflated so that their success as artists was inseparable from their virtues as women.

Sofonisba Anguissola's painting established new conventions for self-portraiture by women artists. Although the extensive sixteenth- and seventeenth-century literature on her includes little specific information about her work, and no monograph or *catalogue raisonné* exists at present, she is the author of at least fifty paintings now in museums and private collections. While it is absurd to call her the equal of Titian in portraiture, as did Baldinucci in the seventeenth century, or to dismiss her completely for lacking skill in drawing, as did Sydney Freedberg in 1971, her lack of training compared with that of the major male artists of her day is evident in many of her works. Little art historical work has yet been done on her innovative naturalism in genre and portrait paintings, her significant role as a link between northern Italian and Spanish portraiture of the sixteenth century, and her influence on later northern Italian portraiture. She is, as Ann Sutherland Harris notes, unique in her astonishing variety of portraits, and in producing more self-portraits than any artist between Dürer and Rembrandt. At least one work by Anguissola, *Bernardino Campi Painting Sofonisba Anguissola* (probably late 1550s) suggests not only that she was aware of the value of her own image as an exemplar of female achievement, but also that she understood the importance of the master–pupil relationship and her unique role as a producer of images of women. Here she paints herself as if she were being painted, perhaps the first historical example of the woman artist consciously collapsing the subject-object position.

37

Anguissola's birth has been listed as early as 1532–35 (Harris and Nochlin) and as late as 1540 (Takacs) and we know that she died in Palermo in 1625. She was the daughter of Amilcare Anguissola, a widower and nobleman who apparently decided to educate his seven children according to the humanist ideals of the Renaissance in the belief that they would bring honor to their city. Several of the daughters became painters. Sofonisba, and Elena, studied with the Cremonese painter, Bernardino Campi, and she later worked with Bernardino Gatti. In turn, she instructed her sisters Lucia and perhaps Europa. Her noble birth and her youth when she began her short three-year apprenticeship (most male painters of the time trained for a minimum of four years) quickly established her as a prodigy. Amilcare Anguissola's ambitions for his daughter are expressed in two letters in which he solicited the support of Michelangelo. In the first of these, dated 1557, he thanked him for his advice: "we are much obliged to have perceived the honorable and affable affection that you have and show for Sofonisba; I speak of my daughter, the one whom I caused to begin to practice the most honorable virtue of painting. . . . I beg of you that . . . you will see fit to send her one of your drawings that she may color it in oil, with the obligation to return it to you faithfully finished by her own hand. . . ." Michelangelo, who is known to have helped a succession of young artists by sending them drawings, had requested from Anguissola a difficult subject—a weeping boy. She sent him a drawing of her brother, Asdrubale, titled *Boy Bitten by a Crayfish* (before 1559). A letter from Michelangelo's friend Tomaso Cavalieri, written to Cosimo de Medici on January 20, 1562, included the drawing as a gift along with another drawing by Michelangelo. Anguissola's early works, including the charming *Three Sisters Playing Chess*, are characteristic of the mid-sixteenth-century school of northern Italian painting in their emphasis on blacks and greens and their rough scumbled surfaces.

It was the Duke of Alba, advised by the governor of Milan, who called the attention of the Spanish court to her work. She was escorted to Spain with great ceremony in 1559 and served as court painter and lady-in-waiting to the Queen, Elizabeth of Valois, until 1580, and was paid in the customary manner with rich gifts rather than a stipend. Her status at court is indicated by the fact that, before she left, the King arranged her marriage to a wealthy Italian and provided a dowry.

One of the few documented examples of Anguissola's Spanish period is a *Self-Portrait* (1561), depicting the artist as a serious, conservatively dressed young woman at the keyboard of a spinet. She

25 Sofonisba Anguissola *Boy Bitten by a Crayfish* before 1559

is accompanied by an old woman, perhaps a chaperone who went with her to Spain. Anguissola's presentation of herself as a modest young woman of refinement and culture places the work in a tradition of self-portraits which articulate the Renaissance ideal of the artist as gentleman/woman rather than artisan. The presence of the musical instrument may show Anguissola's skills as a member of a cultured noble family at a time when musical accomplishment, long recognized as desirable for noblemen and women, was becoming a mark of culture for artists of both sexes.

The self-portrait relates to a group of works executed in northern Italy where Spanish influence had been strong since the early part of the sixteenth century when Milan had come under direct Spanish rule. Anguissola's portraits, like the late portraits of Giovanni Battista

26 Sofonisba Anguissola *Self-Portrait* 1561

27 Giovanni Moroni *Portrait of a Man (The Tailor)* c. 1570

28 Titian *La Bella* c. 1536

Moroni (who was born during the 1520s in Bergamo, not far from Cremona), were executed under the shadow of Titian, the influence of the Counter Reformation and the conservatism of Philip II's Spain.

27 Moroni's *Portrait of a Man (The Tailor)* (c. 1570) reveals a similar treatment of the figure and the simplified dark wall. As in Anguissola's *Self-Portrait*, the figures make eye contact with the spectator; in both attention is drawn to the face and hands. The portrait tradition introduced into Spain by Moroni and Coello during Philip II's reign clearly influenced Anguissola's painting. Yet her self-portrait may also be read as indicating her position at the Spanish court and her awareness of Philip II's cultural aspirations. Its date, 1561, corresponds to the date when Philip moved his court from Toledo to Madrid, where the Prado Palace provided a regal setting for the artists who worked for him. Philip modeled his court on the lavish Burgundians and he cultivated musicians as well as artists. His

74

own love of music is well documented, and it is not surprising that in one of her first self-portraits from Spain Anguissola should choose to emphasize the qualities that ensured her position in the royal household.

Anguissola's complex relationship to the traditions of northern Italian and Spanish portraiture has led to her work being confused not only with that of Titian, Leonardo da Vinci, and Moroni, but also Van Dyck, Sustermans, Coello, and Zurbarán. An inventory of pictures in the Spanish royal collection in 1582 mentioned a portrait of the Queen of Spain by her hand, "excellent painter of portraits, above all the painters of this time," yet very few works remain from her more than twenty years in Madrid (much work of her Spanish period may have perished in a fire in the Prado in the seventeenth century).

As long as she stressed her status as a gentlewoman, Anguissola's actions as a professional painter did not conflict with the ideology of Renaissance womanhood outlined in Castiglione's *Courtier*. At the same time, she worked in a period when the discourses of representation, sexuality, and morality were beginning to meet in representations of the female nude. A glorification of erotic and aesthetic experience underlies the Neoplatonic influence on sixteenth-century painting. In his *Theologia Platonica*, Marsilio Ficino had argued that physical beauty excites the soul to the contemplation of spiritual or divine beauty. As painting began to record a more sensuous ideal of beauty, writers like Agnolo Firenzuola, author of the most complete Renaissance treatise on beauty, published in 1548, described the preferred attributes of female beauty. The description of the noblewoman with fair skin, curling hair, dark eyes and perfectly curved brows, and rounded flesh recalls a number of paintings of the period, including many by Titian.

Anguissola's self-portrait is posed much like Titian's painting called *La Bella* (c. 1536), but there the resemblance ends. Though recognized as a portrait, Titian's painting is the first well documented case of a portrait sold as a work of art rather than a description of a specific person. Under the influence of Neoplatonism, beauty became associated with idealized womanhood. In poetry, ideal personifications dwelled on specific anatomical features. Although *La Bella* is an ideal portrait, Titian treats his sitter—who looks out of the frame with candid gaze, the curves of her flesh visible under the rich brocade of her bodice—with the reserve appropriate to a high-born lady. Elizabeth Cropper has described the portrayal of her physical beauty as a synecdoche for the beauty of painting itself because it transposes

26
28

the material world into spiritual value. Paintings such as this led to a long and complex tradition in which anonymous female beauty was identified with sexuality, often with the sexual availability of the artist's model or mistress. Identifying the painting of female beauty with the artist's sexual access to the women who modeled for him, the poet Pietro Aretino wrote around 1542 that Titian's brushes were equivalent to Love's "arrow."

Sofonisba Anguissola's age and sex prevented her from engaging in an aesthetic dialogue which revolved around Neoplatonic concepts of the metaphoric relationship between paint and beauty, the earthly and the sublime, the material and the celestial. That Vasari and other male writers responded to Anguissola and her sisters as prodigies of nature rather than artists is even more understandable in the context of aesthetic dialogues which identify the act of painting with the male artist's sexual prowess. Anguissola could not use paint as a metaphor for possessible beauty without violating the social role that made possible her life as a painter. As an artist, she participated in a world of sensation and pleasure; to do so as an unmarried woman would exceed and violate nature. It is her virtue which both Anguissola and her biographers stress. Her self-portraits return the focus of painting to the personal, which cannot be read as heroic, or larger than life, or divine. Instead they reveal the inner attributes of modesty, patience, and virtue.

Among the major works believed to be by Anguissola is the largest of the Tudor portraits in the National Portrait Gallery in London, a full-length portrait of Philip II long believed to have been painted by Coello. It has been reattributed to Anguissola though the attribution remains questionable. Although the pose apparently derives from Titian's full-length *Philip as a Young Man* (1550–51) in the Prado, the composition is reversed. Broad surfaces of scumbled pigment, combined with the candour of the representation, strip the work of the artifice associated with much contemporary formal portraiture. A 29 portrait of a Cremonese doctor, also in the Prado, and signed by Sofonisba's sister, Lucia, reveals a similar dignity and humanity. Other works by Anguissola, like the late *Virgin with Child*, reveal her closeness to Correggio and Luca Cambiaso, as well as the circle of the Campi.

Amilcare Anguissola's decision to dedicate his daughter to art set a precedent. Other Italian artists took on female pupils, and the introduction to a collection of poems assembled on the occasion of the death of Titian's pupil, Irene di Spilimbergo, records that, "having

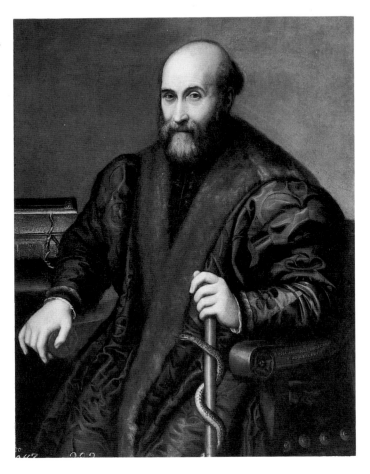

29 Lucia Anguissola
*Portrait of Pietro
Maria, Doctor of
Cremona* c. 1560

been shown a portrait by Sofonisba Anguissola, made by her own hand, presented to King Philip of Spain, and hearing wondrous praise of her in the art of painting, moved by generous emulation, she was fired with a warm desire to equal that noble and talented damsel." Anguissola's invitation to the court of Philip II was the precedent for many other women artists who, excluded from institutional help— academic training, papal and civic patronage, guilds and work-shops—found support in the courts of Europe between the sixteenth and the eighteenth centuries. Her work also directly influenced that of Lavinia Fontana, one of a group of important women artists produced by the city of Bologna in the late sixteenth and seventeenth centuries.

The Other Renaissance

If women artists had a Renaissance, it surely took place in Bologna rather than Florence or Rome, and in the sixteenth and seventeenth centuries rather than the fifteenth. Properzia de' Rossi, Lavinia Fontana, Elisabetta Sirani, and Artemisia Gentileschi (the latter not from Bologna) may be the best-known women artists of their day, but our knowledge of their careers is far from complete and theirs are but a few of the many names scattered through the literature of this period.

Bologna was unique among Italian cities for having both a university which had educated women since the Middle Ages and a female saint who painted. By the fifteenth century the organization of the guilds under the spiritual protection of specific saints had established St. Luke, who was believed to have painted miracle-working icons including one of the Virgin Mary, as the patron saint of painters. Painters in Bologna, where the guilds remained powerful long after they had lost political and economic effectiveness in the rest of Italy, had their own saint.

Caterina dei Vigri (St. Catherine of Bologna, canonized 1707), whose cult flourished in the sixteenth and seventeenth centuries, is another example of the transmission of learning and culture by women in convents. Born into a noble Bolognese family in 1413 and educated at the court of Ferrara, she entered the Convent of the Poor Clares there after her father's death in 1427. She was known for her Latin and skill in music, painting, and illumination. Elected abbess soon after the Poor Clares moved to Bologna in 1456, her reputation as a painter grew swiftly. According to accounts by her friend and biographer, Sister Illuminata Bembo, she "loved to paint the Divine Word as a babe in swaddling bands, and for many monasteries in Ferrara and for books she painted him thus in miniature." The best-known of her writings, *The Seven Weapons*, recounts the spiritual battles of a religious woman who saw her intellect and will in conflict with the submission and obedience demanded by the Church.

BEATA · KATHERINA ·

30 Giovanni
Benedetti, "S.
Caterina de Vigri,"
Libro devoto 1502

31 Marcantonio
Franceschini
S. Caterina Vigri
seventeenth century

Although references to Caterina dei Vigri's painting enter the literature in the sixteenth century, attempts by feminist scholars to assemble an oeuvre for her have proved disappointing. The small group of works preserved in the Convent Church, the Corpus Domini of the Order of Santa Caterina dei Vigri in Bologna, show a naive and untrained hand, or hands, at work. X-rays taken in 1941 of the most famous of her paintings, a St. Ursula now in Venice, reveal an indecipherable inscription underneath her signature. Nevertheless, although we know all too little about her achievements, the significance of a woman painter, saint, and patron of painters to sixteenth-century Bologna, whose civic pride and ecclesiastical authority then reached new heights, should not be underestimated.

St. Catherine of Bologna's cult, stimulated by her miracles and her mystical autobiographical writings, dates from the exhumation of her perfectly preserved body (now enshrined in the church of the Corpus Domini) shortly after her death in 1463. Pope Clement VII formally authorized her cult in 1524 and in 1592 the title *Beata* was conferred on her. The cult, enormous and ideally suited to the pietistic temper of Counter-Reformation Italy, flourished through the seventeenth century along with her reputation as a painter. Malvasia mentions her among a group of painters active in Bologna between 1400 and 1500 and a representation of her playing her violin to an assembled Heavenly Host of musical angels and plump putti appears in a preparatory drawing by Marcantonio Franceschini for his fresco cycle illustrating events from her life in the Corpus Domini.

The presence of St. Catherine's cult in Bologna was only one of a number of factors that worked to create an unusually supportive context for educated and skilled women in that city. After the church, the most important institution in Bologna was the university, founded in the eleventh century. By the time it began admitting women in the thirteenth century, it was Italy's most famous center of legal studies and was also widely known as a school of the liberal arts. The city prided itself on women learned in philosophy and law— Bettisia Gozzadini, Novella d'Andrea, Bettina Calderini, Melanzia dall' Ospedale, Dorotea Bocchi, Maddalena Bonsignori, Barbara Arienti, and Giovanna Banchetti, who all wrote, taught, and published.

The connections between the university and the arts in Bologna need to be documented, but we do know that the publishing houses that grew up around the university encouraged the rise of a group of miniaturists during the thirteenth and fourteenth centuries that, in addition to women lay miniaturists, included a Carmelite nun, Sister

32 Diana Scultore *Christ and the Woman Taken in Adultery* 1575

Allegra, and another woman identified only as "Domina Donella miniatrix." The existence of women printmakers in the seventeenth century such as Veronica Fontana, a famous maker of woodcuts who illustrated Malvasia's *Felsina Pittrice* in Bologna, or, the previous century, Diana Scultore, a well-known engraver in the school 32 founded by her father Giovanni Ghisi in Mantua, points to a still unwritten history of women in the publishing trade in Renaissance Italy. Social historians have noted that in Bologna at the beginning of the fifteenth century women outnumbered men, a fact which may well have encouraged their participation in trades like painting and printing which remained under guild control until at least 1600. Luigi Crespi's *Vite de Pittori Bolognesi* (1769) lists twenty-three women active as painters in Bologna in the sixteenth and seventeenth centuries; at least two of them—Lavinia Fontana and Elisabetta Sirani—achieved international stature.

Women artists in Bologna benefited from the civic and ecclesiastical patronage that accompanied the naming of the Emilian region around Bologna as a papal state in 1512 (culminating in the election of

the Bolognese Ugo Buoncompagni as Pope Gregory VIII in 1572), the artistic competition that developed between Rome and Bologna, and the fact that the Renaissance ideology of exceptional women could be used to claim unique status for the city and its women.

Bolognese art of the sixteenth and seventeenth centuries was an art of elegance and sensibility produced for learned and aristocratic patrons and imbued with the sentiments and moral imperatives of the Counter-Reformation attempt to reform the Catholic Church. The abundance of work available for artists must have eased women's access to commissions, despite the incidents of male jealousy and spiteful accusations that dogged the careers of de' Rossi and others. The Church served as an active patron throughout the sixteenth century and noble families, desiring to demonstrate their wealth and refinement, ordered frescoes and wall decorations for their palaces and furnished them and churches with chapels complete with elegant and tasteful altarpieces. Encouraged to combine wealth with intellectual and cultural pursuits, members of Bologna's richest families joined literary and scientific academies; a self-portrait of the 1570s by the painter Lavinia Fontana places the artist firmly in the context of this learned and cultivated citizenry. She depicts herself as prosperous and scholarly, in the act of writing and surrounded by antique bronzes and plaster casts from her private collection. Although Fontana had no claim to noble birth, Vasari identifies her family with the educated elite of Bologna and her early self-portraits present the image of an educated woman. A *Self-Portrait* of 1578 repeats the conventions of Anguissola's *Self-Portrait* of 1561, showing Fontana at the keyboard of a clavichord with a female servant, barely visible in the background, holding her music. An empty easel stands in front of the window and an inscription identifies her as LAVINIA VIRGO PROSPERI FONTANAE.

That the women artists of Bologna were exceptional is without question. While their work relates more directly to that of their male contemporaries than to that of other women, and confirms the dominant artistic and social ideologies of its time and place, the extent to which Fontana and Sirani at least were integrated into the cultural life of Bologna deserves far more study. They are exceptions in a history of artistic production by women which forces us to confront women's tangential relationships to artistic institutions and systems of patronage. It remained for Artemisia Gentileschi in the seventeenth century to negotiate a new relationship to dominant cultural ideologies and her case is considered at the end of this chapter.

The building campaign intended to make the Bologna municipal church of San Petronio the largest in Italy after St. Peter's brought forward Properzia de' Rossi, Renaissance Italy's only woman sculptor in marble. A drawing pupil of Marcantonio Raimondi, de' Rossi first achieved recognition for her miniature carvings on fruit stones. Her ambitious shift from these to public commissions in the 1520s apparently brought her close to overstepping the bounds of "femininity" and Vasari, while assuring his readers of her beauty, musical accomplishment, and household skills, also relates that she was persecuted by a jealous painter until she was finally paid a very low price for her work and, discouraged, turned to engraving on copper.

De' Rossi was first commissioned to decorate the canopy of the altar of the newly restored church of S. Maria del Baraccano. She then submitted a portrait of Count Guido Pepoli as a sample of her work for the rebuilding at San Petronio and was commissioned for several pieces. Records of payment indicate that she completed three sibyls, two angels, and "two pictures" before abandoning the work. The "pictures" probably refer to bas-reliefs of the *Visit of the Queen of Sheba to Solomon* and a *Joseph and Potiphar's Wife* (c. 1520), now in the museum of San Petronio.

Joseph and Potiphar's Wife perfectly expresses the persistence of the 8 classical ideal in sixteenth-century Bologna, combining it with a notion of elegance derived from the work of the major figures of Emilian art of the period: Correggio and Parmigianino. The Biblical story of Joseph fleeing from his seductress was a popular one in the early days of the Counter Reformation. The balanced and muscular bodies, as well as their classical dress, reveal de' Rossi's familiarity with antique sources, while the energy of the figure in motion points toward Correggio's exuberant figural groups. De' Rossi died in 1530, still a young woman, four years after the last recorded payment for her work at San Petronio. The city of Bologna continued to pride itself on having produced her, but it remained for her followers to develop the anti-Mannerist tendencies of Bolognese art under the spiritual influence of the Counter Reformation and the artistic influence of the Carracci and Guido Reni.

Lavinia Fontana began painting around 1570 in the style of her father and teacher, Prospero Fontana, whose work combined Counter-Reformation pietism, Flemish attention to detail, and a growing northern Italian interest in naturalism. The diverse strands of classicism, naturalism, and mannerism were united in Prospero

Fontana's desire to produce religious art that was clear and persuasive in accordance with the teachings of Cardinal Gabriele Paleotti, Bishop and later Archbishop of Bologna, whose influence was widely felt in the arts. Prospero Fontana's pupils—Lavinia Fontana, Ludovico Carracci, and Gian Paolo Zappi—inherited these tendencies.

Fontana's early self-portraits, and the small panels intended as private devotional pieces, combine the influence of her father with the naturalism of the late Raphael and the elegance of Correggio and Parmigianino. Although Fontana became best known as a portraitist, she also executed numerous religious and historical paintings, many of them large altarpieces. Paintings like *Saint Francis Receiving the Stigmata* (1579) and the *Noli Me Tangere* (1581) adhere closely to the religious ideology of spiritual and social reform expressed through prayer, devotion, and contemplation. "Popularized" religious paintings such as Fontana's *Birth of the Virgin* (1580s) and her *Consecration to the Virgin* (1599) often incorporate domestic motifs or familial pieties, reinforcing Paleotti's desire to extend pastoral care to individual families through prayer and instruction.

The *Birth of the Virgin* is closer to a genre scene of family life in Bologna than to its Biblical source, despite its outdoor setting and nocturnal illumination. It balances a sense of monumentality and decorum with a naturalism close to that of the Cremonese school, and was influenced by Anguissola, whose work Fontana knew and admired and who no doubt provided an important artistic model for her. Fontana's *Consecration to the Virgin*, originally intended for the Gnetti Chapel in S. Maria dei Servi in Bologna, combines figures elongated according to Mannerist conventions with greater naturalism in the treatment of the children's figures. Prospero Fontana's influence continued to be felt in Fontana's later religious paintings, as did that of Paleotti, for links between the Bishop and the painter's family remained strong.

By the late 1570s, Fontana's fame as a portraitist was firmly established. Despite her adherence to the principles of naturalism advocated by the Carracci family, she was prevented from joining the Carracci academy, founded in the 1580s, because of its emphasis on drawing from the nude model. Her *Portrait of a Gentleman and His Son* (1570s) recalls Anguissola's *Portrait of a Young Nobleman* (1550s) in its straightforward pose and in the quiet dignity of the figures. At the same time, the painting reveals the calculated mix of moderate social responsibility espoused by Paleotti and the worldly pretensions of the Bolognese aristocracy which insured Fontana's success as a

33 Lavinia Fontana
Birth of the Virgin 1580s

portraitist. The elegant, elongated fingers and the brilliance of the rich
detail on the sitter's garments oppose their monumentality and social
rank to the sober space they inhabit.

Fontana's marriage to Gian Paolo Zappi in 1577 was contracted
with a provision that the couple remain part of her father's household;
her husband subsequently assisted her and cared for their large family.
When the Bolognese Cardinal Buoncompagni succeeded to the
papacy in 1572 papal patronage for Bolognese artists increased.
Prospero Fontana had enjoyed the patronage of three previous popes;
Fontana received her first papal commission, and a summons to
Rome, from the local branch of the Pope's family. It is a sign of her
status as a painter that she was able to postpone moving to Rome until
the papacy of Clement VIII, which did not occur until after her father

34 Felice Casoni *Lavinia Fontana* 1611

died. She left for Rome around 1603, preceeded by her husband and son and a painting, a *Virgin and St. Giacinto*, commissioned by Cardinal Ascoli. The painting created a demand for her work in Rome. Working in the palace of Cardinal d'Este, she painted a *Martyrdom of St. Stephen* for the basilica of San Paolo Fuori le Mura. The painting, destroyed in a fire in 1823, is known today only through an engraving of 1611 by Callot. Baglione reports that the work was a failure with the Roman public and that Fontana, in despair, renounced public commissions and returned to portrait painting.

Late portraits, like the *Portrait of a Lady with a Lap Dog* (c. 1598) are worldly and sophisticated. The exquisite details of costume and furnishings isolate the sitters against a space rendered in a broad and simplified manner. Prices for Fontana's portraits soared with her election to the old Roman Academy, allowing her to pursue her interest in collecting art and antiquities. Contemporaries report that she executed portraits of Pope Paul V, as well as those of ambassadors, princes, and cardinals, a testament to the continuing patronage of women artists by aristocrats and ecclesiastics. Her reputation continued to grow and in 1611, shortly before her death, a portrait medal was struck in her honor by the Bolognese medallist Felice Antonio Casoni. The face contains a dignified portrait and an inscription identifying her as a painter. On the reverse, an allegorical 34 female figure in a divine frenzy of creation sits surrounded by compasses and a square, as an earlier Renaissance emphasis on

mathematics and inspired genius belatedly modifies the ideal of the Renaissance woman artist.

Women artists like de' Rossi and Fontana set an important precedent for women of seventeenth-century Italy, particularly in the area around Bologna. Yet the work of the two best-known of those women—Artemisia Gentileschi (c. 1593–1652), born in Rome but active in Florence, Naples and London, and Elisabetta Sirani (1638–1665), whose short life was spent entirely in Bologna—was even more powerfully shaped by the pervasive influences of Michelangelo Merisi da Caravaggio and Guido Reni. Caravaggio's insistent naturalism, shallow pictorial space, and dramatic use of light generated among his followers a large body of paintings characterized by unidealized, boldly illuminated figures placed against dark, mysterious backgrounds. Guido Reni, who inherited the mantle of the Bolognese school from the Carracci at whose academy he was trained, blended elegant refinement and naturalistic expression. In character and personality, these two influential figures could not have been more different: Reni, educated and cultured, perpetuated the image of the gentleman artist; Caravaggio, rebel and outlaw, epitomized a new role for the artist as bohemian.

Like many women artists of the time, Gentileschi and Sirani were the daughters of painters. Orazio Gentileschi was one of the most important of Caravaggio's followers; Giovanni Andrea Sirani a pupil and follower of Reni, and an artist of considerably less interest than his daughter. Gentileschi is the first woman artist in the history of Western art whose historical significance is unquestionable. In the case of Sirani, her early death has prevented a full evaluation of her career despite her evident fame during her life. Sirani's father took all her income from a body of work which she herself, following a custom gaining favor during the seventeenth century, catalogued at 150 paintings, a figure now considered too low. Despite her catalogue, no monograph exists and her reputation has suffered from an over-attribution of inferior works in Reni's style to her. As Otto Kurz notes; "The list of paintings to be found under her name in museums and private collections and the list of those paintings which she herself considered as her own work, coincide only in rare instances."

Sirani has frequently been dismissed as one of several insignificant followers of Reni in Bologna, and a painter of sentimental madonnas. But the subtlety of her pictorial style, and the graceful elegance of her touch, have prompted recent reevaluations of her significance in relation to that of contemporaries in Bologna like Lorenzo Pasinelli,

35

35 Elisabetta Sirani *The Holy Family With a Kneeling Monastic Saint* c. 1660

Flaminio Torre, and the Fleming Michele Desubleo. Sirani's *Portrait of Anna Maria Ranuzzi as Charity* (1665) is an outstanding example of 38 Bolognese portraiture in the second half of the seventeenth century.

The proud gaze of Madame Ranuzzi, the younger sister of Count Annibale Ranuzzi, who commissioned the painting, and the wife of Carlo Marsigli by whom she had two sons, is intensified by concentrated brushwork. Lively touches of red and blue illuminate the overall color scheme of grays, lilacs, and browns and set off the rich purples in garments and background which envelop the figures. Despite the virtuoso brushwork and richness, the emphasis in the work is on Ranuzzi's maternity rather than her social rank.

Sirani's *Judith with the Head of Holofernes* (Walters Art Gallery, Baltimore) is perfectly in keeping with the grace, elegance, and pictorial refinement which secularized the subject for wealthy Bolognese patrons. Yet it also suggests that Sirani shared the seventeenth century's interest in female heroines; Sirani and Gentileschi produced numerous paintings on the theme of the heroic woman who triumphs by her virtue. In addition to several Judiths, both women painted penitent Magdalenes and monumental sibyls.

36 Elisabetta Sirani *Portia Wounding Her Thigh* 1664

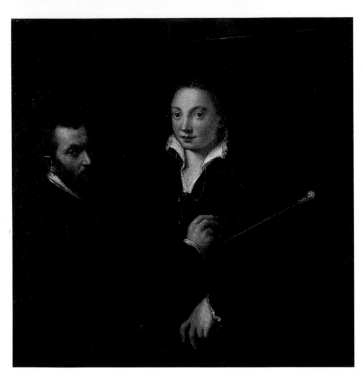

37 Sofonisba
Anguissola *Bernardino
Campi Painting Sofonsiba
Anguissola* late 1550s

39 Lavinia Fontana >
*Consecration to the
Virgin* 1599

38 Elisabetta Sirani
*Portrait of Anna Maria
Ranuzzi as Charity* 1665

In addition, Gentileschi offered several allegorical female figures, St. Catherine, a Cleopatre, and a Lucretia, among others, while Sirani supplied a *Timoclea* (1659), unusual in its depiction of the defiant heroine, and a *Portia Wounding Her Thigh* (1664). The latter was commissioned by Signore Simone Tassi and intended for an overdoor in a private apartment. The subject belongs with a group of themes, including the rape of Lucretia, which explore the relationship between public political and private, often sexual behavior.

Sirani chose the moment at which Portia wounded herself to test her strength of character before asking Brutus to confide in her. The work's sexualized content is evoked through the titillating image of female wounding and the figure's almost voluptuous disarray, but its other meanings are more complicated and return us to the issue of how sexual difference is produced and reinforced. Stabbing herself deeply in the thigh, Portia has to prove herself virtuous and worthy of political trust by separating herself from the rest of her sex; (in Plutarch's words) "I confesse, that a woman's wit commonly is too weake to keepe a secret safely: but yet, Brutus, good education, and the company of vertuous men, have some power to reforme the defect of nature. And for my Selfe, I have this benefit moreover: that I am the daughter of Cato, and wife of Brutus."

The composition reinforces Portia's removal from the world of women. She is physically separated from the women who spin and gossip in another room, betraying their sex by talk. Presenting woman as a "defect" of nature, Christian doctrine often used the volubility of woman as a metaphor for her uncontrolled desires. Removed from the private world of women to the public world of men, Portia must assert her control over speech before she can claim exceptional status. She demonstrates, finally, that women who prove their virtue through individual acts of bravery can come to be recognized as almost like men. The rich colors and the confident brushwork in paintings such as these established Sirani's reputation in Bologna as a phenomenon.

Sirani's skill and the speed with which she worked led to gossip that her father was claiming her work as his own in order to exploit the publicity value of a female prodigy in the workshop. In order to repudiate the all too familiar allegation that her work was not her own, she became accustomed to working in public. Around 1652, she opened a school for women artists in Bologna. There she trained a number of younger women artists who, for the first time, were not exclusively from families of painters, as well as her two younger

sisters, Anna Maria and Barbara, who eventually produced their own altarpieces for local churches.

Sirani's death in 1665 was followed, on November 14, by a massive public funeral in the Dominican church attended by a large and distinguished crowd of mourners. The funeral announcement described her as ˙PITTRICE FAMOSISSIMA and the lavish scheme of decoration for the ceremony was supervised by the artist Matteo Borbone. A catafalque, intended to represent the Temple of Fame, was erected in the middle of the nave. The octagonal structure of imitation marble, its cupola-shaped roof supported by eight columns of pseudo-porphyry, had a base decorated with figures, mottoes, and emblematic pictures and, on a platform, a life-size figure of the dead artist painting.

Sirani was eulogized in a funeral oration which was also a rhapsody of civic pride in the city of Bologna. Her funeral, the final identification of her fame with that of the city which had produced her, was comparable to the funerals of other well-known sixteenth- and seventeenth-century artists in that they were accorded the privileges of other distinguished citizens. In the fifteenth century, Ghiberti had requested that his body be interred in Florence's Santa Croce in the company of the noblemen to whose position he aspired as an artist. Less than a hundred years later, Michelangelo's body was transported from Rome back to his native Florence in 1564, where a sumptuous catafalque was erected in the Medici family basilica of San Lorenzo. In Bologna, Reni's funeral in 1642 was also treated as a public event with masses offered for him in towns surrounding Bologna, and as far away as Rome. His body was carried to San Domenico with great pomp and honor past huge crowds in the streets. Upon Sirani's death, Bologna's two most famous artists of the seventeenth century were laid to rest side by side in the ancestral tomb of the wealthy Bolognese, Signor Saulo Giudotti. A testament to their public civic status as artists, the internment was also deeply ironic; during his life, the eccentric Reni had refused to have anything to do with women, barring them from his house in fear of poison or witchcraft at their hands.

The fame of Sirani in Bologna during her lifetime was rivalled by only one other woman artist in Italy: Artemisia Gentileschi, a painter whose life and work are a challenge to humanist constructions of feminine education and deportment. In May 1606, Caravaggio fled Rome, accused of stabbing a young man to death. Among his followers in Rome were Orazio Gentileschi, a founder of the style

40 Artemisia Gentileschi *Judith Decapitating Holofernes* c. 1618

that came to be known throughout Europe as Caravaggism, and his daughter Artemisia, whom Ward Bissell has identified as one of the two most important Caravaggisti to reach maturity between 1610 and 1620. Caravaggio and the Gentileschi family (which included a son as well as the daughter born in 1593) were far removed in lifestyle and temperament from the learned painters of the Bolognese school with their emphasis on piety and refinement. Historical accounts of the lawless bohemian artist, whose hands were as skilled with the

41 Artemisia Gentileschi *Self-Portrait as the Allegory of Painting* 1630s

dagger as with the paintbrush, and in whom a revolutionary style of painting commingled with unrestrained passions, usually begin with Caravaggio, though Rudolph and Margaret Wittkower have skilfully traced its prototype to the sixteenth century. Archival research on the Gentileschi family has produced a history rich in court orders and libels, as well as the famous trial in 1612 of Orazio's assistant and Gentileschi's teacher, Agostino Tassi, on charges that he had raped the nineteen-year-old girl, withdrawn a promise of marriage, and taken away from the Gentileschi house paintings that included a large *Judith*. The truth of the matter remains buried under conflicting seventeenth-century documents and modern readings of those documents which have often imposed anachronistic attitudes on seventeenth-century sexual and matrimonial mores. At its heart, the trial had less to do with Artemisia Gentileschi's virtue than with Tassi's relationship to Orazio Gentileschi's legal property, which included his daughter. Germaine Greer's argument, that the trial, and the publicity which accompanied it, removed the remaining traditional obstacles to the development of Gentileschi's professional life, is convincing up to a point. But it ignores the equally favorable confluence of Orazio Gentileschi's defiant reputation and his unswerving support of his talented daughter. Mary Garrard's recent monograph on the artist, which also brings together in English all the documents relating to the artist, has convincingly shown how this public scrutiny of female sexuality reshaped those issues of gender and class relevant to Gentileschi's subsequent emergence as a major artist.

The growth of naturalism in the seventeenth century led to a new emphasis on the depiction of courage and physical prowess in representation. Images of heroic womanhood, qualified by the moralistic rhetoric of the Counter Reformation and well suited to the demands of Baroque drama, replaced earlier and more passive ideals of female beauty. This new ideal, traceable in the work of the Carracci and Reni circles as well as in the followers of Caravaggio, coincided with expanding roles for the artist which admitted a wider range of behavior and attitudes, and assured even the unconventional Caravaggio of the continuing patronage of the powerful cardinal, Scipione Borghese. However colorful Gentileschi's life, and accounts vary widely, it was marked by a sustained artistic production (despite the fact that she married and had at least one child) equalled by few women artists.

43 Among Gentileschi's earliest works is a *Susanna and the Elders*, inscribed ARTE GENTILESCHI 1610, which already displays precocious

evidence of her later development. The opportunity to examine the work (long inaccessible in a private collection) when it appeared in the exhibition, *Women Artists 1550–1950*, in 1977 has resolved earlier arguments about its attribution in favor of Artemisia rather than Orazio, despite a formal and coloristic debt to the older Gentileschi.

The painting, executed in Rome only a year after she began her career (if we are to believe Orazio's testimony at the trial), has sources in similar representations by members of the Carracci circle, as well as in a *David and Goliath* (c. 1605–10) by Orazio. The Apocryphal story of the attempted seduction of Joachim's wife, Susanna, by the two elders was extremely popular in Italy by the late sixteenth century and provided a scenario through which virtue could be proved triumphant. Rape and seduction were closely linked in the eyes of the Renaissance viewer; here the drama is played out in terms of control over looking and the differing relationships of male and female to the visual field. Male possession of the female body is initiated through a look which surprises the unsuspecting and defenseless woman at her bath and arrests her in a prolonged moment of voyeuristic and pleasurable contemplation. "The nude's erotic appeal could be heightened," Mary Garrard argues in an important article on the painting, "by the presence of two lecherous old men, whose inclusion was both iconographically justified and pornographically effective." The frequency with which Susanna is assigned a complicitous role in this drama of sexualized looking, as we see in Tintoretto's version of 1555–56, points to the theme as one of primary importance in the use of representation to confirm an ideology of dominance over powerlessness, in which woman's voluptuous body is affirmed as an object of exchange between men.

Gentileschi's version departs from this tradition in significant ways. Removing Susanna from the garden, a traditional metaphor for the bounteous femininity of nature, Gentileschi isolates the figure against a rigid architectonic frieze which contains the body in a shallow and restricted space. The figure's almost complete nudity, a dramatic departure from a convention of gracefully and titillatingly draping the body, transforms her into a distressed young woman whose vulnerability is emphasized by the awkwardly twisting body. Other representations of the subject in Italian painting, including those by the Carracci circle like Ludovico Carracci and Sisto Badalocchio (c. 1609), reinforce the male gaze by directing both gazes toward the female body. The conspiratorial glance of one elder toward the viewer in Gentileschi's representation is perhaps unique. It also

42

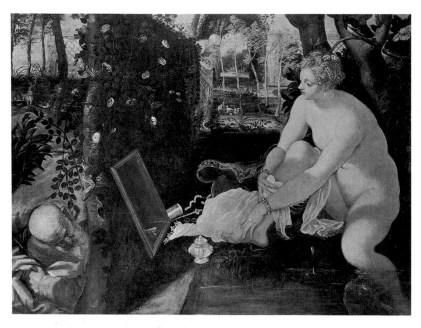

42 Tintoretto *Susanna and the Elders* 1555–56

produces a more disturbing psychological content, as the triangle inscribed by the three heads, and the positioning of the arms, not only focuses Susanna as the object of the conspiracy, but also implicates a third witness, a spectator who receives the silencing gesture of the older male as surely as if "he" were part of the painting's space. The figure of Susanna is fixed like a butterfly on a pin between these gazes, two within the frame of the painting, the other outside it, but implicitly incorporated into the composition. Abandoning more traditional compositions in which Susanna's figure is off-center, along a diagonal or orthogonal line which allows the spectator to move freely in relation to the image, Gentileschi moves the figure close to the center of the composition and uses the spectator's position in front of the canvas to fix her rigidly in place.

Gentileschi's biography has often been read in her representations. More remarkable for her development as a painter, however, is the sophistication of this early intuitive and empathetic response to a familiar subject. *Susanna and the Elders* offers striking evidence of Gentileschi's ability to transform the conventions of seventeenth-

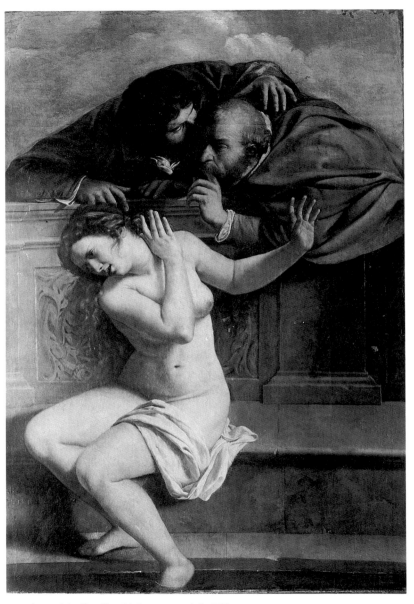

43 Artemisia Gentileschi *Susanna and the Elders* 1610

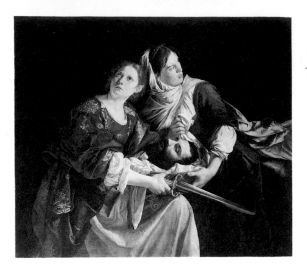

44 Orazio Gentileschi
*Judith with Her
Maidservant* c. 1610–12

century painting in ways that would ultimately give new content to the imagery of the female figure.

Tassi's eventual acquittal at the celebrated trial in Rome, which included Gentileschi's torture by thumbscrew in an attempt to ascertain the truth of her statements, and Gentileschi's subsequent marriage to a wealthy Florentine were followed by several years in Florence where she enjoyed an excellent reputation as a painter, executed several of her most important works, and joined the Accademia del Disegno, the archives of which include several references to her between 1616 and 1619. The Florentine period, which ended with her return to Rome in 1620 according to Bissell' chronology, seems to have included the *Judith With Her Maidservant*, the *Judith Decapitating Holofernes*, and an *Allegory of the Inclination* commissioned in 1617 for the salon ceiling in the Casa Buonarotti in Florence.

Gentileschi's *Judith With Her Maidservant* is the first of six known variations on the popular theme from the Old Testament Apocrypha which relates the story of the slaughter of the Assyrian general, Holofernes, by the Jewish widow, Judith, who crept through enemy lines to seduce and then decapitate the sleeping general. The mythology of women of power and courage was, however, a male mythology. Invented and sustained largely by male writers and painters, it was seldom taken up by women. The monumental composition, penetrating naturalism, powerful lighting, and use of contemporary models, are the major indicators of Gentileschi's fully developed Caravaggism. In this painting, as in the earlier *Susanna and*

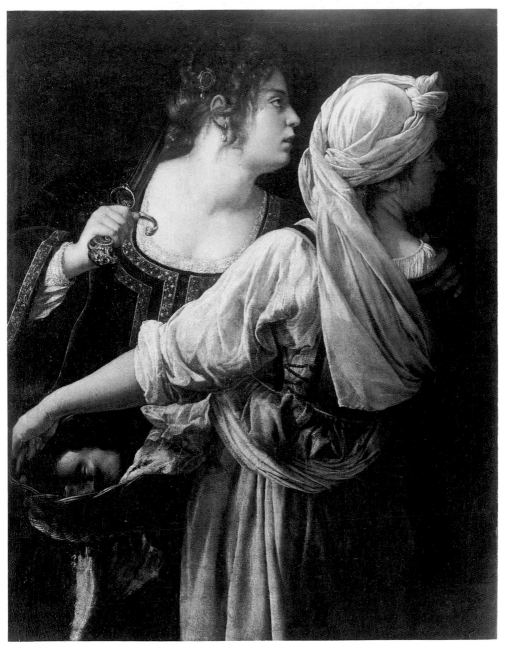

45 Artemisia Gentileschi *Judith with Her Maidservant* c. 1618

the Elders, she emphasizes the complicity of the two figures by squeezing them into the same space, mirroring their bodies, and repeating the direction of the two gazes. The focused intensity, reinforced by the clenched hand that clutches the sword hilt, is a radical departure from Orazio Gentileschi's version of the same subject (c. 1610–12). In the latter, the stability of the pyramidal composition created by the positioning of the bodies of the two women emphasizes the figures' passivity, while the directing of their gazes outward in different directions works to defuse their intensity and commitment to a shared goal—the death of the enemy leader. In yet another version of the same subject, Giovan Giosefa dal Sole's *Portrait of a Woman as Judith*, executed at the end of the century, the presence of Holofernes's head lends a merely anecdotal touch to the languid figure of Judith, an image of sensual pleasure who, with breasts bared, turns toward the spectator.

The most insistent feature of Gentileschi's *Judith Decapitating Holofernes*—the ferocious energy and sustained violence of the scene—has attracted extensive critical commentary, often by writers who have found intimations of Gentileschi's personal experience as the recipient of Tassi's sexual advances in the scene. Yet the naturalistic details—the choice of the moment of the decapitation and the blood which jets from the severed arteries—are present in several other seventeenth-century versions, including those of Caravaggio and Johann Liss, whose *Judith in the Tent of Holofernes* (c. 1620) rivals Gentileschi's in lurid detail. A more relevant source for Gentileschi's representation may be a lost work by Rubens, known today only through an engraving by Cornelius Galle I (1576–1650), which sheds light on the painting's iconography as well as its gruesome nature. Rubens's work provides a possible source for the powerful female figure with its muscular arms, neck, and upper torso, but is significantly different from Gentileschi's rendering in its attention to the graceful and revealing swirl of drapery around the female body. Despite pictorial sources in Caravaggio, Rubens, and Orazio Gentileschi, there is nothing in the history of Western painting to prepare us for Gentileschi's expression of female physical power, brilliantly captured in the use of a pinwheel composition in which the interlocking, diagonally thrusting arms converge at Holofernes's head. It is not the physicality of the female figures alone, however, which makes it unusual, but its combination with restructured gazes. The coy glances and averted gazes of Western painting's female figures are missing here. The result is a direct confrontation which

disrupts the conventional relationship between an "active" male spectator and a passive female recipient. Although Gentileschi's work shares subjects and female heroines with that of a great many other seventeenth-century painters from Francesco del Cairo and Valerio Castello to Guercino, Carlo Saraceni, and Guido Reni, and active, muscular male figures appear in works like Bartolomeo Manfredi's *Mars Punishing Amor* (c. 1610), its celebration of female energy expressed in direct rather than arrested action was profoundly alien to the prevailing artistic temper.

The theme of Judith and Holofernes is repeated in the work of other seventeenth-century women artists, but theirs contain none of the characteristics that distinguish Gentileschi's. A *Judith and Her Handmaiden* painted by Fede Galizia, the daughter of a miniaturist from Trento, at the end of the sixteenth century, reiterates the conventions of refined female portraiture in combination with the stern, moral message of the severed head. Sirani's *Judith*, despite following Gentileschi's chronologically, is closer to the mannered elegance of Bolognese painting than to the new pictorial ideals of the Gentileschi family.

By the time Artemisia Gentileschi arrived in Naples in 1630 she was a celebrity, living magnificently and enjoying the patronage and protection of the nobility. An allegorical figure of *Fame*, dated 1632, and a *Self-Portrait as the Allegory of Painting* (1630s) are important 41 works which signal her transition to a more refined later style. *Self-Portrait as the Allegory of Painting* has been thoroughly analyzed as a sophisticated commentary on a central philosophical issue of later Renaissance art theory, and an audacious challenge to the core of artistic tradition in its creation of an image unavailable to any male artist—an allegorical figure which is at the same time a self-image. Following Ripa's description of the image of *Pittura*, Gentileschi has given herself the attributes of the female personification of Painting: the gold chain, the pendant mask standing for imitation, the unruly locks of hair that signify the divine frenzy of artistic creation, and the garments of changing colors which allude to the painter's skill. The richly modulated colors—red-browns, dark green, blue velvet—are repeated in the five patches of color on the palette. The work belongs to a tradition in which painting is identified as one of the liberal arts, but here artist and allegory are one. Unlike the self-portraits of Anguissola discussed in the previous chapter, here, for the first time, a woman artist does not present herself as a gentlewoman, but as the act of painting itself.

Domestic Genres and Women Painters in Northern Europe

The conditions that made possible the participation of relatively large numbers of women in the art of Northern Europe predate the seventeenth century. Women in the North appear to have enjoyed greater freedom and mobility in the professions than their Italian contemporaries in the fifteenth and sixteenth centuries. Although substantial documentation is missing, women's names already appear in fifteenth-century archives in Flanders. Archives of the studio of Guillaume Vrelant, which produced many volumes of illuminated manuscripts in Bruges, mention an Elisabeth Scepens who was Vrelant's student in 1476 and did some work for the court of Burgundy (as did Margaretha van Eyck earlier in the century with her brothers Jan and Hubert). After Vrelant's death, Scepens ran the business with his widow (who, like many women of the time, inherited the business on the death of her husband) and she is listed as a member of the artist's guild from 1476 to 1489. In 1482, Agnes van den Bossche secured an important commission to paint the Maid of Ghent on a banner for her hometown; in 1520, a group of marching widows in a procession of the city guilds caught Dürer's eye when he visited Antwerp and he noted their presence in his journal.

Like Anguissola in Italy, the two best-known northern women painters of the sixteenth century were supported by royal families: Caterina van Hemessen as painter to Mary of Hungary, the sister of Charles V of Spain (after she abdicated her regency of the Low Countries and returned to Spain); Levina Teerlinc at the English court of Henry VIII. Van Hemessen, the daughter of the prominent Antwerp painter Jan Sanders van Hemessen, was trained by her father and may be the so-called Brunswick Monogrammist identified with him. Her religious paintings include a *Rest on the Flight into Egypt* (1555) and a *Christ and Veronica*, as well as several paintings by her father on which she appears to have worked.

A pair of signed portraits, executed in 1551 and 1552, depict a stylish
46 couple against a dark ground in three-quarter views with the direct and sensitive realism characteristic of her work. Van Hemessen

46 Caterina van Hemessen *Portrait of a Man* c. 1550

married Christian de Morien, the organist at Antwerp Cathedral, in 1554 and the pair were taken to Spain by Mary. Although she provided for the couple for life, no work remains from the Spanish period.

Levina Teerlinc, who was invited to England by Henry VIII and retained as court painter by his three successors—Edward VI, Mary I, and Elizabeth I—was one of a number of Flemish women artists, among them Katherine Maynors, Alice Carmellion, Ann Smiter, and the Hornebout family, who were active in England in the production of miniatures, then extremely popular as articles of dress. Teerlinc was the eldest of five daughters of the miniaturist Simon Bining and was the only portrait miniature painter of Flemish origin known to have been employed at court between the death of Hans Holbein the Younger in 1543 and the emergence in 1570 of Nicholas Hilliard (the first native-born miniaturist in English history and the man whose subsequent career almost entirely eclipsed hers). She married a painter named George Teerlinc and by January 1546 her name appears in court account books as "king's paintrix." Not until 1599 was Hilliard granted an annuity equal to hers, forty pounds a year, and hers was

higher than that granted to Holbein. Comparisons such as these can be misleading, however, as court painters were customarily paid with gifts as well as money.

Although Teerlinc's life at court, where she was Gentlewoman of the Privy Chamber, is well documented, little work has been firmly attributed to her. As gentlewoman to Queen Elizabeth, Teerlinc had to present her with a New Year's gift each year. They begin in 1559 with a small picture of the Trinity and include annual gifts of miniatures. Teerlinc is probably the first painter to whom the Queen sat and Roy Strong identifies these images as important documentary evidence of the appearance of the young Elizabeth before her cult transformed her into an iconic image. Elizabethan state portraiture played an important role in the vast struggle concerning images which divided the reformed and Roman churches in sixteenth-century England and Teerlinc's part in establishing the conventions which led to an imperial iconography of the Elizabethan court deserves further study. Strong has attributed the first frontal majestic images of the Queen, the image on the Great Seal and numerous documents, to drawings by Teerlinc and the origins of the representation of Elizabeth Virgo must be sought in her images.

Van Hemessen and Teerlinc were part of a strong tradition of court patronage for women from the sixteenth to the eighteenth centuries. Court appointments exempted women from guild regulation during the Renaissance and they provided women artists with an important alternative to academies and other institutions which increasingly restricted or prohibited their participation. As gentlewomen and

painters, women's social and professional lives were elided; their presence at court both affirmed the breadth of court patronage and insured that educated and skilled women were available as teachers and attendants.

During the second half of the sixteenth century northern artists continued to travel to Italy for training; after that, they increasingly received their professional training in Holland where the guild system remained firmly in place. Although we know of no women painters engaged in landscape and history painting during this period, the spread of humanism and the educational and domestic ideology of the Protestant Reformation increased literacy among women in the North and their participation in the visual arts. By the seventeenth century, Northern European art was dominated by new, middle-class ideals reflecting the growth of commerce and the Protestant Church. A domestic ideology shifted attention from the church to the home, particularly after the iconoclastic fury of the mid-century restricted art to that produced for the home. The themes that characterize Dutch seventeenth-century painting—still-life, genre scenes, flower painting, and topographical landscape—reflect the prosperity of the middle class and the emergence of painting as a secure investment for a non-aristocratic clientele seeking art for their homes.

Dutch seventeenth-century painting continues to challenge art history's emphasis on Italian Renaissance art as a model. When artists—whether because of Protestant interdictions against religious images in seventeeenth-century Holland, or the later focus on leisure by a growing middle class in nineteenth-century France—have turned to everyday life for subjects, the results have often diverged sharply from the conventions of Italian painting. Yet those conventions continue to color our ideas about spectatorship, content, and patronage. To paint everyday life is to paint the activities of women and children, as well as those of men; and to record the realities of domestic spaces, as well as to aggrandize public, historical, religious, and mythological events.

The art that developed in Holland (the term commonly used in English for the seven United Provinces that formed the Dutch Republic) in the seventeenth century reflects the antihumanism of Dutch Calvinism, the rapid growth and spread of the natural sciences, and the wide-ranging changes in family life and urban living that grew out of this prosperous, literate, Protestant culture. Although an official hierarchy of subject-matter reflected in theory that of Italian painting (with historical subjects at the top and still-life at the

bottom), in fact, painters of flower pieces were among the highest paid artists of the time. And although Calvinism recapitulated the medieval call for chastity and obedience for women, the realities of Dutch life encouraged a diversity of activity for women and a level of self-development that enabled a number of them to become professional painters. The variety of subjects in Dutch painting is far greater than indicated here, and the relationship of Dutch artists to Italian art far more complex, but an examination of two areas of Dutch painting—genre and flower painting—reveals new aspects of the intersection of gender and representation.

A famous critique of northern art attributed by Francisco de Hollanda to Michelangelo is among the first accounts to weigh the differences between Italian and northern painting in terms of gender. "Flemish painting . . . will . . . please the devout better than any painting of Italy," Michelangelo is recorded to have said. "It will appeal to women, especially to the very old and the very young, and also to monks and nuns and to certain noblemen who have no sense of true harmony. In Flanders they paint with a view to external exactness or such things as may cheer you and of which you cannot speak ill, as for example saints and prophets. They paint stuffs and masonry, the green grass of the fields, the shadow of trees, and rivers and bridges, which they call landscapes, with many figures on this side and many figures on that. And all this, though it pleases some persons, is done without reason or art, without symmetry or proportion, without skillful choice or boldness and, finally, without substance or vision." This criticism of northern painting as lacking symmetry and harmony (that is, mathematical proportion and ideal form), and as therefore inferior to Italian painting and worthy of the admiration only of women, the pious, and the uneducated, draws striking distinctions between the painting of northern and southern Europe. If, as Svetlana Alpers has argued, Italian Renaissance art elaborates the viewer's measured relationship to objects in space, praises mastery in mathematics and literature, and asserts a process of art-making aimed at the intellectual possession of the world, then Dutch art functions very differently. In Dutch painting, pictures serve as descriptions of the seen world and as moralizing commentaries on life rather than as reconstructions of human figures engaged in significant actions. In "Art History and Its Exclusions: The Example of Dutch Art," Alpers convincingly demonstrates the implications of this distinction for the representation of women in Dutch art and for transforming the relationship between the artist as male observer and the woman

observed: "The attitude toward women in [Italian] art—toward the central image of the nude in particular—is part and parcel of a commanding attitude taken towards the possession of the world." By contrast, Dutch genre painting details women's occupation in the activities of everyday life, while paintings of single female figures in interiors, like Vermeer's many works on the themes of women reading or sewing which begin in the middle of the seventeenth century, use the absorption of these activities to draw attention to the elusiveness of women as subjects. No longer emphasizing the tension between a male viewer and woman as the object of sight, available for male viewing pleasure, Vermeer and other northern artists allowed woman her own self-possession, her own unavailability to control by another's gaze. Instead, the gaze of the artist/spectator lingers over the surfaces of objects, enjoying the play of light on rich fabrics, the subtlety of color and the fineness of detail that make up the painting's surface. What Alpers has called a "mapping" of the surfaces of objects, with its close attention to materiality and detail, has important implications for feminist readings. Elevating grandiose conception over intimate observation, writers on art from Michelangelo to Sir Joshua Reynolds have identified the detail with the "feminine." "To focus on the detail," Naomi Schor suggests in *Reading in Detail*, "and more particularly on the *detail as negativity* is to become aware . . . of its participation in a larger semantic network, bounded on the one side by the *ornamental*, with its traditional connotations of effeminacy and decadence, and on the other, by the *everyday*, whose 'prosiness' is rooted in the domestic sphere of life presided over by women."

Much Dutch genre painting of this period does indeed lovingly catalogue the images and objects of the Dutch household, and its middle-class and Protestant orientation contributed to new social roles for the artist and new kinds of content. The relatively low prices paid by a large public interested in paintings as embellishment for the home encouraged the recruiting of artists primarily from middle- and lower-class families, and a continuing lack of distinction between painting and other craft traditions which provided furnishing for the home. The role of women as spectators in seventeenth-century Holland, actively making decisions about the circulation and consumption of images, remains to be analyzed and theorized.

The use of the term "genre" to describe paintings of everyday life is relatively recent. In the seventeenth century paintings were identified by subject; scenes of daily life ranged from banquet and brothel paintings to interiors, family groups, and women and servants

engaged in domestic activities. There is evidence to suggest that over the century the content of these paintings, whose numbers increase steadily up to the 1660s and then grow sharply in the 1670s, moved from allegorical or emblematic to more descriptive. The debate about whether to read these images as symbolic or realist continues, but it appears that many paintings both describe actual scenes and have pictorial sources in popular emblematic literature like Jacob Cats's emblem books (in which a motto, a picture, and a commentary elicit a moral injunction).

Seventeenth-century Holland also had a large and powerful group of non-professional practitioners of the arts. When Houbraken published his *Groote Schouburgh der Nederlantsche Konstschilders en Schilderessen* (The Story of Netherlandish Painters *and* Paintresses) in 1718, he placed next to a portrait of Rembrandt one of Anna Maria Schurman, an accomplished scholar and feminist who drew, painted, and etched as an amateur (and who was admitted to the Utrecht Guild

48 of St. Luke in 1641). Although two self-portraits are the only works that exist today by Schurman's hand, the woman that Dutch poets called their "Sappho and their Corneille" was an important voice in the call for independent women in Dutch culture.

The Protestantism of Dutch art eliminated the Blessed Virgin as a female model, while the lack of a strong Neoplatonic movement in the North prevented the identification of female form with ideal beauty in painting. Instead, the imagery of the home assumed a central place in Dutch iconography—as a microcosm of the properly governed commonwealth and as emblematic of education and the domestication of the senses. The well-ordered household, a condition for an orderly society, consisted of the family, their servants and belongings. Within the home, the primary emblem of the domestic virtue that insured the smooth running of society was the image of a woman engaged in needlework, sewing, embroidery or lacemaking.

The imagery of the domestic interior provides a context in which to observe the increasing prosperity of the Dutch Republic through the material goods that fill the home. There are surprisingly few paintings that have as their subject the actual commerce and trade that underlay the seventeenth century's wealth, for such subjects could not easily be reconciled with Calvinist ambivalence toward the acquisition of money. The domestic interior, on the other hand, was a worldly embodiment of Christian principles and an appropriate setting for the display of goods. These paintings offer a multi-layered view of the realities of Dutch social and economic life at the time, including the gendered division of labor in key occupations like cloth production. They also warn of the dangers of unrestrained female sexuality (for example, the negative implications of men and women "exchanging" places in activities related to cloth production).

During the course of the century, images of men and women weaving and spinning underwent significant changes in response to shifts in domestic ideology, as well as in cloth production. In 1602, the governor of Leiden's guild of say-weaving (a cloth like serge) commissioned a series of eleven glass paintings depicting the process of say-cloth manufacture in Leiden (along with Haarlem the major center of cloth production). All that remains are eleven preparatory drawings by Isaac Claesz van Swanenburgh. Linda Stone has shown the drawings to depict the industry in a favorable and idealizing light. In *Spinning and Weaving*, men and women work together in a large room but, as in other depictions of labor, men do the actual weaving while women's activities are restricted to washing, spinning, winding, and carding the wool. Women were prohibited from certain aspects of making cloth in professional workshops and working conditions for women and children were far worse than those for men. Many children, especially orphans, worked fourteen-

hour days for a couple pennies a week. The organization of cloth production by entrepreneurs ("drapiers" wealthy enough to afford the purchase of raw materials which they then jobbed out to spinners and weavers) encouraged a strict division of labor and the use of women and children as a means of keeping wages low.

By the 1630s, the pure woolen industry in Leiden was prominent enough for its guild to establish a guildhall (*lakenhal*) of its own. A local artist, Susanna van Steenwijck-Gaspoel, was commissioned in 1642 to execute a painting of the new building. The wife of the architectural painter, Hendrik van Steenwijck de Jonge, she was paid six hundred guilders for the painting (an astonishing sum at a time when most nonhistorical paintings sold on the open market for less than fifty guilders each). The building is rendered in a simplified, almost schematic, style which clearly emphasizes its architectural details, including five sculptured plaques on the facade showing the cloth production process.

By mid-century, paintings by Cornelis Decker, Thomas Wijck, Gilles Rombouts, and others had firmly established the conventions for depicting weaving as a cottage industry in which the weaving itself is always done by a man (though often a woman sews or spins nearby). Such paintings emphasize the accoutrements of weaving and the lower-class nature of the occupation, as opposed to the large-scale manufacture of wool and linen in Leiden and Haarlem. They reinforce a tradition of commending workers' industriousness which originates in sixteenth- and seventeenth-century emblem books and didactic tracts. In Jacob Cats's emblems, the weaver's shuttle is a *memento mori*, a reminder that life flies past as swiftly as the shuttle moves across the loom. There is evidence to suggest, however, that these depictions of industrious weavers replace earlier and more vulgar representations carried over from medieval times which equate the mechanical motion of the loom with copulation. Linda Stone has located the shift from this view to a new respect for a pious laity in the evolution of Reformation thinking. In Biblical and mythological tales, the Virgin appears frequently as the spinner of life, a model of female virtue to be emulated by other women. Representations of women spinning in Dutch art increasingly refer not to the profession of cloth production, as do those of men weaving, but to the moral character of the spinner and the domestic nature of the activity.

The Dutch translation of Cesare Ripa's well-known *Iconologia* in 1644 introduced a wide variety of allegorical female figures into

49 Illustration from
Johann van Beverwijck
*Van de Wtnementheyt des
Vrouwelicken Geslachts*
1643

50 Susanna van
Steenwijck-Gaspoel *The
Lakenhal* 1642

northern art, many of which were subsequently transformed into emblems of domestic bliss. Dr. Johann van Beverwijck's *Van de Wtnementheyt des Vrouwelicken Geslachts (On the Excellence of the Female Sex)* appeared in 1643 with a portrait of Schurman as a frontispiece and a representation of Dame World transformed into an ideal of the family home, "the fountain and source of republics." Martin Luther had demanded that women labor with distaff and spindle and in the engraving illustrating van Beverwijck's essay, 49 Adam labors in the fields while Eve spins within the house. The author's call for women's emancipation is carefully modulated by his continuing adherence to domestic models in which education and the professions are legitimized for women only in the presence of domestic skills; "To those who say that women are fit for the household and no more, then I would answer that with us many women, without forgetting their house, practice trade and commerce and even the arts and learning." Cats's emblems, on the other hand, reinforced a more conservative and no doubt more widely held view; "The husband must be on the street to practice his trade; The wife must stay at home to be in the kitchen." It was marriage and domesticity which contained women's animal instincts according to both popular and medical sources; it was under the sign of the distaff and spindle that female virtue and domesticity were joined.

One result of growing prosperity in Holland during this period was a focus on woman's sexuality as an object of exchange for money. Representations of women spinning, embroidering, and making lace often conveyed ambiguous and sexualized meanings. Judith Leyster's 60 *Proposition* (1631) is one of a number of paintings that imbricate the discourses of domestic virtue and sexuality. Here, the proposition is initiated by a man who leans over the shoulder of a woman deeply absorbed in her sewing. With one hand on her arm, he holds out the other hand, filled with coins. Refusing to look up and engage in the transaction, she completely ignores his advances.

Presented as an embarrassed victim rather than a seducer, Leyster's female figure is depicted as an embodiment of domestic virtue at a time when the growth of Calvinism was accompanied by a resurgence of brothels. Themes of prostitution and propositions provided an opportunity for moralizing; paintings based on these themes often exploit the idea that women who reject their "natural" roles become temptresses who lead men into sin. Leyster's treatment of the theme is unprecedented in Dutch painting and its intimate and restrained mood does not reappear until some twenty-five years later.

It has been cited as a prototype for later versions of the theme, such as Gerard TerBorch's so-called *Gallant Officer* (c. 1665) and Gabriel Metsu's *An Offer of Wine* (1650s), as well as Vermeer's many paintings of men interrupting women at their work.

Two other paintings by Leyster are among the earliest representations in Dutch art of women sewing by candlelight. *A Woman Sewing by Candlelight* (1633) is one of a pair of small circular candlelight scenes with full-length figures showing the influence of Hals and the Utrecht Caravaggisti. Although art history has been complicit in generalizing such representations into embodiments of domestic virtue, significant differences in fact exist in the presentation of this type of female labor in Dutch art, as well as in the class and material circumstances of the women engaged in it. A series of engravings of domestic work by Geertruid Roghman, daughter of the engraver Hendrik Lambertsz and sister of the painter and etcher Roelant Roghman, made about the middle of the century, emphasizes the labor of needlework rather than the leisure and reverie that it has come to signify in paintings like Vermeer's *Lacemaker* (c. 1665–68). In Vermeer's painting, a stylish young woman bends over her bobbins completely absorbed in her task. In contrast, Roghman's figures are often in strained poses with their heads bent uncomfortably close to their laps as if to stress the difficulty of doing fine work in the dim interiors of Dutch houses of the period. Surrounded by the implements necessary to their activities—spindles, combs, bundles of cloth and thread—they demonstrate the complexity and physical labor of the task. *Woman Spinning* (before 1650) is the fourth in a series of five engravings whose others are sewing, pleating fabric, cleaning, and cooking. Roghman's woman is without the moralizing inscription integral to emblematic representations, and the emphasis on the woman's concentration, her sympathetic relationship to the watching child, and the careful description of objects evoke a mood of balance and order.

If Roghman's engravings express the utilitarian aspects of cloth production in the Dutch home, Vermeer's and Caspar Netscher's paintings of lacemakers rely on rich colors and fabrics to reinforce the intimacy and sensuality of women in repose. Vermeer's lacemaker is a woman making the bobbin lace then popular among prosperous Dutch women, not for profit, but as an indication that northern women were as accomplished at the production of luxury goods as their better-known French and Flemish contemporaries.

Needlework and lacemaking had very different roles in the lives of women of the upper and lower classes. The expansion of the Dutch

51 Vermeer *The Lacemaker* c. 1665–68

52 Judith Leyster *A Woman Sewing By Candlelight* 1633 >

market for lace exports, after France imposed high duties on its own products in 1667, renewed interest in the skill of lacemaking, long an occupation for upper-class women. The activity became identified with charity and the reeducation of wayward girls in domestic virtues, and provided suitable employment for orphans. The finest bobbin lace was done by professional linen seamstresses, but an ordinance issued by the Amsterdam town council in 1529 indicates that poor girls could earn a living from lacework. Bobbin lace of the kind shown in Vermeer's painting was also made in orphanages and charitable institutions.

The association of needlework with feminine virtue focused attention on this aspect of female domestic life as the site of a growing struggle over conflicting roles for women. In his *Christiani matrimoni institutio*, Erasmus of Rotterdam, the leading Dutch humanist of the sixteenth century, had satirized the preoccupation with needlework at the expense of education for women of the nobility; "The distaff and spindle are in truth the tools of all women and suitable for avoiding

idleness. . . . Even people of wealth and birth train their daughters to weave tapestries or silken cloths. . . . it would be better if they taught them to study, for study busies the whole soul." In *The Learned Maid, or Whether a Maid may be a Scholar*, Schurman argued that girls should be taught mathematics, music, and painting, rather than embroidery: "Some object that the needle and distaff supply women with all the scope they need. And I own that not a few are of this mind. . . . But I decline to accept this Lesbian rule, naturally preferring to listen to reason rather than custom."

Throughout the seventeenth century, painting served both domestic and scientific ends; that which was accurately observed pleased the eye and in turn confirmed the wisdom and plan of God. Science and art met in this period in flower painting and botanical illustration. The task of describing minute nature required the same qualities of diligence, patience, and manual dexterity that are often used to denigrate "women's work." Women were, in fact, critical to the development of the floral still-life, a genre highly esteemed in the

seventeenth century but, by the nineteenth, dismissed as an inferior one ideally suited to the limited talents of women amateurs.

Until well into the sixteenth century, the major source for plant illustrations in popular herbal guides was not nature but previous illustrations. Not until the publication of Otto Brunfels's *Herbarium vivae eicones* in 1530–32, with woodcuts by Hans Weidnitz, did illustrators begin working directly from nature. Many of these herbals were hand-painted and it is known that Christophe Plantin of Antwerp employed women illuminators to color the botanical books he produced. The herbals formed the basis of the development of systematic knowledge of flowering plants which took place in the sixteenth and seventeenth centuries. Side by side with the study of medicinal herbs was knowledge through folk medicine largely handed down by country women. In his herbal Brunfels alluded to "highly expert old women." Slightly later, Euricius Cordus remarked that he had learned from "the lowliest women and husbandmen." The rapid growth of the natural sciences, stimulated by botanical and zoological knowledge brought back by European voyagers and explorers, transformed the sciences of botany and zoology. The microscope, invented in Holland in the late sixteenth century, was applied to the study of plants and animals, and systems of plant classification developed. The emergence of horticulture as a leisure-time activity for the wealthy led to the development of the flower book, the transition from the medicinal and practical model of the herbals to the appreciation for beauty alone that encouraged the practise of flower painting.

Before 1560, most garden plants were European in origin; during the seventeenth century colonization and overseas exploration led to the importation of vast numbers of new species. According to Herman Boerhaave (1668–1738), "practically no captain, whether of a merchant ship or of a man-of-war, left our harbours without special instructions to collect everywhere seeds, roots, cuttings and shrubs and bring them back to Holland." The century's passionate interest in the cultivation and illustration of flowers proceeded hand-in-hand with a belief that all the world could be brought into the home for study.

The laying out of gardens extended the idea of the *kunstkamer* (collections of rare objects and curiosities including shells, minerals, and fossils). Pattern books of floral designs, like Pierre Vallet's *Le jardin du roy tres chrestien Henry IV* (1608), dedicated to Marie de Medici who later commissioned some expensive flower pieces, served

as sources for embroidery designs. Crispijn van de Passe's *Hortus floridus*, published in Utrecht in 1614 and an immensely popular work, contained over two hundred plates in which the naturalism of the floral presentation was heightened by the addition of insects and butterflies to the plant stalks. Jacques de Gheyn was a pioneer among painters of flowers and a man who engraved, limned, and painted on glass as well as oils. During the century, many women also practiced the ancillary arts of botanical illustration or flower painting for textile and porcelain manufacturers, but only two women, Maria van Oosterwyck and Rachel Ruysch (see below), appear to have had a steady and prestigious clientele for their flower paintings.

Between 1590 and 1650, Utrecht and Antwerp emerged as the major centers of flower painting in oils, perhaps influenced by Antwerp's prominent role in botanical publishing during the second half of the previous century. The first school of Netherlandish flower painting developed in Antwerp around Jan "Velvet" Breughel and his followers. The earliest group of painters of still-lifes and flowers included Clara Peeters, who was born in Antwerp in 1594 and who worked there with Hans van Essen and Jan Van der Beeck (called Torrentius). The term "still-life" did not appear in the Netherlands until about 1650 and these works were more commonly identified by type: "little banquet," "little breakfast," "flower piece," etc. Peeters signed and dated her first known work in 1608. Of the fifty or so paintings by her hand which have been identified, five represent *Bouquets*; the others are descriptive paintings featuring glasswares, precious vases, fruits and desserts, breads, fish, shells, and prawns, sometimes with flowers added. Harris and Nochlin have identified her work as earlier than almost all known dated examples of Flemish still-life painting of the type she made, commonly known as the "breakfast piece" because of its assembly of fruits and breads. As fewer than ten pictures of flowers and fewer than five compositions of fruit produced in the Netherlands can be securely dated before 1608, she appears to be one of the originators of the genre, along with Breughel and Osias Beert, and something of a prodigy as her first dated piece was executed when she was only fourteen years old. Although she sometimes included flowers in her still-life compositions, pure flower paintings by her are rare and their arrangements are simple and natural in comparison with Breughel's and Beert's more formal and profuse compositions.

Peeters's major contribution was in the formation of the banquet and breakfast piece; four paintings dating from 1611 include elaborate 53

displays of flowers, chestnuts, bread rolls, butter, and pretzels piled into pewter and delft dishes and presented against austere, almost black backgrounds. In one of them, multiple reflections of the artist's face and a window are just discernible in the bosses of an elaborately worked pewter pitcher. These paintings are among the masterpieces of seventeenth-century still-life, a fact made all the more remarkable by the youth of the artist. Peeters's meticulous delineation of form and the imposing symmetry of her paintings, along with her virtuoso handling of reflective surfaces must have encouraged the spread of still-life painting later in the century, but little documentary material about her remarkable career or her patrons has yet surfaced.

The growing interest in botanical illustration, the emergence of the Dutch as Europe's leading horticulturalists in the seventeenth century, and the development of flower painting as an independent category all contributed to the passion for floral illustration of all kinds. Flowers were often included in *vanitas* and other kinds of moralizing

53 Clara Peeters *Still-life* 1611

54 Judith Leyster *Yellow Red of Leiden* c. 1635

55 Illustration from Jan Commelin *Horti Medici Amstelodamensis Rariorum Plantarum Descriptio et Icones* 1697–1701

representation as signs of the fleeting nature of life. Their emblematic and symbolic associations followed them into still-life and flower painting.

During the 1630s the tulip, first brought from Turkey to England during the reign of Elizabeth I, came under intense speculation. Between 1634 and 1637 fortunes were won and lost and "tulipomania" dominated economic news with the most famous blooms selling for thousands of times more than any flower painting; by 1637 the craze had burned out. Although Judith Leyster is best known today for her genre scenes, she was a skilled watercolorist who made botanical illustrations that included prized striped tulips like the *Yellow-Red of Leiden* for "Tulip Books," sales catalogues commissioned by bulb dealers to enable them to display their wares to customers when the flowers were not in season. 54

Commissions such as these were profitable for artists like Leyster, although the majority of these books were copies of originals made by unskilled artists. Women did, however, participate in the production of engravings for botanical works and a particularly fine and detailed

example of the work of the many women active in illustrations for
55 books can be seen in Jan Commelin's *Horti Medici Amstelodamensis Rariorum Plantarum Descriptio et Icones* (1697–1701). The original paintings made for the illustration of this and other books by the two Commelins are mainly the work of Johan and Maria Moninckx.

The Dutch colonies in the East and West Indies, South America, India, and the Cape acted as a further stimulus to botanical and zoological illustration. Seven volumes of natural history drawings made in Brazil by Albert van der Eckhout, Zacharias Wagner and other artists are now in the Staatsbibliothek in Berlin. Other drawings from the Dutch East Indies are in Leiden. However, the most remarkable of these illustrations were by Maria Sybilla Merian who
56 transformed the field of scientific illustration. Primarily an entomologist, Merian has also been called one of the finest botanical artists of the period following the death of Nicholas Robert in 1680.

Born in Germany of a Swiss father and a Dutch mother, Merian's art, nevertheless, derived almost entirely from the great flower painters of seventeenth-century Holland. Her father was an engraver of some note who contributed the illustrations to the florilegium of Johann Theodor de Bry. Shortly after his death, when Merian was an infant, her mother married the Dutch flower painter Jacob Marrell. Merian showed an early interest in insect life and as a youth began to work with Abraham Mignon. In 1664 she became a pupil of Johann Andreas Graff, and subsequently his wife. In 1675, her first publication, volume one of a three-part catalogue of flower engravings, titled *Florum fasciculi tres*, was issued in Nuremburg. The second volume followed in 1677, and both were reissued with a third in 1680. Together they were known as the *Neues Blumen Buch* (New Flower Book), a work which, although less well-known than her work on insects, contains delightful, hand-painted engravings of garden flowers, colored with great delicacy. The plates in several cases depend closely on her father's edition of de Bry's *Florilegium* of 1641 and on Robert's *Variae ac multiformes florum species expressae . . .*, published in Rome in 1665. Merian was also a skilled needlewoman and the book was intended to provide models for embroidery patterns, and perhaps also for paintings on silk and linen.

In 1679 Merian published the first of three volumes on European insects illustrated with her own engravings, *Der Raupen wunderbare Verwandelung und sonderbare Blumennahrung* (The Wonderful Transformation of Caterpillars and Their Singular Plant Nourishment), and the work was enthusiastically received by the scientific commun-

56 Maria Merian *African Martagon* 1680 57 Rachel Ruysch *Flowers in a Vase* after 1700

ity. "From my youth I have been interested in insects," she remarked, "first I started with the silkworms in my native Frankfurt-am-Main. After that . . . I started to collect all the caterpillars I could find to observe their changes . . . and painted them very carefully on parchment." The insects are shown in various stages of development, placed among the flowers and leaves with which they are associated. The second and third volumes appeared in 1683 and 1717 and together the works comprise a catalogue of 186 European moths, butterflies, and other insects based on her own research and drawings. The fact that the insects were observed directly, rather than drawn from preserved specimens in collectors' cabinets, revolutionized the sciences of zoology and botany and helped lay the foundations for the classification of plant and animal species made by Charles Linnaeus later in the eighteenth century.

Merian left her husband in 1685 and converted to Labadism, a religious sect founded by the French ex-Jesuit, Jean de Labadie (who

later married Anna Maria Schurman). The Labadists did not believe in formal marriage or worldly goods, rejected infant baptism, denied the presence of Christ in the Eucharist; they also established missions, including one in the Dutch colony of Surinam. Spending the winter with her two daughters in the Labadist community in the Dutch province of Friesland, Merian had access to a fine collection of tropical insects brought back from Surinam. Goethe relates that, determined to rival the exploits of the French naturalist Charles Plumier, and sponsored by the Dutch government, she set sail for South America in 1698 with her daughter, Dorothea. They spent nearly two years collecting and painting the insects and flowers there; the result was the magnificent *Metamorphosis Insectorum Surinamensium* which appeared in 1705 and was translated into several languages. Merian did not undertake the engravings, as she had for her earlier works, and the sixty large plates were engraved by three Dutch artists who used the superb watercolor studies she had made. Although Merian's work continues to be of interest to art historians as well as naturalists, its impetus was always scientific inquiry. The book's finest plates are among the most beautiful scientific illustrations of the period.

The latter half of the seventeenth century also witnessed the second major period of flower painting. Jan Davidsz de Heem, Maria van Oosterwyck, Willem van Aelst, and Rachel Ruysch achieved international stature as painters of floral pieces. Flower painters rarely if ever made their paintings directly from nature; instead they relied on drawings, studies, and botanical illustrations. The paintings often include blossoms with widely differing blooming seasons. Elaborate montages of colors and textures, they are spiritual responses to the world of nature, rich collages of blooms in an age when flowers were commonly grown in separate beds by species and combined only after they had been cut and were soon to die.

Maria van Oosterwyck, the daughter of a Dutch Reformed minister and one of a growing number of women painters who were not the daughters of artists, was sent to study with the prominent flower painter Davidsz de Heem in Antwerp in 1658. She later worked at Delft, where she was the only female professional painter of the century (but does not seem to have been a member of the guild), Amsterdam, and The Hague. Her earliest dated work, a *Vanitas* of 1668, expresses a moral on the transience of worldly things and the vanity of earthly life. Oosterwyck included a great range of objects, all lovingly painted, including pen and ink as symbols of the professional life, account book and coins pointing to worldly wealth

58 Maria Merian *Metamorphosis Insectorum Surinamensium* 1705

and possessions, and musical instruments and a glass of liqueur as signs of worldly pleasures soon to pass away. The accompanying flowers, animals, and insects reinforce the theme of the transience of life and the constant presence of sorrow and death.

Oosterwyck worked slowly, building up tight, complex compositions with marvellous surfaces. A *Still-life with Flowers and Butterflies* (1686) displays a glass of flowers resting on a ledge and containing several kinds of roses, iris, and two butterflies, the last perhaps symbols of life's transience. Louis XIV's purchase of one of her flower paintings was followed by the patronage of other royalty, including Emperor Leopold, William III of England, and the Elector of Saxony; this painting, one of her last still-lifes, was either commissioned or purchased by King William and Queen Mary from the artist, who visited England in the year after it was painted.

Rachel Ruysch was born in 1664 to Frederick Ruysch, a professor of anatomy and botany in Amsterdam, and Maria Post, the daughter of an architect. Encouraged in her love of nature by her father's vast collection of minerals, animal skeletons, and rare snails, she was apprenticed at the age of fifteen to the celebrated flower painter, van Aelst, the originator of the asymmetrical spiralling composition 57 which became Ruysch's hallmark. Compositions like *Flowers in a Vase* balance a swirl of twisting blossoms along a diagonal axis. The 61 variety of blooms and colors, and the painter's subtle touch and impeccable surface treatment distinguish her work. In 1701, Ruysch and her husband, the portrait painter Juriaen Pool, became members of the painters' guild in The Hague. Between 1708 and 1713, she was court painter in Düsseldorf, but on the death of her patron, the Elector Palatine Johann Wilhelm, she returned to Amsterdam where she worked until her death in 1750 at the age of eighty-six.

Ruysch's status and undeniable achievement encouraged many other Dutch women to become painters. Among those who went as painters to the courts of Germany in the eighteenth century were Katherina Treu (c. 1743–1811), Gertrued Metz (1746–after 1793), and Maria Helena Byss (1670–1726). Other women, like Catherina Backer (1689–1766), famous in her time as a painter of flower and fruit pieces, and Margaretha Haverman, a Dutch flower painter who enjoyed great success in Paris and who was unanimously elected to the Académie Royale in 1722, were instrumental in the spread of flower painting among women and a testament to the expanding roles for women in seventeenth-century Holland.

Amateurs and Academics: A New Ideology of Femininity in France and England

If we are to believe the Goncourt brothers' account of life in eighteenth-century France, written a century later, "woman was the governing principle, the directing reason and the commanding voice of the eighteenth century." Never before in Western Europe had so many women achieved public prominence in the arts and intellectual life of a restricted aristocratic culture. Never had a culture been so immersed in the pursuit of qualities later derided as "feminine;" among them, artifice, sensation, and pleasure. It is not surprising that the fortunes of the best-known women artists of the century, among them Rosalba Carriera, Elisabeth-Louise Vigée-Lebrun, Adélaide Labille-Guïard, and Angelica Kauffmann, are inextricably bound up in the changing ideologies of representation and sexual difference that accompany the shift from a courtly aristocratic culture to that of prosperous middle-class capitalist society.

The emergence of professional women painters of the stature of Kauffmann in England, and Vigée-Lebrun, Labille-Guïard, and Anna Vallayer-Coster in France during the second half of the century is astonishing given the increasingly rigid construction of sexual difference that circumscribed women's access to public activity. Neither their position as exceptions nor later dismissals of them as pandering to the most insipid demands of their age for sentimental paintings account for their phenomenal success or their official status as court painters. They were able to negotiate between the taste of their aristocratic clients and the influence of Enlightenment ideas about woman's "natural" place in the bourgeois social order, and this fact deserves much closer attention than it has received.

As long as the woman artist presented a self-image emphasizing beauty, gracefulness, and modesty, and as long as her paintings appeared to confirm this construction, she could, albeit with difficulty, negotiate a role for herself in the world of public art. In this chapter, I will show, firstly, that the reasons for the success of female Academicians in their own day became the cause of their dismissal by subsequent generations of art historians; secondly that the ability of

these artists to absorb into their persons the qualities which critics sought in representations of women became the most pervasive standard against which to judge their work; and finally, that women artists, professionals and amateurs, played a not insignificant role in constructing, manipulating, and reproducing new ideologies of femininity in representation.

In the course of the eighteenth century, the court art of French monarchs from Louis XIV, the "Sun King," to Louis XVI was supplanted, first by the artistic tastes of a wealthy urban elite identified with the interests of the king, but also determined to use the visual arts to legitimize their own aristocratic pretensions; and subsequently, by the republican demands of a growing, progressive middle class. In his *Painters and Public Life*, Thomas Crow has shown that the revolutionary political discourse that emerged in France during the second half of the century originated in the bourgeois public sphere of the city. Oriented around language and speech, it evolved out of a complex dialogue with the discourse of an earlier, absolutist public sphere—that of the court of Louis XIV at Versailles with its resplendent visual imagery centered on the bodily image of the father/king.

During the rule of Louis XIV (1643–1715), coins of the realm and engravings carried representations of the king as *pater familias*. Murals at Versailles, painted during his reign, incorporate symbolic images of his ministers as naked children, *putti* in extravagant painted scenarios confirming the divine right of French kings. The Académie Royale de Peinture et de Sculpture, founded in 1648 under royal auspices as a way of avoiding guild control over the visual arts, stressed the role of the academicians as learned theorists rather than craftsmen or amateur practitioners. Assuming control of artistic education, it controlled style. Establishing a hierarchy of genres with history painting at the top—followed by portraiture, genre, still-life, and landscape—it determined prestige. At the core of the Academy program was the course of instruction in life drawing. Closed to women, it provided the training for the multifigured historical and mythological paintings so important in reinforcing and reproducing the power of the court.

Vast processions and theatrical court spectacles in Louis XIV's time reproduced an exclusively masculine dynamic of power in which the elevation of the king to divine status constructed a hierarchy under which all his subjects, male and female, were subordinated. "Domesticated" and "unmanned" were the charges later leveled by Enlightenment authors who came to despise the "effeminized" status

59

128

59 Engraving with Louis XIV as *pater familias*, late seventeenth century

of non-royal men under the absolutism of the *ancien régime*. In this hierarchical social structure, class was a more powerful determinant of status than gender; upper-class women were more closely identified with men of their class than with women of the lower classes and paintings emphasize and reinforce these class distinctions.

When the Venetian artist Rosalba Carriera (1675–1757), invited by the financier and art collector Pierre Crozat, arrived in Paris in 1720— in the company of her mother, sister, and brother-in-law, the painter Gian Antonio Pellegrini (1675–1741)—Louis XIV had been dead for five years. Under his successor, the boy king Louis XV (1715–1774), the court was removed to Paris, where it remained for seven years. It was the artists of the Crozat circle (which briefly included Carriera as well as Antoine Watteau) who provided the new ruler with a visual imagery that completed the transition from the previous century's iconography of power to an aristocratic decorative style with international appeal.

The return of a circle of wealthy aristocrats from Versailles to Paris led to a great demand for paintings to decorate elegant townhouses. Instead of an art revolving exclusively around the court, the decorative style later known as Rococo also incorporated the interests of the urban nobility, as well as important commercial groups.

60 Judith Leyster *The Proposition* 1631

61 Rachel Ruysch *Flowerpiece* after 1700

The sumptuous, pleasure-loving art which resulted—with its curvilinear surface patterns, lavish gilding, dainty decorations of flowers and garlands, elaborate costumes, and stylized manners—gave visual form to feeling and sensation. Although the court returned to Versailles in 1722, Paris remained a major artistic center. Large commissions resulted in handsome incomes for favored painters. The Rococo style belonged to a world in which birth determined social status, adultery was accepted as a necessary antidote to loveless, arranged marriages, and servants and wet-nurses relieved upper-class women of many of the burdens of keeping house and nursing infants.

Carriera stayed in Paris for only one year, as part of an international group of artists drawn to the city by wealthy patrons like Crozat. Yet in that short time her work contributed to forming the new, aristocratic taste which adapted the conventions of an earlier court art to a world in which visual display was no longer exclusively in the service of monarchical need. No woman painter of the century enjoyed as great a success, nor had as much influence on the art of her contemporaries, as Carriera. She was the first artist of the century to fully explore the possibilities of pastel as a medium uniquely suited to the early eighteenth-century search for an art of surface elegance and sensation. She and Pellegrini (who had been commissioned to paint a huge allegorical ceiling in the Banque de France) played a key role in popularizing the Rococo manner in France and later England, where George III was a major collector of her work.

The daughter of a minor Venetian public official and a lacemaker, for whose lace she drew the patterns as a child, Carriera began her artistic career decorating snuff boxes and painting miniature portraits on ivory. Exactly how she came to pastels we do not know. It appears that by the early 1700s a friend of the Carriera family was sending the chalk sticks to her from Rome. Changes in the technology of binding colored chalks into sticks, leading to the development of a much wider range of prepared colors, expanded the availability and usefulness of this medium, but it seems to have been Carriera who introduced a taste for the soft fabricated chalks into France. The dry chalk pigments were similar to those used in women's make-up; and theater, masquerade, make-up, and pastel portraiture formulated an aesthetic of artifice in early eighteenth-century France, at whose center was a woman artist: all these factors indicate important directions for future research.

Carriera's loose, painterly technique with its subtle surface tonalities and dancing lights revolutionized the medium of pastel.

Dragging the side of a piece of white chalk across an under drawing in darker tones, she was able to capture the shimmering textures of lace and satin, and highlight facial features and soft cascades of powdered hair. The first of her many commissions in Paris was to paint the ten-year-old monarch, Louis XV. He cannot have been an easy subject for she confided to her diary after one sitting that, "his gun fell over, his parrot died, and his little dog fell ill." Despite the flattering depiction of the young monarch, the artist's careful posing of her sitter highlights his regal bearing and inaccessibility. Only in her own self-portraits is the superficial flattery demanded by her aristocratic clientele abandoned in favor of a probing realism.

The triumphant year in Paris included several meetings with Antoine Watteau, the most prominent early eighteenth-century French painter. Watteau, responsible for the pictorial development of the *fête galante*, with its sources in the imagery of the theatrical *commedia dell'arte* and its complete freedom of subject-matter, also struck a new balance in his work between nature and artifice. He demonstrated his enthusiasm for Carriera's work by asking for one of her works in exchange for one of his and made at least one drawing of her while she was in Paris. Crozat, in turn, commissioned a portrait of Watteau from her in 1721. Far more psychologically intense than her 62 depiction of Louis XV and members of the French and Austrian courts, the pastel's strong highlights and deep shadow illuminate his complex personality.

Carriera's successes in France culminated in her unanimous election to the Académie Royale in October 1720. By 1682 seven women, most of them miniaturists or flower painters, had been admitted. They included Sophie Chéron, the daughter of the miniaturist Henri Chéron and a painter, enamellist, engraver, poet and translater of the Psalms, who was unanimously elected in 1672 with a reception piece judged, "powerfully original, exceeding even the ordinary proficiency of her sex." With that accolade, the doors banged shut, the Académie revised its original policy and ceased admitting women. Carriera's admission coincided with a brief period when the freedom, colorfulness and charm of the Rococo manner dominated the arts. Only when allure took precedence over instruction did artists in France experience some freedom from academic learning. Watteau himself benefited from the short time of liberality in the arts at the end of Louis XIV's reign; both he and Carriera, who had the additional advantage of being a foreigner, were able to circumvent earlier theoretical and academic requirements.

At the time of Carriera's year in Paris, learned women were becoming increasingly conspicuous in the public life of the new urban intelligentsia. It was as leaders of salons, a social institution begun in the seventeenth century, that a few women were able to satisfy their public ambitions and become purveyors of culture; the Salons of Julie de Lespinasse, Germaine Necker de Stael, Madame du Deffand, Madame de La Fayette, Madame du Sevigné, Madame du Châtelet, and others became famous as sites of artistic, philosophical and intellectual discourse. The salons flourished during a period of delicate equilibrium between the competing claims of public and private life; the famous *salonières* of the period succeeded in establishing themselves in an intermediary arena between the private sphere of bourgeois family life and the official public sphere of the court. In this

unique social space, in gatherings attended primarily by men, certain women spoke with great authority in support of the new Enlightenment literature, science, and philosophy. For artists like Carriera and, later in the century, Vigée-Lebrun, the salons provided a context in which class distinctions were somewhat relaxed and artists from middle-class backgrounds (Vigée-Lebrun's father was a minor painter, her mother a hairdresser) could meet upper-class patrons on more or less equal footing.

Marie Loir's *Portrait of Gabrielle-Emilie le Tonnelier de Breteuil, Marquise du Châtelet* (1745–49) is one of a number of paintings by women artists of *salonières* and other women intellectuals, evidence of a tradition in which women often represented women. Loir, a member of an artistic family active in Paris as silversmiths since the

seventeenth century, was a pupil of Jean François de Troy. In 1762, she was elected to the Académie of Marseilles, one of a number of provincial academies established to encourage regional artists. Unlike the Académie Royale in Paris, they admitted amateurs of both sexes and did not exclude women from prizes or exhibitions. Loir's painting depicts the Marquise du Châtelet, a prodigy who read Locke in the original at seventeen, who became a respected mathematician, physicist and philosopher, and a famous hostess. Her lovers included two of the most prominent intellectuals of the day—Voltaire and Pierre-Louis Moreau de Maupertuis, essayist, scientist, and mathematician. Although perhaps based on Jean Marc Nattier's portrait of the Marquise exhibited in the Salon of 1745, Loir's composition is more straightforward and less dramatically idealized than many contemporary portraits. The marquise is shown against a wall of books. Her dark eyes are bright with intelligence and the iconography of the painting makes reference to her scientific and mathematical interests. She holds a pair of dividers and a carnation, symbol of love.

This work belongs to a time when the mannerisms, artifices, and intellectual focus of salon society were repeated in the stylistic innovations of the official art of the period. The decade in which Loir produced her portrait also saw Boucher decorating a love nest for the wealthy Madame de Pompadour. Many of Boucher's mythological and pastoral scenes of the 1740s were commissioned by this woman, whose role in shaping the official art of her time deserves reexamination. Art historians have tended either to underrate her, perhaps because the art of her period—architecture, interiors, tapestries, porcelains, and painted decorations—is an art of collaboration rather than individual achievement, and blurs the distinctions between "fine" and "minor" arts; or over-attribute the development of a "feminine" sensibility in the arts to her influence. In fact, the "femininizing" language of artistic production in early eighteenth-century France predates her by years and must be explored in relation to the construction of gender as part of the ideology of monarchical power at the end of Louis XIV's time. The actual role of women in the formation of this aesthetic is still buried under layers of cultural prejudice and art historical bias.

Boucher's paintings are exemplary of the new aristocratic art which emphasized ornament, tactile sensation and mutual pleasure rather than ideologies of power defined in terms of gender. They belong to the intimate world of the boudoir; the palette is light, the flesh tints pearly. While his female nudes correspond to the

voluptuous conventions of the Rubenesque tradition, his male figures are notably languid, attentive, and sensual, passive inhabitants of an aristocratic Arcadia whose resources had, in fact, been sucked dry by oppressive taxation under Louis XIV.

By the middle of the century, the brief power of the *salonières* was being challenged by intellectuals. The public response to the dissolute power of the aristocracy, and the women who were associated with it, had far-reaching implications. Although primarily attended by men, the salons signified "femininity;" first, because of the influence wielded by the women who ran them and, second, because of their identification with an aristocratic aesthetic tied to a century-old opposition in French painting between classicism and preciosity. The "feminine" power now attributed to the *salonières* was also linked to earlier, and widely distrusted, court traditions dominated by the image of the father/king. Preciosity, identified with the Rococo style and the decadence of the court, was redefined by Enlightenment thinkers as a feminine counterpart to a new, masculine ideal of *honnêteté*, or virtue. It is not surprising that writers like Jean-Jacques Rousseau, who gave clearest expression to middle-class values at mid-century, specifically contested this sphere of female influence.

Rousseau viewed the *salonière* as a threat to the "natural" dominance of men, the salon as a "prison" in which men were subjected to the rule of women. His writings, many of them aimed at formulating a "natural" sphere of influence for women, are shaped by his rejection of a public role for women as speakers, using and in control of language. The fiction of a "natural language" which Rousseau promotes in his novel *Emile* (1762) rests on a strong connection between natural language and politics by caricaturing female citizenship as a monstrous aberration. It is the *salonière's* crime to usurp authority, to speak the language of authority, of citizenship, instead of the "natural" language of family duty. "From the lofty elevation of her genius," Rousseau notes, "she despises all the duties of a woman and always begins to play the man. . . . [She] has left her natural state."

Rousseau's attack on the theater in his *Lettre à d'Alembert* (1759) included the remark that when the mistress of the house goes wandering in public, "her home is like a lifeless body which is soon corrupted." Rousseau's identification of the female body with the home is apt in an age of rapidly changing class structure. The body is a primary site of class conflict, manifested in customs, styles, and manners. While the hierarchical structures of the monarchy and

aristocracy favored superior/inferior relationships, as well as comple-
mentary relationships among men and women of the same social
class, the new bourgeois ideology depended for its success on the
location of affection and sexuality in the family. Containing the
female body within the private domestic sphere, as Rousseau
advocates, served as a means of controlling female sexuality in an age
obsessed with establishing paternity because of the high illegitimacy
rate. And it freed men to pursue occupations outside the home.

The ideal of femininity produced through activities like needlew-
ork and drawing contributed directly to the consolidation of a
bourgeois identity in which women had the leisure to cultivate artistic
"accomplishments." Love of needlework was, Rousseau asserts in
Emile, entirely "natural" to women; "Dress making, embroidery,
lace making come by themselves. Tapestry making is less to the
young woman's liking because furniture is too distant from their
persons. . . . This spontaneous development extends easily to drawing,
because the latter art is not difficult – simply a matter of taste; but at no
cost would I want them to learn landscape, even less the human
figure." Although the actual circumstances of middle-class women's
lives varied widely, the ideology of femininity which Rousseau and
others rationalized as "natural" to women was a unifying force in
making a class identity. The artistic activities of growing numbers of
women amateurs working in media like needlework, pastel, and
watercolor, and executing highly detailed works on a small scale,
confirmed Enlightenment views that women have an intellect
different from and inferior to that of men, that they lack the capacity
for abstract reasoning and creativity, but are better suited for detail
work. Such activities, however, should not be understood as having
been exclusively imposed on women, for many women found both
pleasure and fulfillment in these arts. Professional women painters
also helped to construct such a femininity.

64 Catherine Read's *Lady Anne Lee Embroidering* (1764), Angelica
65 Kauffmann's *Grecian Lady at Work* (1773), Françoise Duparc's
Woman Knitting, and Marguerite Gérard's *Young Woman Embroider-
ing* (1780s) are four among many paintings executed by women artists
who worked professionally during the second half of the century
which depict women engaged in the "amateur" traditions. They
cannot be read as simple reflections of existing reality, however, for
Fanny Burney relates that Read, who produced a number of images
of women sewing, was incapable of altering a dress. Comparing
Kauffmann's *Grecian Lady at Work* and a drawing of the artist herself

64 Catherine Read
Lady Anne Lee
Embroidering 1764

65 Françoise Duparc
Woman Knitting late
eighteenth century

66 Mary Delaney,
flower collage, 1774–88

with an embroidery hoop reveals sharp distinctions between the image of the embroiderer used to impose a contemporary ideal of femininity on the classical past, and the awkward gestures that often accompany needlework in reality.

In England, as in France, painters had to negotiate between aristocratic and middle-class taste, and between amateur and professional classifications. Although there was a strong amateur tradition for both sexes, women continually found their artistic activities equated with their femininity. For women aspiring to history painting and Academy membership, "unnatural" ambition had to be mediated by strict conformity to the social ideology of femininity.

English painting in the second quarter of the eighteenth century reveals both the influence of France and the close relationship between English and French intellectuals. Boarding schools, staffed by impoverished gentlewomen, taught drawing and watercolor to the daughters of the upper and middle classes. The publication of drawing manuals, the availability of prints for study, the existence of clean, ready-to-use watercolors, and the taste for picturesque scenery, all

67 Anne Seymour
Damer *The Countess
of Derby* c. 1789

contributed to the growing numbers of middle- and upper-class
women in England taking up drawing as a fashionable activity.

Mary Delaney ,(1700–88) was seventy years old when she began to
produce collages of cut paper flowers mounted on sheets of paper 66
colored black with India ink. The collages, botanically accurate and
life-size, drew high praise from botanists and from artists; Joshua
Reynolds claimed never to have seen such "perfection and outline,
delicacy of cutting, accuracy of shading and perspective, harmony
and brilliance of colours." Hugh Walpole wrote rapturously of his
cousin Anne Seymour Damer (1748–1828), the only woman sculptor 67
of note in England before the twentieth century; "Mrs. Damer's busts
from life are not inferior to the antique. Her shock dog, large as life
and only not alive, rivals the marble one of Bernini in the Royal
Collections." But Damer, a wealthy upper-class woman, was
considered an eccentric by her friends and was lampooned in the
public press for her effrontery in aspiring to carve academic nude
figures. In a satiric engraving published in 1789 she is shown wearing 68
gloves as she chisels away at the nude backside of a standing Apollo.

141

68 *The Damerian Apollo* 1789

Women's artistic endeavors were more readily accepted when confined to "feminine" media and executed in their own homes, even if the magnitude of their productions challenged what was considered appropriate as feminine "accomplishment." A diary entry by Sir Walter Calverly in 1716 noted that, "My wife finished the sewed work in the drawing room, it having been three and a half years in the doing. The greatest part has been done with her own hands. It consists of ten panels." Among Lady (Julia) Calverly's "sewed work" recorded in contemporary account books was a six-leaf screen
69 stitched with scenes from Virgil's *Eclogues* and *Georgics* (1727). Each of the leaves is 5 feet 9 inches high, and 20½ inches wide, but this prodigious effort remains outside the categories on which all but feminist art historians have focused their attention.

Angelica Kauffmann (1741–1807), on the other hand, was a professional woman in the age of the amateur, and the first woman painter to challenge the masculine monopoly over history painting exercised by the Academicians. The daughter of a minor Swiss ecclesiastical painter, Kauffmann spent her youth traveling with her

father. In Italy in the 1760s, she copied the paintings of Correggio in Parma, the Carracci in Bologna, and numerous Renaissance works in the galleries of the Uffizi in Florence. Her time there coincided with the full flowering of the English passion for work in the Grand Manner, a heady mix of classicizing and Neoclassical tendencies introduced the previous decade by English artists and designers such as Robert Adam, Richard Wilson, and Joshua Reynolds, whose years of study in Rome eventually revolutionized British taste.

In Italy, Kauffmann met the American painter Benjamin West and became part of a group of English painters that included Gavin Hamilton and Nathaniel Dance. Her meeting with Winckelmann in Rome in 1763 proved decisive. She began to derive a Neoclassical manner from his ideal of noble restraint, basing her style on the

69 Lady Calverly, embroidered screen, 1727

frescoes at Herculaneum and the romantic classicism of the German painter Raphael Mengs. Her *Zeuxis Selecting Models for His Picture of Helen of Troy*, based on a Roman copy of a Greek *Venus Kallipygos* in the Museo Nazionale in Naples, which she probably copied during her stay there in 1764, suggests an early awareness of what were then the most popular antique themes among English painters.

Kauffmann's determination to execute large-scale historical works, despite no access to training from the nude model on which the conventions of history painting were based, is a mark of her ambition. As early as 1752, the Abbé Grant had lamented the obstacles that lay between another woman artist and history painting. "At the rate she goes on," he noted of Catherine Read, the pastel artist sometimes called the "English Rosalba," who had settled in Rome to complete her artistic training in 1751, "I am truly hopeful she'll equal if not excel the most celebrated of her profession in Great Britain . . . were it not for the restrictions her sex obliges her to be under, I dare safely say she would shine wonderfully in history painting too, but as it is impossible for her to attend public academies or even design and draw from nature, she is determined to confine herself to portraits."

Kauffmann arrived in London in 1765 or 1766. She met Reynolds shortly thereafter; within a year she had earned enough money painting portraits of aristocratic men and women to buy a house. Her success enabled her to begin the historical works for which her years in Rome had prepared her and which at the time represented the only route to consideration as a serious artist in England. The first opportunity to exhibit them came in 1768 on the occasion of a visit from King Christian VII of Denmark. She sent a *Venus Appearing to Aeneas*, *Penelope With the Bow of Ulysses*, and *Hector Taking Leave of Andromache*. The display of these paintings the following year at the Royal Academy exhibition, along with Benjamin West's *Farewell of Regulus and Venus* and *Venus Mourning the Death of Adonis*, identified Kauffmann and West as the initiators of the Neoclassical style in England. James Northcote, in a biography of Reynolds, commends her history paintings as second only to two canvases submitted by West. Subsequent exhibitions confirmed the originality of her work with its transparent brushwork and rich color, its elegant restatement of its classical sources, and its innovative use of subjects drawn from medieval English history as well as from the antique. The fact that Reynolds persuaded John Parker of Saltram, later Lord Morley, to purchase all of Kauffmann's works in addition to his thirteen portraits probably enabled her to persist as a history painter.

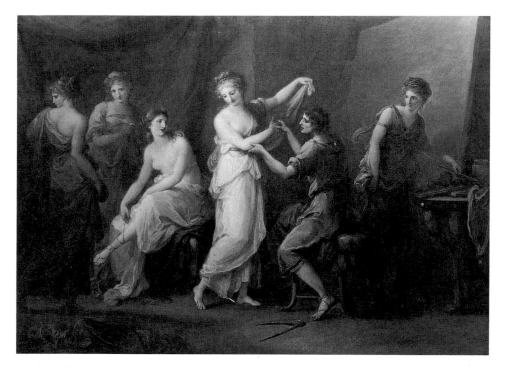

70 Angelica Kauffmann *Zeuxis Selecting Models for His Picture of Helen of Troy*
c. 1764

Kauffmann's academic success can be attributed to her association
with the foremost history painters of her day, and to the fact that she
arrived in London, after the study in Italy expected of all serious
painters in oils, at a propitious moment. The reasons for her enormous
popular and professional following are more complex. By the 1770s,
her works, widely known through engravings by William Ryland,
had not only inspired other painters but had also reached a much
broader audience, often through designs for the decorative arts, such
as a china service with classical motifs, based on her paintings. She is
associated with Robert Adam, the most fashionable Neoclassical
architect of the time. She provided allegorical figures of Compo-
sition, Invention, Design, and Coloring for the ceiling of the
Academy in its new location at Somerset House (later removed to the
entrance hall of Burlington House) and throughout the 1780s, when
she traveled abroad with her second husband, the painter Zucchi, she
continued to send major historical canvases back to London.

71

78

71 Vase (after Angelica Kauffmann) c. 1820

The 1968 exhibition, "Angelica Kauffmann and Her Contemporaries," offered a major revaluation of Kauffmann's relationship to other history painters and her profound influence on her contemporaries. Twentieth-century art historians have often disregarded the plurality of attitudes to classical art which Robert Rosenblum identifies as central to Neoclassicism. Dismissing the romantic and decorative aspects of the movement, they have favored the severe, heroic classicism most fully expressed in David's work at the end of the century and which profoundly influenced the development of nineteenth-century painting. Kauffmann has been dismissed for her inability to "achieve much Roman gravity" and the works of her contemporaries praised for being "full-blooded" in comparison. Kauffmann's relative lack of training in drawing, over which she had little control, has been used to prove the inferiority of her work to that of her male contemporaries, while her role in the development of an aesthetic of "sentiment" has been largely ignored. The romanticizing of Kauffmann that spread her legend to a general population through

engravings also no doubt encouraged later writers to dismiss her as charming but inconsequential, but, ironically, it was her public status and historical commissions that were the focus of eighteenth-century attacks.

Much of the satire directed against women artists at the time coincided with their efforts to enter the field of history painting and Peter Pindar's pointed commentary, in his "Odes to the Royal Academicians," singled out Kauffmann's inability to work from the nude:

Angelica my plaudits gains,
Her art so sweetly canvas stains
Her dames so gracious, give me such delight
But were she married to such gentle males
As figured in her painted tales,
I fear she'd find a stupid Wedding Night

Throughout this doggerel, despite its element of truth, runs a familiar refrain—the woman artist should confine herself to painting "sweet," "gracious," and "delightful" representations of women, representations which reinforce descriptions of the artist herself as "charming," "graceful," and "modest." Attacks such as this mount in direct proportion to the public stature of the woman artist and cannot be separated from the charge that by taking up a public activity woman either unsexes herself or, in this case, unsexes men.

Similar problems confronted academic women painters in France. The portraits of Vigée-Lebrun and Labille-Guïard reveal that both painters sometimes manipulated their brushstrokes to emphasize gender differences. The brusque, taut surfaces and intense gazes of the male sitters in Vigée-Lebrun's portraits of the painters Joseph Vernet (1778) and Hubert Robert (1788) are almost entirely missing from her 72 portraits of women. The focused mental energy of these figures (Robert's hair springs from his head as if electrified) are in sharp contrast to the many portraits of women with their softened contours and misted surfaces. Such flaccid surfaces (later criticized as "weak") cannot continue to be used to prove artistic inferiority given the differing stylistic conventions evident in the male portraits.

Like Kauffmann in England, the three women painters working under royal patronage in France during the 1770s and 1780s—Vigée-Lebrun (1755–1842), Labille-Guïard (1749–1803), and Vallayer-Coster (1744–1818)—were never far from critical responses conflat-

72 Elisabeth-Louise
Vigée-Lebrun *Hubert
Robert* 1788

74 ing the woman and the work. All except Labille-Guïard were
royalists at heart, but the paintings they executed in the years before
the French Revolution—ranging from the still-lifes of Vallayer-
Coster to the portraits of Vigée-Lebrun and Labille-Guïard—reveal
the awkwardness of negotiating between the competing ideologies of
increasingly antithetical groups: the royal family with its aristocratic
followers and expectations that art should flatter, and the middle class
with its growing demand for paintings of moral virtue. In the years
just before the French Revolution Vigée-Lebrun and, to a lesser
extent perhaps, Labille-Guïard were significant in introducing the
imagery of the "natural" into the iconography of the aristocracy.
Vigée-Lebrun's many portraits of herself and other women dressed in
the simple Grecian gowns of the Neoclassical revival helped to
disseminate an image of the unencumbered "natural" female body
and the new image of motherhood associated with it.

The Paris in which these women worked was that of Louis XVI and
Marie Antoinette. The prestige of the Académie Royale had been
undermined at mid-century by the founding of the Académie de

148

Saint-Luc in 1751 as a belated attempt to reassert guild control over the arts. The Académie de Saint-Luc, with irregularly scheduled exhibitions and no fixed residence, was nevertheless not insignificant in fostering the careers of women artists. Its broad membership included frame-makers, gilders, varnishers, women apprentices, and husband and wife teams, in addition to painters. Both Vigée-Lebrun and Labille-Guïard began their professional lives in its exhibitions and Harris reports that about three percent of its members during the second half of the century were women, most of them portraitists working in oils, pastels, and miniatures. The resolution limiting membership in the Académie Royale to four women after the election of Vallayer-Coster and Marie Giroust-Roslin in 1770 may have been prompted by this rapidly expanding population of female amateurs seeking places to exhibit.

During the 1760s, the competing exhibitions sponsored by the Académie de Saint-Luc drew large groups and vociferous public response. Increasingly, middle-class audiences demanded an art of moralizing sentiment rather than the grand public narrative and historical paintings that had characterized earlier Salons. Thomas Crow has traced the development of the cult of *sensibilité* in French painting to Jean-Baptiste Greuze's (1725–1805) ability to endow the more intimate domestic scenes, popularized by a large market for engravings of Flemish domestic paintings, with the kind of nobility originally associated with history painting.

The desire for an art which confirmed contemporary moral values dominates criticism at mid-century. Diderot's praise of Greuze and Chardin during the 1760s for the dignity and virtue of their representations opposes them to Boucher, of whom he wrote after the Salon of 1765: "I do not know what to say of this man. Degredation of taste, of color, of composition, of character, follow upon deprivation of morals. What can there be in the imagination of a man who passes his life with loose women of the lowest classes?"

Anna Vallayer-Coster, like Chardin before her, was patronized both by the court and by wealthy bankers and merchants drawn to the modest themes and carefully crafted surfaces of her still-lifes, painted 75 in the realist tradition of Chardin. Her patrons included the Marquis de Marigny, whose position was close to that of minister of arts under Louis XV, and her marriage to a wealthy lawyer and member of parliament in 1781 insured her social standing.

Vallayer-Coster was trained by her father, who was the king's goldsmith and a tapestry designer before establishing his own studio

in Paris in 1754. She submitted an *Allegory of the Visual Arts* and an *Allegory of Music* to the Académie Royale as reception pieces in 1770. Both works were included in the Salon of 1771 and immediately drew comparisons to Chardin's work. But although close in spirit to Chardin, she was no mere imitator. Her works, models of simplicity, order, and crisp realism, make only a few concessions to a middle-class taste increasingly drawn to Chardin's rustic kitchen interiors with their copper and enamel wares.

In addition to paintings by Vallayer-Coster, the Salon of the Académie of Saint-Luc in 1774 also included the work of Labille-Guïard, Vigée-Lebrun and Anne-Rosalie Boquet. All three women worked in pastel as well as oil. Labille-Guïard's *Portrait of a Woman in Miniature*, an oval miniature on ivory which was in fact a self-portrait, was accompanied by a pastel *Portrait of a Magistrate* and a *Sacrifice of Love*. Although she had not yet completed her apprenticeship (and was at the time a pupil of Quentin de la Tour), one critic noted that these small works showed great promise. Vigée-Lebrun had submitted as reception pieces a *Portrait of Monsieur Dumesnil*, Rector of the Académie, as well as several pastels and oils, among them three works representing painting, poetry, and music.

Unlike Labille-Guïard, who studied both with La Tour and François-Elie Vincent, Vigée-Lebrun acquired almost all her artistic training independently. Largely self-taught, her early success was a result of ambition, determination, and hard work. She copied numerous works by old and modern masters in private collections, artists' studios, and salon exhibitions but, like other women of the day, she was barred from study of the live nude model. Her first portraits were members of her own family, but her marriage to Jean-Baptiste-Pierre Lebrun—artist, restorer, critic and dealer—established her as a major figure in the social life of aristocratic urban Paris.

From the first exhibition of the works of Labille-Guïard and Vigée-Lebrun, it is possible to observe the development of the often noted "rivalry" by means of which critics opposed one woman to the other, a "rivalry" to which we shall return as it served ends other than that of establishing the relative merits of their work.

The Salon de la Correspondance, founded in 1779, held its first exhibition in 1782. Labille-Guïard submitted several pastels and drew the first unsubstantiated charges that her teacher, Vincent, who also exhibited, had touched up her works. In response to these accusations, she invited prominent academicians to sit for her, a wise decision for, in addition to stilling her critics, it also gained her access to politically

powerful male painters of a kind normally reserved for the young men who had trained under them.

Again in 1782, critics made pointed references to the two women proposed for Académie Royale membership the following year. Labille-Guïard's portraits of 1782, in addition to *The Count of Clermont-Tonnerre*, the son of the *maréchal* of Clermont-Tonnerre and a precocious military leader, included those of distinguished academic painters. Her *Portrait of the Painter Beaufort* was submitted to the Académie as a reception piece and she was admitted under the category "painter of portraits" at the same meeting that admitted Vigée-Lebrun. The latter, however, determined to be admitted as a history painter rather than the lower ranked portraitist, had produced five history paintings within the previous three years. Despite a carefully calculated reception piece titled *Peace Bringing Abundance*, she was admitted without specific category and only on the intervention of Marie Antoinette, whose portrait painter she had become in 1778. Royal intervention was necessary to overcome the Director's opposition, Jean-Baptiste-Marie Pierre, on the grounds that Vigée-Lebrun's husband was a picture dealer and election was forbidden to anyone in direct contact with the art trade.

Vigée-Lebrun and Labille-Guïard's first appearance together as academicians took place in the Salon of the Académie Royale in 1783. It was then that the critics, previously content to vascillate between the two women, unequivocally took sides. The critic in the *Impartialité au Salon* identified them as "rivales de leurs gloires" (glorious rivals). Bauchaumont was friendly toward Labille-Guïard but clearly preferred Vigée-Lebrun; the critic of *Le Véridique au Salon* compared their talents.

Some sort of rivalry between the two painters was no doubt inevitable. Vigée-Lebrun, industrious, beautiful, and socially in demand, was the Queen's favorite painter. Labille-Guïard, sober and hard-working, had been appointed official painter to the Mesdames of France, the King's aunts, in 1785 and worked diligently for success which seemed to the public almost thrust on Vigée-Lebrun. No record remains of Labille-Guïard's feelings about Vigée-Lebrun; the latter's memoirs, notable for their self-absorption, dismiss Labille-Guïard in a few curt passages. The artificial "rivalry" thrust on them enabled critics to give voice to accusations that reminded audiences that famous, or infamous, public women such as these had exceeded their "natural" domain. The price they paid was accusations of sexual misconduct; Vigée-Lebrun was accused by one critic of having

"intimate" knowledge of her sitters. Even more important perhaps is the fact that the "rivalry" preserved the separation of men and women. By comparing two successful women artists almost exclusively to one another, it became unneccessary to evaluate their work in relation to that of their male contemporaries, or to abandon rigid identifications between female painters and their imagery.

In the second half of the century there was a wide range of new family images. Greuze's *The Good Mother*, the popular attraction at the Salon of 1765, was praised by Diderot; "It preaches population, and portrays with profound feeling the happiness and inestimable rewards of domestic tranquility. It says to all men of feeling and sensibility: 'Keep your family comfortable, give your wife children; give her as many as you can; give them only to her and be assured of being happy at home.'" Carol Duncan has demonstrated how, as the iconography of painting transformed the sensual libertine of the early eighteenth century into a tender mother by the end of it, authors following Rousseau's example argued that wet-nursing was against nature and that only animals and primitive mothers were so little emotionally bonded to their offspring that they could allow others to assume this function. A similar argument against swaddling, that it artificially constricted the infant, was also a sign of the middle–class origins of these new attitudes, for only women whose labor was entirely domestic could attend to the needs of the liberated baby; among rural women who needed their hands free to work in the fields

swaddling persisted well into the nineteenth century. Labille-Guïard's pastel *Portrait of Madame Mitoire and Her Children* (1783) is the first of her works reflecting the new ideology of the bourgeois family. The painting, showing Mme. Mitoire holding a baby to her breast while another child gazes adoringly at her from the side, combines the voluptuousness of Flemish painting and the adornments of French aristocratic style with allusions to nature in the flowers woven into the mother's elaborate hairstyle. The middle-class counterpart of dedicated motherhood in Labille-Guïard's work can be found in *Homework*, a small oval painting in which a young mother, very simply attired, instructs the female child who crouches at her knee. The work, whose attribution to Labille-Guïard has recently been challenged, has the modest appeal of a northern domestic painting, but the message comes straight from Rousseau who, in *Emile*, advises women to educate girl children at home, and from Chardin who, at mid-century, introduced themes of middle-class domesticity into French painting.

76

74 Adelaide Labille-
Guïard *Portrait of
Marie-Gabrielle Capet*
1798

The cult of blissful motherhood was one of the most obvious expressions in representation of the new and evolving ideology of the family. No longer was the family viewed as simply a lineage; instead, it began to be conceived as a social unit in which individuals could find happiness as husbands and wives, fathers and mothers. Marguérite Gérard, a student and sister-in-law of the painter Jean-Honoré Fragonard, collaborated with him in developing the themes of
77 maternal tenderness and loving families. Although not a member of the Académie Royale (she was prevented from membership by the decree limiting the number of women to four), she exhibited widely, particularly after the French Revolution when the Salon was opened to women.

The ideology of the happy family was, however, riddled with contradictions. Laws depriving women of all rights over property and person accompanied the eulogizing of marriage as a loving partnership. Attitudes toward children also shifted dramatically in the course of the century as earlier neglect gave way to a growing belief that the true wealth of the country lay in its population. As the birthrate dropped in the eighteenth century with the first widespread use of birth control (the average family size of 6.5 children in the seventeenth century dropping to 2 in the eighteenth), children became more precious and campaigns to change child-rearing
76 practices began. Paintings like Labille-Guïard's *Madame Mitoire* recapitulate the iconography of the opulent nude, but place her in a new, maternal role surrounded by adored and adoring children.

The Salon of 1785 was a key exhibition for both Labille-Guïard and Vigée-Lebrun. The former's portraits consolidated her reputation and the critical competition between the two women painters turned toward her. As a result of her success in this Salon, Vigée-Lebrun
79 received the commission for her *Portrait of Marie Antoinette with Her Children*, a monumental work of political propaganda which has been called one of the masterpieces of eighteenth-century political painting and the last serious attempt to revive the Queen's reputation.

Vigée-Lebrun had been painting Marie Antoinette since 1778. Her many portraits of the Queen—whose marriage represented a political alliance between the royal families of France and Austria and who was by 1778 already widely distrusted by the French citizenry—reveal her ability to transform the far from beautiful queen into a memorable likeness through the power of her idealizing abstraction.

By 1784, after the birth of her third child, Marie Antoinette had realized the extent to which she had alienated the population, as well

as powerful factions in the court, with her frivolity and profligacy. Widely held in contempt as queen and as the mother of future kings, Marie Antoinette had withdrawn into a small circle of family and friends. Her claim that "I wish to live as a mother, to feed my child and devote myself to its upbringing" convinced no one in the face of widely circulated attacks on her virtue in clandestine publications with titles like *The Scandalous Life of Marie Antoinette* and *The Royal Bordello*, the latter a pornographic tract ascribing depraved tastes to her and treating her children as bastards.

This spectacle of the Queen as a courtesan led Louis XVI's ministers to a decision to counter the bad press by projecting a positive and wholesome image of her with her children at the next Salon. The result, a painting by the young Swedish artist Adolphe-Ulrich Wertmuller, pleased no one. Exhibited at the Salon of 1785, the painting was widely denounced for depicting "an ugly queen

76 Adelaide Labille-Guïard *Portrait of Madame Mitoire and Her Children* 1783

77 Marguérite Gérard *Portrait of the Architect Ledoux and his Family* c. 1787–90

78 Angelica Kauffmann, design in the ceiling of the central hall of the Royal
Academy, London, 1778

frivolously dressed and gamboling in front of the Temple of Love at
Versailles with her two children." Two critics, however, called for a
painting which would present the Queen as a mother "showing her
children to the nation, thus calling forth the attention and the hearts of
all, and binding more strongly than ever, by these precious tokens, the
union between France and Austria."

 A new painting was commissioned from Vigée-Lebrun before the
Salon of 1785 had closed its doors. The political importance of it was
indicated by the fact that it issued from the office of the King's
Director of Buildings and that Vigée-Lebrun was paid the colossal

79 Elisabeth-Louise Vigée-Lebrun *Portrait of Marie Antoinette With Her Children* 1787

price of 18,000 livres, more than was paid for the most important historical paintings and far more than the 4,000 livres which Wertmuller had received for his painting.

Following David's advice, Vigée-Lebrun based her pyramidal composition on the triangular configurations of certain High Renaissance Holy Families. The painting depicts Marie Antoinette dressed in a simple robe and sitting in the Salon de la Paix at Versailles surrounded by her children. The play of light and shadow across the figures blends their individuality into personages who transcend their historical context. The monumental and imposing image of the *mater familias* is softened by the presence of the children grouped around her, her son pointing at the empty cradle which commemorates a recently deceased daughter, her older daughter leaning affectionately against the royal arm. The grouping of the children around Marie Antoinette emphasizes the central role of women in the generational reproduction of class power at the same time that it points toward the new ideology of the loving family.

By the time the 1787 Salon opened, the political situation had deteriorated. The work was hung only after the official opening from

fear of a hostile public reaction. Critical ambivalence about the work, however, centered around the impossibility of resolving two different ethoses: the divine right of kings transferred from the image of the *pater familias* to the figure of Marie Antoinette as queen, and the new bourgeois ideal of happy motherhood. This iconographic confusion was widely noted and contrasted with the universally popular image of motherhood presented in the same Salon in Vigée-Lebrun's self-portrait with her daughter Julie. This touching image of 80 young motherhood perfectly illustrates the contradictions between idealized representation and lived experience. Not only was Vigée-Lebrun herself sent away to a wet nurse as a child, but she remarks in her memoirs that the day she went into labor with her daughter, she took pride in not allowing incipient motherhood to interrupt her at her professional activity and continued to paint between labor pains.

Vigée-Lebrun's *Portrait of Marie Antoinette with Her Children* 79 (1787) was hung almost beside, and on the same level, as Labille-Guïard's *Portrait of Madame Adélaide*. The fact that the paintings were 81 of identical size further called attention to them as studies in royal opposites: Vigée-Lebrun's an attempt to resuscitate a vilified queen, Labille-Guïard's a portrait of one of Louis XVI's aunts representing the virtues of the old court.

81 Adelaide Labille-Guïard *Portrait of Madame Adélaide* 1787

82 The Salon of 1785 also included David's *Oath of the Horatii*. The severity and rationality of David's Neoclassicism, and his themes of patriotic virtue and male heroism, are important forerunners of the political and social upheavals of the next decade. The presentation of a world in which sexual difference is carefully affirmed is fully realized here. Not only are clear distinctions drawn between the male figures who, erect and with muscles tensed, swear allegiance with drawn swords, and the female figures who swoon and weep, but the entire composition reinforces the work's separation into male and female spheres. The arcade that compresses the figures into a shallow frieze-like space also contains the women's bodies within a single arch. Their passive compliant forms echo the poses and gestures of Kauffmann's female figures, but here the sexual division into separate and unequal parts, which is intimated in so many earlier works, is given the absolute definition soon to be institutionalized in revolutionary France.

By 1789, the conflict between radical republicanism and social conservatism in France was fully evident. Although Vigée-Lebrun enjoyed unanimous critical acclaim in the Salon of that year with her portraits of the Duchess of Orleans, Hubert Robert, Alexandrine Emilie Brongniart, the wife of the architect Rousseau, and her

daughter, her personal reputation had been destroyed by malicious rumors about her alleged affair with the exiled finance minister Calonne, whose portrait she had painted in 1785. Attacks against the Queen also continued, many denouncing her as an inversion of everything women were supposed to be: an animal rather than a civilized being, a prostitute rather than a wife, a monster giving birth to deformed creatures rather than children. On October 6, following the march on Versailles by women of the market protesting against the bread shortage, Vigée-Lebrun left France with her daughter for what became a twelve-year exile.

The attacks on prominent public women revealed the fears of the revolutionaries that women, if allowed to enter the public realm, would become not women but hideous perversions of female sexuality. Debates over the political rights of women raged during these early years of social unrest. Many *cahiers*, or notebooks, of 1789 remind their readers that women are excluded from representation in the Estates-General; publications by Condorcet, Olympe de Gouge, and others argue the issue of women's role in a revolutionary society. During the next two years the situation of women artists changed dramatically.

On September 23, 1790, Labille-Guïard addressed a meeting of the Académie Royale on the subject of the admission of women (still limited to four). While proving to the satisfaction of the academicians

83 *Amazone, Françaises Devenues Libres* c. 1791

that the only acceptable limit was no limit, she at the same time voted against women as professors or administrators. The reorganization of the Académie Royale won for women the right to exhibit at the Salon, but the free art training offered at the Ecole des Beaux-Arts remained closed to them, as did the right to compete for the prestigious Prix de Rome. The Salon of 1791 was chosen by a jury of forty, only half of them academicians. The paintings numbered 794; 190 of them by non-academicians and 21 of them by women. The opening of the Salon to women proved decisive and in the years after the Revolution large numbers of women exhibited. In 1791 Labille-Guïard, who supported the new regime, exhibited eight portraits of deputies of the National Assembly.

It is David's heroic brotherhood, however, that came to emblematize the new Republic. Images of brotherhood displaced earlier representations of fatherhood. Mothers, except very young ones, are also largely absent. The image of the goddess of Liberty created in November 1793 drew heavily on Rousseau's ideal of the pregnant and nursing mother to personify the regeneration of France. That year also witnessed the repression of all women's political societies by the Jacobins who argued that women were intellectually and morally incapacitated for political life.

Despite attempts to restrain the activities of women, women artists made progress in the years after the Revolution. Although denied admission to the Ecole des Beaux-Arts and the prestigious Class of Fine Arts of the Institute until almost the end of the nineteenth century, less restricted access to the Salon, and a loosening of the dominance of historical and mythological painting, led to increasing representation of women in Salon exhibitions. In the Salon of 1801 14.6% of the artists were women; by 1835 the percentage of women exhibiting had grown to 22.2%. Women excelled at portraiture and sentimental genre; Marguérite Gérard, Pauline Auzou, Constance Mayer, Mme. Servières, Jeanne-Elisabeth Chaudet, and Antoinette Haudebourt-Lescot were all singled out for critical notice. The most ambitious painter of historical subjects was Angelique Mongez, a pupil of David and Regnault, whose *Alexander Mourning the Death of Darius's Wife* was awarded a gold medal in the Salon of 1804. Themes of women in history, myth, and love predominated in the work of Henriette Lorimier, Auzou, Nanine Vallain, Servières, and Mayer. David's role as a teacher of women painters during this critical period calls for further study, as do the circumstances in which these and other women painters worked after the Revolution.

Sex, Class, and Power in Victorian England

Modern feminist campaigns emerged out of a complex of nineteenth-century reform movements in Western Europe and America. A commitment to the emancipation of women was characteristic of reformers from Charles Fourier and Saint Simon in France to John Stuart Mill, Harriet Taylor, and Robert Owen and the Chartists in England, as well as the American Fourierites and Transcendentalists. In America, the Abolition, Temperance and Suffrage movements profoundly influenced the lives of middle- and upper-class women aspiring to professional careers in the arts.

Nineteenth-century reform movements were part of a growing middle-class response to widespread social and economic changes following the Industrial Revolution. As aristocratic and mercantile capitalism evolved into industrial capitalism, the middle class emerged as the dominant political and social force. Novels, plays, paintings, sculpture, and popular prints contributed to forging a coherent middle-class identity out of the diverse incomes, occupations, and values that made up the class in reality.

Anatomy, physiology, and Biblical authority were repeatedly invoked to prove that the ideal of modest and pure womanhood that evolved during Queen Victoria's reign (1837–1901) was based on sound physiological principles. Even after the loosening of restrictions on professional training, women faced formidable obstacles in obtaining art training equal to that of male students. Not only was it widely believed that too much book learning decreased femininity, exposure to the nude model was thought to inflame the passions and disturb the control of female sexuality that lay at the heart of Victorian moral injunctions. "Does it pay," wrote an irate member of the public to the Board of Directors of the Pennsylvania Academy in 1883, "for a young lady of a refined, godly household to be urged as the only way of obtaining a knowledge of true art, to enter a class where every feeling of maidenly delicacy is violated, where she becomes so hardened to indelicate sights and words, so familiar with the persons of degraded women and the sight of nude males, that no

possible art can restore her lost treasure of chaste and delicate thoughts . . . ?" Nudity, exposure to women of questionable virtue who worked as models, stimulation of the senses—at issue was power over female sexuality, itself a recurring motif in nineteenth-century art and literature.

Sermons, moral tracts, and popular literature relied on the same sources to prove that differences between the sexes were either innate or, if environmental in origin, necessary. The Woman Question, as the debate that raged at mid-century came to be known, circled a range of conflicting ideals, expectations, and demands that affected women. What capabilities did women have? What was the "natural" expression of femininity in an age in which gender was organized around an ideology of separate spheres for men and women? What contribution could middle-class women make to society when they were removed from all productive labor except childbirth?

The Cult of True Womanhood was a double-edged sword. Women were presented as morally and spiritually superior to men, and given primary responsibility for managing the home, but their lives were tightly restricted in other ways. The middle-class ideal of femininity stigmatized many groups of women as deviant—those who remained unmarried, who worked, or were slaves, or immigrants, or social radicals. Although much contemporary feminist scholarship has focused on the oppression of Victorian women in a stratified society, recent work by social historians has also emphasized the positive aspects of the separation of the sexes; specifically, the deep friendships and community of purpose that developed among women.

By the second half of the century, the feminine ideal, increasingly recognized as unattainable by large numbers of "surplus" women who exceeded men of marriageable age and by most working-class women whose families could not afford economically dependent women, was being challenged on both sides of the Atlantic. The census of 1851 in Britain revealed that many middle-class men failed to earn incomes large enough to support their female relatives. In America, Civil War casualties and the drain of young men to the western frontier left many women without potential partners. Economic realities and a growing realization that many women in the new industries were working under deplorable conditions intensified the demands for reform by middle-class women.

Women artists existed in a contradictory relationship to the prevailing middle-class ideals of femininity. They were caught

between a social ideology that prohibited the individual competition and public visibility necessary for success in the arts, and the educational and social reform movements that made the nineteenth century the greatest period of female social progress in history. The qualities which defined the artist—independence, self-reliance, competitiveness—belonged to a male sphere of influence and action. Women who adopted these traits, who turned their backs on amateur artistic accomplishments accepted as beautifying or morally enlightening, or who rejected flower painting in watercolor for historical compositions in oil, risked being labelled as sexual deviants. Art reviews from the period are full of charges that aspiring women artists risk "unsexing" themselves. While critics held up Rosa Bonheur and Elizabeth Thompson (Lady Butler) as examples for other women precisely because they did not "paint like women," few women had access to Thompson's wealth and upper-class connections or Bonheur's unconventional and wholly supportive female household.

Between 1840 and 1900, several hundred women exhibited in Liverpool, Manchester, Birmingham, Glasgow, and smaller cities throughout the British Isles. Others, including Thompson, Henrietta Ward, Sophie Anderson, Rebecca Solomon, Joanna Boyce, and Jessica and Edith Hayllar, exhibited at the Royal Academy and similar exhibitions. Their work is situated at the intersection between the growing demand for increased education and employment for women, the artistic conservatism of British painting at the time, and the social ideology of separate spheres.

During Victoria's reign, the status of women changed dramatically. In 1837, married women had few legal rights. The Divorce Act of 1857, which liberalized divorce for women, the publication in 1869 of Mill and Taylor's *The Subjection of Women*, which exposed the legal subordination of one sex to the other as morally wrong, the Married Women's Property Act of 1870, which enabled women to retain their own earnings or rent, and the Matrimonial Causes Act of 1884, were milestones on the way to legal protection for women outside marriage. Although social themes first surfaced in British painting in the late 1830s, flourishing during the 1840s and 1850s, such events hardly dominate British painting at the time. Nor do we find other than scattered images of female activists like Florence Nightingale, the most illustrious woman of her day, or Harriet Martineau, a widely read writer and social commentator. Instead, Victorian painting emphasizes the romantic, sentimental, and moralizing aspects of everyday life.

The 1850s, a period of intense agitation for educational reform for women, witnessed the founding of The Society for the Promotion of Employment for Women, the Victorian Printing Press, and the Society of Female Artists. The last, formed in 1856, served as an alternative exhibition site for women. With the change of name in 1872 to the Society of Lady Artists, full membership was restricted to professional women and limited to twenty-three in number. Some women, like Anna and Martha Mutrie, who exhibited successfully at the Royal Academy, ignored the Society; others sent smaller works, or exhibited pictures previously shown elsewhere (a practise forbidden by the Royal Academy).

Wider opportunities for exhibiting accompanied expanded art education for women, but did not solve the problems of access to official institutions and equal opportunity. The complex issue of art training for women deserves its own study, for in demanding access to art training and life classes women were not only challenging codes of feminine propriety and sexual conduct; they were also claiming the right to actively see and represent the world around them, and to command genius as their own. As women began to press for the training that would enable them to compete as professional artists, their struggle became part of the larger one for educational reform.

Until the founding of specialized art schools for women in Britain and America during the second quarter of the century, the teaching of drawing and painting to women was included with skills like embroidery, lace-making, dancing, and music. Beginning in the 1840s, schools were founded to provide training in design for women who were forced to support themselves. In America, the Woman's Art School of Cooper Union, the Lowell School of Design at the Massachusetts Institute of Technology, the Pittsburgh School of Design, and the Cincinatti School of Design were an important stage on the way to women's infiltration of predominantly male systems of education in the fine arts, but all stressed "suitable" areas like china painting and needlework. The association of women with these areas of production, as well as their continuing educational segregation, fueled charges that art by women was "mediocre."

In Britain, the Female School of Art and Design was founded in 1843 as one of the government Schools of Design. Although men often transferred from the schools of design to the Royal Academy, the existence of a Female School became an excuse for not admitting women to the Royal Academy Schools. Women art students who were not content to be trained in design at the Female School, or to be

84 "Lady Students at the National Gallery," *Illustrated London News* November 21, 1885

taught privately, were often held up to a mix of ridicule and charming patronization in popular publications like the *Illustrated London News* 84 and *Punch*.

Colleges for women who desired training as governesses were established in London in 1848, followed by the admission of women to the National Art Training School as part of the decision to promote women as art teachers. In 1862, the Royal Female School of Art was founded. Some fine art training was available but not in the design schools. Other women, among them Barbara Bodichon (1827–91) and Laura Herford, studied at the Ladies College in Bedford Square (founded in 1849) which offered some art instruction to women.

Barbara Bodichon's liberal Unitarian family and private income gave her far greater freedom than that enjoyed by most upper- and middle-class women in Britain. A student of Corot, Hercules Brabazon and Daubigny, and a friend of Mrs. Anna Jameson, Bodichon also wrote extensively on the political, legal, and educational disabilities of women. She was one of several artists who belonged to the Langham Place Circle, a group of progressive women who founded the *English Women's Journal*. During the 1850s, the group campaigned for women's education, employment, property

rights, and suffrage. Jameson, Bodichon, and the painters Eliza Fox, Margaret Gillies, and Emily Osborn all signed the group's petition demanding access to the Royal Academy School in 1859. Rejected on the grounds that it would have required setting up separate life classes, the petition was followed by an embarrassing incident in 1860 when Herford applied using only her initials, and was admitted. This oversight led to five female students being permitted to draw from ancient statuary and plaster casts in the Antique School.

In Britain, as in America, women often worked together, sharing models and experience, and often commemorating each other and the members of their households in their paintings. The private household is at the center of a huge increase in works on the theme of everyday life between 1830 and 1849. Paintings of domestic life, courtship, Christian virtues, and the dangers of transgression, confirmed widely held attitudes, but they did little to redirect attention to other areas of concern. The many images of women in domestic settings produced by respected painters like Charles Cope, John Everett Millais, Richard Redgrave, and the Hayllar sisters shaped and disseminated ideals that were central to middle-class life. While the work of some women artists is indistinguishable from that of their male contemporaries in its adherence to ideologies of class and gender, that of others reveals a more skeptical attitude and a desire to renegotiate the terms of feminine dependency.

The enshrinement of the Victorian middle-class woman at home contributed to the pictorial celebration of madonna-like women and to an emphasis on the stages of women's lives through which femininity is defined and secured. Cope's *Life Well Spent* (1862) and George Elgar Hick's three paintings titled *Woman's Mission* (1863), including the panel "Companion to Manhood," are but a few examples of the many paintings which stress women as nurturers and care-givers. "Woman's power is for rule, not for battle," intoned one critic of the day, "and her sweet intellect is not for invention or creation, but for sweet ordering, arrangement, and decision. . . . This is the true nature of home—it is the place of Peace: the shelter, not only from all injury, but from all terror, doubt, and division."

The removal of women to the private sphere of the family made scenes of family life seem particularly appropriate for women artists. "It may be that in the more heroic and epic works of art the hand of man is best fitted to excel; nevertheless there remain gentle scenes of home interest, and domestic care, delineations of refined feeling and subtle touches of tender emotion, with which the woman artist is

eminently entitled to deal," noted the *Englishwoman's Review* in 1857. Jane Bowkett's images of middle-class women and children at home, Henrietta Ward's visions of domestic bliss, and the Hayllars' paintings of domestic interiors all contributed to shaping representations of domesticity without challenging widely held beliefs. 85

Images such as these do not, however, express a single unified attitude or "feminine" point of view. While Bowkett's *An Afternoon in the Nursery* suggests that chaos results when women are absorbed in their own pleasures (here, reading a book) rather than attending to the needs of children, Edith Hayllar's (1860–1948) *Feeding the Swans* (1889) emphasizes the symmetry and order of the well-run household. The architectural setting and the deep banks of foliage in Hayllar's painting stress the orderly human pairings within and the clearly demarcated stages of female life.

85 Edith Hayllar
Feeding the Swans
1889

86 Alice Walker *Wounded Feelings* 1861

Other paintings by women reveal the uneasy aspects of feminine sexuality constructed around male protection and approval, domesti-
86 cation and family pleasures. Alice Walker's *Wounded Feelings* (1861) depicts a group of elegantly dressed young men and women in a festive interior. In the foreground, a darkened interior, a woman turns to console another who has left the happy scene inside, throwing down her glove and fan as she goes. Beyond her, in an inner room filled with couples, women gaze intently at their male partners. Here, Deborah Cherry has shown, rituals of courtship and the conventions of male/female pairing are opposed to the sympathy and solidarity of female friendship.

A more ambiguous sexuality is also characteristic of the photo-
87 graphs by Clementina, Lady Hawarden (1822–65). An amateur in the tradition of Lewis Carroll and Julia Margaret Cameron, Lady Hawarden was an aristocratic woman who used her camera to capture the intimate aspects of female life in domestic settings. The soft romanticism of her approach and the languid grace of her subjects are in sharp contrast to the feeling of entrapment produced by the walls and mirrors against which she frequently posed her subjects.

The ideal of the clean, well-ordered Victorian home resisted representations of the physical labor required to efface dirt and maintain the leisure of upper- and middle-class families. Female servants generally appear in painting and photography as submissive and obedient women confined to their duties at home. Yet the diaries of Hannah Culwick, a working-class English woman who was photographed between 1853 and 1874, speak another reality: "I'm getting more used to the family now so I don't mind them seeing me clean upstairs as much as I used to, but I do like the family to be away for housecleaning 'cause one can have so much more time at it and do it more thoroughly and be as black at it as one likes without fear o' being seen by the ladies. 'Cause I know they don't like to see a servant look dirty, however black the job is one has to do."

Household manuals emphasizing the proper conduct of servants, their industriousness and cleanliness, underscore the time-consuming managerial skills required of the middle- and upper-class women who ran large households filled with children, servants, and relatives. Although they do not appear frequently in paintings, the physical presence of servants in the home made them readily available as a

87 Clementina, Lady Hawarden, photograph of a model, 1860s

subject for women artists. At least one of Augusta Wells's sketchbooks is filled with studies of female servants, while Joanna Boyce executed several studies and paintings of women servants in the 1850s. Her painting, *Our Servant*, exhibited at the Royal Academy in 1857, is typical of these representations in giving dignity and presence to working-class women within a set of middle-class expectations about domestic labor.

The household was just one aspect of Victorian prosperous life which depended on abundant "cheap" labor in order to function smoothly and efficiently. While female servants protected richer women from domestic drudgery and physical labor, other women, the majority of them underpaid and forced to work in unhealthy or dangerous conditions, supported the British economy. After 1841, the situation of female factory and mill workers formed a major subject of public debate. Their plight, however, rarely enters the art of the period before the 1850s. Even Ford Madox Brown's epic painting *Work* (1852–65), which monumentalizes the subject of labor, emphasizes the worth of the English laboring man and relegates women to marginal positions. Although urban working-class women are almost non-existent as subjects for painting of the period (and are just beginning to appear in photography), a few representations of governesses, one of the few paid occupations open to middle-class women, do exist.

By 1851, there were approximately 25,000 governesses in Britain and they are the subject of works by Richard Redgrave, Emily Osborn, and Rebecca Solomon. Osborn's *Home Thoughts* (1856) emphasizes the isolation of the governess who often traveled far from home with her employers, but who was seldom consulted in their
89 plans. Solomon's *The Governess* (1854) contrasts the silent governess in her discreet dark dress with the fashionably dressed and animated figure of the young wife who plays the piano for her attentive husband. Within the tightly structured Victorian world of home and family, the governess has no secure place.

The plight of middle-class women who were unmarried or otherwise forced to support themselves is the subject of Osborn's
90 *Nameless and Friendless* of 1857 which depicts a young woman accompanied by a boy entering an art dealer's shop with a painting and a portfolio of prints or drawings. The painting is carefully structured to emphasize the commodification of women in the art trade and the isolation and helplessness of the single woman in patriarchal society. While the dealer studies the painting with barely

88 Anna Blunden *The Seamstress* 1854

disguised contempt, the other male figures in the room focus their gazes on the woman, turning their attention away from a print showing a dancer's nude legs and toward the cowering woman. The message is clear: women have no place in the commerce of art; they belong to the world of art as subjects, not makers or purveyors.

Other paintings which take into account the actual conditions of overworked and underpaid female labor at the time include Anna Blunden's *The Seamstress* of 1854. Its subject is the needlewomen who 88 labored in dim light in tiny rooms to produce fine hand-sewn clothes for upper- and middle-class customers. The painting was exhibited at the Society of British Artists in 1854 accompanied by a quotation from Thomas Hood's "The Song of the Shirt" (1843), a poem which had directed attention to the plight of the seamstress, as did the exhibition of five pictures by Redgrave on the theme of women forced to earn their own living: "Oh but to breathe the breath/ Of the cowslip and primrose sweet/ With the sky above my head/ And the grass beneath my feet/ For only one short hour/ To feel as I used to feel/ Before I knew the woes of want/ And the walk that costs a meal."

The work's quasi-religious tone, as a woman who has been laboring throughout the night clasps her hands and gazes heavenward at the first light of day, contrasts sharply with the reality of laboring for hours over the tiny stitches of a man's dress shirt. The painting was executed in the context of an investigation into the working conditions of women in the clothing trades and the system of outworking or "sweating" used in the 1840s and 1850s. The working conditions of these women were the subject of reports in Parliament, as well as articles in *Fraser's Magazine*, the *Pictorial Times*, and *Punch*, but middle- and upper-class reformers generally directed their energy toward improving working conditions rather than ending this kind of exploitative labor.

The theme of women's labor intersects with that of female sexuality and men's control over the bodies of women. It has been argued that the stability of the Victorian household rested in part on the existence of prostitutes; domesticated middle-class femininity was secured through constant contrast with the perils of unregulated female sexuality. Acknowledging the extent to which the purity and morality of the middle-class woman was defined in opposition to the immorality of the prostitute, the *Westminster Review* noted in 1868 that, "Prostitution is as inseparable from our present marriage customs as the shadow from the substance. They are two sides of the same shield."

The 1840s saw the publication of a series of treatises on prostitution including Ralph Wardlaw's *Lectures on the Female Prostitute* (1842) and James B. Talbot's *The Miseries of Prostitution* (1844). It is at this moment, as Susan Casteras suggests in her study of images of Victorian womanhood, that depictions of prostitutes in painting begin to increase, peaking in the 1850s and 1860s. In an age obsessed with virginity and prostitution, themes of the prostitute and the fallen woman found a wide audience. Holman Hunt's *The Awakening Conscience* (1854), Dante Gabriel Rossetti's *Found* (1854), Ford Madox Brown's *Take Your Son, Sir!* (c. 1857), and Augustus Egg's *Past and Present* (1858) are among the many representations of woman's fall from virtue and its consequences executed by members of the Pre-Raphaelite Brotherhood.

Although middle-class women joined in support of prostitutes in the campaign to repeal the Contagious Diseases Act, which subjected prostitutes in selected garrison towns to enforced examinations and treatment, there is little to suggest that they took on this aspect of life as a subject for painting. In contrast to the many depictions of fallen

women by male painters, we have only a description of a single work by the feminist Anna Mary Howitt. Her painting, *The Castaway* (1854), exhibited at the Royal Academy in 1855, is now lost and known only through a description by Rossetti; "Rather a strong-minded subject involving a dejected female, mud with lilies dying in it, a dustheap and other details."

Images of prostitution, like the moralizing sentiments of domestic genre painting, focus attention on one of the most complex and ambivalent aspects of Victorian thought, the attitude to female sexuality. Exploring this issue as it intersects, and is veiled by, the discourses of medicine, vivisection, pornography, and animal imagery reveals some of the ways that representation functioned in the construction of female sexuality. It also sheds further light on the phenomenal popularity in England of the French painter Rosa Bonheur.

Few subjects in painting drew as large an audience, or were as widely reproduced, as those pertaining to animals. British love for animals is legendary. From Queen Victoria, who commissioned Maud Earl and Gertrude Massy to execute portraits of the royal dogs, to John Ruskin, who refered to his favored female painters as "pets," large segments of Victorian society held a special place in their hearts for domesticated animals. Sir Edwin Landseer, the Queen's favorite painter and one of the most successful animal painters in history, built his reputation on paintings in which animals, often dogs, signify masculine, class-specific moral values.

Images of animals frequently symbolized the vices and virtues of women. Constantly exhorted to rise above their "animal" natures, women were pursued by animal exemplars. Elizabeth Barrett Browning's image of the caged bird in the poem "Aurora Leigh" (1856) was exploited by both men and women as a sign of domesticated femininity. A painting of a woman pressing her lips against the bars of a cage containing a small bird and titled *A Pet* was 92 exhibited in 1853 by Walter Deverell, accompanied by an unidentified quotation; "But after all, it is only questionable kindness to make a pet of a creature so essentially volatile." William Rossetti was quick to comment on the work's quasi-erotic mood of passion and intensity.

It was the search for expressions of feeling unencumbered by social constraints that underlay both the embrace of animal imagery in nineteenth-century Britain and the fame enjoyed by Rosa Bonheur there. Bonheur was the most famous woman artist of the nineteenth century and one of the greatest animal painters in history.

89 Rebecca Solomon *The Governess* 1854

91 Evelyn Pickering de Morgan *Medea* 1889

90 Emily Mary Osborn *Nameless and Friendless* 1857

She came to England in 1856 for a visit following the success of *The Horse Fair* (1855) at the previous year's Paris Salon. Born in Bordeaux in 1822, she was an anomaly among women artists of her day. A critical and financial success by 1853, she was radical in her personal life, but artistically and politically conservative, a confirmed monarchist and a realist whose reputation was soon eclipsed by the more radical pictorial styles of French modernism.

Bonheur's mother, who died when the child was eleven years old, taught her to read, draw, and play the piano. Her father, a minor artist, supervised her artistic training, convinced she would become a painter who would fulfil his radical Saint Simonian ideals about women.

Bonheur's critical reputation grew slowly but steadily throughout the 1840s. She received a gold medal for *Cows and Bulls of the Cantal* in 1848, but her greatest success before *The Horse Fair* came in 1849 when she sent *Plowing in the Nivernais* to the Salon. She based the work on a description of oxen in George Sand's celebrated pastoral novel of 1846, *La Mare au Diable* (The Devil's Pod), on her long study of animals in nature, and on the paintings of Paulus Potter, a Dutch seventeenth-century painter of cows whose work she admired.

92 Walter Deverell *A Pet*
1852–53

Celebrating rural work in the tradition of Courbet and Millet, Bonheur emphasized the nobility of laboring animals against a broad expanse of sky painted with the light and clarity of Dutch seventeenth-century painting.

Bonheur's *Horse Fair* became one of the best-known and loved of all nineteenth-century paintings. A quarter-size version of the work went to England to be engraved by Thomas Landseer. During the next decade, the English dealer Gambart published lithographs of her work, including twelve horse studies. Britain, where she enjoyed her greatest fame during the 1860s and 1870s, was also her chief source of income. On her first visit, she met Queen Victoria, who arranged a private viewing of *The Horse Fair* at Buckingham Palace, and other luminaries.

Critics were quick to note the vitality and fidelity to nature of Bonheur's work. "The animals, although full of life and breed, have no pretensions to culture," noted *The Daily News* in 1855. The subjects and the detailed and accessible style of Bonheur's paintings appealed to British middle-class audiences. Her fame in Britain, however, also coincided with a period of impassioned public debate about animal rights and animal abuse around the issue of vivisection. The debate touched on the lives of women as well as animals and it is important for what it reveals about the way that control over the bodies of women and animals was articulated around identifications with nature and culture, sexuality and dominance. The same images which expose the helplessness of animals were used to reinforce the subordinate and powerless position of women in relation to the institutions of male power and privilege.

As early as 1751, when Hogarth published his series of engravings called the *Four Stages of Cruelty*, British art had made the connection between the torture of animals and the torture of women. Hogarth's prints move from a scene in which a young Tom Nero skewers a dog in the presence of a variety of youthful animal torturers, to his flogging of a horse and then his murder of his mistress. Hanged, his body given over to medical dissectors, the persecutor of animals who became the murderer of woman becomes himself the victim of medical abuses.

The message conveyed to British audiences by Bonheur's horses and dogs was the opposite of Hogarth's. They emphasize the animals' freedom and uncorrupted nature, their loyalty, courage, and grace; in the words of one critic they were "like nature." In a curious way, middle-class Victorian women's love for animals (by 1900 women

95

94 Elizabeth Thompson (Lady Butler) *Calling the Role After an Engagement, Crimea* 1874

WEST HIGHLAND BULL.

95 *West Highland Bull* engraved after Rosa Bonheur, 1866

96 Rosa Bonheur *Plowing in the Nivernais* 1848

supported the antivivisection movement in numbers exceeded only by their numbers in suffrage societies) and the widespread involvement of working-class men and women in the animal rights movement forged an unusual bond between the classes. The issue, however, was more far-reaching than the plight of animals. The issue was power, or rather the powerlessness that middle-class women and working-class men and women experienced in the face of the institutionalized authority of middle- and upper-class men.

During the nineteenth century, the new medical science of gynaecology removed much women's health care from midwives' hands, placing women's bodies under the control of male doctors and submitting women to the horrors of early gynaecological practice. Elizabeth Blackwell, the first American female doctor, noted that the popular operation which removed healthy ovaries as a treatment for menstrual difficulties was akin to "spaying." It is not surprising that many women came to identify with the plight of vivisected and abused animals.

The publication of Anna Sewell's novel *Black Beauty* in 1877 97 provided one focus for equating the situation of women with that of animals. Referred to by its author as "the autobiography of a horse," *Black Beauty* is in fact a feminist tract deploring the cruel oppression of all creatures, especially women and the working class. Black Beauty is both a working animal, at the mercy of owners who range from kind to cruel, and a beautiful piece of property, like a wife. The novel was immensely popular (it sold 12,000 copies in its first year of publication in England) partly because many Britons had come to realize that the animal rights issue was really a human rights issue.

Black Beauty became part of the social consciousness of the age, but the identification of women with horses also entered the Victorian imagination in other ways. Horses and horsey dialogue were frequently used to inculcate docility in workers and assertive women. A story which appeared in the *Girls Own Paper* of 1885 used the dialogue between a horse named Pansy and Bob, her master, as a not-so veiled reference to the contemporary demand for women's rights; "Pansy, the mare, was a very different character. She held strong views on the subject of equality. . . . If she had lived at a time when the question of women's rights and the extension of the suffrage were agitating the feminine mind, one might have thought that Pansy had pondered the matter in relation to horses." However, Pansy's strong views are soon beaten out of her and she becomes a docile and devoted servant to her master.

The language that "tames" Pansy the horse is the language of both
Victorian pornography and gynaecological practice. In the porno-
graphic novels, women are "broken to the bit," saddled, bridled, and
whipped into submission. The obverse of the ideology which
enjoined women to rise above their animal natures was a pornogra-
phic imagination which reduced them to animals in order to control
them. In gynaecological practice, women faced the language of
control as they were strapped to tables and chairs for examinations,
their feet placed in footrests called "stirrups" (in general use after
1860).

Rosa Bonheur's paintings, and the intense response they provoked
in British middle-class audiences, are inseparable from the complex
system of signification through which femininity was produced and
controlled. Horses (and women) were beautiful pets/animals; they
also represented a challenge to male domination. The parallels which I
have drawn here might not have been articulated by a Victorian
audience. Nevertheless, they indicate the ways that images function,
not as a reflection of an unproblematic "nature," but as signs within
broader systems of signification and social control. In a similar fashion
the paintings of Elizabeth Thompson (1846–1933), although they

catapulted their creator to instant personal fame as a woman who had overcome the limitations placed on her sex, must also be read as part of the middle- and upper-class effort to assert control—in this case over the British army.

Like Bonheur, Elizabeth Thompson (1846–1933) refused to be restricted to "feminine" subjects. She painted the world of war and soldier's lives, a world which was understood to belong to men, and she also experienced dazzling success, for a relatively brief period. She has been called "the first painter to celebrate the courage and endurance of the ordinary British soldier."

Thompson came from a wealthy and privileged background. Like Bonheur, she had a father who believed in female education and development and who devoted much time to his two daughter's progress (her sister was the feminist, socialist poet and critic Alice Meynell). Thompson began oil painting lessons in 1862 with William Standish in London. She then enrolled in the elementary class at the Female School of Art, but soon left because she didn't like the design-oriented curriculum. Returning to the advanced class in 1866, she supplemented the training available in the draped life class by attending a private "undraped female" life class.

By the early 1870s, Thompson had achieved a moderate success with her first battle watercolors. Her choice of military history as a subject (without benefit of military connections in her family before her marriage or first-hand knowledge of battle) is a mark both of her ambition and her realization that the subject was "non-exploited" in British painting. *Missing* (1872) was accepted by the Royal Academy, but it was *Calling the Role After an Engagement, Crimea* (1874) which brought her instant success when it was exhibited there. 94

Calling the Role . . . graphically depicts the Grenadier Guards mustering after a battle in the Crimean War (1854–56). The influence of Meissonier and early nineteenth-century battle painting is evident in its large format and meticulous realism and Thompson had, in fact, visited the Paris Salon in 1870. Despite the painting's academic and conservative style, its cool black and gray palette brilliantly evokes the grim Crimean campaign with its weary soldiers and snow-covered battlefields.

The superficially chivalrous tone assumed by critics who lauded the work masked more derogatory messages contained in the assumption that she must have been a nurse to have witnessed such injury and illness. "There is no sign of a woman's weakness," noted *The Times*, while the critic for *The Spectator* commended "a thoroughly manly

98 Elizabeth Thompson (Lady Butler) *Inkermann* 1877

point of view." Ruskin joined a group of passionate admirers that
included Queen Victoria but, like the others, he made it clear that such
work was not the province of the womanly woman. "I never
approached a picture with more iniquitous prejudice against it than I
did Miss Thompson's," he wrote in his "Academy Notes, 1875,"
"partly because I have always said that no woman could paint; and
secondly, because I thought what the public made such a fuss about
must be good for nothing. But it is Amazon's work this, no doubt of it,
and the first fine pre-Raphaelite picture of battle we have had."

 Rejecting the dramatic moment and heroic action associated with
the history of battle painting, Thompson introduced an anti-heroic
realism and a sympathetic attention to the sufferings of the rank and
file soldier that struck an immediate chord in a society engaged in
revaluating Britain's role in the Crimea. Paintings like *Calling the
Role . . ., Balaclava* (1876), commemorating the charge of the Light
98 Brigade, and *Inkermann* (1877) helped to shape middle-class percep-
tions of the British army's ineptitude. Thompson's emphasis on the
suffering of the individual soldier, and her redefinition of war as
tragedy rather than cultural heroic, reinforced the government's
decision to institute new regulations which abolished the system of
purchased army commissions and promotions by which upper-class
men had secured positions of rank and privilege in the army.

Although Thompson was the best-known woman producing historical paintings on a grand scale, a number of other women turned to the writings of women and to history's heroic women for subjects that would enable them to enter the field of history painting. While women artists were seldom, if ever, given public commissions for history paintings, they nevertheless produced large and important works which proposed new readings of historical events. Often they retold historical incidents from a woman's point of view, as in Lucy Madox Brown Rossetti's *Margaret Roper Receiving the Head of Her Father, Sir Thomas More, from London Bridge* and Henrietta Ward's *Queen Mary Quitted Stirling Castle on the Morning of Wednesday, April 23 . . .*, based on Agnes Strickland's account in *Lives of the Queens of Scotland* (1850). The only woman other than Ward to receive high praise for her historical painting during this period was Emily Osborn. Her *Escape of Lord Nithsdale from the Tower* (1861) stressed the active courageous women who rescued Lord Nithsdale from the Tower of London where he had been imprisoned for his support of the Stuart cause. Other works reported women's support and friendship, or their strength. Evelyn Pickering de Morgan's *Medea* of 1889 replaces conventional male representations of Medea as a cruel temptress and the murderer of her children with an image of a woman skilled in sorcery.

99

91

99 Henrietta Ward *Queen Mary Quitted Stirling Castle on the Morning of Wednesday, April 23 . . .* 1863

100 Anna Lea Merritt *War* 1883

Not all women shared Thompson's ambition to paint "masculine"
100 subjects. Anna Lea Merritt's *War* (1883) was presented by its author as
upholding womanhood in the face of Thompson's challenge. Merritt,
an American from Philadelphia who settled in London after marrying
her teacher, described it as, "Five women, one boy watching army
return—ancient dress. It shows her respect for the classical tradition. It
also shows the women's side of war—the anxieties, the fears & the
long wait as opposed to the glorification of war (q.v. Lady Butler)."

Merritt, like many other women in Victorian England, upheld the
ideology of separate spheres. Opposing the purity and passivity of the
idealized women on the balcony to the men of action parading below,
she affirms the dominant view of acceptable femininity defined in
terms of passivity and domesticity while at the same time offering a
critique of masculine enterprises. American women artists, as we shall
see, faced similar challenges.

Toward Utopia: Moral Reform and American Art
in the Nineteenth Century

Women's labor was a necessary part of the building of America and, although the legal status of women in the colonies was limited and men played the central economic role, women enjoyed rights and privileges denied them in Europe. Nevertheless, as the workplace moved outside the home during the nineteenth century, here also a growing ideology of domesticity linked women to a specific set of sex roles. In emphasizing the split between "work" and "home," and centering salvation in the latter, the cult of domesticity also established the American home as a refuge from the desecrations of the modern business world, a place where spiritual values could be cultivated, and a measure against which to evaluate women's cultural productions.

Seeking to extend the refining influence of domestic life, large numbers of middle-class women in America were caught up in the Christian reform movements that promoted the abolition of slavery, temperance, and universal suffrage. The identification of these social reform movements with an ideology of the home as a site of edification and enlightenment has led modern feminist historians to refer to this union of social reform and women's rights as "domestic feminism."

Needlework and painting were considered appropriate handicrafts for women and during the first half of the century women are well represented among American folk artists. Little formal training was available and many women, like Eunice Pinney, were self-taught 101 amateurs who worked at their art whenever they had free time. One of the first professional artists in colonial America, Henrietta Johnson, executed rather stylized Rococo portraits in pastel in Charleston, South Carolina, in the first two decades of the eighteenth century. She was succeeded by the miniaturists Sarah Goodridge and Anne Hall, by the Peale women of Philadelphia, by Herminia Borchard Dassel, who exhibited elegant portraits of wealthy New Yorkers at the National Academy of Design, and by Jane Stuart, the daughter of Gilbert Stuart who—despite his refusal to instruct her—ground his

101 Eunice Pinney *The Cotters, Saturday Night* c. 1815

colors, filled in his backgrounds, and copied his works for sale after he died penniless.

The impetus toward social reform in America was supported by a group of progressive New England individualists, many of them Quakers or Unitarians. Steeped in a Transcendentalism shaped by Ralph Waldo Emerson's credo of self-determination, the beliefs of free-thinkers and social Utopians like Bronson Alcott often extended to their wives and families. Louisa May Alcott became one of the most successful novelists of her day, and her sister May's promising career as an artist was cut short by her death in childbirth. Anne Whitney, Harriet Hosmer, Lilly Martin Spencer, Louisa Lander, and numerous other prominent women artists came from families whose reformist tendencies extended to a belief in wider opportunities for women. By mid-century, as educational reform led to greater openings for women, there was a schism between women who thought of themselves as amateurs and those who had begun to think of art as a profession.

From the beginning, women's social organizing drew on skills inculcated at home. Needlework and textile manufacture, increasingly polarized in the nineteenth century between a household activity expected of virtually all women and an income-producing occupation in an industrializing society, became a focus of women's political organizing. Women's traditional skills as producers of cloth were transferred to industrial production. Female workers were the first industrial workers in America following the wide-scale development of textile mills in Lowell, Massachusetts, around 1826. The Lowell mills experiment, begun with the idealistic hope that the exploitation of women workers in England could be avoided in America, failed. The intertwined histories of labor reform, feminism, and abolition in America can be seen in the founding of the Female Labor Reform Association in 1845 in response to the deplorable conditions under which women worked in the mills. Although unsuccessful in agitating for a ten-hour working day and a six-day week for women in the Lowell mills, the association's actions led to the first government inquiry into labor conditions in the United States.

Women quickly used their skills in needlework to connect the domestic sphere and the public world of collective social action. Needlework cases bearing popular abolitionist slogans appeared and, 102 by 1834, women were selling needlework items to raise money for the abolitionist cause. "May the points of our needles prick the slave owner's conscience," declared Sarah Grimké, one of the first women to speak publicly against slavery. Pieced quilts also began to show reform thought. In recent years, traditional quilts have been exhibited as "art" in galleries and museums, where they display a formal affinity with geometric abstract painting when displayed against blank white walls. The fact that these striking examples of women's skill and labor have been taken out of context and commodified must not, however, blind us to their narrative, autobiographical, social, and political content.

As early as 1825, the popular quilt pattern known as "Job's Tears" was renamed "Slave Chain." Another pattern, called "Underground Railroad" contains a series of light and dark squares leading to central 103 areas identified with the "safe houses" that sheltered escaping slaves on their route north. Slavery was avoided as a subject by most literary men in America, and it was women who often drew attention to the abolitionist cause. Harriet Beecher Stowe's *Uncle Tom's Cabin* (1852) has been called the most important act by an individual to advance the cause of abolition; other women, notably the British Harriet

102 Needlework case with abolitionist slogan, c. 1830–50

Martineau, the Swedish reformer Frederika Bremer, and the Black leader Sojourner Truth, were quick to draw the obvious parallels between the condition of women and that of slaves; "the plight of slave and woman blends like the colors of the rainbow," wrote Grimké.

The full impact of the women's movement began to be felt with the first United States National Women's Rights Convention in Seneca Falls, New York, in 1848. A quilt produced just a few years later suggests the new spirit among American women. Its series of appliquéd squares show a woman engaging in what were at the time radical activities for women: driving her own buggy with a banner advocating "WOMAN RIG(HTS);" dressed to go out while her husband, wearing an apron, remains at home; and, most daring of all, giving a speech in public.

114

Geography and class played a significant role in shaping the experiences of nineteenth-century American women artists. Most of the women who became part of the century's expatriot phenomenon came from wealthy and educated East Coast families. In addition to

competing for public commissions, the first generation of professional women sculptors were able to depend on family connections and on an emerging group of wealthy private collectors and philanthropists, many of them women. Caught up in the tensions between the vigor of the young American Republic and the legacy of European culture that shaped the literature of Nathaniel Hawthorne, Henry James, and others, they looked to Europe for liberation from the restrictions placed on women at home. Other women, like the painter Lilly Martin Spencer, as well as many of the women trained in the design professions, were part of the westward expansion of the arts and the professionalizing of education for those middle-class women forced to support themselves. The emergence of a new, middle-class buying public also played a not inconsiderable role in the dissemination of their work.

Lilly Martin Spencer (1822–1902) is an exception among nineteenth-century American artists: a married woman from Ohio who depended on her art to support her thirteen children and her husband (who stayed home and assisted her in professional and domestic duties); a child of communitarian Fourierite parents who claimed to have little time for politics or feminism; an artist who refused the opportunity to go to Europe for training as did many other American artists.

Spencer's painting belongs to the period when American art shifted from an untutored folk expression to styles based on academic

103 "Underground Railroad," c. 1870–90

traditions and the study of European art. One of America's most important genre painters at mid-century, Spencer's career is closely linked to the growing demand for popular prints to decorate middle-class homes. Despite her parents' progressive views, and an education that ranged from Shakespeare, Locke, and Rousseau to Molière, Pope, and Gibbon, there is a testy note in her reply to a letter from her mother in 1850 urging her to be more of a feminist activist. "My time dear mother," she wrote, "to enable me to succeed in my painting is so entirely engrossed by it, that I am not able to give my attention to anything else. . . . You know dear mother that that is your point of exertions . . . like my painting is mine, and you know dear mother as you have told me many times that if we wish to become great in any one thing we must condense our powers to one point."

The first exhibition of her work in Ohio in 1841 brought her to the attention of Nicholas Longworth, a wealthy Cincinnati philanthropist who supported a number of artists then emerging from the western frontier. Longworth offered to assist her in going to Boston to study with Washington Allston or John Trumbull and then to Europe. Instead, she moved with her father to Cincinnati, where she studied with the successful portrait painter James Beard. The nature and extent of her training are unknown.

Spencer's first major success came in 1849 when her painting, *Life's Happy Hour*, was selected by the Western Art Union for engraving. Subscribers to the Art Union, established in Cincinnati in 1847, paid a fixed sum in exchange for an annual engraving of an "important" painting by an American artist and a chance to win an original work of art in an annual lottery. Although often criticized for exploiting artists and vulgarizing public taste, the art unions were instrumental in developing the aesthetic tastes of the new buying public.

After her work was shown at the National Academy of Design in 1848, Spencer moved her family to New York in order to obtain the additional training that would enable her to meet the growing demand for images of happy, self-sufficient domesticity. The good-natured humor and clumsy drawing of her work belong to the American folk tradition of exaggerated humor and sentimental nostalgia. Many of her paintings, especially those depicting children at play like *The Little Navigator* and *The Young Teacher*, were purchased during the 1850s and 1860s for the French firm of Goupil, Vibert and Co. and sent to Paris to serve as the basis for lithographs, many of them hand-colored by women working in a factory-like process. The prints were then returned to America for sale.

104

The founding of the Cosmopolitan Art Association in 1854 expanded Spencer's market through its periodical, *The Cosmopolitan Art Journal*, which was aimed at a female audience with the leisure and education to read magazines. Spencer's *Fi! Fo! Fum!*, exhibited at the National Academy of Design in 1858, was produced as a frontispiece the following year. The unpretentious and detailed rendering of *Fi! Fo! Fum!* found a responsive audience among the journal's readers for this scene of family intimacy as a defense against threats from the outside world. Wide reproduction spread Spencer's name across America but, despite her role in defining a popular imagery, she herself struggled financially throughout much of her life.

The demands placed on Spencer by the need to support her family and to satisfy a large, often unsophisticated, middle-class audience were very different from those confronting the first generation of professional women artists who trained abroad during the 1850s and 1860s. Female art students, whose families were willing to support their aspirations, flocked to Europe. Barred from art academies, they sought private instruction in the studios of male painters and sculptors, often at high cost. Their experiences abroad are detailed in May Alcott's *Studying Art Abroad*, in the diaries of Marie Bashkirtseff, a young Russian art student in Paris in the 1880s, and in the letters of

104 Lilly Martin Spencer *We Both Must Fade* 1869

Harriet Hosmer, Anne Whitney, Mary Cassatt, and others. "Here," wrote Hosmer from Rome, "every woman has a chance if she is bold enough to avail herself of it, and I am proud of every woman who is bold enough. . . . Therefore I say honor all those who step boldly forward, and in spite of ridicule and criticism, pave a broader way for women of the next generation." Hosmer's sentiments were repeated by other women throughout the century; "After all give me France," wrote Cassatt in 1893. "Women do not have to fight for recognition here if they do serious work."

Harriet Hosmer was one of the many Neoclassical sculptors who followed Horatio Greenough to Rome after 1825 in search of good marble and skilled carvers, historical collections of classical sculpture, and an inexpensive and congenial environment. She was the first of a group of women sculptors active in Rome in the 1850s and 1860s which included Louisa Lander, Emma Stebbins, Margaret Foley, Florence Freeman, Anne Whitney, Edmonia Lewis, and Vinnie Ream Hoxie.

These sculptors have entered art history bound together as Henry James's "strange sisterhood of American 'lady sculptors' who at one time settled upon the seven hills in a white marmorean flock." James's vivid description has obscured the real differences that existed among them. Their training, attitudes, and level of professional achievement varied widely, and their work ranged from the Neoclassical style and subjects of American pre-Civil War public sculpture to the greater realism of the late nineteenth century.

Like other successful women of their day, the members of the "White Marmorean Flock" were encouraged to pursue independent lives and careers by liberal parents, other women involved in public reform activity, and by the fact that the Neoclassical movement was understood as an extension of Classical Greece when a flourishing of the arts had accompanied political liberty. Sculpture was associated with the elevated moral and spiritual values which legitimized female reform activity. In a letter to her patron, Wayman Crow, written before her departure for Rome, Hosmer explained why sculpture was superior to painting; "I grant that the painter must be as scientific as the sculptor, and in general must possess a greater variety of knowledge, and what he produces is more easily understood by the mass, because what they see on canvas is most frequently to be observed in nature. In high sculpture it is not so. A great thought must be embodied in a great manner, and such greatness is not to find its counterpart in everyday things."

The same moral arguments which legitimized some women's choice of sculpture as a profession were frequently used by critics to contain their production within the boundaries of the acceptably feminine. Writing about women sculptors in Rome, the art critic of the *Art Journal* noted in 1866 that they were; "Twelve stars of greater or lesser magnitude, who shed their soft and humanizing influence on a profession which has done so much for the refinement and civilization of man." He went on to argue, however, that sculpture by women belonged in a domestic setting where it was "destined to refine and embellish many a home."

Mainstream feminism in nineteenth-century America was reformist at heart, directed toward righting social wrongs rather than radically restructuring relationships between the sexes. In competing for public commissions, and in producing work that was, however conservative in style, largely indistinguishable from that of their male contemporaries, and which was often monumental in scope and conception, these sculptors succeeded more than any other women before them in integrating themselves into a male system of artistic production. Although their work includes numerous representations of women, they often chose to depict strong, active females and they struggled to escape the devaluation that accompanied the identification of their work as "feminine."

The "sisterhood" was among the first group of American women to exchange marriage and domesticity for professional careers; all except Hoxie remained single. "Even if so inclined," remarked Hosmer, "an artist has no business to marry. For a man, it may be well enough, but for a woman, on whom matrimonial duties and cares weigh more heavily, it is a moral wrong, I think, for she must either neglect her profession or her family. . . ." Instead, Hosmer's profession became her "family" and she constantly referred to her sculptures as "children," using the term which reassured the Victorian middle class that although some women had turned their backs on marriage, they remained bound by the codes of respectable femininity. "Rosa Bonheur may not have had that wonderful spark of genius . . .," wrote Gertrude Atherton in 1899, "[but] she always finished a picture with the loving care of a conscientious mother, who insists that her children shall be clean and well-dressed. . . ."

Women embarking on professional careers at mid-century were constantly confronted by circumscribed views of femininity. Only friendships with other women provided some measure of freedom from the demands of marriage, family, and home. Intense, passionate,

and committed relationships between women offered a quasi-legitimate alternative to marriage. The passionate nature of women's relationships with one another was accepted because of a widely held belief that, since genital sexuality was exclusively defined in relation to men, women's love for one another could only be an extension of their pure and moral natures. Hosmer, on the other hand, who openly defied convention by riding her horse astride through the streets of Rome and meeting male sculptors for breakfast in cafés, diffused criticism by adopting the persona of a playful tomboy rather than a grown woman. Although the sculptor William Wetmore Story was enchanted with her as a talented child, others were not convinced. "Miss Hosmer's want of modesty is enough to disgust a dog," wrote the sculptor Thomas Crawford. "She has had casts for the *entire female* model made and exhibited them in a shockingly indecent manner to all the young artists who called upon her. This is going it *rather strong*."

Harriet Hosmer is often coupled with William Wetmore Story as the leading American sculptors of their day. She was the first woman to go to Rome and almost all of her most important work was executed during her first decade there. Born in Watertown, Massachusetts, in 1830, Hosmer was educated at a liberal school and decided early to become a sculptor. Refused admission to an anatomy class in Boston, she enlisted the aid of a school friend's father in St. Louis. Wayman Crow, who became her most loyal and consistent patron, arranged for her to take anatomy lessons from Dr. J. N. McDowell. The Medical College of St. Louis was one of the few places that allowed women to study the human body; even so, Hosmer received her instruction privately in the doctor's office while the rest of the class met as a group.

Hosmer carved her first full-size marble, *Hesper* or *The Evening Star* (1852), by herself in her Watertown studio, often working ten hours a day. The work, inspired by Tennyson's poem "In Memoriam," received positive critical notice and Hosmer's friends, who included the Boston actress Charlotte Cushman, encouraged the young sculptor to go to Rome for further study. She sailed with her father and Cushman in 1852.

Famous among other things for her theatrical portrayals of male roles like Romeo and Cardinal Wolsey, Cushman became a pivotal figure among the Anglo-Americans in Rome, providing Hosmer with rent-free lodging for the next seven years. Although Cushman is now primarily associated with women sculptors, Hosmer was merely

the first of a circle of artists, both men and women, who benefited from the actress's friendship and professional support. Cushman and Story were rivals for social leadership in Rome and the venomous comments sometimes directed at women artists in her circle (like Crawford's denunciation of Hosmer) must be read in the light of this factional rivalry.

Cushman encouraged the sculptor John Gibson, who did not normally accept pupils, to instruct Hosmer. He agreed after seeing photographs of *Hesper* and gave her a studio in his garden. *Daphne* (1854) and *Oenone* (c. 1855), Hosmer's first full-length allegory, followed her apprenticeship with Gibson. Although critics commended *Oenone's* simplicity and classic grace, Hosmer's first public success came not with a full-size figure but with a "fancy" or "conceit." *Puck on a Toadstood* (1856) was the first of several "conceits" which her contemporaries found "native to a woman's fancy." Replicas of the work, one of them purchased by the Prince of Wales, eventually earned the artist some $50,000 and insured her fame, but the decision to produce a purely commercial work was precipitated by her father's sudden financial losses and her need to be financially independent in order to remain in Rome.

In 1855, Louisa Lander (1826–1923) arrived in Rome, having previously modelled portrait busts in Washington, D.C. Her *Virginia Dare* (1860) takes its subject from Richard Kakluyt's writings about Virginia Dare, the first White woman born in the New World. The fate of the young woman, who disappeared with the rest of the Roanoke Colony, is not known, and Lander's sculpture is a symbolic portrait. Her nudity, and the fishnet she holds, are unusual interpretations of the theme and the figure's erect stance and bold gaze are a departure from the usual Neoclassical convention of displaying the female nude with chin dropped and gaze lowered.

Stebbins (1815–82), who began as a painter, became interested in 105 sculpture after meeting Cushman in Rome in 1856. The actress's companion for many years, and later her biographer, Stebbins worked on historical and religious subjects, followed in 1867 by a large *Columbus*, which now stands in Brooklyn, New York. Cushman steadfastly supported Stebbins's professional life; among other works, a statue of the educator Horace Mann for the State House in Boston and the *Angel of the Waters Fountain* (c. 1862) for New York's Central Park were commissioned with the actress's help.

Women Neoclassical sculptors also produced a number of images of women responding with fortitude and moral courage to the

vicissitudes of fate and the powerlessness experienced by women under patriarchy. They range from Whitney's *Lady Godiva* (1861) and *Roma* (1869), and Lewis's *The Freed Woman and Her Child* (1866) to Hosmer's *Beatrice Cenci* (1857) and *Zenobia in Chains* (1859). 106 *Beatrice Cenci* was Hosmer's response to the moment in Shelley's verse drama, *The Cenci*, when, through sleep, Beatrice temporarily escapes the horror of having murdered her odious and incestuous father. The sculpture responds to the spirit of Shelley's poem, as does a dialogue in blank verse titled "The Cenci's Dream: In the Night of Her Execution," written by Whitney and published in 1857. Hosmer's version also has sources in Guido Reni's portrait of the young woman, then the most admired seventeenth-century painting in Rome, and in Stefano Maderno's *Saint Cecilia*.

The story of Zenobia, the third-century Queen of Palmyra who 107 was defeated and captured by the Romans, had been popular for over a century. Although the theme has many nineteenth-century literary sources, visual representations are rare and Hosmer's is unique in its archeological detail. The draped figure is proportioned according to antique canons; the features are based on an antique coin and the garment and ornaments on a mosaic in San Marco in Florence.

Hosmer also consulted frequently with Mrs. Jameson, who had included a chapter on Zenobia in her *Celebrated Female Sovereigns* (1831). Departing from her literary sources, she presents a queen who does not succumb to defeat, who responds with fortitude to her capture and humiliation. Unlike the many writers who linked Zenobia's downfall to personal failings, Hosmer instead chose to emphasize her intellectual courage, fusing Christian ideals with a nineteenth-century feminist belief in women's capability.

The first exhibition of *Zenobia in Chains* in England in 1862 brought a disappointing critical response and Hosmer, like many women artists before her, was forced to respond to charges that her work was not her own, and might even have been produced by John Gibson, her former teacher. In December 1864, Hosmer responded to the charges in an article in *Atlantic Monthly* in which she explained that all Neoclassical sculptors depended on skilled artisans, working from models produced by the artist, to do the actual carving; "The artist is a man (or woman) of genius; the artisan merely a man of talent."

Exhibited in the United States the following year, *Zenobia in Chains* was a triumphant success, taking its place alongside Hiram Power's *Greek Slave* (1847) as a testament to nineteenth-century moral ideals. But although both figures are captive and not in control of their fates, *Zenobia's* resolute dignity stands as a rebuke to the *Greek Slave's* prurient, if allegorical, nudity. More than one critic lauded Hosmer's figure as an embodiment of the new ideal of womanhood. Newspaper articles acclaimed the work and 15,000 people clamored to see it in Boston.

The success of *Zenobia in Chains* enabled Hosmer to establish herself in an impressive studio in Rome, but although she produced large fountains for Lady Eastlake and Lady Marion Alford, who also supported Gibson and Elisabet Ney, her production gradually declined for reasons which are not yet clear.

Nathaniel Hawthorne published his novel *The Marble Faun* in 1859 and immortalized the women sculptors of Rome in the characters of the artists Hilda and Miriam who play out a drama of art, morality, and human frailty. Hawthorne himself was far from reconciled to the idea of independent women; "all women as authors are feeble and tiresome," he wrote to his publisher, "I wish they were forbidden to write on pain of having their faces deeply scarified with an oyster shell." His novel becomes a kind of literary revenge on the new womanhood as he rewrites female creativity, making the gentle and

108 Margaret Foley *William Cullen Bryant* 1867

pure Hilda's "art" nothing more than exquisite copies of Italian masterpieces, and constructing a tragic end for Miriam's more passionate creativity.

The novel elicited mixed reactions: Emerson dismissed it as "mere mush," while Hosmer, rejecting the plot as "nothing," was drawn to its "perfection of writing, beauty of thought, and for the perfect combination of nature, art and poetry. . . ." The strongest denunciation came from Whitney; "*The Marble Faun*, which I am trying hard to read, is a detestable book," she wrote to the painter Adeline Manning in 1860, emphatically rejecting Hawthorne's characterization of the woman artist.

Women artists continued to go to Rome well into the 1860s. The last two women to set out before the Civil War were Margaret Foley, who arrived around 1860, and Florence Freeman, who came in 1861. Foley (1827–77) had begun carving and modeling in Vermont where she was born. Recruited for the textile mills in Lowell, she taught Saturday art classes there before going to Boston to become a cameo cutter and sculptor. Her bronze *Stonewall Jackson*, cast in London in 1873, was the first Confederate Civil War monument in America. Freeman(1836–76), who had studied with Richard Greenough in Boston, specialized in bas-reliefs and was closely connected to Cushman's circle. Her bust of *Sandophon, the Angel of Prayer*, based on a Longfellow poem, was owned by him.

108

It is the work of Anne Whitney and Edmonia Lewis which is most powerfully connected with the human rights issues of their day, which often demanded a less allegorical and more naturalistic sculptural treatment. During the Civil War years, and before going to Rome, both sculptors worked in Boston where for part of the time they maintained studios in the same building. Whitney, like Hosmer, came from a liberal Unitarian family in Watertown, Massachusetts, that traced its roots to the Massachusetts Bay Colony. Lewis (1845– after 1909) was the only major American woman artist of color in the nineteenth century. Part Black, part Chippewa Indian, part White, she was educated at Oberlin College, one of 250 students of color enrolled there before the Civil War. Accused of poisoning two friends with drugged wine in what appears to have been a prank turned tragic, she was beaten by vigilantes, arrested and tried, and defended by the most famous black lawyer, John Mercer Langston, before being released and making her way to Boston.

Whitney (1821–1915) was a poet before she became a sculptor and the publication of her fifteen sonnets "To Night" in 1855 in *Una*, the first women's rights publication, brought her to the attention of the leading feminists of the day. Her friendships with Elizabeth Blackwell, Lydia Maria Child, whose *History of the Condition of Women in Various Ages and Nations* had been published in 1835, and Lucy Stone, the women's rights leader and first woman from Massachusetts to receive a college degree, were crucial to her decision to pursue a career in sculpture.

By 1863, Whitney had executed her first life-size sculpture, a *Lady Godiva* (1861), based on Tennyson's heroine who braved mockery and humiliation for the sake of an oppressed peasantry. Her social concerns were strengthened through attendance at emancipation meetings and anti-slavery conventions. Her *Africa* (1863) portrayed a symbolic mother of an African race rising from slavery.

In Boston, Lewis had an introduction to William Lloyd Garrison and through him she met other abolitionists and suffragists. Her introduction to the Boston art community, however, was less positive. After three male sculptors refused to instruct her, she copied fragments of sculpture lent her by the portrait sculptor Edward Brackett and turned to Whitney for informal lessons. Conscious of the extent to which the White community regarded her as an exotic (a characterization that pursued her to Rome in Henry James's slighting remark that "one of the sisterhood, if I am not mistaken, was a negress, whose colour, picturesquely contrasting with that of her

plastic material, was the pleading agent of her fame"), and afraid that she would be accused of not having done her own work, Lewis later refused additional training.

In 1864, she was at work on a bust of Robert Gould Shaw, the leader of the Negro regiment from Massachusetts during the Civil War and the subject of works by Whitney and Foley. Lewis also modeled medallions in clay and plaster of John Brown, Garrison, Charles Sumner, and Wendell Philips. Among her earliest works is a bust of Maria Weston Chapman, an ardent worker for anti-slavery.

Whitney's arrival in Rome in 1866 was preceded by that of Lewis. With Chapman's and Cushman's professional support, Lewis turned to Black and Indian themes. An ideal figure of Hagar (1871) illustrated, in her words, "her strong sympathy for all women who have struggled and suffered," and while in Rome she completed *The Freed Woman and Her Child* (1866) and *Forever Free*, both on the 110 subject of emancipation.

By 1867, she was working on a "group" intended as a gift for Garrison in honor of his work in support of her people. *The Freed Woman and Her Child* (now lost) and *Forever Free* recall the stirring sentiments of the Emancipation Proclamation of 1863; "all persons held as slaves . . . are, and henceforward shall be, free." In the former, a woman hearing of her emancipation, kneels in thanksgiving. Lewis herself described the subject as "a humble one, but my first thought was for my poor father's people, how I could do them good in my small way." The woman reappears in *Forever Free*, originally called *The Morning of Liberty*, kneeling beside a male slave who raises his left arm in triumph, brandishing his broken chains and standing firmly on a cast-off ball and chain.

Edmonia Lewis's later life remains obscured by rumor and mystery. Whitney's return to Boston in 1871, on the other hand, was followed by a government commission for a marble statue of Samuel Adams for the Capitol in Washington and the loss of a competition in 1875 for a statue of Charles Sumner when it was learned that a woman 109 had won. The bronze was finally erected in Harvard Square in 1902.

By the time Whitney received her commission for Samuel Adams, the first federal commission had already gone to another woman. Vinnie Ream Hoxie's imposing figure of Abraham Lincoln was 111 unveiled in Statuary Hall in the Capitol in 1871. In many ways, the circumstances surrounding the commission sum up all the ambivalence expressed toward this first generation of professional American women. Hoxie, born in Madison, Wisconsin, in 1847, studied there

109 Anne Whitney *Charles
Sumner* 1900

110 Edmonia Lewis *Forever
Free* 1867 >

111 Vinnie Ream Hoxie >
Abraham Lincoln 1871

briefly before moving to Washington in 1862 where she received
some training in sculpture. After executing a portrait bust of Lincoln,
she met the president. Her model of the man who, in her words, was
one "such as will elevate the human race and ennoble human nature,"
was entered in the congressional competition for a memorial to the
slain leader in 1866. The final congressional deliberations included
attacks on Hoxie's youth and inexperience by several senators; others
praised her beauty and charming demeanor. The criticism quickly
deteriorated into attacks on female sculptors and the inappropriate
behavior of women desiring to execute large monuments, which in
fact masked profound artistic differences between the East Coast
artistic and intellectual elite and challenges to its hegemony from the
South and West.

The commission was finally awarded to Hoxie. Her moving
depiction of the weary and bowed president was enthusiastically
received and the young sculptor became an instant celebrity. The
mood of celebration was short-lived. The *New York Tribune* attacked
Hoxie's technical abilities, describing her Lincoln as a "frightful
abortion," and the artist as a "fraud." Charging once again that the
sculpture was not her own work, the sexualized language of the

critical attack reveals the unconscious belief that female ambition exceeded and violated nature.

As the ensuing controversy widened, Whitney applauded an article in the feminist weekly, *The Revolution*, in which the author "deprecates all this personal twaddle about hair and eyes. . . . And I hope, in mercy, suffrage and other things that belong to us will come soon and lift us out of—get us above, I mean—hair, eyes, and clothes. . . ." Hosmer also came to her defense; "We women artists will not hear that we are imposters without asking for proof. . . . [Hoxie] is as much entitled to the credit of her work as any artist I know. . . . We resent all such accusations as unjust, ungenerous, and contemptible."

Hosmer's emphatic response, and her faith in women's abilities, reflected the increasing public confidence that American women were displaying during the 1870s and 1880s. By 1876, when the Centennial Exposition opened its doors in Philadelphia, women represented almost one fifth of the labor force and their part in the "century of progress" celebrated by the fair was evident in more than six hundred exhibits displaying their achievements in journalism, medicine, science, business, and social work. During the second half of the century, women also contributed to defining a new art.

Separate but Unequal: Woman's Sphere and the New Art

The Philadelphia Centennial Exposition of 1876 represented a milestone in women's struggles to achieve public visibility in American cultural life. Approximately one tenth of the works of art in the United States section were by women, more than in any other country's display. Emily Sartain of Philadelphia received a Centennial gold medal, the only one awarded to a woman, for a painting called *The Reproof* (now lost). Sartain's painting was displayed in the United States section, but the exhibition also boasted a Women's Pavilion with over 40,000 square feet of exhibition space devoted to the work of almost 1500 women from at least 13 countries.

Presided over by Elizabeth Duane Gillespie, Benjamin Franklin's great-grand-daughter and an experienced community leader, the Women's Centennial Executive Committee had raised over $150,000 amid considerable controversy. The building's existence as a segregated display area had been contested from the beginning. "It would, in my opinion," wrote the Director of Grounds, "be in every respect better for *them* to occupy a building exclusively their own and devoted to women's work alone." To others, the presence of a separate exhibition facility for women at the Exposition signaled an institutionalizing of women's productions in isolation from those of men. Sensitive to the implications of exhibiting women's art only in relation to other areas of feminine creative activity, and angered because no attention was given to women's wages and working conditions, radical feminists refused to participate. "The Pavilion was not a true exhibit of women's art," declared Elizabeth Cady Stanton, because it did not include samples of objects made by women in factories owned by men. Ironically, the building became both the most powerful and conspicuous symbol of the women's movement for equal rights and the most visible indication of woman's separate status.

The Pavilion's eclectic and controversial exhibits included furniture, weaving, laundry appliances, embroideries, educational and scientific exhibitions, and sculpture, painting, and photography, as

well as engravings. Jenny Brownscombe, a graduate of Cooper Union and one of the first members of the Art Students' League of New York sent examples of the genre subjects she drew for *Harper's* 112 Weekly. Among the many paintings by women were the landscapes of Mary Kollock, Sophia Ann Towne Darrah, and Annie C. Shaw; the still-lifes of Fidelia Bridges and Virginia and Henrietta Granberry; drawings of old New York by Eliza Greatorex; historical subjects by Ida Waugh and Elizabeth C. Gardner; and portraits by Anna Lea Merritt. The Philadelphia sculptor Blanche Nevins sent plaster casts of an *Eve* and a *Cinderella*; Florence Freeman offered a small bust. Foley and Whitney sent bas-reliefs and statuettes, and Whitney also provided a bronze cast of the *Roma*, a bronze head of an old peasant woman asleep, and a fountain for the center of the Horticulture Hall.

The lumping together of fine arts, industrial arts, and handicrafts, and of the work of professional and amateur artists implicitly equated the work of all women on the basis of gender alone. Critics were quick to challenge the displays for their lack of "quality" and women once again found themselves confronting universalizing definitions of "women's" production in a gender-segregated world.

112 Jenny Brownscombe *The New Scholar* 1878

In 1876 Louisa May Alcott, using the proceeds from her writing to pay for her sister's European art education, sent May to Paris for further study. May Alcott's copies of Turner's paintings had won Ruskin's praise in London and she was determined to succeed as an artist. Her letters home describe a comfortable lifestyle with a supportive group of female art students sharing meals and encouraging each other's ambitions. The woman they most admired in Paris was Mary Cassatt, who with several other women painters became the first women to align themselves with a stylistically radical movement.

Cassatt (1844–1926), daughter of a wealthy Pennsylvania businessman, became a student at the Pennsylvania Academy in 1861, taking her place among a number of dedicated women students which eventually included Alice Barber Stephens, Catherine A. Drinker, Susan MacDowell Eakins, Anna Sellers, Cecilia Beaux, and Anna Klumpke. By 1866, she was settled in Paris where she was soon joined by the rest of her family. Her teas were a mecca for younger women, she was generous with introductions and advice, and her professional commitment was an inspiration to the young students. "Miss Cassatt was charming as usual in two shades of brown satin and rep," wrote May Alcott to her family in Concord, "being very lively and a woman of real genius, she will be a first-class light as soon as her pictures get a little circulated and known, for they are handled in a masterly way, with a touch of strength one seldom finds coming from a woman's fingers."

Alcott's comments reveal the conflicts still facing the woman artist caught within an ideology of sexual difference which gave the privilege to male expression and often forced women to choose between marriage and a career. These conflicts make up Louisa May Alcott's short novella *Diana and Persis* (written in 1879 but only recently published). The novel's female characters were modeled on herself and her sister, and on their friends among the White Marmorean Flock. One chapter is titled "Puck" in reference to Hosmer's successful piece. Alcott explores the connections between art, politics, spinsterhood, and the female community. Persis, a young painter funded by her family to study abroad, wins minor recognition in the Paris art world (where May Alcott had a still-life accepted in the Salon of 1877). Devotion to her art and devotion to home and family are her consuming passions, but after first choosing art, Persis discovers that as a True Woman she cannot deny her feelings and her desire for domestic life. May/Persis demanded the right both to

113 Alice Barber Stephens *The Female Life Class* 1879

marital happiness and artistic success, but her expectations ran counter
to the structures of patriarchal nineteenth-century society. She loudly
proclaims her allegiance to an earlier, heroic generation of female
artists like Rosa Bonheur, but in the end her choice of marriage limits
her options as an artist.

During the years when Cassatt, May Alcott, and other young
women flocked to Paris for study, the city itself was undergoing
dramatic changes. The rebuilding of Paris by Baron Haussmann and
Napoleon III in the 1850s and 1860s physically transformed the city.
T. J. Clark, Eunice Lipton, Griselda Pollock, and others have ably
demonstrated the evolution of a new social matrix as artists and
writers, prostitutes and the new bourgeoisie were drawn into the
streets and parks, the cafés and restaurants. Baudelaire's call for an art
of modern life emphasizing the fleeting and transitory moment, and

the fugitive sensation was embodied in the contemporary focus and realist approach of Degas's and Manet's paintings, in the broken brushstrokes and fleeting gestures of Impressionism, and in the poetic imagery of the flâneur, that exclusively masculine figure who moved about the new public arenas of the city relishing its spectacles.

The collapse of the Second Empire in 1870 and the establishment of the Third Republic in 1875 produced an increasingly democratized middle-class culture. By the 1870s, an active consuming public thronged the boulevards, department stores, and international expositions. The painters later known as the Impressionists—Claude Monet, Camille Pissarro, Berthe Morisot, Pierre-Auguste Renoir, Edouard Manet, Edgar Degas, Alfred Sisley, Mary Cassatt, and others—produced their own version of modernity, but their stylistic innovations and their new subject-matter must be seen in the larger context of a restructuring of public and private spheres.

In "Modernity and the Spaces of Femininity," Pollock maps the new spaces of masculinity and femininity and articulates the differences "socially, economically, subjectively" between being a woman and being a man in Paris at the end of the century. Some women were drawn to Impressionism precisely because the new painting legitimized the subject-matter of domestic social life of which women had intimate knowledge, even as they were excluded from imagery of the bourgeois social sphere of the boulevard, café, and dance hall. Recent feminist scholarship has focused on the fact that, as upper-class women, Morisot and Cassatt did not have access to the easy exchange of ideas about painting which took place among male artists in the studio and the café. Yet despite Morisot's inability to join her male colleagues at the Café Guerbois, the Morisots were regulars at Manet's Thursday evening soirées, where they met and talked with other painters and critics. Likewise, Cassatt and Degas regularly exchanged ideas about painting. And there is considerable evidence to suggest that Impressionism was equally an expression of the bourgeois family as a defense against the threat of rapid urbanization and rapid industrialization: domestic interiors, private gardens, seaside resorts. Although Morisot's access to public sites was limited, critics of the time appear not to have ranked the subject-matter of her work in any way differently from that of her male colleagues, though most of them agreed that her presentation of it was more "agreeable."

Work now being done on the social meanings produced by Impressionist paintings suggests a complex relationship between the

new painting and the new middle-class family (to which most of the Impressionists belonged). Moreover, the decision to work *en plein air* and to forego the historical subjects, with the complex studio set-ups and multiple models they required, transformed the relationship between the painter's daily life and his or her studio life; this aspect of Impressionism deserves more study for it profoundly shaped women's relationship to the movement.

During the earlier nineteenth century, academic painters in France often maintained studios in, or near, their homes, but it was the decision to paint scenes of everyday life that moved the easel into the drawing room. Visiting Mme. Manet, Morisot's mother is able to offer a commentary on Manet's painting-in-progress of Eva Gonzales, as the women sit in the studio while Manet works. When Degas sketches in the Morisot garden after lunch, Mme. Morisot provides her own critique; "Monsieur Degas has made a sketch of Yves, that I find indifferent; he chatted all the time he was doing it. . . ." "Your life must be charming at this moment," Edmé Morisot wrote enviously to her sister in 1869, "to talk with Monsieur Degas while watching him draw, to laugh with Manet, to philosophize with Puvis."

Recent publications by Pollock, Tamar Garb, Kathleen Adler, and other feminist art historians have exhaustively documented the work of women Impressionists in relationship to the new painting. Tracing the constraints placed on women like Cassatt, Morisot, Gonzales, and Marie Bracquemond by the social ideologies of bourgeois culture, they have explored the development of their work and isolated their specific contributions to the imagery of Impressionism.

Berthe Morisot numbered Manet, Renoir, Degas, Pissarro, and Monet among her friends. Written about by Emile Zola and Stéphane Mallarmé, among others, she was described in 1877 by the critic for *Le Temps* as the "one real Impressionist in this group." Yet until the appearance of revisionist art histories, and the first major retrospective of her work in 1987, art historians almost exclusively framed her work within the structures of her associations with male painters. There is no evidence that Morisot, or Cassatt, were patronized by their painter friends. Yet they moved in an artistic circle in which the threat of women was never entirely silenced. "I consider women writers, lawyers, and politicians (such as George Sand, Mme. Adam and other bores) as monsters and nothing but five-legged calves," declared Renoir. "The woman artist is merely ridiculous, but I am in favor of the female singer and dancer." Renoir's comment divides women by class and occupation. Working-class women are admired

for entertaining men; professional women with public roles are seen as usurpers of male authority or destroyers of domestic harmony, as they were earlier pictured in Honoré Daumier's lithograph *The Blue Stockings* (1844). The modern feminist movement in France, launched in 1866 by Maria Deraismes and Léon Richer, organized the first international congress on women's rights in 1878, at the height of Impressionism, but Impressionist painting records no traces of this aspect of contemporary life. Nor does it acknowledge the increasing numbers of middle-class women who were seeking training and employment outside the home (in 1866, there were 2,768,000 women employed in non-agricultural jobs in France) for Impressionism presents us with few images of women at work outside the domestic environment.

Morisot and Cassatt's ability to sustain professional lives and negotiate relationships of some parity with their male colleagues was class specific. Morisot's marriage to Manet's brother Eugène, and her family's wealth and continuing support were factors in her success; Cassatt's role as an unmarried daughter carried with it time-consuming domestic responsibilities, but it also provided the secure network of relationships from which she drew her art. Bracquemond (1841–1916), on the other hand, did not come from a prosperous, cultured family and enjoyed no such support. Marriage to the engraver Félix Bracquemond in 1869 provided an introduction into artistic circles, but his jealousy of her work inhibited her development and today she is the least well-known of the women Impressionists.

The Paris of the Third Republic offered a variety of artists' societies and exhibition venues from the official Salon to the Union des Femmes Artistes which, shaped by Rosa Bonheur's example, conducted an annual Salon des Femmes. Women Impressionists related to these exhibitions in varying ways. Gonzales, a friend and pupil of Manet's who had studied at the Chaplin atelier, exhibited only at the official salons. Her *Little Soldier* (1870), influenced by the straightforward realism of Manet's *The Fifer* (1866), was exhibited at the Salon of 1870. Bracquemond and Cassatt exhibited with the Impressionists from 1876. Morisot, on the other hand, was one of the original members of the group, exhibited with them in 1874, and continued to participate in every exhibition save the one held in 1878, the year her daughter was born. She was also included in the group's auction at the Hôtel Drouot in 1875, where her painting, *Interior* (now called *Young Woman With a Mirror*, c. 1875), brought 480 francs, the highest price paid for any painting.

Born in 1841, the youngest of three daughters of a wealthy French civil servant, Morisot and her sister Edmé displayed an early talent for drawing. Their second teacher, Joseph Guichard, was moved to warn Mme. Morisot of the implications of such precocious talent; "Considering the characters of your daughters, my teaching will not endow them with minor drawing room accomplishments, they will become painters. Do you realize what this means? In the upper-class milieu to which you belong, this will be revolutionary, I might say almost catastrophic." Further instruction by Corot and Oudinot strengthened the naturalism of their work and the two sisters exhibited together in four successive salons beginning in 1864. Edmé's marriage to a naval officer in 1869 ended her professional life, a fact she lamented in letters to her sister. Despite the support of her family, and that of her husband Eugène Manet, whom she married in 1874, Morisot's letters frequently express her own hesitations and doubts about her work. "This painting, this work that you mourn for," she wrote to Edmé in 1869 shortly after the latter's wedding, "is the cause of many griefs and many troubles."

Morisot's subjects, like those of Gonzales, Cassatt, Bracquemond, and their male colleagues, were drawn from everyday life. The casual immediacy, lack of sentimentality, and feathery brushstrokes of paintings like *Catching Butterflies* (1873), *Summer's Day* (1879), and *Mother and Sister of the Artist* (1870) meld contemporary subjects with 120 the Impressionist desire to capture the transitory effects of life. Gonzales's *Pink Morning*, a pastel of 1874, is typical of her many 118 interiors with women, while Marie Bracquemond sited many of her 117 works in the family garden, perhaps a secure spot in her troubled life.

Morisot and Cassatt met around 1878, probably through Degas who encouraged Cassatt to exhibit with the Impressionists after the painting she submitted to the Salon was rejected. "At last I could work with complete independence without concerning myself with the eventual judgment of a jury," she later said. "I already knew who were my true masters. I admired Manet, Courbet, and Degas. I hated conventional art. I began to live." Cassatt had been exhibiting for more than ten years when she joined the Impressionist group. Like Morisot, her subjects evolved within the boundaries of her sex and class. Prevented from asking men other than family members to pose, limited in their access to the public life of the café and boulevard, both women concentrated on aspects of modern domestic life. Pollock has ably demonstrated how Morisot's and Cassatt's paintings demarcate the spaces of masculinity and femininity through their spatial

114 *Women Rig(hts)* quilt, 1850s

compressions and their juxtapositions of differing spatial systems. Long considered a painter of unproblematic depictions of mothers and children, Cassatt in fact brought an incisive eye to bear on the rituals and gestures through which femininity is constructed and signified: crocheting, embroidering, knitting, attending children, visiting, taking tea.

116　The intellectual concentration and self-contained focus of Cassatt's depiction of her mother in *Reading "Le Figaro"* (1883) is now understood as relating more directly to representations of the intellectual life of men like Cézanne's *Portrait of Louis-Auguste Cézanne Reading L'Evènement* (1866) than to the history of representations of women. Her painting of her sister Lydia driving a trap, *Woman and Child Driving* (1879), may be unique in late nineteenth-century French painting in depicting a woman doing the driving while a coachman sits idly by; and her many paintings of women and children, though influenced by Correggio's madonnas and children

218

115 Susan MacDowell Eakins *Portrait of Thomas Eakins* 1889

117　Marie Bracquemond *Tea-Time* 1880　　118　Eva Gonzales *Pink Morning* 1874

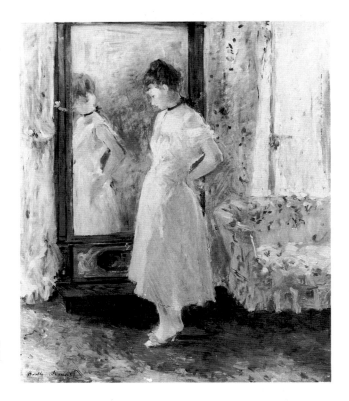

116 Mary Cassat *A Cup of Tea* c. 1880

119 Berthe Morisot *Psyche* 1876

which she greatly admired, are less universalized depictions of maternity than responses to the specific ways that social class is reproduced through the family.

Paintings like Morisot's *Psyche* (1876) and Cassatt's *Mother and Child* (c. 1905) return to the conventional association of women and mirrors. The private daily rituals of women at their toilette were a popular subject for painters in the 1870s and 1880s. Morisot's *Psyche*, with its double-play on the mythological tale of Venus's son Cupid who fell in love with a mortal and on the French term for mirror, or *psyché*, turns on the adolescent woman's contemplation of her own image. Garb and Adler have pointed out that, as there are no representations of men bathing and dressing, we must assume that although symbolic associations with Venus and Vanitas are abandoned, such paintings nevertheless perpetuate notions of vanity as "natural" to women. Yet Morisot's painting is a deeply sympathetic representation of self-awareness and awakening sexuality, while Cassatt's painting emphasizes the role of the mirror in inculcating an idea of femininity as something mediated through observation.

119
121

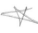

120 Berthe Morisot *Mother and Sister of the Artist* 1870

121 Mary Cassatt *Mother and Child* c. 1905

 The complex and gendered organization of a subject is brilliantly
122 articulated in Cassatt's *Woman in Black at the Opera* (1880). The subject
of the ball, concert, or opera was a popular one among the
Impressionists and one in which event and audience could be
collapsed into the same spectacle. Cassatt, however, suppresses details
of the event in order to concentrate on the figure of a young woman
in black. Intent on the opera, she focuses her glass on the stage. But in
this public world, she herself has become part of the spectacle, and the
object of the gaze of a man in the balcony who turns his glasses on her.

 Issues of public and private space, and amateur and professional
production, also reshaped the design fields during the second half of
the nineteenth century. The new focus on the middle-class home, and
the self-sufficient world which it signified, is central to the reform of
the decorative arts in England and America. Here also, women played
a considerable, if complicated role.

There were markedly more women in the design fields by the 1860s as a result of institutionalized arts education for women. By 1870, Hannah Barlow, trained at the Lambeth School of Art and Design in London and one of the first and most important art pottery decorators, was producing freelance designs for Doulton Pottery. The surge of interest in art pottery was sparked by the efforts of the two most famous ceramic firms in Britain—Minton and Doulton— to produce hand-crafted ware on a large commercial scale for middle-class homes. Commercial production, however, was organized around traditional divisions of labor. While male designers received credit for their designs for china surfaces, the painters, usually female and often working and artisan class, remained anonymous. At the same time, the popularity of china painting as a hobby for upper-class women grew rapidly, becoming an amateur craze after 1870.

A similar situation prevailed in the production of professional secular embroidery. The Royal School of Art Needlework was founded in 1872 to provide suitable employment for gentlewomen and to revive the craft of ornamental needlework. By 1875, with Queen Victoria as its patron and Lady Marion Alford its vice-president, the school's embroidery department was producing crewel work from designs by leaders in the Arts and Crafts Movement like Edward Burne-Jones, William Morris, and Walter Crane.

The first major exhibition of work from the Royal School of Art Needlework took place at the Philadelphia Centennial Exposition in 1876 where its success launched the craft revival in America. Between 1876 and 1891, when new facilities opened at Jane Addams's Hull House in Chicago with an exhibition borrowed from Toynbee Hall—London's center for the application of Arts and Crafts theory to improving the lives of the urban poor—large numbers of women contributed to the reform of design.

At the heart of the Arts and Crafts Movement, as it came to be known in Britain and America, was a pre-industrial medieval ideal of a fusion of the designer and the maker. Revolting against the anonymous authorship and shoddy craftsmanship of industrially produced goods, William Morris dreamed of a socialist utopia in which individuals were not alienated from their labor. The origins of the Movement in Britain lay in nineteenth-century medieval revivals like Gothic, but the spirit of rural craft collaboratives which Morris envisioned belonged to the nineteenth century's idealization of a rural way of life fast giving way to industrialization and urbanization. Wishing to make art available to everyone, and to unite artists,

designers, and craftworkers around the ideals of craftsmanship, good design, and the renewed dignity of labor, Morris dreamed of setting up small workshops and countrywide organizations which could revive dying traditions like lace-making and crewel embroidery.

Morris anticipated a day when the sexual division of labor within the arts would vanish and even domestic life would be equally shared by the sexes. Anthea Callen's *Women Artists of the Arts and Crafts Movement* (1979) elaborates another reality—the gradual evolution of an entirely traditional sexual division of labor within the Movement itself, with women staffing the embroidery workshops and men conducting the business and serving as named designers. Above all, Callen emphasizes, it was men who evolved the Movement's philosophy, articulated its goals, and organized the major aspects of its production.

Women, primarily family or friends of Morris and his colleagues, were involved in the Morris firm itself from the beginning. In the 1850s, Morris and his wife Jane had revived the lost art of crewel embroidery by studying and "unpicking" old examples (an undertaking which has generally been credited to Morris alone). Morris

124 Mary McLaughlin,
Losanti porcelain, c. 1890

then left the production of embroideries in medieval techniques to his
wife and her sister Elizabeth. In 1885, Morris placed his daughter May
in charge of the embroidery workshop. Georgiana Burne-Jones, the
wife of Edward Burne-Jones, was also soon involved in embroidery
and wood engraving while Charles Faulkner's sisters, Kate and Lucy,
painted tiles, executed embroidery and, Kate at least, designed 123
wallpaper. Apart from the embroidery section, however, the Morris
firm employed few women in its workshops and the general
involvement of women was heavily weighted in the direction of
traditionally "feminine" undertakings like lace and needlework.

In addition to embroidery designed by Morris, Burne-Jones, and
Crane and executed at the Royal School of Art Needlework, the
decorative arts displayed at the Philadelphia Centennial Exposition in
1876 included Doulton pottery, Ernest Chaplet's "Limoges" glazes,
and Japanese-influenced proto-Art Nouveau ceramics. Ceramics and
embroidery had the greatest impact on American women.

The American Arts and Crafts Movement was more stylistic than
ideological (with the exception of Gustave Stickley and Elbert
Hubbard's ideal of a return to the simple, community life of pre-

227

125　Maria Longworth Nichols
(Storer), vase, 1897

126　Candace Wheeler, printed silk, c. 1885

industrial America). Yet it provided many middle-class women with a socially respectable and humanitarian outlet for their artistic productions. Candace Wheeler, a wealthy and progressive New Yorker, was impressed by the embroideries of Morris and Company. Struck by the fact that needlework could have financial value, "for it meant the conversion of the common and inalienable heritage of feminine skill in the use of the needle into a means of art expression and pecuniary profit," she envisioned a society similar to the Royal Society of Art Needlework which would organize the sale of needlework, china painting, and other crafts, by women who needed
126　income. Between 1877 and 1883, Wheeler organized the Society of Decorative Art of New York City and worked with Tiffany in setting up a company called Associated Artists, in which she was in charge of textiles, embroidery, tapestry, and needlework, while Tiffany took charge of glass design. By 1883, she was running an enormously successful textile company composed entirely of women and producing printed silks and large-scale tapestries.

　　The display of china painting by members of the Cincinnati Pottery Club at the Philadelphia Centennial Exposition represented the vanguard of a surprising number of American women who went

on to professional careers in the field of art pottery, despite the fact that women's involvement in the Arts and Crafts Movement began with socially prominent women wishing to perfect their skills as an accomplishment.

Among the many visitors to the ceramics display was Mary Louise ¹²⁴ McLaughlin (1847–1939) of Cincinnati, whose experiments with reproducing the underglaze slip decoration on Haviland faience pieces became the prototype for art pottery decoration in the United States for the next quarter century. Women, many of whom began as amateur china painters, were behind the formation of the Newcomb, Pauline, Robineau, and other American art potteries. McLaughlin's rival was Maria Longworth Nichols (later Storer, 1849–1932), who had also begun experimenting with underglaze techniques at the Dallas Pottery in Cincinnati after the Philadelphia Exposition. In 1879, Nicholas Longworth offered his daughter premises of her own and the Rookwood Pottery was founded in the Spring of 1880.

Her family's wealth, her father's long history of artistic patronage, and her own social standing in Cincinnati made possible Nichols's increasing professionalism. Her work was viewed as both morally and artistically charitable for she "follows the traditions of her family in devotion to the wellbeing and advancement of her native place." She herself summarized her objective as "my own gratification" rather than the employment of needy women; perhaps not surprisingly, most of the early Rookwood pieces were produced by amateurs. In 1881, Nichols began the Rookwood School of Pottery Decoration. ¹²⁵ Two years later, she employed her old friend, William Watts Taylor, to take over the administration and organization of the pottery. Taylor, who had little sympathy for lady amateurs, soon closed the school as a pretext for evicting the amateurs, who were then largely replaced by men.

Despite its labor practices, which included a division between designer and decorator that became the model for most art potteries, the Rookwood Pottery played a formative role in the development of art pottery in America, winning a gold medal at the Paris Exposition Universelle of 1889. The full history of women's involvement in the art pottery movement, including the Cincinnati women's training centers and art clubs, remains to be written. What little we know of the careers of Mary McLaughlin, Mary Sheerer, the Overbeck sisters, Pauline Jacobus, and Adelaide Robineau offers tantalizing evidence of a female presence in the American Arts and Crafts Movement which extended to other areas of production as

well. Intimately connected with women's roles as domestic and social reformers, the art pottery movement also represented a move by American middle-class women to professionalize the decorative arts.

By the time the World's Columbian Exposition (or World's Fair) opened in Chicago in 1893, American women had evolved a new sense of identity and purpose. Goals and strategies varied widely among feminists, and there were still many women not involved in the struggle for equal rights and the vote, but representatives of all groups came together to organize a woman's building intended to prove that women's achievements were equal to those of men. "The World's Columbian Exposition has afforded woman an unprecedented opportunity to present to the world a justification of her claim to be placed on complete equality with man," stated the preface to the official edition of *Art and Handicraft in the Woman's Building*, edited by Maud Howe Elliott.

The direction of the Woman's Building was in the hands of Mrs. Palmer Potter, a wealthy Chicago art collector, and her 117-member Board of Lady Managers. Palmer herself did not advocate equal rights for women, but her belief in women's potential was characteristic of

mainstream middle-class feminism at the time. Although women had made great strides in education, art training, and social organizing, they still lacked the vote. And they remained caught between the demands of careers and motherhood, struggling continually against the limitations placed on them by the social category of femininity, against the trivializing of their work in relation to that of men, and against the mythologizing of its "otherness."

Elliott's description of the Woman's Building, designed by Sophia G. Hayden, a young graduate of the Massachusetts Institute of Technology architecture and design program, expressed her own acceptance of the ideology of separate spheres; "At that time [the first half of the nineteenth century] the highest praise that could be given to any woman's work was the criticism that it might be easily mistaken for a man's. Today we recognize that the more womanly a woman's work is the stronger it is. In Mr. Henry Van Brunt's appreciative account of Miss Hayden's work, the writer points out that it is essentially feminine in quality, as it should be. If sweetness and light were ever expressed in architecture, we find them in Miss Hayden's building." Sweetness and light are not, however, the criteria generally applied to architecture and Hayden's building, in fact, was admirably suited to the Neoclassical Beaux-Arts style which dominated the Fair's buildings.

129

129 Sophia Hayden, Woman's Building at the World's Columbian Exposition, Chicago, 1893

The tensions underlying Elliott's and Van Brunt's comments were felt throughout the exposition, nowhere more keenly than in the Woman's Building. In 1889, tension was already evident between the Woman's Department, which had as one of its goals the building of a women's exhibition space, and the Queen Isabella Society, a suffragist group which did not want a segregated women's exhibition. The divisions between the various factions involved in the Woman's Building make a complex chapter in the history of late nineteenth-century American feminism. Nevertheless, women's creative presence was more powerfully felt in Chicago in 1893 than at any other time in the country's history.

The Board of Lady Managers had solicited historical and contemporary artifacts from around the world with the intention of demonstrating that women "were the originators of most of the industrial arts," having been the original makers of household goods, baskets, and clothing. Ethnographic displays sent by the Smithsonian Institution documented women's work in the form of embroidery, textiles, and basketry from American Indian, Eskimo, Polynesian, and African tribes. Women's contributions to industries from sheepshearing and raising silkworms to patents for household aids were included and the Women's Library, organized by the women of New York, included seven thousand volumes written by women around the world. Frederick Keppel, a well-known print dealer, provided 138 prints by women etchers and engravers from the late Renaissance to the present, including Diana Ghisi, Elisabetta Sirani, Geertruid Roghman, Maria Cosway, Marie de Medici, Angelica Kauffmann, Caroline Watson, Marie Bracquemond, Rosa Bonheur, Anna Lea Merritt, and Mary Cassatt. Visitors to the Woman's Building passed beneath murals of *Primitive Woman* and *Modern Woman* executed by Mary McMonnies and Cassatt.

Some professional women continued to resist exhibiting alongside amateurs in a building that included everything from household goods to embroidery, and others wished to exhibit with men in the Fine Arts Building. The result of the segregation and the wide range of amateur and professional production, wrote one critic, was a "gorgeous wealth of mediocrity." Although the Metropolitan Museum declined a request to send Bonheur's *Horse Fair*, the fine arts exhibition in the Woman's Building included works by respected artists like Cecilia Beaux, Vinnie Ream Hoxie, and Edmonia Lewis, as well as cat paintings by a seventy-two-year old Belgian artist named Henrietta Ronner and two paintings of dogs by Queen

Victoria. Elizabeth Thompson's *Quatre Bras* and Anna Klumpke's
Portrait of Miss M.D. were displayed, along with busts by Anne
Whitney and Adelaide McFayden Johnson of prominent women in
the suffrage, women's, and temperance movements. The largest
exhibitions at the Fair were from women's craft associations in
Britain. Rookwood Pottery and the Cincinnati Pottery Club were
also well represented.

In the end, despite the unevenness of its displays and the critics'
argument that mediocrity was the only possible result when
"femininity was the first requisite and merit a secondary consider-
ation," the Woman's Building overwhelmed visitors by the sheer
magnitude and ambition of its displays. The building summed up
women's past achievements, and made visible the multiple ways they
had renegotiated the ideology of separate spheres, but the future
belonged to a new generation and a new century. Mrs. Palmer's
speech at the opening of the building did not ignore the fact that, by
1893, radical American women perceived the ideology of separate

spheres as a male invention and a male response to feared competition in the work place.

By 1893, a new female heroine had emerged in the popular literary imagination, though her presence is barely recorded in painting. The novels of Grant Allen, Thomas Hardy, and George Gissing present female heroines who were in direct conflict with the traditional values of conservative society. Flaunting convention, the New Woman drinks, smokes, reads books, and leads a healthy athletic life. The photographer Frances Benjamin Johnson (1864–1952) burlesqued her delightfully in a self-portrait photograph and she is the subject of Albert Morrow's 1897 poster, *The New Woman*, for *Punch*. Also in 1897, the *Ladies Home Journal* serialized six illustrations by Alice Barber Stephens which collectively outlined the facets of new womanhood. Along with *The Woman in Religion, The Woman in the Home*, and *The Beauty of Motherhood*, they included *The Woman in Business, The Woman in Society*, and *The American Girl in Summer*. By 1900, feminists were demanding not just voting rights for women, but their right to higher education and the right to earn an income, and the modern woman had appeared.

131 Albert Morrow *The New Woman* 1897

132 Frances Benjamin Johnson *Self-Portrait* c. 1896

Modernism, Abstraction and the New Woman, 1910–25

Abstraction in painting and sculpture developed simultaneously in a number of European capitals during the first decade of this century. Its course, inextricably bound up with the formal developments of Post-Impressionism and Cubism, and with a desire to break with nature and infuse the resulting art with a profound spiritual content, has been extensively traced. In this chapter, I want to discuss several less often explored aspects of the development of abstraction in the early twentieth century. First, there is the extent to which its visual language derives from that of the decorative arts, particularly textiles, and why. Second, how did the fashion designs that resulted from geometric abstraction, when worn, come to signify modernity and, at the same time, to obscure very real kinds of social change that would ultimately erode the ideal of individual artistic freedom so prized by modern artists at the beginning of this century? Finally, how are we to view the unusual fact that women functioned both as producers of this new visual culture and as the signifiers of its meaning?

Between 1863, when Baudelaire situated fashion at the heart of the modernist imperative ("Be very sure that this man [Constantin Guys] makes it his business to extract from fashion whatever element it may contain of poetry without history, to distill the eternal from the transitory") and 1923, when the Russian avant-garde artist Alexandra Exter defended the Industrial Dress ("The rhythm of modern life demands a minimum loss of time and energy. . . . To present day fashions which change according to the whims of the merchants we must counterpose a way of dressing that is functional and beautiful in its simplicity") fashion has played a complex, contradictory, and sometimes quixotic role in defining the attitude toward the art which we now think of as modernist.

Baudelaire discerned the signs of modern life in "the ephemeral, the fugitive, the contingent," locating them in individual style and gesture, and opposing them to the eternal (by which he meant the classical tradition which underlay French official art of the mid-nineteenth century). More recently, art historians have argued for a

view of modernity as more than just the desire to be "of the time." The emergence of new kinds of painting in late nineteenth-century France has been tied to the concurrent development of new sets of myths about modernity shaped by the new city of Paris under the Second Empire. Central to the new territory of modernity were "leisure, consumption, the spectacle and money." Modernity is both linked to the desire for the new that fashion expresses so well, and culturally tied to the development of a new visual language for the twentieth century—abstraction.

Art Nouveau, an international style in the decorative arts characterized by stylized linear surface motifs derived from natural forms, arrived in Germany in 1896 with Hermann Obrist's exhibition of thirty-five monumental embroideries at a Munich gallery. By the turn of the century, the Arts and Crafts Movement pervaded all aspects of Munich's artistic life. The new aesthetic demanded a new relationship between art and life, a sanctioning of the present, and a merging of the fine arts and crafts. For artists like Wassily Kandinsky, who arrived in Munich in 1896, the move toward an abstract formal language carried with it an implicit threat—that of "decoration" devoid of content. "If we were to begin today to destroy completely the bond that ties us to nature, to steer off with force toward freedom and to content ourselves exclusively with the combination of pure colour and independent form," warned Kandinsky in *Concerning the Spiritual in Art* (1910, published 1912), "we would create works that would look like a geometric ornament, which, grossly stated, would resemble a tie, a carpet."

There is no doubt both of the influence of Jugendstil or Art Nouveau design on early Kandinsky paintings like *Moonrise* (1902), and of the early critical success of those works of his which were "ornamental" or "decorative." In her study of Kandinsky in Munich, Peg Weiss has located the artist's gradual move toward abstraction in the convergence of strong Jugendstil tendencies embracing abstract ornamentation with a symbolic move toward inner significance and spiritual revolution influenced by Symbolist poetics.

Throughout the Munich period, Kandinsky continued to work both in painting and in crafts. In 1904, he had become actively involved in The Society for Applied Art in Munich and the catalogue for the 1906 Salon d'Automne lists seven items of craft designed by him. Another member of the Society was Margarethe von Brauchitsch, a talented craftswoman whose embroidery designs had attracted notice at the World Exposition in Paris in 1900. Brauchitsch

133 used highly stylized motifs from nature, as well as fantastic, abstract "improvisations" in her embroidery designs. Examples from 1901 to 1904 show a close relationship with work of the Wiener Werkstätte in Vienna, a design collaborative founded in 1903. Weiss identifies her greatest influence on Kandinsky, however, as coming through her participation in the Reform Dress Movement.

By the end of the nineteenth century, the issue of reforming women's dress had become one aspect of wider feminist concerns. The bustles, whalebone stays, and tight lacings so fashionable in the 1880s had come under attack in progressive circles as criminal in their manipulation and obstruction of female movement and breathing. In Britain in the 1890s, dress reform was often linked to Socialism, though some historians have argued that by that date reform dress had become more an issue of taste than politics. The new "healthy" styles, however, indicate a shift from earlier notions of clothing as indicating class and occupation to a more modern preoccupation with clothing 134 as a means of creating identity. Kandinsky's experiments in fashion design also take into account the practical goals of the reform movement. His designs are important in identifying women's fashion as one of the arenas within which modernist artists, determined to free themselves from representation, explored new kinds of meaning.

Paintings by Kandinsky from the Munich period were influenced by Russian folk art, Tunisian abstract geometric motifs, and, through his companion Gabriele Münter's intervention, Bavarian glass painting. Münter (1877–1962) had come to Munich in 1901 in search of training. Denied access to the Munchener Akademie, women were forced to seek private instruction or attend the studios of the

Kunstlerinnenverein, the association of professional women artists. Quickly bored with academic teaching, Münter moved to the Phalanz School where Kandinsky encouraged her. The couple first visited Murnau in 1908 with the painters Jawlensky and Marianne Werefkin, settling there the following year. It was in Murnau that both took the decisive step toward greater abstraction. Reducing form to simplified color shapes bounded by dark contour lines, Münter synthesized the expressiveness of Fauve color with an ordered formal organization often based on pyramidal forms. Her *Boating* 128 (1910) replaces the informality of Impressionist paintings on the theme with a tightly structured and hierarchical ordering in which Kandinsky dominates the group compressed into the shallow space of the boat. Against the striking backdrop of the Murnau landscape, Kandinsky assumes a commanding role in the composition while Münter rows the boat. Access to his image is controlled by Münter's position at the bottom of the canvas; we see him as she sees him.

Münter's *Portrait of Marianne von Werefkin* (1909) situates the 135 figure in her multicolored flower hat and violet scarf against a striking gold background. The simplification of the figure into blocks of color, the pyramidal form, and the replacement of modelling by a

135　Gabriele Münter *Portrait of Marianne
von Werefkin* 1909

134　Wassily Kandinsky, dress design, c. 1904

heavy black outline are characteristic of her Murnau paintings with their debt to Bavarian glass painting. Münter, not Kandinsky, first collected examples of this folk tradition and both artists subsequently experimented with pure colors on the back sides of plates of glass. While Münter retained an interest in the bold patterns and broad planar simplification of this painting, the translucent colors and flat simple shapes provided Kandinsky with a new formal syntax. As he moved toward pure abstraction between 1909 and 1912, these new ways of thinking about surface plane became the carriers for the spiritual content which he believed would ultimately define the "new" art and remove it from the domain of the decorative.

During these same years, artists in England and in France were also abandoning naturalism in favor of stylized abstractions. In London, the major critical and theoretical voice was that of Roger Fry, soon identified with the painters and writers of the Bloomsbury circle. The
127 work of Vanessa Bell (1879–1961), Roger Fry, Duncan Grant, Wyndham Lewis, and others associated with Fry's Omega Workshops (an experiment in home design by artists) was equally concerned with fusing a pictorial language derived from the decorative arts with a new content associated with the formal lessons Fry deduced from Post-Impressionism. Between 1910 and 1912, Fry organized two major Post-Impressionist exhibitions in London out of a desire to attack the philistine tastes of the British middle class. In his introduction to the catalogue for the first exhibition, which opened at the Grafton Galleries in the winter of 1910, he noted; "There comes a point when the accumulations of an increasing skill in mere representation begin to destroy the expressiveness of the design. . . ."

Within a year of the 1910 exhibition, Bell and Grant had begun their experiments in decoration with lacquered boxes, introducing geometric patterns derived from mosaic and tile work. In May 1913, Fry opened the Omega Workshops in Fitzroy Square, London. As indebted as this collaborative experiment in modern design was to the theories of Post-Impressionism, its closest models were not the Arts and Crafts Movement (for Fry staunchly rejected the socialism and architectural orientation of that movement), but the Wiener Werkstätte and the experimental fashion and design studios of Paris which Fry had visited in 1911. Since 1910, Fry had been building a coherent theory of aesthetics upholding the supremacy of form over narrative content. The publication of Clive Bell's *Art* in 1914 with its emphasis on "significant form" also promoted an aesthetic in which design and color alone were to carry content.

137 Vanessa Bell *Cracow* 1913

136 Firescreen designed by Duncan
Grant and embroidered by Lady Ottoline
Morrell, 1912

The Omega Workshops became a meeting place for like-minded artists and gave them a livelihood through designing and decorating fabrics, furniture, pottery, and other small items. Their innovative significance lay in the fact that they were modelled on *haute couture* fashion experiments in Paris and, like the Arts and Crafts Movement in the previous century, they sought to challenge the Victorian distinction between high and low art, or between art and craft. As no contracts were given to participating artists, their products were tacitly understood to be privileged, distinct from other forms of labor and indistinguishable from "art." That many of the workshop's patrons were wealthy women—Lady Desborough, Lady Curzon, Lady Ottoline Morrell, Lady Cunard, Lady Drogheda—the same women who patronized the fine arts and the couture houses, set up a relationship between class and modernity that had far-reaching implications.

Omega designs for curtains, bedspreads and boxes were prominently displayed at venues like the Daily Mail Ideal Home exhibition and the Allied Artists exhibition. Typical of the items shown were 136 screens with stylized nearly abstract motifs designed by Grant and Bell and embroidered by Morrell, and abstract printed linens like *Cracow*, designed by Bell in 1913. Many of the designs were based on 137

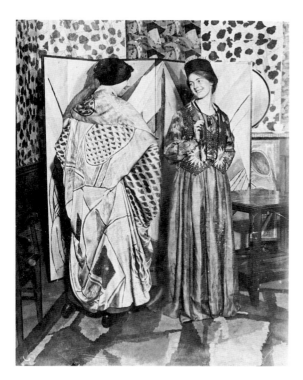

138 Winifred Gill and Nina
Hamnett modelling dresses at the
Omega Workshops, c. 1913

oil paintings. Like the early abstractions of Kandinsky and Mondrian, those of Bell and Grant were derived from nature; the process of formal simplification and abstraction resulted in tightly structured compositions which replaced anecdotal content with absolute aesthetic values. The exaggerated distinctions which art historians have made between Bell's easel paintings and her decorative work has obscured the significant role of decoration in the development of the
127 structure and lyrical and sensuous color harmonies that underly her later figurative works.

The eight works which Bell exhibited in "The New Movement in Art" at the Mansard Gallery in London in 1916 included four abstract paintings closely related to her current work in fabrics. The previous year, she had taken charge of a new program introducing dressmaking into the Omega. The smock-like simplicity of dresses modelled
138 by the painters Winifred Gill, Bell and Nina Hamnett recall earlier Reform Dress styles. The Omega experiment in dress design was not a success and few sold, perhaps because the designs were too exotic for

the Omega's clientele. Even Bell's sister, Virginia Woolf, was shocked by the bold colors and patterns; "My god! What clothes you are responsible for! Karin's clothes wrenched my eyes from the sockets— a skirt barred with reds and yellows of the violent kind, a pea-green blouse on top, with a gaudy handkerchief on her head, supposed to be the very boldest taste. I shall retire into dove color and old lavender, with a lace collar and lawn wristlets."

During the years when Omega was most active, ease of movement and primacy of color as expressive medium also characterized Sonia Delaunay's work in both painting and decoration. Delaunay (1885– 1974) , a Russian artist who moved to Paris in 1905 and in 1910 married the Cubist painter Robert Delaunay, synthesized Post-Impressionism, early Matisse, and Russian folk art in paintings like the *Portrait of Tchouiko* (1906) and *Young Finnish Woman* (1907). Like her husband, Delaunay soon became firmly convinced that modernity could best be expressed through a dynamic interplay of color harmonies and dissonances which replicated the rhythms of modern urban life. Robert Delaunay's *Red Eiffel Tower* of 1911 derived its interlocking facets and dynamic forms from Picasso's Cubist paintings of the same years, and its highly keyed palette from Fauve painting. Sonia Delaunay's first piece of decorative art, and first completely abstract work, however, was a pieced quilt influenced by 139 Russian peasant designs and made shortly after the birth of her son in 1911. It developed from many sources, including Delaunay's knowledge of early Cubist painting. She later attributed her move away from painting to a desire to put her husband's career first; "From the day we started living together, I played second fiddle and I never put myself first until the 1950s."

Delaunay's work with textiles and embroidery encouraged her to break down forms and emphasize surface structure. She quickly began designing book covers, posters, lampshades, curtains, cushion covers, and other objects for her home. Throughout 1912, while Robert Delaunay experimented with a theory of simultaneity based on the use of light to unify contrasting colors, Delaunay produced objects through which the theory was submitted to the play of actual light. Her painting of 1912, *Simultaneous Contrasts*, reveals an interest 142 in the dynamics of surface design which then became her primary concern, whereas Robert Delaunay's *Simultaneous Windows* of the same year reflects his consuming interest in the problem of spatial illusion. In retrospect it is perhaps significant that Robert Delaunay, who worked so closely with her, was convinced that it was through

textiles that Delaunay learned to use color freely, later commenting of her painting that, "The colors are dazzling. They have the look of enamels or ceramics, of carpets—that is, there is already a sense of surfaces that are being combined, one might say, successively on the canvas."

Dissatisfied with the inherently static qualities of painting as a medium, during the Summer of 1913 Delaunay began to make simultaneous dresses, in reaction against the drabness of current fashions. Their patterns of abstract forms were arranged both to enhance the natural movement of the body and to establish a shimmering movement of color. The poet Blaise Cendrars's remark of 1913, "On her dress she wears her body," suggests that the female body itself was being perceived as an important signifier for modernity. In the twentieth century, as we shall see, it was fashion which translated the principles of abstraction to, and defined modernity for, a broad public. At the same time, the production of art as commodified object is linked to the commodification of the female body after the First World War.

News of Delaunay's simultaneous dresses spread swiftly. According to Cendrars, someone, "sent a telegram to Milan, describing our general get-up and, precisely, and in detail, Mrs. Sonia Delaunay's 'simultaneous dresses.' Milan spread this information through the world as a Futurist manifestation, so that our behavior, gestures, and harlequin costumes . . . were known to the entire world, particularly to the avant-garde, which wanted to be up with the latest Paris fashions. Our extravagances especially influenced the Moscow futurists, who modelled themselves after us."

By 1913, the Italian Futurists were exploiting the idea of clothing as a signifier for revolutionary modernism. Futurist attitudes toward feminism, however, were deeply compromised from the beginning by their cult of virility. "We want to glorify war—the only cleansing act of the world—militarism, patriotism, the destructive act of the anarchists, beautiful ideas which kill, and contempt of women," proclaimed the Futurist manifesto of 1909. "We want to destroy museums, libraries, to combat moralism, feminism and all such opportunistic and utilitarian acts of cowardice."

Giacomo Balla, the movement's foremost theorist, proclaimed dress as an element in a philosophy of dynamic change and novelty (now identified with avant-garde modernism), in which Futurism was to move out of the gallery and museum and into the street, but most Futurist costume design was for male dress and was conceived as an assault on social conventions. Balla's 1914 manifesto, "The Antineutral Dress," proposed replacing the drabness of men's suits with a "living plastic complex." "Futurist clothes," he commented, "will be dynamic in form and colors." Balla's manifesto owes much to Delaunay's pioneering experiments, and the designs which resulted, in both Paris and Milan, marked the beginning of a new wave in fashion which rose to general popularity a decade later. Intervening, however, were both the First World War and the October Revolution of 1917.

Nowhere is the defining of modernity more firmly rooted in social idealism than in the Russian avant-garde to which Cendrars referred. Russian art in the first decade of the twentieth century was divided between artists like Vladimir Tatlin, Alexandra Exter, Liubov Popova, and Kasimir Malevich who welcomed European innovations in the arts, and those like Natalia Goncharova and Mikhail Larionov who believed that only by reference to their own cultural traditions could Russian artists express ideas of any importance. The unusual importance of women in the Russian avant-garde—where

they were treated as full equals—grew from nineteenth-century radical political movements in which women of the intelligentsia were motivated by a strong desire to serve the people, but their lasting success as producers of the new art owes much to the breakdown of traditional distinctions between the fine and applied arts.

Russian art in the years before the Revolution of 1917 developed along two broad paths. While some artists worked primarily in two dimensions, others emphasized construction, texture, and design. Neoprimitivism, Cubofuturism, Rayonism, Suprematism, and Constructivism coexisted and artists looked to both Paris and Moscow for support. The ballet impresario Serge Diaghilev's exhibition of younger Russian artists at the Salon d'Automne in 1906 brought the painter Mikhail Larionov to Paris, and his long-time companion Natalia Goncharova (1881–1962) exhibited first in the same exhibition. Her Neoprimitivist work was succeeded by the Rayonist paintings which began before 1914 when she left Russia to work with Diaghilev's Ballets Russes in Paris. Paintings like *Rayonist Garden: Park* (c. 1912–13) fuse Fauvism, Cubism, and indigenous Russian Decorative-Primitivism in the refracted rays of light which scatter color across the canvas surface.

140

140 Natalia Goncharova
Rayonist Garden: Park
c. 1912–13

141 Nadezhda
Udaltsova *At the Piano*
1914

In 1912, Larionov and Goncharova participated in both the second
Blaue Reiter exhibition in Munich and in Fry's second Post-
Impressionist exhibition in London. That same year, Larionov's
manifesto, "The Donkey's Tail," published in Moscow, proclaimed
the independence of his group from Western art values and their
commitment to developing a Russian national art. The first Rayonist
exhibition included Goncharova, Larionov, and Malevich, whose
abstract work was greatly influenced by that of Goncharova, plus
examples of children's art, sign painters' work, and traditional
popular woodcuts (*luboks*).

The work of Tatlin, Exter, Popova, and Nadezhda Udaltsova, on
the other hand, was more closely tied to Cubism. Tatlin's 1913
Counter-reliefs, his first experiments with real materials in real space,
originated after a visit to Picasso. Udaltsova (1885–1961), after
attending the Académie de la Palette and receiving instruction from
the Cubist painters Metzinger, Le Fauconnier, and Segonzac in Paris
in 1911, returned to Russia in 1913 and worked with Popova in
Tatlin's Moscow studio where they fused Cubist principles with
Russian folk art and used letters and fragments of words in collages,
paintings, and constructions. Exter (1884–1949), an early associate of 141

247

David Burliuk (whose manifesto, "A Slap in the Face of Public Taste" (1912), advocated the principles of disharmony, dissymmetry, and disconstruction), met the Cubists in Paris in 1912. By 1913, her collages were producing effects of expansive space through wedges of flat, crude color.

143

Futurist costume entered the Russian vocabulary in exhibitions, lectures, and demonstrations by Burliuk, Olga Rozanova, Larionov, Goncharova, and other Cubofuturists. Marinetti's Futurist tour of Russia in 1914 led Exter, Rozanova, and Archipenko to participate in the "Free Futurist Exhibition" at the Galleria Sprovieri in Rome in 1914. The years from 1914, when Russia was forced into intellectual and cultural isolation, to 1917 are the zenith of the avant-garde movement in Russia, as many artists who had been living abroad— among them Marc Chagall, El Lissitsky, and Kandinsky—were forced to return home. The leading artists shared a belief in the coming political revolution and in the need to produce a new art for the people. Their sources lay in Russian peasant art and in European modernism, but their vision was utopian. Their search for a new aesthetic language compatible with the modern reality of industrializing Russia led them to anti-illusionistic, two-dimensional compositions in which the surface plane and/or painterly texture became the focus.

Popova (1889–1924), the daughter of a wealthy family, first studied painting in Moscow. She spent the winter of 1912–13 in Paris where she worked under Le Fauconnier and Metzinger at La Palette and met Udaltsova. Also influenced by Futurism, her reliefs from around 1918 develop their abstract idiom from what she called "the painterly architectonics," interpreting Cubism and Futurism as "the problem of form" and "the problem of the movement of color." "Texture is the content of painterly surfaces," she wrote in 1919.

149

While Popova emphasized color and texture, other painters, such as Rodchenko and Exter, emphasized line which they considered the pictorial counterpart of rhythm. Exter's *Line-Force Constructions* of 1919–20 develop a logical system of lines in relation to each other that was eventually most fully realized in her innovative costume and theater designs of the 1920s. But it was the needs of a revolutionary society which forced artists to abandon painting in favor of utilitarian applications of the principles of modernism.

After the Revolution, several art schools were combined to form the SVOMAS (Free State Art Studios). Since established artists were often opposed to the goals of the Revolution, the way was opened for

young avant-garde artists to enter the state educational system. Rozanova (1886–1918), a friend of Malevich, turned to Suprematism following Cubist and Futurist experiments. Believing that art belonged to the proletariat and should reflect the essential elements of industrial and urban life, she founded in 1918 an Industrial Art Section of IZO Narkompros (the Visual Arts Section of the Commissariat for Public Education), which she headed with Rodchenko. Although she died suddenly of diphtheria in November of that year, her work set the tone for what was to follow.

By 1921 Productivism—the belief that art should be practised as a trade and that the production of well designed articles for everyday use was of far greater value than individual expression or experiment—dominated the teaching of art in Russia. In that year, Popova embraced the utilitarian position of Constructivism along with Rodchenko and Varvara Stepanova (1894–1958), with whom she later designed textiles. In September 1921, Rodchenko, Stepanova, Alexander Vesnin, Popova, and Exter organized an exhibition called "5 × 5 = 25" to display the results of their past year's work in "laboratory art." The catalogue announced the "end of painting" as an expressive medium and in the "Productivist Manifesto" which accompanied the exhibition Stepanova and Rodchenko called for artists to serve the public. Textile and dress design were central in the Productivist desire to fuse completely the artistic and technological aspects of production, but before examining this aspect of Russian art in the 1920s it is important to consider what had happened in Western Europe in the intervening years.

Sonia and Robert Delaunay had spent the war years in Spain and Portugal. It was while in Barcelona in October 1917 that they heard the news of the Russian Revolution, an event which signaled the end of the income from Sonia's wealthy family on which they had relied. Nevertheless, they celebrated the change. Delaunay was resolved to find a market for her creations in the applied arts, so they moved to Madrid to earn a living. Her first opportunity came through Diaghilev, whose ballet sets and costumes were instrumental in combining visual art and theatrical design. Invited to design costumes (while Robert Delaunay designed the sets) for *Cléopâtre*, one of the 144 most successful ballets in the company's repertory, Delaunay produced a two-dimensional geometric ordering of discs and boldly frontal geometric designs ideally suited to the angular processional quality of the ballet's movements. Lengths of fabric wrapped around the human form animated the body of the dancer. Through

142 Sonia Delaunay *Simultaneous Contrasts* 1912

Diaghilev, Delaunay was introduced to prominent members of Spanish society and, with backing from an English bank, she soon opened a small shop, the Casa Sonia, which introduced modern design to Spain.

Returning to Paris in 1921, the Delaunays quickly became absorbed into the Dada milieu there. They were accepted by the nihilistic Dada group largely because, due to Delaunay's integration of painting and decoration, they lived their art in every aspect of their lives. Moreover, they shared their commitment to breaking free from the static quality of painting by applying the language of abstraction as widely as possible with other Dada collaborators. Jean Arp and his wife, Sophie Taeuber-Arp (1889–1943), had been active participants in Zurich Dada since the founding of the Cabaret Voltaire in 1916; Raoul Hausmann and Hannah Höch (1889–1978), whose pioneering experiments with photomontage helped sever the photograph from

143 Alexandra Exter *Composition* 1914

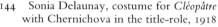

144 Sonia Delaunay, costume for *Cléopâtre*
with Chernichova in the title-role, 1918

145 Hannah Höch *DADA-Dance*
1919–21

its existence as an autonomous artifact and emphasize its role in
ideological production, were members of Berlin Dada. Höch's
145 *DADA-Dance* (1919–21) juxtaposes machine parts with a female
dancer and a model who is elegantly dressed and posed but whose
head has been replaced by that of a Black. Violent distortions of scale
and a rejection of conventionalized femininity undermine the
commodification of the idealized female body and its relationship to
mass-produced goods. In collages like *The Tailor's Flower* (1920),
forms signifying abstraction are set uneasily next to the cultural signs
of femininity so that gender and art are shown as social productions.

 The emergence of an abstract geometric style in Taeuber-Arp's
work around 1915 reflected her interest in the work of Kandinsky,
Robert Delaunay, and Paul Klee, but probably derived its horizontal/
vertical syntax from her training in textiles. She had specialized in
textiles at the schools of applied arts in Saint Gallen and Hamburg, and
she was a Professor of Textile Design and Techniques at the School of
Applied Arts in Zurich from 1916 to 1929. Working between media,
she explored the relation of color and form in the belief that there was
little distinction between ornamentation and "high art" when the
"wish to produce beautiful things—when that wish is true and

profound—falls together with striving for perfection." She and Jean Arp began working collaboratively in 1915, producing paintings, collages, embroideries, and weavings with shared motifs, like a collage and the embroidery based on it which date from 1916. 146–7

Working with paper, cloth, embroidery, and other materials enabled Arp and Taeuber-Arp to free themselves from pictorial traditions. In an introduction to the catalogue for an exhibition, "Modern tapestries, embroideries, paintings, drawings," held in Zurich in 1915 Arp had written; "These works are put together from lines, planes, forms, and colors. They try to approach the unfathomable and eternal values above mankind. They are a reaction against egotistical human concerns. They show hatred for the shamelessness of human existence, a hatred of paintings as such."

The Dada contempt for traditional painting as a static, materialistic form, unable to communicate the vitality of modern life, found a sympathetic spirit in Delaunay, but it was her employment of a variety of media and her liberal attitude to breaking down the distinction between art and craft that probably inspired the Dadaists. The poet René Crevel left a moving description of the vitality of the Delaunay apartment: "At the entrance . . . there was a surprise. The walls were covered with multicolored poems. Georges Auric, a pot of paint in one hand, was using the other to paint the notes of a

146 Jean Arp *Paper Cut with Paper Cutter* 1918

147 Sophie Taeuber-Arp *Vertical Horizontal Composition* c. 1916–18

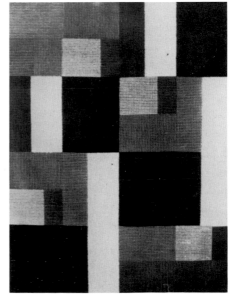

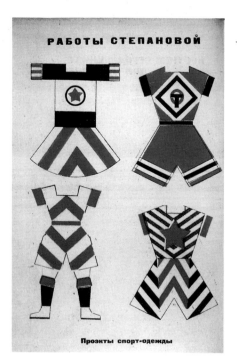

РАБОТЫ СТЕПАНОВОЙ

Проэкты спорт-одежды

148 Varvara Stepanova *Designs for Sports Clothing* 1923

149 Liubov Popova *Painterly Architectonics* 1918

marvelous treble clef. Beside him Pierre de Massot was drawing a greeting. The master of the house invited every new guest to go to work and made them admire the curtain of gray crêpe de Chine on which his wife, Sonia Delaunay, had through a miracle of inexpressible harmonies deftly embroidered in linen arabesques the impulsive creation of Philippe Soupault with all his humor and poetry. . . . After five minutes at the home of Sonia Delaunay no one is surprised to find that it contains more than a certitude of its happiness. . . . you enter the home of Sonia Delaunay and she shows you dresses, furniture, sketches for dresses, drawings for furniture. Nothing that she shows you resembles anything you have ever seen at the couturiers or at furniture displays. They are really new things. . . ." In 1922, Delaunay began producing embroidered and simultaneous scarves for sale. A maquette for "Curtain-Poème" by Soupault in 1922 led to a series of "dress/poems" on which colors and words were brought into everchanging relationships through the movement of the body. Dada poets wrote poems for Delaunay's creations and Tzara, Crevel, and Louis Aragon all wore clothes she had designed and made.

254

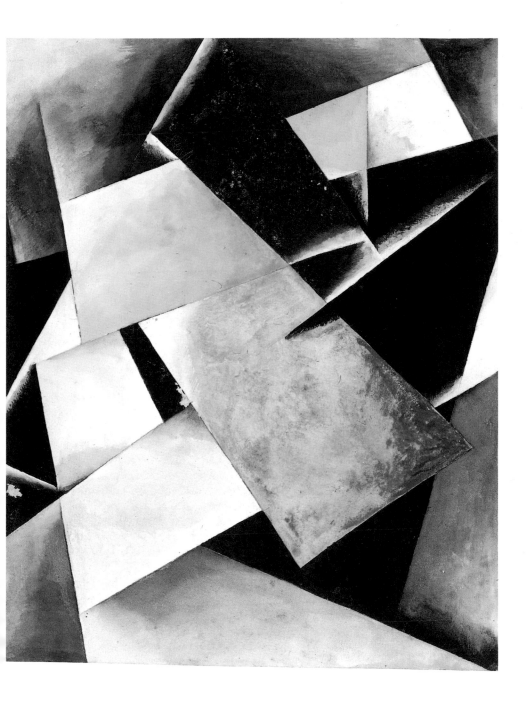

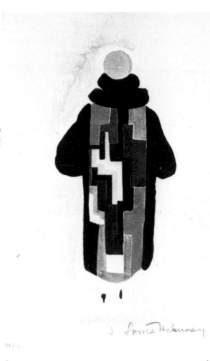

150 Sonia Delaunay,
appliquéd coat, 1920s

In early 1923, the Union of Russian Artists in Paris organized an evening of dance, performance, and exhibition at the Bal Bullier (a popular dance hall frequented by avant-garde artists). The participants included Delaunay, Goncharova, Larionov, and Fernand Léger. Delaunay designed a booth of modern fashions which displayed her scarves, ballet costumes, embroidered vests, and coats. It was her first presentation of clothing and design in a fully unified exhibition setting, and the first of many fancy dress events of the 1920s in which artists and socialites joined, fusing production and consumption of the new image of the modern. Later in 1923, Dada artists in Paris restaged Tzara's play *Le Coeur à Gaz*. Costumes by Delaunay exhibited the same frontal abstract and geometric conception soon to be displayed on the backs of fashionable society women in Paris who bought her appliquéd coats. So successful were these designs that they were purchased by architects like Gropius, Mendelsohn, and Breuer for their wives, and by actresses like Gloria Swanson, whose purchase spread the new fashion to America.

Delaunay's designs were also well represented in an evening organized by the collector Laurent Monnier the following year at the Hotel Claridge. In a parade of fashions from past, present, and future,

256

her designs represented the style of the future. Poems by Jacques Delteil accompanied the models and summarized Delaunay's ideals; "Immobility is dead and this is the reign of movement/ Movement is born at the heads to spread among the stars/ The circular colored movement which is at the center of everything/ which is everything/ And look, a dress is a dance."

The evolution of Delaunay's fashion and textile designs, which by 1923 were being commercially produced, reflects both the French textile industry's attempt to recover quickly from the slump caused by the War by identifying their designs with contemporary avant-garde art, and new ways of thinking about the body and display. Avant-garde spectacles like Dada performances helped break down earlier notions about clothing as a cover for the body, replacing them with an image of the body as a fluid screen, capable of reflecting back a present constantly undergoing redefinition and transformation.

Although Delaunay's designs included costumes worn by male artists, their commercial development was entirely directed toward women's wear. The avant-garde myth that these transformations of the relationship between the body and modern life were prompted by the acts of unique individuals was soon challenged as competing ideologies began to use images of the body as signifiers for other kinds of social meanings.

The years during which Delaunay was most involved in textile and clothing design in Paris correspond to the period when Russian artists sought to find socially useful applications for their aesthetic theories. In Russia, many architectural and other plans by avant-garde artists remained theories only because of crippling shortages of raw materials after the Revolution and the Civil War of 1918–21. Yet Moscow had a large textile industry and designs for textiles and clothes were valuable for the practical application of Constructivist ideas about materials and the application of design principles to everyday life.

At the beginning of 1923 an article appeared in *Pravda* urging artists to address industrial problems. The first artists to respond were Popova, Rodchenko, Stepanova, Tatlin, and Exter who sent sketches to the First State Textile Factory in Moscow, but only Popova and Stepanova entered mass production. The results were bright, simple geometric patterns. "Anonymous" geometric/mechanical and abstract motifs articulated the individual's place within industrial civilization, while kinetic forms symbolized emancipation and mobility.

152,154

148

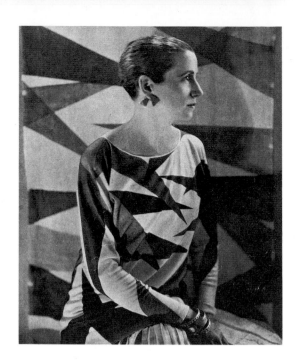

Tatlin and Rodchenko developed clothing designs that offered solutions to the new social functions of clothing, but it was Popova and Stepanova who rethought the whole cloth and clothing design process within the framework of the existing industry. Both wanted to link textile design to the principles of dress design and in an article of 1929, "Present Day Dress—Production Clothing," Stepanova defined the challenge facing them; "The basic task of the textile artist today is to link his [*sic*] work on textiles with dress design . . . to outlive all the craft methods of working, to introduce mechanical devices . . . to be involved in the life of the consumer . . . and most importantly to know what happens to the cloth after it is taken from the factory." Stepanova's article rejects the pre-revolutionary concept of fashion which stressed form and decoration and instead defines the aesthetic effect as a by-product of the physical movement required in everyday activities. Popova's 1923 essay, "The Dress of Today is the Industrial Dress," also argued for a redefinition of dress as function rather than object; "Fashion, which used to be the psychological reflection of everyday life, of customs and aesthetic taste, is now being replaced by a form of dress designed for use in various forms of labor, for a particular activity in society. This form of dress can only be *shown*

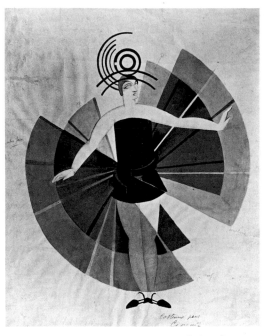

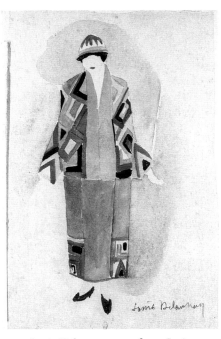

152 Alexandra Exter, costume design for a woman for *La Fille d'Hélios* 1922

153 Sonia Delaunay, page from *Sonia Delaunay, ses peintures, ses objets, ses tissus simultanes* 1925

154 Liubov Popova, design for a flannelette print and a coat and skirt using these, c. 1924

during the process of work. Outside of practical life it does not represent a self-sufficient value or a particular kind of 'work of art.'"

In Paris Russian and French design came together in 1925. That year an Exhibition of Decorative and Industrial Arts was organized to exalt the fusion of art and commercial enterprise in decorative design. Delaunay set up a shop called The Simultaneous Boutique with the furrier Jacques Heim; Russian artists sent clothing, fabric, and industrial objects. Close similarities between Soviet "Communist" and Western "capitalist" textile designs were immediately apparent, raising questions about the actual content of the new fashion. In 1925, *Vogue* magazine also showed abstract textiles in an article entitled "Paris Paints its Frocks in Cubist Patterns." "Like wash drawings, accented with one note of color, are these new modernist costumes and accessories . . .," proclaimed the editors. Quickly spreading across Western Europe and America, and shifting from one-of-a-kind designs for wealthy women to mass produced clothing for the middle class, "modern" textile and clothing designs by Delaunay and Russian artists carried the image of the New Woman to a wide public, but this new image served ends that had little to do with actually changing the conditions of life for most women.

That the New Woman is the Modern Woman is reiterated in mass market publications of the 1920s. She is Nancy Cunard, wealthy and bohemian daughter of the English shipping family, whose exploits are documented in Dada memoirs of the period. She is Coco Chanel, doyenne of the French fashion world who around 1910 had adapted sportswear to daily life and capitalized on feminizing masculine fashion, posing in the "little black dress" that became the hallmark of 1930s fashion and was photographed by Man Ray. Above all, in the popular imagination, she is Victor Marguerite's Monique Lerbier, the heroine of *La Garçonne*, an enormously popular novel which sold twenty thousand copies in advance of its 1922 publication date and, by 1929, was translated into many languages and had sold over one million copies. Monique Lerbier wore her hair and skirts short, danced, played sports, took courses at the Sorbonne, and worked in an interesting job.

The real relationship between a 1920s ideal of fashion and glamor which stressed the modern woman's youth and sexuality and the reality of most women's lives was far more complex, and the ideal that had been derived originally from avant-garde art masked profound economic and cultural changes. The popularizing of the image in mass market publications altogether avoided mention of

155 Man Ray *Coco Chanel* 1935

another Modern Woman whose image was also defined in this same period—the lesbian woman whose emergence in the visual arts owes much to the paintings of Romaine Brooks.

An American, born in Rome in 1874, Brooks spent most of her life in Paris fleeing from the physical and psychological deprivations she had suffered at the hands of her mother and her insane brother St. Mar, which she detailed in her autobiography, *No Pleasant Memories*. Brooks met the wealthy American poet Natalie Barney in 1915 and, although she participated only indirectly in the literary salon which Barney made famous, the two women spent the rest of their lives in close proximity at the center of a community of women committed to producing serious art.

The appearance around 1900 of a cross-gender figure whose behavior and/or dress manifested elements commonly identified as "masculine" corresponded to an early twentieth-century medical model which constructed lesbianism around notions of perversion, illness, inversion, and paranoia. The ideology of the "third sex," the soul of a man trapped in a woman's body, advanced by pioneering sexologists like Havelock Ellis and Krafft-Ebing, was rooted in destructive and homophobic attitudes. This new image of the mannish lesbian did, however, enable women to break the asexual

mold of romantic friendship through which nineteenth-century women had expressed their relationships with one another. It was this image which Barney devoted herself to refuting and which Brooks embodied in her portraits of women.

Barney's pursuit of beauty centered on the androgynous body. Drawing on the tradition of Sappho, she embraced classical and Pre-Raphaelite images of imposing enigmatic female beauty. Brooks's portrait of Barney, *The Amazon* (1920), is the only one of her female portraits which does not involve cross-dressing. The painterliness of the fur that wraps Barney's body like a cloak emphasizes her concentrated intelligence. As a study in female intelligence it is remarkable, but Brooks's other female portraits, with their tuxedos, pinched faces, and morning coats, expose the self-divisions, "the pain the male costume produces on and in the female figure." A Whistlerian palette of black, gray, and white renders female images, like the *Self-Portrait* of 1923, tense and secretive. This new female image, although freed from patriarchal constructions of the female body as an object for male delight, stands in uneasy relationship to the rhetoric and commodification of the modern woman.

156 Romaine Brooks *The Amazon* (Natalie Barney) 1920

Brooks's female types are as much a part of the early twentieth century's production of new images of the female body as are more conventional images of the New Woman, but it is the images produced by modernists like Delaunay and the Russian artists which became the basis of a modern ideology in which the commodified image of woman signifies her expanded role as consumer. According to Stewart Ewen, those in industry in Western Europe and America were often the most enthusiastic proponents of the new womanhood for they realized that liberated women were more able consumers. One result was the many advertisements which show the fashionably dressed flapper at work. Manufacturers were happy to present women with a reconstituted ideal which gave much notice to their new identity as industrial workers and consumers. Industries that marketed cosmetics and other personal care items mushroomed in the 1920s and the "new look," which had come from the innovations of the avant-garde, became ideologically useful as a banner standing for newness and innovation generally as purchasable properties.

Finally, this manipulation of working woman's independent purchasing power also masked her increasingly routine work life, as

157 Romaine Brooks *Self-Portrait* 1923

well as complex and far-reaching changes in the institution of the family that accelerated after the First World War. The growth of rationalized labor—or assembly line production—after the War came to define jobs for women as rote and contributed to growing conflicts between work and family activities for many women. Working women's independent purchasing power threatened the traditional structure of the family and became the basis for an ideology of gender relations which defined women as managerial, in charge of consumption in the family. Although men were still viewed as breadwinners, women were now cultivated as general purchasing managers. The threatening underside of these new gender relations is well expressed in articles which appeared in *Vogue* and other popular publications in 1925. "While there are yet vestiges of family life about us, and households, as households, still exist, it would surely be seemly to examine the characters of those who once held the position of leadership in them. We refer to fathers," opens one such lament.

The popular advocacy of the image of the New Woman was international in scope. And although the specific social and economic situations of different countries after the War affected the ways that her image was conflated and appropriated for ideological purposes, the image itself is generally most responsive to the needs of industrial capitalism no matter in which country. Renate Bridenthal, Atina Grossman, and other historians have convincingly argued that despite much rhetoric about the rights and liberation of women, and despite a coherent visual imagery celebrating the sexually free working woman, no fundamental changes in women's traditional roles are evident in Weimar Germany. And in France, the New Woman may have been sexually liberated, but she did not win the right to vote until 1946.

In the end, the image that promised a new world for the modern woman in twentieth-century industrial society would exist as a reality only for wealthy and privileged women. As it filtered to masses of working women, it functioned more and more as a fantasy, remote from the realities of most women's lives but strenuously asserted through media campaigns as a means to promote consumption— selling youth, beauty, and leisure along with the latest fashions.

The Independents

Referring to women artists as "independents" is already an arbitrary and misleading designation for no artist is independent of the complex of economic, social, and cultural practices through which art is produced. Nor can lumping together a diverse group of women be intellectually or theoretically justified when it produces alliances reducible only to gender. Yet at the same time, many women artists working in the late nineteenth and early twentieth centuries had an ambiguous relationship with the developing mythology of the vanguard modern artist.

The view of the modern artist as a heroic (male) individualist finds its fullest expression in the literature of post-Second World War art. The emergence of a self-conscious set of practices and characteristics through which the modern in art is understood, and the closely related notion of an "avant-garde" as the dominant ideology of artistic production and scholarship, coincides with the emergence of a first generation of women artists with more or less equal access to artistic training.

Vanguard ideology marginalizes the woman artist as surely as did the guilds in the fifteenth century, and the academies in the seventeenth and eighteenth. There is no female Bohemia against which to measure the exploits of a Suzanne Valadon, no psychoanalytic equating of artistic creativity and female sexuality, no Romantic legacy of the woman artist as an intense, gifted, and spiritual being. If Expressionism, as feminist art historians have argued, stands as a revolt of "sons" against "fathers," the relationship of Paula Modersohn-Becker, Käthe Kollwitz, and other women artists to German Expressionism is difficult to elucidate. In eliding representation by women with the social production of middle-class femininity, the work of Suzanne Valadon is left in a representational void, subject only to the creation of a new myth of the woman artist as "undiscovered." Valorizing stylistic innovation and monumental size leaves little room for the modest, stylistically consistent paintings of Gwen John and Florine Stettheimer. Identifying woman with nature

and imaging femininity in its instinctive, enigmatic, sexual, and destructive aspects places major female practitioners of landscape painting like Georgia O'Keeffe and Emily Carr in an impossible double-bind in which femininity and art become self-cancelling phrases. Admitting women artists to canonical art history only retrospectively, and basing evaluations of their work on what Anne Wagner has called a "heroics of survival," removes artists from the social contexts which, in fact, made possible their work. Constructing woman as a signifier for male creativity banishes to the margins of the avant-garde a group of gifted women Surrealists.

Another aspect of the early Modernist myth which is receiving increasing attention from feminist art historians and critics concerns the extent to which the major paintings—and sometimes sculptures—associated with the development of modern art wrest their formal and stylistic innovations from an erotically based assault on female form: Manet's and Picasso's prostitutes, Gauguin's "primitives," Matisse's nudes, Surrealism's objects. Modern artists from Renoir ("I paint with my prick") to Picasso ("Painting, that is actual lovemaking") have collaborated in fusing the sexual and the artistic by equating artistic creation with male sexual energy, presenting women as powerless and sexually subjugated.

In her article, "Domination and Virility in Vanguard Painting," Carol Duncan traces the further sexualizing of creativity in the work of the Fauves, the Cubists, and the German Expressionists. She concludes that the vanguard myth of individual artistic freedom is built on maintaining sexual and social inequalities: "The socially radical claims of a Vlaminck, a Van Dongen or a Kirchner are thus contradicted. According to their paintings, the liberation of the artist means the domination of others; his freedom requires their unfreedom. Far from contesting the established social order, the male-female relationship that these paintings imply—the drastic reduction of women to objects of specialized male interests—embodies on a sexual level the basic class relationships of capitalist society."

Suzanne Valadon and Paula Modersohn-Becker were two of the first women artists to work extensively with the nude female form and their paintings both collude with, and challenge, such configurations. Confronted with the powerful presence of Valadon's nudes, critics were unable to sever the nude from its status as a signifier for male creativity; instead, they severed Valadon (who was not a "respectable" middle-class woman) from her femininity and allowed her to circulate as a pseudo-male, complete with "masculine power"

266

and "virility." "And perhaps in this disregard for logic," wrote Bernard Dorival, "in this inconsistency and indifference to contradiction, lies the only feminine trait in the art of Suzanne Valadon—that most virile—and greatest—of all the women in painting."

Dorival's critical position is similar to that taken by many twentieth-century critics who, having jettisoned one half of the ideology of separate spheres bequeathed them by nineteenth-century critics, have confidently asserted that "art has no sex," and at the same time admitted to the canon only work by women artists which might be contained by the term "virile." Nevertheless, Valadon's status in the eyes of Dorival and other contemporary critics was not sufficient to insure her place in histories of modern art. Although she exhibited at the Société Nationale des Beaux-Arts, the Indépendants, and at private galleries like Berthe Weil and Bernheim-Jeune, and although Ambroise Vollard published and sold her engravings in 1897, by the 1920s her work was all but ignored.

The illegitimate daughter of a laundress, Valadon (1867–1938) became an artist's model in the early 1880s after working as a circus performer. Posing for Puvis de Chavannes, Toulouse-Lautrec, Renoir, and other artists, she was part of the sexually free bohemian life of early twentieth-century Paris. Her entrée to the world of art came not through education, for she was largely self-taught, but through her identification with a class of sexually available artist's models, an association which liberated her from any lingering expectations about respectability and allowed her to enter into the sort of easy relationship with other artists and with her patrons which we seldom see in the careers of middle-class women artists of those years.

The subject of the nude in art brings together discourses of representation, morality, and female sexuality, but the persistent presentation of the nude female body as a site of male viewing pleasure, a commodified image of exchange, and a fetishized defense against the fear of castration leaves little place for explorations of female subjectivity, knowledge, and experience. The difficulty of distinguishing between overtly sexualized (i.e., voyeurism, fetishism, and scopophilia) and other forms of looking, and the fact that the male relationship of power and control over the female image would seem to allow women only a vicarious pleasure in looking, has prompted a significant body of feminist literature on issues of spectatorship.

Valadon's female nudes fuse observation with a knowledge of the female body based on her experience as a model. Rejecting the static

and timeless presentation of the monumental nude that dominates Western art, she emphasizes context, specific moment and physical action. Instead of presenting the female body as a lush surface isolated and controlled by the male gaze, she emphasizes the awkward gestures of figures apparently in control of their own movements. Valadon often placed her figures in specific domestic settings, surrounding them with images of domesticity and community, as in

158 *Grandmother and Young Girl Stepping into the Bath* (c. 1908), a striking departure from the practises of her contemporaries, like Renoir, who referred to *his* models as "beautiful fruit."

Like Degas, who recognized and encouraged her talent, Valadon often turned her bathers away from the viewer and depicted them absorbed in their own activities. But in her emphasis on the tension of the body as it executes specific movements there is little or no attempt to establish the closely framed single point of visual connection between viewer and model that is the hallmark of Degas's many pastels of bathers. The nakedness of Valadon's figures is specific to the act of bathing. Her nudes are full-bodied, weighty, and sturdy.

162 Although sensuous, they stand in opposition to the archetypal and fertile female figures so prevalent in the avant-garde circles of Gauguin and the Fauves.

The shift from the imagery of seductive and devouring femininity produced by Symbolist painters and poets to an ideology of "natural womanhood" which identified the female body with biological nature was part of a reaction against feminism and the neo-Malthusians. Modest gains made by women in education and employment in France at the end of the nineteenth century provoked an intense anti-feminist backlash. It culminated in the battle over control of reproductive rights in France. Indignation among demographers over declining birth rates at the end of the nineteenth century was taken up by literary figures such as Zola, whose novel *La Fécondité* (1899) gave fictional form to a growing cult of fertility; "There is no more glorious blossoming, no more sacred symbol of living eternity than an infant at its mother's breast." The cry was taken up by artists, including Gauguin, whose colonization of the "natural" female Tahitian body reinforced early Modernism's exaltation of the "natural" female body always subject to the literal and metaphoric control of man.

Among the work of women artists associated with Expressionism, that of Paula Modersohn-Becker and Käthe Kollwitz most clearly reveals the clash between Modernist ideology and social reality.

158 Suzanne Valadon *Grandmother and Young Girl Stepping into the Bath* c. 1908

Caught between the artistic and social conservatism of the Worps-
wede nature painters and the influence of French Modernism,
Modersohn-Becker struggled to produce images that embodied both
poles of experience. Kollwitz (1867–1945) was committed to an art of
radical social content unrivalled in her day, and her choice of graphic
realism as a style, her exclusive use of printmaking media, and her
production of posters and humanitarian leaflets, all contributed to
later devaluations of her work and its dismissal by art historians as
"illustration" and "propaganda."

Born in Dresden in 1876, Modersohn-Becker was the child of
comfortably middle-class parents who encouraged her artistic
interests until she showed signs of serious professional ambition. She
made her first visit to the Worpswede artists' community in northern
Germany in the Summer of 1897 where she began to study with Fritz

Makensen. Encouraged by Julius Langbehn's eccentric book *Rembrandt as a Teacher* (1890), and by their interest in Nietzsche, Zola, Rembrandt, and Dürer, the Worpswede painters embraced nature, the primitive simplicity of peasant life, and the purity of youth. Langbehn's book became the textbook of the "Volkish" movement, a utopian reaction against industrialization which celebrated the rural values of the peasantry. Although she settled more or less permanently in the village after completing her studies in 1898, later marrying the painter Otto Modersohn, Modersohn-Becker did not share the group's disdain for academic training; the flattened and simplified forms that mark her mature style derive from the influence of French painters, particularly Cézanne and Gauguin, whose work she saw during four visits to Paris between 1899 and 1906, the year before her premature death.

Modersohn-Becker's interest in her models as personifications of nature developed in the context of the Worpswede artists' cultivation of the "earth mother," but it was not until after her first trip to Paris in 1899 that it entered her work as a major theme. One of Fritz Makensen's first Worpswede canvases was a life-sized *Madonna of the Moors* (1892) and as early as 1898 Modersohn-Becker recorded her impression of a peasant woman suckling a child in her diary; "Frau Meyer, a voluptuous blonde. . . . This time with her little boy at her breast. I had to draw her as a mother. That is her single true purpose." Linda Nochlin has also pointed to sources for Modersohn-Becker's cultivation of the imagery of fecund maternity in J. J. Bachofen's *Mutterecht* (1861), which was reissued in 1897 and widely circulated among artists and writers. Surrounding her figures with a tapestry of flowers and foliage, Modersohn-Becker ignored conventional perspective and anecdotal detail to produce monumental images of idealized motherhood; "I kneel before it [motherhood] in humility," she wrote.

Her diary records an ambivalence toward marriage, motherhood, and art. Modeled on the diaries of Marie Bashkirtseff, Modersohn-Becker, unlike the former, had little sympathy for the growing women's movement. Although Karl Scheffler's misogynist *Die Fraue und die Kunst* (Woman and Art) was not published until 1908, the year after her death, its sentiments were commonly accepted throughout the period of Modersohn-Becker's development as an artist. Scheffler emphasized woman's inability to participate in the production of culture because of her ties to nature and her lack of spiritual insight. Modersohn-Becker's own ambivalence on these points is recorded in

an allegorical prose poem in which she acknowledges her artistic ambitions as "masculine" and remarks on the mutual exclusivity of female sexual love and artistic success.

Modersohn-Becker participated in the second Worpswede group exhibition in the Bremen Kunsthalle in 1899, despite attempts by the director of the Kunsthalle to dissuade her. Negative critical response focused mainly on the work of the women artists in the colony and Modersohn-Becker left almost immediately for Paris. There she entered the Académie Colarossi and visited galleries showing the work of Puvis de Chavannes, the Barbizon painters, Courbet, and Monet. Gradually rejecting the Worpswede artists' commitment to a crude naturalism, her work began to record influences from Rodin, Japanese art, Daumier, Millet, and other French painters. By 1906, back in Germany, she had requested a copy of Gauguin's autobiography, *Noa Noa*, from her sister in Paris and had thrown off her husband's artistic influence.

Viewing Gauguin's retrospective exhibition in Paris in 1906 helped move Modersohn-Becker's figurative works in the direction of a primordial power sought through nature. Her nude self-portraits may be the first such paintings in oil by a woman artist, but as such, they are strangely ambiguous. Rejecting Gauguin's romantic nostalgia, she carries the simplification of form to an extreme which blunts the sensuality normally assigned female flesh in the history of art. The immobility, monumentality, and gravelly surfaces of these self-portrait nudes universalize the images, but the careful scrutiny of the female body and the frank confrontation between the woman and the artist fuse the issues of femaleness and creativity in new ways. 160

Modersohn-Becker's archetypal fertility images of 1906 and 1907, *Mother and Child Lying Nude* and *Mother and Child* are closely related to Gauguin paintings like the *Kneeling Day of the God*, but they clothe the subject of fertility and nurture with dignity, while at the same time collaborating with a late nineteenth-century ideology of timeless, unvarying "natural" womanhood. The subtext of violence and control that accompanies Gauguin's representations of Tahitian women is missing from Modersohn-Becker's paintings with their lowered viewpoint and direct gaze. Gauguin's many paintings of Tahitian women replay the unequal relationship of the male artist and the female model in the inequities of the white male artist's relationship to native women in a colonialized society. His paintings bind women to nature through repetitions of colors, patterns, and 159

159 Paula Modersohn-Becker *Mother and Child Lying Nude* 1907

contours; crouching female figures are placed in a submissive relationship to the downward gaze of the male artist and the women's blank gazes offer little insight into the specifics of their lives.

Modersohn-Becker's death shortly after giving birth provides an ironic commentary on the gulf between idealized motherhood and the biological realities of fecundity. Nochlin has pointed out this disjunction, observing that it is Käthe Kollwitz's depictions of women and children that insert motherhood "into the bitterly concrete context of class and history."

Kollwitz replaces the archetypal imagery of female abundance with the realities of a poverty which often prevents women from nourishing their children or enjoying their motherhood; in *Portraits of Misery III*, a lithograph, and in many other works, pregnancy without material support is cause for grief rather than rejoicing. Kollwitz, the first woman elected to the Prussian Academy of the Arts (1919) and the foremost graphic artist of the first half of the twentieth

160 Paula Modersohn-Becker *Self-Portrait with Amber Necklace* 1906

century, was encouraged to draw as a child by her father. Studies in Berlin and Munich followed a period of training in Königsberg (now Kaliningrad) under the engraver Rudolph Maurer. In 1891, she married Dr. Karl Kollwitz and settled in Berlin where she came in contact with the industrial workers of Berlin through his practice. A socialist, feminist (founder of the Frauen Kunstverband [Women's Arts Union] in Berlin in 1913), and pacifist, the themes of war, hatred, poverty, love, grief, death, and struggle dominate her mature work.

Influenced by Max Klinger's engravings, by Zola's realism, and by the memory of her father reciting Thomas Hood's "The Song of the Shirt" with its passionate appeal on behalf of working women, she turned to themes of social conditions and to the expressive mediums of engraving and lithography. Kollwitz's first major success came with a cycle of three engravings and three lithographs titled *The Weavers' Uprising* (1895–97). Based on Gerhart Hauptmann's play, *The Weavers*, about the revolt of the Silesian weavers in 1844, the cycle moves from the sufferings, including death, of the weavers to their decision to take collective action. Somber grays and blacks and sharp lines relieved by strong lights powerfully evoke the weavers' tragic revolt against inhumane working conditions.

As a result of the success of *The Weavers' Uprising* (which proved so politically effective when exhibited in 1898 that the Kaiser refused to award Kollwitz the gold medal she had won), Kollwitz was appointed to teach graphics and nude studies at the Berlin Künstlerinnenschule. Her subsequent concentration on the mother and child theme developed hand in hand with a series of personal tragedies which included the death of a son in the First World War and the loss of a grandson in the Second. Documenting the suffering that results from war and poverty led Kollwitz away from the expressions of individual torment that mark the work of her contemporaries Edvard Munch and James Ensor and that would soon dominate German Expressionism. Although her work shares the graphic expressiveness of the prints by members of the Brücke and Blaue Reiter groups, she increasingly came to see Expressionism as a rarefied art of the studio, divorced from social reality. "I am convinced," she wrote in her diary dating from 1908, "that there must be an understanding between the artist and the people such as there always used to be in the best periods in history."

Kollwitz's insistence on the social function of art divorced her work from the Modernist cultivation of individual artistic freedom. Vanguard mythologies have proved equally difficult to sustain in the

161 Käthe Kollwitz, "Attack," *The Weaver's Uprising* 1895–97

face of work which refuses the scope, and often the scale, of Modernist ambitions.

Despite regular exhibitions, Gwen John (1876–1939), like Valadon, was until recently most often presented as an "unknown," to be regularly "rediscovered" by subsequent generations of curators and critics, always in relation to her brother Augustus John, whose work bears little similarity to hers; her lover, the sculptor Auguste Rodin; and her patron, the American collector John Quinn.

Though she knew Picasso, Braque, Matisse, Rodin, and many other contemporary artists, and read widely, John had little interest in the theoretical aspects of artistic movements. Nor was she a joiner. Born and raised in Wales, and educated at the Slade School in London under Whistler's influence, John went to France at the age of twenty-

162 Suzanne Valadon *The Blue Room* 1923

seven and remained there for the rest of her life. Her work contains
superficial affinities with that of Rodin, Puvis de Chavannes,
Vuillard, Bonnard, Modigliani, and Rouault, but its dry surfaces,
restrained color and patterned brushwork are closer to the paintings
produced by the Camden Town Group in London than to the French
Modernists. Her reliance on intimate subject-matter was shaped by
her early experiences at the Slade and her paintings, subdued in tone,
and formal in arrangement, evoke powerful emotional responses.

John first exhibited in 1900 at the New English Art Club, returning
to Paris after that exhibition partly to escape Augustus John's
influence over her life. She supported herself by posing as an artist's
model, often for English women artists, and by the Summer of 1904
she was posing for Rodin. John's relationship with Rodin belongs to

276

163　Gwen John *A Corner of the Artist's Room, Paris, 1907–1909*

the difficult history of women who, lacking familial and social support for their endeavors, have annexed their talent to that of male mentors and seen their own work suffer as a result. But it is art historians who have extracted her life from the historical circumstances in which she lived, and from the lives of the hundreds of other women painters working in London and Paris in the same years. Like many other women artists, she has been "rediscovered" as an exception and re-presented as unique.

Rodin defined his own artistic genius in sexual terms and his critics followed suit; "The period when Rodin was caught up in the grand passion of his life coincided with the creation of his most impassioned works," notes one twentieth-century critic. "Such was his innate vigor, even in decline, that everything which flowed from his hands with such dangerous facility bore the imprint of genius. . . ." John, like the sculptor Camille Claudel (1856–1920), who entered Rodin's studio as an assistant in 1883 and remained to become model, lover, collaborator, and artist in her own right, saw her creative life merged with that of Rodin in the eyes of others. Claudel's assistance in Rodin's studio helped insure his myth of superhuman productivity during the 1880s and early 1890s, and much of her creative output remains to be disengaged from his work of these years. John's

164 Camille Claudel *Auguste Rodin*
1892

relationship with Rodin, while equally intense, was not played out through their commitment to a shared medium. Describing herself as "une petite morceau de souffrance et de désir," and expressing a growing coldness toward painting, she nevertheless continued to paint, executing numerous drawings and at least a dozen paintings during her first decade in Paris.

Distinctive themes emerged in John's work during this period: simple interiors bathed in soft light and isolated female figures set against textured walls. Formally constructed, these works capture specific moments filled with light and atmosphere. The repetition of compositions is characteristic of her mature work and provided a means for the formal investigations which were her primary concern as a painter.

163
165

John's reflective, dedicated life allowed her to live largely independent of the social obligations placed on most women of her time, but critics continue to search for the "essentially feminine" in her work. The term "feminine" has also been used to build contexts within which to view the work of other women who moved in avant-garde circles, but whose personal and idiosyncratic styles have no place in vanguard mythology. Marie Laurencin's work was promoted by the poet Guillaume Apollinaire, who introduced her to

165 Gwen John *Young Woman Holding a Black Cat* c. 1914–15

166 Frida Kahlo
The Broken Column 1944

That's what society thinks of me so I'm going to put it down on paper, instead of ruling above the sterotype.

167 Leonora Carrington
Self-Portrait 1938

the Cubist painters; Florine Stettheimer's social relationships with the New York avant-garde before and after the First World War proved more binding than her artistic ties to them. Both artists embraced the decorative and the fanciful in their work, and both fashioned a myth of the feminine that allowed them to be heard, but that insured they would never be taken as seriously as their male colleagues.

Educated at the Lycée Lamartine and at the Académie Humbert, where she met the Cubist painter Georges Braque, Laurencin (1885–1956) had a long, stormy affair with Apollinaire, which placed her in the group of artists who gathered around Picasso in the studio at the Bateau Lavoir, a run-down former wash house in Montmartre. Her painting *Group of Artists* (1908) includes Apollinaire, Picasso, herself, 168 and Picasso's companion, Fernande Olivier, but the presence of herself and Olivier in the painting signals friendship rather than art.

In his 1913 treatise, *Les Peintres Cubistes: Méditations esthétiques*, Apollinaire called her a "scientific Cubist," but in fact her work has little to do with Cubism's conceptual and formal investigations. Instead it was her "femininity" which became the artistic yardstick against which her work was measured. She brought "feminine art to major status," claimed Apollinaire, but it was as his muse that she entered the Modernist mainstream and it was this construction which provided the Surrealists with a new image of the creative couple. Henri Rousseau's painting of Apollinaire and Laurencin, *The Muse Inspiring the Poet* (1909), presents her as a nature goddess. Apollinaire designated her "a little sun—a feminine version of myself," thereby removing her entirely from the creative ferment that propelled his male friends. "Though she has masculine defects," he wrote, "she has every conceivable feminine quality. The greatest error of most women artists is that they try to surpass men, losing in the process their taste and charm. Laurencin is very different. She is aware of the deep differences that separate men from women—essential, ideal differences. Mademoiselle Laurencin's personality is vibrant and joyful. Purity is her very element." Laurencin exhibited alongside the Cubists in 1907, and from 1909 to 1913, while Florine Stettheimer had only a single solo exhibition during her lifetime. After 1916, she exhibited only at the Independent Society of Arts Annuals, using her wealth and social position as a defense against art world intrusion and elaborating a notion of the "feminine" until her life and her art became largely indistinguishable.

Born in Rochester, New York, in 1871, Florine Stettheimer was the youngest of five children in a prosperous family. She studied at the

Art Students' League in New York from 1892 to 1895 and then travelled in Europe with two of her sisters, taking painting lessons in Germany and visiting museums. The outbreak of war in 1914 forced the Stettheimer sisters to return to New York where the family home soon became famous as the social center of a group of avant-garde art dealers, dancers, musicians, artists, and writers. Stettheimer's paintings of this period are bright, calligraphic sketches full of personal symbolism, amusing anecdote, and social satire. Her unique personal style evolved out of a rigorous academic training, but her paintings focus almost exclusively on the social milieu in which she lived. The *Studio Party* (1917), like many of her other works, includes her social and artistic circle: Maurice Sterne, Gaston and Isabelle Lachaise, Albert Gleizes, Leo Stein, her sisters.

169 Stettheimer produced paintings as part of a self-consciously cultivated lifestyle which drew few, if any, distinctions between making art and living well. Protected by her wealth from having to exhibit or sell, she further insulated herself from the professional art world through her demand that any gallery wishing to exhibit her works be redecorated like her home. Stettheimer's exaggerated

168 Marie Laurencin
Group of Artists 1908

169 Florine Stettheimer
Cathedrals of Art 1942
(unfinished)

"femininity" was a way of establishing a role for herself as a woman and an artist; her contemporary, Georgia O'Keeffe, on the other hand, spent much of her life trying to escape attempts by critics and a well-meaning public to read her life in her work.

O'Keeffe's place in the history of American modern art, while far more secure than that of Stettheimer, remains circumscribed by critical attempts to create a special category for her. Her career, the critic Hilton Kramer later wrote, "is unlike almost any other in the history of modern art in America," for it embraced its whole history, from the founding of Alfred Stieglitz's gallery with its shocking displays of European Modernism to the eventual acceptance of modern art in America. And it anticipated by some years the color field paintings of Clyfford Still, Helen Frankenthaler, Ellsworth Kelly, Barnett Newman, and others. The "rediscovery" that began her recent meteoric rise to the forefront of American art came only with her retrospective exhibition at the Whitney Museum, New York, in 1970 when a new generation of viewers were drawn to the uncompromising example of her life and the quiet integrity of her work.

Her relationship to her colleagues in the circle around Stieglitz, with whom she began living in 1919—the painters Marsden Hartley, Charles Demuth, Arthur Dove, and the photographer Paul Strand— was often equivocal. Referring to them as "the boys," she later commented that, "The men liked to put me down as the best woman painter. I think I'm one of the best painters." O'Keeffe chose to live much of her life away from New York, developing her paintings in relation to the vast, austere landscape of the southwestern United States, particularly the area around Abiqui, New Mexico, where she moved permanently after Stieglitz's death in 1946.

Born in 1887, O'Keeffe studied anatomical drawing with John Vanderpoel at the Art Institute of Chicago in 1905; two years later she was in New York studying painting at the Art Students' League. Quickly losing interest in academic styles derived from European models, she left to work as a commercial artist in Chicago. After attending a course on the principles of abstract design taught by Alan Bement—a follower of the art educator Arthur Wesley Dow—she taught Dow's principles in schools in Virginia, South Carolina, and Texas. She met Stieglitz after she sent a batch of abstract charcoal drawings based on personal feelings and sensations to Anita Politzer, a friend in New York who subsequently took them to Stieglitz.

In 1916, Stieglitz was one of the organizers of "The Forum Exhibition of Modern American Painters." The only woman included among the seventeen leading American Modernists was Marguerite Zorach, a California artist who helped introduce Fauve painting into the United States, but who is better known for her brilliant abstract tapestries. Thus, O'Keeffe was not the only woman shown by Stieglitz at his avant-garde 291 Gallery, but her situation there was unique.

O'Keeffe's paintings of the 1920s—from the planar precisionist
171 studies of New York's buildings and skyline to the New Mexico landscapes with their distilled forms and intense colors, and the many paintings of single flowers—are intensely personal statements expressed in the reductive language of early Modernism. Her emergence during the early 1920s as an artist of great promise coincided with what appeared to be more liberal attitudes toward women including their increased attendance in art schools. Between 1912 and 1918, a number of women students at the Art Students' League, among them Cornelia Barnes, Alice Beach Winter, and Josephine Verstille Nivison, contributed drawings and illustrations to the radical Socialist magazine, *The Masses*, which promoted women's

causes from suffrage to birth control. Other women produced paintings addressing current social realities, like Theresa Bernstein's *Suffragette Parade* (1916) and *Waiting Room—Employment Office* (1917), which depicts a group of weary women waiting for jobs.

Throughout the 1920s, the complex associations between O'Keeffe's paintings of natural forms and the female body elicited readings which the artist herself recognized as ideological constructions. Responding to the widespread popularizing of Freud's ideas in America, Henry McBride noted; "Georgia O'Keeffe is probably what they will be calling in a few years a B.F. (before Freud) since all her inhibitions seem to have been removed before the Freudian recommendations were preached upon this side of the Atlantic. She became free without the aid of Freud. But she had aid. There was another who took the place of Freud. . . . It is of course Alfred Stieglitz. . . ." 170

The ideology of femininity, which presented O'Keeffe as Stieglitz's protégée, that constructed her considerable talent as "essentially feminine" legitimized male authority and male succession. "Alfred Stieglitz presents" read the announcement for O'Keeffe's 1923 exhibition at his gallery; the following year he declared, "Women can only create babies, say the scientists, but I say they can produce art—and Georgia O'Keeffe is the proof of it."

In a decade of declining birth rates women were confronted by a barrage of literature urging them to stay home where, as mothers and homemakers, they became perfect marketing targets for a new peacetime economy based on household consumption. Throughout the 1920s, O'Keeffe was forced to watch her work constantly appropriated to an ideology of sexual difference built on the emotional differences between the sexes which supported this social reorganization. Men were "rational," manipulating the environment for the good of their families; women were "intuitive" and "expressive," dominated by their feelings and their biological roles. She was shocked when, in 1920, Marsden Hartley wrote an article casting her abstractions in Freudian terms and discussing "feminine perceptions and feminine powers of expression" in her work and that of Delaunay and Laurencin. "No man could feel as Georgia O'Keeffe," noted the Modernist critic Paul Rosenfeld in 1924, "and utter himself in precisely such curves and colors; for in those curves and spots and prismatic color there is the woman referring the universe to her own frame, her own balance; and rendering in her picture of things her body's subconscious knowledge of itself."

170 Georgia O'Keeffe *Black Hollyhock, Blue Larkspur* 1930

Criticisms such as these constructed a specific category for O'Keeffe. Hailed as the epitome of emancipated womanhood, she was accorded star status, but only at the top of a female class. The biological fact of her femininity took precedence over serious critical evaluations of her work. At the time when radical feminists were advocating "androgyny," and designers like Coco Chanel were "masculinizing" women's fashions, the art world countered by presenting a woman who was "emancipated" but "feminine," and in a class by herself. While Edmund Wilson lauded her "particularly feminine intensity," and the *New York Times* critic declared that, "she reveals woman as an elementary being, closer to the earth than men, suffering pain with passionate ecstasy and enjoying love with beyond-good-and-evil delight," O'Keeffe threatened to quit painting if Freudian interpretations continued to be made. Complaining that Hartley's and Demuth's flower paintings were not interpreted erotically she struggled against a cultural identification of the female with the biological nature of the body that has long been used to assign woman a negative role in the production of culture. It is hardly

286

171 Georgia O'Keeffe *The American Radiator Building* 1927

surprising that she responded with so little sympathy to attempts by feminist artists and critics during the 1970s to annex her formal language to the renewed search for a "female" imagery.

O'Keeffe met the Canadian painter Emily Carr (1871–1945) at Stieglitz's gallery in 1930. Although no details remain of the brief meeting, these two major figures in North American landscape painting were evidently sympathetic. If O'Keeffe finally found the art world's insistent refusal to allow her painting to stand in relation to that of her contemporaries a burden and a barrier to her development as a painter, Carr's isolation in British Columbia saved her from most such intrusions. After studying painting in San Francisco, London, and Paris for short periods between 1890 and 1910, Carr's strong, brooding paintings of the Pacific northwest and its Indians went almost completely unnoticed until the 1920s, when she met Mark Tobey and the painters of Canada's Group of Seven. Although never formally a member of the group, she exhibited with them beginning in 1927 in an exhibition called "Canadian West Coast Art: Native and Modern." Like O'Keeffe, Carr built an intensely personal style from a range of influences, and she distilled essential forms from a monumental and imposing nature and presented them without sentiment, moralizing, or anecdote. The breadth of these painters' visions, and the muscularity of their forms, should provoke new investigations into the contributions made by women artists to the traditions of modernist landscape painting. The success of such

172　Emily Carr *Landscape with Tree* 1917–19

173 Germaine Richier *The Batman* 1956

investigations will, however, rest on our ability to redraw the boundaries between woman, nature, and art.

During the 1930s, the sculptors Germaine Richier and Barbara 173
Hepworth also elaborated the connections between nature's cycles of generation and erosion. Hepworth (1903–75), one of England's 174
leading sculptors, studied at the Leed's School of Art and at the Royal College of Art in London where she and Henry Moore became fascinated by the interplay of mass and negative space. Visits to the studios of Constantin Brancusi and Jean Arp in Paris in 1931 encouraged Hepworth to explore biomorphism within an increasingly abstract vocabulary. Living with the painter Ben Nicholson in the 1930s, she was an active participant in the development of abstraction in England. She worked steadily, even after the birth of triplets in 1934 slowed her sculptural production, and gradually evolved a totally abstract, geometric vocabulary.

Adrian Stokes, the painter and essayist, was a member of the group in England—with the painter Paul Nash and the physicist J. D. Bernal—who helped define this formal vocabulary. Writing in *The Spectator* in 1933 after Hepworth's exhibition at Reid and Lefevre, he

174 Barbara Hepworth *Two Forms* 1934

noted; "These stones are inhabited with feeling, even if, in common
with the majority of 'advanced' carvers, Miss Hepworth has felt not
only the block, but also its potential fruit, to be always feminine. . . ."

This generative metaphor was deeply internalized by artists
working under the influence of Surrealism. In a poem written in the
early 1930s and dedicated to Max Ernst, the English poet David
Gascoyne celebrated "the great bursting womb of desire." Jean Arp
also chose procreation as a metaphor for artistic generation, writing in
1948 that "art is a fruit that grows in man, like a fruit on a plant or like
a child in its mother's womb." The reasons for this particular trope lie
outside the present work, but its effects proved nowhere more
conflicting than for women artists in the Surrealist movement.

No artistic movement since the nineteenth century has celebrated
the idea of woman and her creativity as passionately as did Surrealism
during the 1920s and 1930s. None has had as many female
practitioners, and none has evolved a more complex role for the
woman artist in a modern movement. André Breton's romantic
vision of perfect union with the loved woman as the source for an art
of convulsive disorientation that would resolve polarized states of
experience and awareness into a new, revolutionary surreality was
formulated in response to a culture shaken by war. He advanced his

image of the spontaneous, instinctive woman in a social context in which women were demanding the right to work and to vote, and the French government was promoting pronatalism as a strategy for repopulating the war-ravaged country. "The fate of France, its existence, depends on the family," declared a slogan of 1919, the same year that Breton, recently demobilized, returned to Paris. The following year a law was passed forbidding the mere advocacy of abortion or birth control; by 1924, when the First Surrealist Manifesto appeared, Breton had dedicated himself to liberating woman from such "bourgeois" considerations.

The image of ethereal and disruptive womanhood which enters Breton's poetry of the 1920s owes much to Apollinaire's imbrication of erotic and poetic emotion, his reliance on Symbolist polarities to express the duality of female nature, and his presentation of Laurencin as muse and eternal child. But the Surrealist woman was also born out of Freud's ambivalent and dualistic positioning of woman at the center of the creative and the subversive powers of the love instinct, in her incompatible roles as mother and bearer of life, and destroyer of man.

During the 1930s, women artists came to Surrealism in large numbers, attracted by the movement's anti-academic stance and by its sanctioning of an art in which personal reality dominates. But they found themselves struggling toward artistic maturity in the context of a movement that defined them as confirming and completing a male

175 Eileen Agar
Ploumanach 1936

creative cycle and that metaphorically obliterated subject/object polarities through violent assaults on the female image. Not surprisingly, most women ended by asserting their independence from Surrealism.

Almost without exception, women artists saw themselves as outside the inner circle of poets and painters which produced Surrealist manifestos and formulated Surrealist theory. Most of them were young women just embarking on artistic careers when they came to Paris; many of them did their mature work only after leaving the Surrealist circle. Often they came to Surrealism through personal relationships with men in the group rather than shared political or theoretical goals. Yet they made significant contributions to the language of Surrealism, replacing the male Surrealists' love of hallucination and erotic violence with an art of magical fantasy and narrative flow.

Surrealism's multiple and ambivalent visions of woman converge in its identification of her with the mysterious forces and regenerative powers of nature. Women artists were quick to draw on this identification, but they did it with an analytic mind and an ironic stance. Artists like Leonora Carrington (b. 1917), Leonor Fini (b. 1918), the American painters Kay Sage (1898–1963) and Dorothea

176 Leonor Fini *Sphinx Regina* 1946

Tanning (b. 1912), and the Spanish–Mexican artist Remedios Varo (1913–63) received varying degrees of formal training. Yet they meticulously built up tight surfaces with layers of small and carefully modulated brushstrokes. However fantastic their imagery, they often worked with the precision and care of illustrators, as if their creative model was scientific investigation rather than Surrealist explosiveness. Fini's many paintings of bones and rotting vegetation—like *Sphinx Regina* (1946)—and Varo's carefully crafted scientific fantasies—like *Harmony* (1956) and *Unsubmissive Plant* (1961)—resituate the woman artist in the worlds of science and art. \qquad 176

Women artists dismissed male romanticizing of nature as female and nurturing (or female and destructive) and replaced it with a more austere and ironic vision. Bizarre and unusual natural forms attracted the photographic eye of Eileen Agar (b. 1904) and Lee Miller (1908– 175 77), while the Czech painter Marie Černinova, called Toyen (1902– 80), in a series of paintings and drawings executed during and after the Second World War presents nature as a potent metaphor for 177 inhumanity.

Toyen's use of nature as a metaphor for political reality finds an echo in the work of Kay Sage, who met the Surrealists in Paris in 1937 and who spent the War years in New York with the Surrealist painter Yves Tanguy. Her paintings are among the most abstract produced within a Surrealism that embraced symbolic figuration as the key to the language of the dream and the unconscious. A predilection for sharp, spiny forms, slaty surfaces, and subdued melancholy light 178 infuses her landscapes with an air of emptiness and abandonment; she herself identified strongly with these barren vistas stripped of human habitation.

Alienated from Surrealist theorizing about women, and from the search for a female muse, women turned instead to their own reality. Surrealism constructed women as magic objects and sites on which to project male erotic desire. They recreated themselves as beguiling personalities, poised uneasily between the worlds of artifice (art) and nature, or the instinctual life. The duality of the Mexican Frida Kahlo's life (1907–54)—an exterior persona constantly reinvented with costume and ornament, and an interior image nourished on the pain of a body crippled in a trolley-bus accident when she was an adolescent—invests her painting with a haunting complexity and a narrative quality which disturbs in its ambiguity. This is also characteristic of much of the work of another contemporary Mexican artist, Maria Izquierdo (1902–55).

166 Like Kahlo's *Broken Column* (1944), Leonora Carrington's *Self-*
167 *Portrait* (1938) reinforces the woman artist's use of the mirror to assert the duality of being, the self as observer and observed. In *The Second Sex*, Simone de Beauvoir holds up the image of the mirror as the key to the feminine condition. Women concern themselves with their own images, she asserts, men with the enlarged self-images provided

178 Kay Sage *In the Third Sleep* 1944

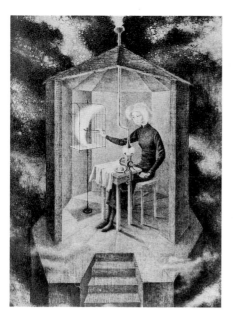

179 Remedios Varo *Celestial Pablum* 1958

180 Dorothea Tanning *Palaestra* 1947

by their reflection in a woman. Kahlo used painting as a means of exploring the reality of her own body and her consciousness of that reality; in many cases the reality dissolves into a duality, exterior reality versus interior perception of that reality. The self-image in the work of women artists in the Surrealist movement becomes the focus for a dialogue between the constructed social being and the powerful forces of the instinctual life, which Surrealism celebrated as the revolutionary tool that would overthrow the control exerted by the conscious mind.

When it came to taking a position vis-à-vis Surrealism's inflammatory erotic language, women artists vacillated. More often than not they approached the issue of eroticism obliquely, focusing attention on aspects of the erotic other than woman's sexual desires. Carrington rejected Freud and turned to alchemy and magic for subjects; Tanning transferred sexuality from the world of adults to that of children. Paintings like *Palaestra* (1947) and *Children's Games* (1942) reveal 180

nubile young girls caught in moments of ecstatic transformation. Their bodies respond to unseen forces which sweep through the room, animating drapery and whipping the children's hair and garments into the air.

Unmoved by Surrealist theorizing on the subject of erotic desire, and by Freud's writings, women appear to have found little theoretical support for the more liberated understanding of sexuality which Surrealism pursued so avidly. Turning to their own sexual reality as source and subject, they were unable to escape the conflicts engendered by their flight from conventional female roles. The imagery of the sexually mature, sometimes maternal, woman has almost no place in the work of women Surrealists. Their conflicts about this aspect of female sexuality reflect the difficult choices forced upon women of their generation who attempted to reconcile traditional female roles with lives as artists in a movement that prized the innocence of the child-woman and violently attacked the institutions of marriage and the family.

Less than positive views of maternity carry over into their work. The most disturbing images of maternal reality in twentieth-century art are to be found in Tanning's *Maternity* (1946), Varo's *Celestial Pablum* (1958), and Kahlo's *My Birth* (1932), *Henry Ford Hospital* (1932), and other paintings on this theme. In Varo's *Celestial Pablum*, an isolated woman sits in a lonely tower, a blank expression on her exhausted face, and mechanically grinds up stars which she feeds to an insatiable moon. The somber palette and matt surface cast their own pall over the work. These paintings are remarkable for their powerful imaging of the conflicts inherent in maternity: the physical changes initiated by pregnancy and lactation, the mother's exhaustion and feared loss of autonomy. The element of erotic violence so prevalent in the work of male Surrealist artists makes its first appearance here in the works of Tanning, Meret Oppenheim (b.1913), and Kahlo that deal with childbirth and motherhood. Now it is violence directed against the self, not projected onto another, violence inseparable from the physiological reality of woman's sexuality and the social construction of her feminine role.

For Kahlo, as for other women artists associated with the Surrealists, painting became a means of sustaining a dialogue with inner reality. Surrealism sanctioned personal exploration for both men and women; in doing so, it legitimized a path familiar to many women and gave new artistic form to some of the conflicts confronting women in early twentieth-century artistic movements.

In and Out of the Mainstream

The emergence of an American avant-garde, along with a body of formalist criticism centered in the writings of Clement Greenberg and his followers, dominates art historical accounts of the period after the Second World War. Nevertheless, abstract and figurative art coexisted despite the increasing critical and curatorial attention directed toward the Abstract Expressionists and their successors after 1948. The ways that the meanings of this Modernist art have been produced, reinforced, and challenged can be observed in the shifting relationship of women's art to broader social formulations and mainstream art during this period. The origins of these shifts lie in the 1930s, the period when American artists began to self-consciously formulate a social role for the visual arts.

During the Depression, American artists under government patronage became an integral part of the workforce and evolved a socially conscious visual language. Working outside the dealer/critic/museum system, male and female artists identified themselves with the labor force. Federal arts projects, like the Works Progress (later Projects) Administration (WPA, 1934–39), supported women's struggles for professional recognition; a 1935 survey of professional and technical workers on relief revealed that among artists receiving aid, approximately forty-one percent were women. The federal section of Fine Arts, a non-relief program which funded murals for public buildings, awarded its commissions on the basis of anonymous competitions in which artists submitted unsigned sketches. Louise Nevelson, Lee Krasner, Isabel Bishop, and Alice Neel were first supported by such programs.

The New Deal's non-discriminatory policies, and the number of women active professionally in the arts, form only part of a larger picture. A backlash against women wage earners during the 1930s took a devastating toll. Caroline Bird has dated the origin of the move to return women from work back into the home to the 1930s, rather than after the Second World War, as is commonly believed, and labor statistics confirm her contention. Mass-market publications, as well as

181 Isabel Bishop *Virgil and Dante in Union Square* 1932

182 Irene Rice Pereira *Untitled* 1951 >

statistics compiled during the 1930s, point to the contradictions between New Deal policies, with Roosevelt as President and Frances Perkins, the first woman in the U. S. Cabinet, as Secretary of Labor, and extensive public hostility toward working women. On the cultural front, at the same time that Marion Greenwood, Minna Citron, Doris Lee, Lucienne Bloch, Neel, Bishop, Nevelson, Krasner, and others, were participating in mural projects which explored the social realities of unemployment and life under the Depression, Hollywood was producing the first of a series of films popularly known as "weepies." Addressed to a female audience, their female protagonists confronted issues or problems specified as "female"— domestic life, the family, maternity, self-sacrifice, and romance.

Women artists active in public arts programs during the 1930s found themselves on a less secure footing in the next decade as government patronage gave way to private art galleries, and as social ideologies promoted sexual difference as cause for removing women from productive labor. In the early 1940s, before the consolidation of Abstract Expressionism, artists in New York worked in styles ranging from Social Realism to Geometric Abstraction. Realists like Isabel Bishop (1902–88) sought to connect the grand manner of classical

181

tradition and Renaissance composition with contemporary urban subjects. Other painters, including John Graham, Stuart Davis, Irene Rice Pereira (1907–71), and Balcomb Greene, continued to espouse the principles of Geometric Abstraction. Still others, influenced by the presence of many Surrealist artists during the War, moved to a biomorphic abstraction responsive to the Surrealist belief that automatism released the rich imagery of the unconscious mind.

The Museum of Modern Art, New York, today perceived as the major cultural institution enshrining Modernist art, in fact came to support the new painting only gradually. The consolidation of Abstract Expressionism as the dominant practice in American modern art pushed to the margins not only women moving toward artistic maturity in other "modern" styles during the 1940s, but also many women professionally active in what would come to be seen as "conservative" and "outmoded" figurative styles. The paintings of women whose careers developed within Abstract Expressionism are not representative of the wide range of work actually executed by women at this time. Nor did these women form a unified "group." Nevertheless, their engagement with this and other issues that defined Modernist art after the Second World War brought them into direct confrontation with artistic and social practices that shaped many women's relationships to mainstream art after the War.

Lee Krasner (1908–84)was involved from the beginning in the search by New York painters for a synthesis of abstract form and psychological content. She trained first at the Women's Art School of Cooper Union and at the National Academy of Design. After meeting Jackson Pollock in 1941, she gave up working from nature and turned to automatism. Her gradual transformation of the figure into abstraction occurred in the context of an intense personal struggle to define herself as an artist and to establish her "otherness" from Pollock, whom she married in 1945.

Turning to interior sources for images, and expressing them through an intuitive gestural language which mobilized the entire body, necessitated confronting how that body had been inscribed as "feminine." To establish herself independently of Pollock's forceful artistic personality she also had to separate herself from a European tradition that included Hans Hofmann and the Cubists, previously the strongest influences on her work. Moving from government-sponsored non-discriminatory art projects to the world of the private dealer/gallery/critic meant watching Mrs. Pollock/wife overshadow Lee Krasner/painter in New York's art world.

183 Lee Krasner *Noon* 1947

As she struggled to lay claim to the all-over images produced through automatism, Krasner began to approach painting as a meditative exercise. In seeking to obliterate figurative reference and hierarchical composition, she worked and re-worked her canvases, scraping them down until nothing remained but granular gray slabs two to three inches thick, most of which she eventually destroyed. Not until 1946 did images begin to appear out of the effaced "grounds" of gray. The "Little Image" paintings which resulted are 183 intuitive, improvisational abstractions. Their small size (most are less than twenty-four by thirty inches) counters the mural-size dramatic canvases which later came to define the ambition of the Abstract Expressionists. Their untranslatable hieroglyphic surfaces suggest unconscious linguistic structures.

The elegant intimacy of Krasner's "Little Images" may be linked to her fascination with Irish and Persian illuminated manuscripts, or with the Hebrew inscriptions familiar from her childhood. The process out of which they emerged, however, and the crisis which generated them, demand rereading in the light of psychoanalytically

oriented theories of the 1970s and 1980s about women's relationship to writing, a term which must be understood in the larger context of meaningful mark-making. The oscillation between women's annexation of male forms and the denial of those same forms that often leads to blankness and silence as women try to find their place within what Xavière Gauthier has called the "linear, grammatical linguistic system that orders the symbolic, the superego, the law," has provoked intense debates among feminists. "It is by writing . . . and by taking up the challenge of speech which has been governed by the phallus, that women will confirm women in a place other than that which is reserved in and by the symbolic, that is, in a place other than silence," argues Hélène Cixous, for example, in "The Laugh of the Medusa" (1975). Art historians have only recently begun to explore the implications of the Abstract Expressionist gesture as a rhetorical device and their investigations promise to shed new light on this important area.

Krasner and other women Abstract Expressionists were well aware of the operations of sexual difference within artistic practice. During the 1940s and 1950s, they confronted the widely held view that women "couldn't paint." Teachers like Hofmann, following an example set earlier by Freud's disciple, Havelock Ellis, believed that "only men had the wings for art." The highest praise he offered his female students, including Krasner, was contained in the remark that continues to haunt so many women; "this painting is so good you'd never know it was done by a woman."

The tensions between an ideology of sexual difference that assured jobs for returned servicemen, supported the shift of population to the suburbs, and provided "meaningful" work for women through homemaking, and vanguard art can be seen in painting and sculpture, by men as well as women. The sculptor David Smith, whose complicated relationship with the sculptor Dorothy Dehner (b. 1901) inflected the work of both during the 1940s, linked the body of woman to home in *The Home of the Welder*, a bronze of 1945–46 with the torso of a woman in bas-relief on one side, and a stylized mother and child in bas-relief on the other. For Smith, the body of woman signified not only physical home, but also the mental and emotional source of male creative activity. For Dehner, the demands of marriage and art proved incompatible and she began to work professionally as a sculptor only after leaving Smith and her home in 1950.

Many women artists, encouraged by their teachers not to link art practice with female experience in order to succeed, confronted the

184

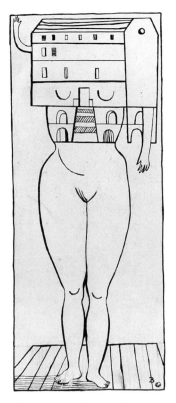

184 Dorothy Dehner *Scaffold*
1983

185 Louise Bourgeois
Femme-Maison c. 1946–47

186 Louise Nevelson
Totem II 1959

difficulty inherent in refuting socially assigned notions of difference while continually pointing to difference and questioning its influence and effects. The nexus of body/home/art is central to the early work of Louise Bourgeois (b. 1911) whose *femme-maison* paintings were 185 exhibited in 1947. Although Bourgeois pointed to the home as a place of conflict for the woman artist, critics read the paintings as affirming a "natural" identification between women and home. Her paintings of 1947 evolved out of earlier ones based on the grid, a structural form familiar to her from her early weaving and tapestry, and from her training in Cubist abstraction. Under the influence of Surrealism, she developed the personal, quasi-figurative imagery of these *femme-maison* paintings with their houses perched on top of women's bodies in place of heads. In these disquieting works, domesticity, imaged through blank facades and small windows, defines women but denies

187 Joan Mitchell *Cross Section of a Bridge* 1951

them speaking voices. "Hers is a world of women," wrote one critic. "Blithely they emerge from chimneys, or, terrified, they watch from their beds as curtains fly from a nightmare window. A whole family of females proves [*sic*] their domesticity by having houses for heads."

In 1949, the Club and the Eighth Street Club were founded and became, along with the Cedar Bar, the major public meeting places for the New York School painters, whose intense discussions with critics and curators concerning the new avant-garde admitted women largely as audience. Although Krasner, Joan Mitchell, Elaine De Kooning, and Mercedes Matter were among the Club's few female members, the painters Paul Brach and Miriam Schapiro (b. 1923), who regularly attended meetings, remember no women at board meetings or policy discussions. Women were "treated like cattle" at the Cedar Bar, Krasner later recalled. Between 1948 and 1951, *Art News* ran articles on Willem De Kooning, Clyfford Still, Mark Rothko, Pollock, and Arshile Gorky. By 1951, *Art News* and Thomas Hess's *Abstract Painting*, published that year, were championing the older artists associated with the new painting. Krasner, still struggling

188 Grace Hartigan *Persian Jacket* 1952

to define her relationship to the new abstraction, found herself placed among a "second generation" that soon included Helen Frankenthaler, Mitchell, Grace Hartigan, Hedda Sterne, Elaine De Kooning, Sonia Getchoff, and Ethel Schwabacher.

Mitchell, Frankenthaler, and Hartigan were ambitious artists who received positive critical support during the early 1950s and whose work was included in major Abstract Expressionist exhibitions. Mitchell (b. 1926) arrived in New York from Chicago in 1949 and participated in the Ninth Street Show in 1951, exhibiting canvases in which amorphous forms, influenced by Gorky's organic shapes, flow in and out of ambiguous spaces. The direct, vigorous brushstrokes of 187 *Untitled* (1950) and *Cross Section of a Bridge* (1951), less raw and violent than those of Kline and Willem De Kooning, are modulated by sensuous surface touches and color. Hartigan's (b. 1922) period of abstraction, on the other hand, was brief, lasting only until 1952, but she produced paintings characterized by strong, gestural brushwork and clashing colors and lines. She was one of the first women artists 188 to earn an international reputation, and her painting *Persian Jacket* (1952) was purchased by the Museum of Modern Art in 1952. Hartigan's subsequent decision to leave abstraction was prompted, however, by the fear that she was borrowing its forms from dominant language.

In 1949, Krasner and Pollock had exhibited in Sidney Janis's group exhibition "Man and Wife." The very title of the exhibition organized women's productions into a subsidiary, socially defined category. The experience, and the negative reviews of her work, proved wrenching and Krasner did not exhibit again until 1951, later destroying most of the paintings from this period. Other women shared her awareness of the deep divisions in the play of sexual difference within social ideology and artistic practise. Krasner and Elaine De Kooning both chose to sign their works with initials only, while Hartigan briefly adopted the sobriquet "George" (in homage to George Sand and George Eliot). In each case, the decision to erase gender as part of the creative process was less an attempt to hide their identities as women than to evade being labelled "feminine" by becoming the man/woman whose creative efforts earned praise.

Helen Frankenthaler (b. 1928) is the only woman painter of the period who has consistently dismissed gender as an issue. Yet critics since the early 1950s follow the model used to contain the considerable talents of O'Keeffe and other previous women artists. Constructing a special category for her work in which color and

touch are read as "feminine," they ceased examining it in relation to its specific historical context and instead linked it to an unchanging and essentialized tradition of women's work.

In 1952, Frankenthaler began staining color directly into large pieces of unsized, unprimed duck laid on her studio floor. *Mountains* 192 *and Sea* (1952), her first major stained canvas, contains richly colored masses and fluid forms reminiscent of Gorky's and Willem De Kooning's biomorphism. Although Frankenthaler benefited from Clement Greenberg's consistent critical support, it was not until the painters Kenneth Noland and Morris Louis adopted her technique that she was accorded status as an "innovator." She was not the first artist to stain canvases but she was the first to develop a complete formal vocabulary from the technique. "It is free, lyrical, and feminine—very different from the more insistent and regular rhythms of the best and most typical Pollocks of the late 40s and early 50s," wrote a later critic, overlooking the fact that both Pollock's and Rothko's use of the staining technique had resulted in softened and sensuous colors.

Atmospheric and landscape references remained strong in the works of Mitchell, Frankenthaler, and Ethel Schwabacher during the 1950s, for Hofmann's influential teachings emphasized nature as a source. All of the artists involved with Abstract Expressionism identified the process of generating images with "nature" ("I *am* nature," Pollock declaimed), but the differing relationships of male and female painters to this very important aspect remain to be clarified. Schwabacher (1903–84) made the transition to Abstract Expressionism through images directly equating biological reproduction and artistic genesis, and both she and Willem De Kooning produced controversial images of women which specifically referred to a nature/culture dichotomy.

After Pollock's death in 1956, Krasner turned to large-scale, hybrid anthropomorphic forms in a series of disturbing paintings which Barbara Rose has called "an exorcism of her feelings of rage, guilt, pain, and loss." A period of intense creative activity followed during which she fully developed a unique idiom. Deliberately choosing colors with "feminine" connotations, she used them in ways that negated their traditional associations. In paintings like *Cat Image* 191 (1957), pastel tones, foliate shapes, and egg forms combine with turgid brushwork and aggressive interpenetrating forms to produce the large works that ultimately secured her place in Abstract Expressionism.

Louise Nevelson (1900–88), like Krasner, also worked with castoff and recycled materials during the 1950s. They, and other women of their generation, worked steadily for many years before receiving the recognition given their male contemporaries at a much earlier date. Despite exhibiting since 1941, and having her work widely acknowledged abroad, Nevelson did not receive a solo museum exhibition in the United States until 1960. Germaine Richier (1904–59), who had exhibited in Europe since 1934, had her first solo exhibition in New York in 1957; Barbara Hepworth's first retrospective exhibition in London, followed by the public commissions that finally enabled her to work at the scale she had long desired, took place in 1954, after twenty-five years of steady work.

Despite a lack of institutional support, however, the period from the mid-1950s to the mid-1960s was important in bringing recognition to a number of women sculptors. Nevelson had studied painting with Hofmann in Munich during the 1930s and won her first sculpture competition at the A.C.A. Galleries, New York, in 1936, but the blatantly sexist critical response to her first major exhibition at the Nierendorf Gallery, also New York, in 1946 drove her from the gallery world for almost ten years. "We learned the artist was a woman, in time to check our enthusiasm," wrote one critic. "Had it been otherwise, we might have hailed these sculptural expressions as by surely a great figure among the moderns."

In 1955, Nevelson exhibited, and was acclaimed for, her first environment, *Ancient Games and Ancient Places*. Fusing Cubism and Constructivism, Dada readymade and Surrealist dream-object, she began constructing entire walls out of crates, boxes, architectural fragments, pieces of pianos, stair railings, chair slats, and other urban bric-à-brac. The matt black of the elements, painted before assemblage, unified form and surface, and the wall-size constructions created new environments within the gallery. *Moon Garden Plus One* (1958), her first entire wall, was arranged in the Grand Central Moderns Gallery to take advantage of its unusual light. "Appalling and marvellous," wrote Hilton Kramer, "utterly shocking in the way they violate our received ideas on the limits of sculpture . . . yet profoundly exhilarating in the way they open an entire realm of possibility." Yet part of the astonishment was directed at a woman working in sculpture and on a scale that rivaled that of male artists.

By the end of the 1950s many artists were turning away from the drama of Abstract Expressionism and denouncing symbolic, mythic, and subjective content as rhetorical devices. A younger generation of

189 Lee Bontecou *Untitled* 1960

artists embraced the mechanical processes and everyday imagery of Pop art, or the non-relational, colorful surfaces of Postpainterly Abstraction and the industrially fabricated geometrical solids of Minimal sculpture. Although faithful to the scale and direct impact of Abstract Expressionism, younger artists cultivated detachment from the process of making images. The exhibition organized by Greenberg at French & Co. in 1959–60 emphasized pure color as an expressive vehicle in works which favored flat, non-textured paint surfaces and non-illusionistic space. Frankenthaler, Jo Baer, Schapiro, Agnes Martin (b.1912)—whose pencilled grids aimed at a balance between the individuality of the mark and the impersonality of the structure—and the English Op artist, Bridget Riley (b.1931), were among the women who adapted to this dominant language of formalist abstraction.

The relative lack of attention paid by mainstream galleries and critics to artists working in alternative ways helped perpetuate the fiction of the mainstream as monolithic and masculine, a world in which women functioned only as exceptions, or in which they were forced to deny any identification with other women. Riley seemed to speak for many ambitious women when she later said; "Women's liberation when applied to artists seems to me a naive concept. It raises issues which in this context are quite absurd. At this particular point in time, artists who happen to be women need this particular form of hysteria like they need a hole in the head."

It is significant, however, that among the women who received the greatest critical attention during the early 1960s were three sculptors whose work, in fact, embodied highly subjective responses to mainstream concerns. In retrospect, the work of Bontecou, Marisol, and Nikki de Saint Phalle appears ever more pointedly at odds with the cultivated detachment and cool imagery of mainstream art, as well as with the slick media-derived female imagery of Pop art.

189 Bontecou (b. 1931) studied sculpture at the Art Students' League with William Zorach and spent several years in Rome on a Fulbright Fellowship. Her large, rugged constructions were fabricated from worn-out commercial laundry conveyor belts which she sewed onto steel frames. First shown in 1960, they were compared to everything from airplane engines to female sexual parts. They exerted a considerable influence on Eva Hesse, Robert Morris, and other Process artists interested in exploring the use of non-traditional industrial materials in sculpture in the late 1960s.

190 Marisol, born in Paris of Venezuelan parents in 1930, had lived in New York since 1950. Around 1954, influenced by Jasper Johns's *Target with Four Faces*, she began putting little terracotta figures in boxes. Her exhibition at the Stable Gallery in 1962 catapulted her into the public eye. "The first girl artist with glamour," Andy Warhol declared and his remark was followed by extensive media attention to Marisol's life, her beauty, and her enigmatic silences. Marisol's representational images based on American figures were immediately linked to Pop art, but her work in fact has sources in Precolumbian art, early American folk carving, and Surrealist dream images. A 1964 exhibition included *The Wedding, Andy Warhol, John Wayne, Double Date*, and *The Babies*. Women encased and imprisoned in wooden blocks and stultifying social roles, endlessly repeated figures, monstrous babies, and Pop heroes dominated. Often she incorporated parts of herself in her work and her obsessive use of self-images, when

190 Marisol *Self-Portrait* 1961–62

combined with stereotypical presentations of women living out circumscribed roles, built a chilling picture of American middle-class life in the 1960s.

Saint Phalle (b. 1930) also offered up images of women that ran counter to formalist aesthetics during the years when Pop art gave us slick nudes, pin-ups, and sex objects. Her work, with its playful absurdity and ephemeral objects, made little critical impact in a New York art world dedicated to Minimalism, but her monstrous female figures were impossible to ignore. A member of the Nouveau Réalistes, a group of European neo-Dada artists active during the 1960s, Saint Phalle's work is a kind of precursor to feminist art concerns of the 1970s. Her large-scale female figures evolved out of earlier assemblage and collage pieces of statuary, figurines, toys, dolls, and other found objects which she reassembled into chaotic tableaux.

The early "Nanas," gaily painted and exaggerated figures at once 196 child-like and monstrous, archetypal and toy-like, were constructed on chicken-wire frames covered with fabric and yarn to create

intricately textured surfaces. Aggressive but also wildly funny, they were like Willem De Kooning *Women* stripped of the violence and misogyny. At the same time, they refused the mythic and romantic fantasies projected by men onto images of women.

In 1966, Saint Phalle produced *Hon* (She), a temporary monument at the Moderna Museet in Stockholm on which she collaborated with 195 Jean Tinguely and Per Olof Ultvedt. Eighty-two feet long, *Hon* lay on her back on the ground, knees raised, heels planted. Spectators entered the figure through the vagina and found themselves in a female body that functioned as playground, amusement park, shelter, and pleasure palace with a milk-bar installed in one breast and an early Greta Garbo film playing elsewhere. Saint Phalle's *Hon* reclaimed woman's body as a site of tactile pleasure rather than an object of voyeuristic viewing; the figure was both a playful and colorful homage to woman as nurturer and a potent demythologizer of male romantic notions of the female body as a "dark continent" and unknowable reality.

During the late 1960s and early 1970s, challenges to the hegemony of Modernism began to take place on many, often overlapping, fronts. Decisions by many artists to work outside the mainstream gallery/dealer system were part of a reaction against the growing commodification of the art object and the dehumanization of Pop, Postpainterly Abstraction, and Minimal art. Process artists reacted against the glamor of the object, replacing machine finished and expensive industrial materials with the by-products of industrial civilization: raw wood, rubber, felt, and other materials of no intrinsic value. Conceptual artists replaced objects with framed propositions and ideas. And, after 1970, many women began to formulate specifically feminist works based on a commitment to radical social change that addressed the ways that women's experience has been suppressed and/or marginalized in Western culture.

Challenges to Modernism occurred on many fronts; not all of them feminist, and not all of them restricted to women. Areas in which the work of women artists had a significant and lasting impact include the use of new materials and processes, the development of collective and collaborative ways of working, earthworks and environmental art, and of course feminist art. It is not possible to acknowledge the contributions of the many women working during this period and the brief survey that follows can only identify a few of the major tendencies and touch upon representative issues raised by women during this period.

312

191 Lee Krasner *Cat Image* 1957

192 Helen Frankenthaler *Mountains and Sea* 1952

Around 1964 the American Eva Hesse (1940–70) began to use industrial materials. She worked with rope, latex, rubberized cheesecloth, clay, metal, and wire mesh in pieces which are additive, tactile, and radical in their witty and iconoclastic use of media.

In 1966, Lucy Lippard included Hesse's work in the exhibition "Eccentric Abstraction" (which introduced the term "process art"). Hesse's notes and diaries form an integral part of the investigative process that made up her work. Although she did not identify herself as a feminist, she was acutely aware of the contradictions between her commitment to her art and the social expectations demanded of women. "I cannot be so many things," she wrote in her diary in January 1964. "I cannot be something for everyone. . . . Woman, beautiful, artist, wife, housekeeper, cook, saleslady, all these things. I cannot even be myself or know who I am." *Hang Up* (1966), a spare rectangular frame with a thin but flexible rod looping out from it and then back, is characteristic of her work in refusing to declare its meaning or to locate an inner "truth;" the frame presents a self-contained object, but the line which registers the mark of the artist is drawn in space, not captured permanently on a surface.

193

Many critics have remarked on the erotic qualities of Hesse pieces like *Ring Around Rosie* (1965) and *Accession* (1967) with their spongy 194 membranes, their interiors bristling with soft projections, and their use of accretion to build up forms. During the later 1960s, sexuality also emerged explicitly in the work of Louise Bourgeois whose personal, intuitive sculptural forms became a rallying point for many younger feminist artists. Bulbous, abstract shapes and penile forms are replicated in a variety of materials from plaster to latex, sometimes merging organically into composite forms, often part phallic, part fecal. The primary, sensual world she evokes is undifferentiated and "polymorphously perverse." One critic described her latex *Fillette* 197 (1968) as "a big, suspended decaying phallus, definitely on the rough side." Other pieces, like her series of small, female figures in plaster, clay, bronze, wax, and marble, are both aggressive and vulnerable.

The work of Bourgeois, Hesse, Marisol, and Saint Phalle implied kinds of content which could not be contained by formalist aesthetics. By 1966, the first rumblings of dissent were beginning to be heard in America and elsewhere. Within a few years, the cultural conflicts that divided a generation of Americans—racism, sexism, and militar-

ism—invaded the art world, until then secure in the belief that aesthetic issues transcended social concerns. It is black artists, and women (black and white)—Romare Bearden, Raymond Saunders, Betye Saar, Faith Ringgold, Emma Amos, May Stevens—who first gave visual form to the growing gulf between the white American dream and the black American reality. Although Pop art's embrace of American media imagery occasionally included images of blacks, their presence had tended to confirm white conventions and stereotypes. It is Romare Bearden's collages, the prints of Elizabeth Catlett, and the paintings of Raymond Saunders and Faith Ringgold which focused attention on the distance between the black community and the American mainstream.

During the 1960s, Catlett, Ringgold, and Stevens investigated the connections between patriarchy, racism, and imperialism. Catlett's (b. 1919) early involvement in the Civil Rights movement informed her sculpture of the 1960s, while Ringgold's (b. 1930) *American People Series* (1963–67) was influenced by the writings of James Baldwin and Amiri Baraka (then Leroi Jones). In 1966, she participated in the first exhibition of black artists held in Harlem since the 1930s, where the aftermath of the Harlem Renaissance of black culture could still be observed in the work of women artists like the painter Lois Mailou

196 Nikki de Saint Phalle *Nana* c. 1965

195 Nikki de Saint Phalle, Jean Tinguely,
Per Olof Ultvedt *Hon* 1966

197 Louise Bourgeois *Fillette* 1968

198 Faith Ringgold *Die* 1967

Jones and the sculptor Augusta Savage. The following year Ringgold
198 exhibited *Die*, a twelve-foot wide mural of a street riot painted in a
simplified representational style influenced by the 30s realism of
painters like Jacob Lawrence and Ben Shahn.

By 1968 May Stevens (b. 1924), who had also played an active role
in the Civil Rights Movement, was producing images in response to
199 the current racial strife. In *Big Daddy, Paper Doll*, fragmented but
menacing male figures are used to explore the relationship between
patriarchal power in the family and in social institutions like the
American judicial system. At about the same time, the Californian
artist Betye Saar (b. 1926) began incorporating stereotypic images of
blacks in collages and constructions. Influenced by Joseph Cornell's
boxes, their content, however, was political and angry rather than
200 dream-like and Surrealist. *The Liberation of Aunt Jemima* (1972), one
of a group of works dealing with white culture's stereotyped images
of blacks, included an Aunt Jemima image holding a small revolver in
one hand and a rifle in the other in a box papered with "mammy"
pictures.

A series of events in late 1969 and early 1970 led to the first protests
against racism and sexism in the American art world; out of these
interventions, and the growing Women's Liberation Movement,
came the feminist art activities of the 1970s. In December 1969, New
York's Whitney Museum Annual opened with 143 artists, only 8 of
whom were women. Ringgold launched a highly effective protest

199 May Stevens *Big Daddy, Paper Doll* 1968

200 Betye Saar *The Liberation of Aunt Jemima* 1972

against an exhibition at the School of Visual Arts in New York organized by Robert Morris, which attacked United States policies of war, repression, racism, and sexism but included no women artists (later corrected due to the effectiveness of the protest). Demonstrations against the Whitney Museum led to the formation of Women Artists in Resistance (WAR); Ringgold organized Women Students and Artists for Black Art Liberation (WSABAL); and the New York Art Strike Against War, Racism, Fascism, Sexism and Repression, organized by the Art Workers Coalition, closed New York museums for one day in May 1970. In the face of protests by blacks, students, and women, the fiction of an art world isolated from broader social and political issues by "objectivity," "quality," and "aesthetics" began to be exposed.

The work of Barbara Chase-Riboud (b. 1939) and Betye Saar was shown at the Whitney Museum (the first major museum exhibition of the work of contemporary black women artists) and Chase-Riboud dedicated the sculpture in her first solo show in New York to the memory of Malcolm X. When the percentage of women artists

201 Faith Ringgold *The Wedding: Lover's Quilt No. 1* 1986

represented in the Whitney Annual rose from fifteen in 1969 to twenty-two in 1970, "museum officials conceded, somewhat reluctantly, that pressure from the women's groups was effective."

The feminist movement in the arts—that is, the commitment to an art which reflects women's political and social consciousness—transformed artistic practice in America during this period through its constant questioning of and challenge to, patriarchal assumptions and ideologies of "art" and "artist." A renewed interest in women artists generally also spread to a number of artists from an earlier generation, many of whom had been professionally active since the 1930s. The work of Bourgeois, Neel, Bishop, Kahlo, Nevelson, and others began to receive the critical and public attention it had long deserved.

During the early 1970s, older women artists responded to the new, more open climate in a variety of ways. While some continued to insist that issues of gender were irrelevant in making art, others spoke out. Nevelson, interviewed by Cindy Nemser, made her views of how women were treated in the art world very clear; Bourgeois participated in feminist meetings and took part in protests while Krasner, insisting that she was not a feminist, nevertheless picketed the Museum of Modern Art along with other women.

The reclaiming of past histories was only one of the many areas of feminist investigation. Throughout the United States and Britain, in groups large and small, private and public, women in the arts began raising questions from where to exhibit as women and how to find space for working, to political, theoretical, and aesthetic issues.

Many women sought forms through which to valorize women's experience. The early 1970s saw an explosion of work which reinserted women's personal experiences into art practice. In 1970 Judy Chicago (b. 1939), a sculptor trained at the University of California in Los Angeles, organized the first feminist art course at the California State College at Fresno. The following year, Chicago and Schapiro established and taught a feminist art program at the California School of the Arts in Los Angeles.

During this period Chicago and Schapiro both made the transition from geometric abstractions in sculpture and painting to works specific to women's experiences of themselves and their bodies in which open, central forms predominated. Central core imagery was 202 part of an attempt to celebrate sexual difference and affirm woman's otherness by replacing connotations of women's inferiority with those of pride in the female body and spirit.

Virginia Woolf – first woman to forge a female form language

202 Judy Chicago, "Virginia Woolf," *The Resurrection Triptych* 1973

The ways that sexual difference is produced and reinforced through representations were central to the work of many women during this period. "A woman must continually watch herself," noted the critic John Berger. "From earliest childhood she has been taught and persuaded to survey herself continually. And so she comes to consider the surveyed and the surveyor within her as the two constituent yet always distinct elements of her identity as a woman." It was through Performance and Video art that many women chose to celebrate the body's rhythms and pains and explore the relationships between the body as the performing agent and the subject of the activity; and the body as site of the spectacle of the woman.

Some early performance works in America by Yoko Ono, Yvonne Ranier, and Carolee Schneeman were connected with Happenings, experimental dance and theater events, and Minimal and Conceptual art. By 1970, Joan Jonas, Mary Beth Edelson, Adrian Piper, Mierle Laderman Ukeles, and others, had begun performance works which relied heavily on narrative and autobiography. During the 1970s, these themes were also central to the work of Laurie Anderson, Eleanor Antin, Jackie Apple, Betsy Damon, Suzanne Lacy, Rachel Rosenthal, Faith Wilding, and Hannah Wilkie.

The self-conscious investigation of female subjectivity through images of the body was one aspect of the desire to celebrate female knowledge and experience. But as early as 1973, when Lucy Lippard listed a series of possible female characteristics in art ("A uniform density, an overall texture, often sensuously tactile and often repetitive to the point of obsession; the preponderance of circular forms and central focus . . . layers or strata; an indefinable looseness or flexibility of handling; a new fondness for the pinks and pastels and the ephemeral cloud-colors that used to be taboo"), there was already critical reaction against the idea of an ahistorical and transcultural female consciousness. While Chicago and Schapiro pointed to prototypes in the work of O'Keeffe and other women artists, other critics argued against celebrating difference in the terms in which it had already been laid down. From the beginning, many feminists reacted strongly to the idea of womb-centered imagery as just another reworking of biological determinism and a restrictive attempt to redefine femaleness. The notion of an unchanging female "essence" remained to be tested against theories of representation which argue that the meaning of visual images is culturally and historically specific and unstable; that is, with no fixed "truth" which can be uncovered.

A number of women painters turned to images of the male and female nude as sites for feminist investigations. Sylvia Sleigh's male nudes combine portrait genre with the nude as a representational type. In *Philip Golub Reclining* (1971), *The Turkish Bath*, and other 203 paintings of the 1970s, she reverses a history in which men contemplate the naked bodies of women. Other painters shifted the vantage point or challenged the idealizing conventions of Western art. Alice Neel (1900–84) had been working figuratively since the 1930s, but it was not until 1974 that she had her first major museum retrospective. Refusing superficial pleasantries, her portraits are vigorous and direct. A series of paintings of pregnant women refused 204 to generalize the expectant female within the conventions of fertility figures and earth mothers; instead, as Nochlin suggests, they dwell on the unnaturalness of pregnancy for modern urban women. In Joan Semmel's (b. 1932) larger-than-life paintings of the sex act, cropping the figures negates the distance and wholeness that fixes the image as a site of voyeuristic viewing pleasure. Surveying her own body, she presents the female image so that we see what she sees.

Many critics, however, have pointed to the difficulty inherent in any attempt to reposition the nude—male or female—in the conventions of Western art.

203 Sylvia Sleigh *The Turkish Bath* 1973

Other women, arguing that religious and symbol systems focused around male images of divinity affirm the inferiority of female power, chose to work with the archetype of the Great Goddess, isolating this image as a symbol of the life and death powers and the waxing and waning cycles of women, the earth, and the moon. Drawing on traditions of goddess worship in the ancient Mediterranean, pre-Christian Europe, Native America, MesoAmerica, Asia, Africa, and other places, Edelson, Damon, and other American artists, and Monica Sjoo, Beverly Skinner, Marika Tell, among others in Britain, used the imagery of the Goddess and goddess worshipping religions as an affirmation of female power, the female body, the female will, and women's bonds and heritage. Ana Mendieta (1948–85), a Cuban artist living in the United States, first used blood in a 1973 Performance piece protesting against rape. Subsequently, she began imposing the traces of her five-foot body on the earth in the environs of Ohio City, Oaxaca in Mexico, and other sites, outlining it with ignited gunpower, stones, flowers, fireworks or having herself bound in strips of cloth and buried in mud and rocks. Her work made powerful

205

204 Alice Neel *Pregnant Maria* 1964

205 Ana Mendieta *Untitled (Silueta Series)* c. 1977

identifications between the female body and the land, and did so in ways which annihilated the conventions of surface on which the traditions of Western art rest. Only traces of the mediated interaction between body and earth remained.

Feminist artists in many countries shared similar concerns, and feminism developed as an international movement, with local socio-economic and ideological factors shaping its expression in different ways. In Britain, feminism developed within an activist socialist politics. One of the earliest groups of women artists to organize was The Woman's Workshop of the Artists' Union, formed to combat the isolation of women through collective creative action. The first "Women's Liberation Art Group" exhibition was held in 1971 at the Woodstock Gallery in London. Two years later, Sjoo's *God Giving Birth* (1969), a birth image inspired by a goddess-worshipping religion and exhibited in the "Womanpower" exhibition, aroused intense controversy and the artist was threatened with legal action on charges of blasphemy and obscenity.

Sjoo, a Swedish artist, Liz Moore, and Skinner were among a group of artists in Britain using figurative imagery in opposition to the orthodoxy of formalist abstraction. At the same time, other women artists were pursuing their goals within contemporary political struggles, focusing attention on inequalities in arts education, as well as on the politics of work and domesticity. In 1974, Kate Walker and Sally Gollop organized "Feministo," an exchange of small art works through the mails. Later exhibited as "Portrait of the Artist as Housewife," the works initiated a sustained dialogue on the ideology of domesticity and femininity which circulated outside the commercial art gallery system. The following year, Mary Kelly, Margaret Harrison, and Kay Hunt collaborated on a documentary exhibition called "Women and Work" based on a group of workers in a Metal Box Company factory in Southwark, London.

Throughout this period, feminist artists challenged the assumptions and conditions of patriarchy using a variety of strategies and political tactics—from political actions demanding equal representation in schools and exhibitions to setting up alternative exhibition sites, and from celebrations of the power and dignity of women's sexuality and fertility/creativity to analyses of the ways that class, race, and gender structure women's lives. The work of the American artists May Stevens and Nancy Spero (b. 1926), exhibited in Britain as well as America, proved central to mapping the terrain of the social body in representation.

206

206 Monica Sjoo *God Giving Birth* 1969

Trained at the Art Institute of Chicago, Spero began work as a figurative artist during the abstract 1960s, and as a political artist in a formalist art world. She chose to work on paper rather than canvas as a rebellion against art world conventions of size and material, using the atom bomb and war as subjects for her first series. Experiments with collaging figures onto rice paper a few years later led to the *Codex Artaud* (1970–71) a work which explored the extremes of language and its limitations, drawing on the example of the French writer Antonin Artuad whose madness liberated him from the conventions of language. As a woman in an unsympathetic art world, Spero identified with Artaud's position as an outsider. Later, her investigations into the problematic areas of feminine subjectivity and language have found support in the writings of Hélène Cixous, who proposed an "écriture feminine," a writing of the female body which she opposes to the authoritarian forms of patriarchal discourse. In Spero's *Codex Artaud*, fragmented images, fragments of words, tongues which swell into the phallus of the Symbolic order which governs language in patriarchy, are all used to reinforce the marginality of Artaud's, and by extension woman's, language.

207–08

< 207, 208 Nancy
Spero *Codex Artaud*
1970–71 (detail)

209 May Stevens
Rosa from Prison
1977–80

In 1972, Spero began thinking again about political subject-matter. With the *Torture of Women in Chile* (1974), she decided to use only images of women in her work. She juxtaposed quotes detailing repression and torture with fragments of text and the fragmented bodies of women to analyze the conditions of the torture of women (which always implies sexual control over the bodies of women) and to explicate the timelessness of this practice. Later, using the female body image as protagonist, and parody, quotation, and repetition as linguistic devices, she explored multiple truths about women, their physical and spiritual strengths, their oppression under patriarchy, and their mythic and historical power.

The work of May Stevens examines specific women's lives in relation to the patriarchal structuring of class and privilege, and the polarities of abnormal/normal, silent/vocal, acceptance/resistance. Weaving her own biography with that of her mother and Rosa 209 Luxemburg in the series of works called *Ordinary/Extraordinary*, she layered her own memories and feelings with the personal and public images of two women, one of whom's life was lived entirely within the confines of family and work, the other of whom played a public

historical role. She exposed the false dichotomy between the public and the private in art and in history, and used paintings, collages and the artist's book to reveal the human side of this Polish German revolutionary and political activist, and to make public the silent life of her own working-class mother, whose personal suffering represents the political oppression of all disadvantaged women for whom, without knowledge of history, collective action is impossible.

During the same period, other women—painters and sculptors—chose to work within mainstream concerns. Throughout the 1970s, women continued to work within expanded definitions of form and materials. While some of this work was specifically feminist other women, ignoring the sex of maker and audience, developed their forms within conceptual and pictorial interrogations of materials and processes which had begun during the 1960s but which gained new momentum and support from the women's movement.

The combining of an abstract formal vocabulary with materials and forms inflected by female associations is characteristic of the work of Joan Snyder, Lynda Benglis, Audrey Flack, and others. Snyder's (b. 1940) paintings of the 1970s related to older traditions of abstraction, while increasingly using personal signs and marks. *Small Symphony*

210 Joan Snyder *Heart-On* 1975

211 Audrey Flack *Leonardo's Lady* 1974

for Women (1974), *Vanishing Theater* (1974–75), and *Heart-On* (1975) 210 combine and recombine themes and images, transforming the individual consciousness behind the Abstract Expressionist gesture into a political response born out of an awareness of the collective experiences of war, the student riots of the late 1960s, and the women's movement. Benglis (b. 1941), after first making narrow wax paintings the length of her arm, began pouring polyurethane pieces, moving from single freestanding objects to rows of extruded forms attached to the wall. Her subsequent use of rubber and latex was influenced by Hesse's choice of materials and by the work of Schapiro and Chicago in California with its developing iconography of female imagery and costuming. Flack (b. 1931), one of the first photorealists, 211 repainted the *vanitas* as an icon of femininity, while Idelle Weber, Sylvia Mangold, Janet Fish, and others introduced new subjects into realist painting.

In the early 1970s, Ringgold began using fabric in soft sculptures, and later in political collage/poems and "story-quilts," made with her 201 mother Willi Posey, a dress-designer. Other women chose fabric, thread, and glitter for their associations with women's cultural traditions.

331

The use and development of non-traditional materials in art, combined with feminist consciousness about the relationship between certain materials and processes and women's cultural and historical traditions, led to an intense questioning of art traditions. Why was Hesse's use of rope exhibited in "art" galleries and museums, while Claire Zeisler's rope pieces remained in "craft" galleries? Why were Jackie Winsor's grids "art" and Lia Cook's grids "craft?" As some distinctions between "art" and "craft" seemed to break down, or at least to fray around the edges, why did some women prefer to continue creating within the "fabric structure process" while others sought to abolish the distinction between "craft" and "art?" The 1971 exhibition, "Deliberate Entanglement," at the University of California in Los Angeles Gallery did much to further the international development of art in fiber during the 1970s and the work of Zeisler, Lenore Tawney, Sheila Hicks, and Magdalena Abakanowicz received international attention with many critics arguing for a rejection of the art/craft dichotomy.

The idea of using fabric as an art material both summed up the iconoclasm of the 1970s and established a context within which to mount a feminist challenge to the way art history honored certain materials and certain processes instead of others. The movement known as Pattern and Decoration, which attracted both men and

212 Magdalena Abakanowicz
Backs 1976–80

213 Miriam Schapiro
American Memories 1977–80

women, formalized the use of fabric and surface elaboration as an assault on the rhetoric of Geometric Abstraction and the gender-biased use of the term "decorative." In California in the early 1970s, Schapiro and Joyce Kozloff (b. 1942) turned to decorative imagery as a source for feminist paintings, and students and faculty at the University of California at San Diego began exploring the motifs and philosophy of Oriental design.

In 1973, Schapiro, building on her use of needlework and fabric in *The Dollhouse* which she had designed with Sherry Brody for the "Womanhouse" exhibition in 1973, began combining fabric collage and acrylic painting in abstract paintings which she called "femm- 213 ages," "a word invented by us to include all of the above activities (i.e., collage, assemblage, decoupage, photomontage) as they were practiced by women using traditional women's techniques to achieve their art—sewing, piecing, hooking, cutting, appliquéing, cooking and the like—activities also engaged in by men but assigned in history to women." Two of Schapiro's femmages were exhibited in 1976— *Cabinet for All Seasons*, and *Anatomy of a Kimono*, a fifty-foot wide 216 painting/femmage in which scale is used to "reinvest what has previously been dismissed as modest with the scope of history painting." The first artist-organized Pattern and Decoration exhibition included Valerie Jaudon's invented surface patterns based on

333

214 Islamic and Celtic traditions and Kozloff's *Hidden Chambers* (1975), a work derived from Islamic tile patterns and based on the opposition of two decorative systems in which the superimposition of colors and pattern leads to a shifting sense of space.

 The critic Jeff Perrone, discussing the Pattern and Decoration movement, which extended well beyond the few artists discussed here, noted in 1976 that in the process of taking over surface patterns decoration always loses the meaning it had in its historical culture. More recently, critics have questioned appropriations which are ahistorical and transcultural and that universalize as a formal device surface decoration from non-Western peoples, without regard to its specific origins. At the same time, many feminists remain divided over whether the attempt to valorize the neglected "other" of high art does not instead perpetuate it as an alternative tradition, a "woman's" tradition.

 Hesse and Bourgeois had used materials uncommon in the history of sculpture to form objects which were powerfully tactile and suggestive, yet which relied on an abstract formal language. Nancy Graves (b. 1940), in her camel sculptures, and Jackie Winsor (b. 1941), in pieces made from plywood, pine, rope, twine, trees, lath and nails, also addressed issues of material and process. The labor-intensive

215 process of binding used by her in works like *Bound Grid* (1971 72), *30 to 1 Bound Trees* (1971), and others, also recalls a hidden history of female productivity in areas like needlework, basketry, and

214 Joyce Kozloff
Hidden Chambers 1975

215 Jackie Winsor
Bound Grid 1971–72

quiltmaking. Winsor's work made visible what has historically been a hidden process—the complexity and labor of women's traditional handicrafts—establishing it in dialogue with traditional mainstream sculptural concerns such as those of scale and material.

Many artists chose to put their works in the landscape rather than the gallery. Graves's desire to connect the processes of art-making with other systems of knowledge, and Winsor's interest in natural materials and sites, were shared by other artists who, during the 1970s, began to use landscape forms and sites. Although the move into the landscape corresponded with a growing public concern for the ecology, earthworks had less to do with ecology in most instances than with expanding the boundaries of art. Although the works of Robert Smithson, Dennis Oppenheim, Nancy Holt, Walter DeMaria, Mary Miss, Alice Aycock, Michelle Stuart, Michael Heizer, and others took place in nature, much of the work found its way back into the gallery in the form of materials and documentation. The monumental scale at which Smithson, DeMaria, Heizer, and Oppenheim worked is shared neither by women artists, nor by many of their European contemporaries, men or women. The reasons, however, have less to do with innate differences between men's and women's sensibilities, or their relationship to the earth and to nature, than with their differing access to the patronage which funded earthworks.

335

Many women sculptors' work reveals a concern with issues of geological time, the perception and experience of landscape, and the earth's annual cycles. It is about experiencing nature in terms of architectural sites, and about psychological, mythical, and historical associations with such sites. Michelle Stuart's (b. 1938) *Earth Scrolls* or drawings of 1973–76, which use rocks from different strata to register color, were based on her direct experience when growing up of the fissures and layers of southern California.

The work of Miss, Aycock, George Trakis, Holt, and Michael Singer uses sculptural form to construct the landscape as the site of a visual and tactile experience. That of the French sculptors Anne and Patrick Poirier invests archeological forms with mythic and fantastic asssociations. Miss's (b. 1944) *Perimeters/Pavilions/Decoys* (1978) included three towers and an underground atrium excavation as places from which to see and experience the land and sky. The scale was human and the whole work provided visual and experiential paradoxes: towers which could be seen into but not entered, underground chambers that could be entered but not seen. Aycock's (b. 1946) *Black Hecate, White Goddess*, and other works, often using the maze as a form, make explicit associations between ancient beliefs in women's powerful identification with the earth and the cycles of nature, and contemporary forms.

Nancy Holt's *Sun Tunnels* (1973–76) also address issues of the timeless quality of the earth and its annual cycles. On a forty-acre site which she purchased in the Great Basin Desert in northwestern Utah, four concrete tunnels are laid in an open X shape marking the seasonal extreme positions of the sun on the horizon. Holes of 7, 8, 9, and 10 inches in diameter in the upper half of the tunnels correspond to stars in four different constellations. Again, an interest in the archaeological and mythical past informs the exquisitely detailed reconstructions of imaginary, or partly imaginary, cultures made by the Poiriers. *Ostia Antica* (1971–73) is an elaborate ten-yard long terracotta reconstruction in model form that is neither fiction nor reality.

During the same period, a number of women painters, not necessarily feminist, made significant contributions to the elaboration of mark and shape as expressive pictorial devices. The work of Hanne Darboven, Jennifer Bartlett, and Dorothea Rockburne grew out of a conceptually based non-gestural abstract language; that of Elizabeth Murray, Susan Rothenberg, Miriam Cahn, Pat Steir, and others, was centered in the new expressionism of the later 1970s. They combine research, discovery, and analysis in their approach to the formal issues

216 Miriam Schapiro *Anatomy of a Kimono* 1976

217 Anne and Patrick Poirier *Ostia Antica* 1971–73

218 Alice Aycock *Maze*
1972

219 Michelle Stuart
Niagara II 1976

220 Hanne Darboven *24 Gesänge–B Form* 1970s

of painting and their work refuses easy categorization within Modernist paradigms.

Around 1965 Darboven (b. 1941), a young German artist, began developing simple but flexible numerical systems. Recorded first in notebooks, the pages of which provided modules for larger installations, the best known of her systems were based on day, month, year, century—the digits added and multiplied until they became unmanageable, and then broken down into progressively smaller areas which could in turn be reexpanded. Graphic records of process and time, the individual pages were combined into wall or 220 room-sized installations. Shortly after graduating from Yale in 1965, Bartlett (b. 1941) began to use chance as a way of selecting paint colors and steel plates for flat surfaces that would adhere to walls. In 1976, she completed *Rhapsody*, a large environmental painting made up of 988 221 square steel plates which took up approximately 154 feet of wall space. Described by the artist as "a conversation, where you start with a thought, bring in another idea to explain it, then drop it," the work had a total of twelve themes, including four kinds of lines, three shapes, four archetypal images (mountain, house, tree, ocean) and twenty-five colors of the kind commonly found in plastic model kits.

Bartlett's interest in systematizing the marks, dots, and strokes that make up representation, and her analysis of shape were shared by other artists. In the late 1970s Gillian Ayres (b. 1930), a British artist whose earlier works were Hard-Edge abstractions, began using heavily impastoed surfaces and stressing the painterly mark as an expressive device. Elizabeth Murray's (b. 1940) formal vocabulary developed out of a collection of simplified shapes based on common household and studio objects. Their fragmentation, layering, and recombination in daring compositions that are part sculpture, part painting shift the emphasis from figuration to abstraction, and from formal play to the conceptual framing of ideas. Pat Steir's (b. 1938) multi-panel paintings, a massive summing up of painting-about-painting, on the other hand, challenge cultural assumptions about artistic "individuality." *The Breughel Series (A Vanitas of Style)* (begun 1981) is a two-part, eighty-panel work in which a still-life of flowers in a vase becomes a visual puzzle combining artistic styles

222

221 Jennifer Bartlett *Rhapsody* 1975–76 (detail)

from the High Renaissance to Abstract Expressionism. Assuming the "hands" of painters from Watteau to Pollock, Steir investigates the essence of style, theirs and hers.

This work of the 1970s reveals an extraordinary diversity of social and artistic practices. Women negotiated new relationships to mainstream issues and art world institutions, and/or established alternative models for female creativity and exhibition sites. Their productions range across many materials and processes, from intimate and personal expressions to collective and monumental public statements. The political and social protests of the late 1960s focused attention on American society not as a "melting pot" but as a collection of multi-ethnic and multi-racial communities, further broken down by class, age, and gender. The development of collaborative and socially conscious working models provided new public forums for the collective expressions of such groups, both in America and Europe.

222　Pat Steir *The Breughel Series (A Vanitas of Styles)* 1981–83 (detail)

DUSTBOWL REFUGEES

223 Judy Baca *The Great Wall of Los Angeles* begun 1976 (detail)

The imagery for many public mural projects, as well as for other public art and performance, evolved in dialogue with local people to produce an art that is socially concerned and artistically strong. In San Francisco, the Mujeres Muralistas, the first women's mural collective, produced stunning public murals fusing the rich tradition of the Mexican muralists with contemporary history. In Los Angeles in 1973, the artist Judy Baca (b. 1949), after completing murals at a state women's prison and at a religious convalescent home, prepared to begin a monumental history painting. The *Great Wall of Los Angeles* runs more than one-third of a mile along a flood control channel in the San Fernando Valley. It contains a history from the prehistoric pueblo to the present, organized in images that include the 1781 founding of Los Angeles, the coming of the railroad, scenes of the deportation of Mexican-Americans in the 1930s and Japanese-Americans the following decade, and the 1984 Olympic Games in Los Angeles. Los Angeles was also the site of Suzanne Lacy's (b. 1945) first citywide organizing feat, *Three Weeks in May* (1977), a three-week examination of and protest about rape. That year Lacy began collaborating with Leslie Labowitz (b. 1946), an artist and theorist who had studied with Joseph

224 Suzanne Lacy and Leslie Labowitz *In Morning and in Rage* 1977

225 Maya Lin *Vietnam Veterans Memorial* 1975

228 Las Mujeres Muralistas, mural, 1974

226 (*left above*) Sonia Boyce *Missionary Position No. 2* 1985

227 (*left below*) Judy Chicago *The Dinner Party* begun 1974

Beuys. Their first collaboration, *In Mourning and in Rage* (1977), was 224 performed outside the Los Angeles City Hall. It brought women together to address the media's sensationalized coverage of a series of murders and, more generally, the spread of violence against women in American cities. Lacy and Labowitz founded "Ariadne: A Social Network," an organization intended to bring together women in the arts, media, and government who were committed to feminist issues.

Not all public work executed during this time was collaborative. Working individually, Maya Lin, a young architecture student, gave new form to the idea of the public monument in her Vietnam War 225 memorial for Washington, D.C. (dedicated in 1982). An austere black granite wall slicing into the ground near the Washington Monument,

its surface inscribed with the names of the thousands of soldiers who gave their lives in a war that deeply divided American society, it succeeded as no monument before in calling forth and embodying a culture's conflicted response to its history.

Women's collective histories did, however, inspire Judy Chicago's *Dinner Party*, a monumental testament to women's historical and cultural contributions which incorporated sculpture, ceramics, china painting, and needlework. Begun in 1974 with the help of the industrial designer Ken Gilliam, by 1978 it had been worked on by more than one hundred women. The piece attracted some of the largest crowds ever to attend a museum exhibition when it was shown at the San Francisco Museum of Modern Art in April 1978. It consisted of an equilateral triangle 48 feet a side with 39 place settings commemorating women in history and legend with an additional 999 names inscribed on the marble floor beneath. Each place included a ceramic plate, with a central raised motif designed by Chicago to symbolize the woman honored, a brilliantly colored runner executed in needlework techniques appropriate to the subject's period, and a cup. The workshop nature of the piece mobilized the energies of hundreds of women and its influence was expanded through an ongoing quilt project and events like Lacy's *The International Dinner Party*, organized to accompany the work in San Francisco.

Chicago's desire to promote social change by creating respect for women's history and productions, to articulate a new language with which to express women's experience, and to address such a work to the widest possible audience was controversial. While some critics applauded the work's social and political intent, others attacked Chicago's central-core images as literal vaginal depictions rather than metaphoric celebrations of female power. Still others viewed the work as playing to the grand scale of conservative Salon painting and reproducing the structures of the Renaissance workshop with its "master" artist and its anonymous apprentices (even though Chicago scrupulously listed the names of all her assistants at the entrance to the gallery). *The Dinner Party's* assumption of a fixed and timeless female lineage and sensibility brought it into conflict with theories that posited femininity as socially produced rather than innate.

A Postmodern Postscript

The pluralism of the 1970s has been viewed as a symptom of the disintegration of the set of practices (abstract painting, minimal sculpture, etc.) through which Modernism was defined. By the late 1970s, a reaction against pluralism, and a backlash against women and minorities, could also be observed within the dominant institutions and discourses of the art world. Exhibitions celebrating the "return" to painting, and focusing on a new generation of male Neoexpressionists—for example, David Salle, Julian Schnabel, and Francesco Clemente—were remarkable for their exclusion of virtually all women: "Zeitgeist" (Berlin, 1982, 40 artists, 1 woman); "The Expressionist Image: American Art From Pollock to Now" (New York, 24 artists, 2 women); "The New Spirit in Painting" (London, 1981, no women). In 1984, women once again picketed the Museum of Modern Art, New York, protesting against the inaugural exhibition of its remodeled galleries ("An International Survey of Recent Painting and Sculpture") in which, out of 165 artists, only 14 were women. The Guerrilla Girls, an anonymous group of women artists, began installing posters on the buildings of Manhattan's Soho district which graphically and statistically documented sexism and racism in New York galleries and museums.

The term Postmodernism has been used to characterize the breaking down of the unified (though hardly monolithic) traditions of Modernism. The women's art movement exists in a dialectical relationship with Modernism's processes and institutions. The complicated relationship between feminist practices, which are both oppositional and also conditioned by terms of Modernism, and dominant cultural forms is the subject of Griselda Pollock's recent essays, "Feminism and Modernism" and "Screening the Seventies: Sexuality and Representation in Feminist Practice—A Brechtian Perspective." This issue remains central to critical debates within Postmodernism and Feminism.

Postmodernism has embraced a wide range of practices—from photography, abstract painting, collage, and drawing, to constructed

229 Paula Rego *The Family* 1988

sculpture, installations and public art, and more or less traditional methods of art-making. Some artists have been political, others have embraced philosophical or theoretical models, still others work intuitively. In the late 1980s, some women artists have received considerable public and critical attention, and certain kinds of feminist practice were incorporated into debates on Postmodernism. Feminist critics, however, remain sensitive to the dangers of confusing

230 Jaune Quick-to-See Smith *Site: Canyon de Chelly* 1980s

tokenism with equal representation, or the momentary embrace of selective feminist strategies with the continuing subordination of art by and about women to what is, in the words of Pollock, "falsely claimed to be the gender free Art of men." It is important to bear in mind that, although debates within the mainstream have often focused on deconstructive art practices, many women artists continue their commitment to political activism and to evolving images,

materials, and processes that address concerns central to women's experiences.

The fact that Postmodernism draws heavily on existing representations, rather than inventing new styles, and that it often derives its imagery from mass media or popular culture, has drawn attention to the ways that sexual and cultural difference are produced and reinforced in these images. The emergence of a set of critical practices within Postmodernism has led to critiques of how media images position women, and of the social apparatus by which images reinforce cultural myths of power and possession. These issues have been central to exhibitions like "Women's Images of Men" (London, 1980), originally organized to protest about Allen Jones's exhibition of women as furniture at the Institute of Contemporary Art; "Issue: Social Strategies by Women Artists" (London, 1980); and "Difference: On Representation and Sexuality" (New York and London, 1985).

Women involved in painting today often find themselves negotiating a complex territory as they seek to locate themselves within a tradition where they have been historically discriminated against and which has been defined in male terms. Women assuming a position in relation to the art of the past and specifically the traditions of painting, confront numerous assumptions—about the creative process, artistic "style" or methods of applying paint, subject, etc. While some women have approached these issues through deconstructing visual imagery and challenging art history's omissions of almost all women from its canon, others have critically explored the processes of image-making and the relationship between mark-making and the social construction of femininity.

Alexis Hunter, Therese Oulton, Nancy Spero, and Ida Applebroog are among the many women painters committed to re-orienting painterly conventions. Around 1980, Hunter (b. 1948), who came to London in 1972 from New Zealand, turned from conceptual and textual work addressing debates within the women's movement to mythic, expressive painting. A 1982 series of large acrylic paintings about women's cycles and the premenstrual syndrome led to a series of paintings entitled *Dreams, Nightmares and Male Myths* which use
233 visual parody to expose the oppressive patriarchal nature of Greek and Christian myth. Oulton's (b. 1953) paintings of the 1980s emphasize the materiality of paint and the expressive gesture as a political stance used to interrogate older conventions of painting. She has argued that; "You don't *clean* a language: you've got a debased form—and if

350

THE ADVANTAGES OF BEING A WOMAN ARTIST:

Working without the pressure of success.

Not having to be in shows with men.

Having an escape from the art world in your 4 free-lance jobs.

Knowing your career might pick up after you're eighty.

Being reassured that whatever kind of art you make it will be labeled feminine.

Not being stuck in a tenured teaching position.

Seeing your ideas live on in the work of others.

Having the opportunity to choose between career and motherhood.

Not having to choke on those big cigars or paint in Italian suits.

Having more time to work after your mate dumps you for someone younger.

Being included in revised versions of art history.

Not having to undergo the embarrassment of being called a genius.

Getting your picture in the art magazines wearing a gorilla suit.

Please send $ and comments to: **GUERRILLA GIRLS** CONSCIENCE OF THE ART WORLD
Box 1056 Cooper Sta. NY, NY 10276

WHEN RACISM & SEXISM ARE NO LONGER FASHIONABLE, WHAT WILL YOUR ART COLLECTION BE WORTH?

The art market won't bestow mega-buck prices on the work of a few white males forever. For the 17.7 million you just spent on a single Jasper Johns painting, you could have bought at least one work by all of these women and artists of color:

Bernice Abbott	Elaine de Kooning	Dorothea Lange	Sarah Peale
Anni Albers	Lavinia Fontana	Marie Laurencin	Ljubova Popova
Sofonisba Anguisolla	Meta Warwick Fuller	Edmonia Lewis	Olga Rosanova
Diane Arbus	Artemisia Gentileschi	Judith Leyster	Nellie Mae Rowe
Vanessa Bell	Marguérite Gérard	Barbara Longhi	Rachel Ruysch
Isabel Bishop	Natalia Goncharova	Dora Maar	Kay Sage
Rosa Bonheur	Kate Greenaway	Lee Miller	Augusta Savage
Elizabeth Bougereau	Barbara Hepworth	Lisette Model	Vavara Stepanova
Margaret Bourke-White	Eva Hesse	Paula Modersohn-Becker	Florine Stettheimer
Romaine Brooks	Hannah Hoch	Tina Modotti	Sophie Taeuber-Arp
Julia Margaret Cameron	Anna Huntingdon	Berthe Morisot	Alma Thomas
Emily Carr	May Howard Jackson	Grandma Moses	Marietta Robusti Tintoretto
Rosalba Carriera	Frida Kahlo	Gabriele Münter	Suzanne Valadon
Mary Cassatt	Angelica Kauffmann	Alice Neel	Remedios Varo
Constance Marie Charpentier	Hilma af Klimt	Louise Nevelson	Elizabeth Vigée Le Brun
Imogen Cunningham	Kathe Kollwitz	Georgia O'Keeffe	Laura Wheeling Waring
Sonia Delaunay	Lee Krasner	Meret Oppenheim	

Information courtesy of Christie's, Sotheby's, Mayer's International Auction Records and Leonard's Annual Price Index of Auctions.

Please send $ and comments to: **GUERRILLA GIRLS** CONSCIENCE OF THE ART WORLD
Box 1056 Cooper Sta. NY, NY 10276

you're a painter, that's the language you've got to work with. . . .
There's no hope in out of the blue creating a new language that's free
232 of all those associations." Oulton's *Spinner* (1986) is one of a series of
paintings called *Letters to Rose* which refuse traditional ways of
"reading" by disrupting conventional modeling, chiaroscuro, and
surface. Directed to the trivializing of women (as flowers and
decorative objects) and women's work (spinning and weaving), they
belong within a crisis in representation initiated by feminist resistance
to the imagery of the female body.

 The work of Rosemary Trockel, Eva Maria Schon, Elvira Bach,
Rebecca Horn, and other German women, was influenced by Joseph
Beuys's conceptual and socio-political art, and the emergence of a
new, "heroic" Expressionism in German painting and sculpture
during the 1970s. These artists also resist unmediated expressions or
"meanings," emphasizing instead ironic commentaries on categories
of human knowledge from morphology and metaphysics to
sociology and archaeology. Trockel's machine knitted paintings
incorporate political symbols or company logos into their fabric. Her
234 intentionally styless and naive drawings, like the paintings of Elvira
Bach, often use female images to parody the sexual stereotypes of

232 Therese Oulton
Spinner 1986

233 Alexis Hunter *Considering Theory* 1982

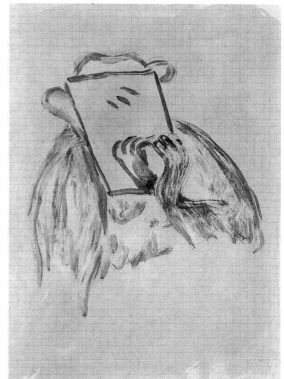

234 Rosemary Trockel *Untitled* 1983

German painting. In England, Paula Rego (b. 1935) returned to the figurative tradition of history painting but used heroic scale, harsh 229 lighting, and theatrical compositions to present a pantheon of female figures traditionally suppressed in accounts of male exploits. *The Soldier's Daughter* (1987), *The Cadet and His Sister* (1988), and other works propose a new iconography for the female heroine. Many contemporary women sculptors, including Magdalena Jetalova, a Czechoslovak now in West Germany, Susana Solano in Barcelona, Heidi Fasnacht in New York, and Alison Wilding in Great Britain, continue the feminist tradition of using materials and working at scales that defy stereotyped notions about "women's" art.

Still other women, and some men, have adopted the radical stance of refusing images of women in their work in order to subvert the use of the female image as object and spectacle. Mary Kelly (b.1941), an 235 American in London, exhibited the opening section of her *Post Partum Document* (begun in 1973) at the Institute of Contemporary Art, London, in 1979. Kelly's multi-sectioned work, like Chicago's *Dinner Party* of the same years, addresses the positioning of woman in

354

patriarchal culture. The assumptions underlying the two works, as well as their visual and conceptual articulation, reveal these artists' very different relationships to theoretical debates within the women's movement. Chicago's piece embodies a belief in female sexuality as an innate quality and was produced when women's demands for an autonomous and self-defined sexuality became a metaphor for the struggle for personal liberation. Kelly's work emphasizes sexuality as an effect of social discourses and institutions and stresses the potentially oppressive socio-psychological production of sexuality.

Kelly's *Post-Partum Document* (1973–79) is a 6-section, 165-part work that uses multiple representational modes (literary, scientific, psychoanalytic, linguistic, archaeological) to chronicle her son's early life and her relationship with him. She noted; "Such work is scripto-visual precisely because feminine discourse is trying to articulate the unsaid, the 'feminine,' the negative signification, in language which is coincident with the patriarchy; for this reason the work is always in danger of being subsumed by it, but insofar as the feminine is said, or articulated in language, it is profoundly subversive."

In *Post-Partum Document*, Kelly deconstructs the psychoanalytic discourses on femininity and the assumed unity of mother and child in order to articulate the mother's fantasies of possession and loss. From the chronicling of the child's first syllabic utterances to the museum parody of diaper stains—mounted in plexi-boxes like the best examples of modernist works on paper—the work proceeds through an elaborate analysis of the process leading to the child's insertion into the patriarchal order as a gendered (male) subject. The use of found objects and fragments of text replaces the idea of motherhood as a simple biological and emotional category with a recognition that it is instead a psychological and social process that is masked by the ideology of "instinctive and natural mothering."

Post Partum Document draws heavily on Lacan's analysis of language and sexuality, and on Foucault's emphasis on sexuality as an effect of social discourses and institutions. Like Freud, Lacan believed that the child's psychosexual development was fundamentally determined at the moment of the Oedipal crisis. Before that the child belongs within the realm of the Imaginary, where it believes itself to be a part of the mother and perceives no separation between itself and the world; there is no difference and no absence, only identity and presence. The child enters the Symbolic order with the acquisition of language and the child's acceptance of the Law of the Father as a prohibition against the child's incestuous desire for the mother, giving

355

up imaginary identity with all other possible speaking positions. The male child enters a Symbolic order in which the penis signifies the phallus which stands for patriarchal power and law; the female child is confronted with her lack of the penis and its phallic power. If the phallus is the privileged signifier in Western society, and the penis its physical stand-in, then women can only occupy a position of lack, of otherness.

During the late 1970s and the 1980s, a number of artists, male and female, tried to decenter language within the patriarchal order, exposing the ways that images are culturally coded, and renegotiating the position of women and minorities as "other" in patriarchal culture. Some of these strategies were feminist, others were part of more generalized Postmodernist discourses. Their effectiveness as interventions and their potential to change the structures of viewing and image consumption remain controversial. Jenny Holzer's "Truisms" and Barbara Kruger's juxtapositions of fragmented images with bits of text are part of their decision to appropriate and deconstruct the dominant language of mass media and advertising. Like other artists developing critiques, Holzer and Kruger believe that in criticizing a tradition the codes of that very tradition must be employed.

In Kruger's (b. 1945) blown-up, severely cropped photographs of women, and in their short accompanying text the viewer is confronted with the message that something is wrong. Her texts often
236 conflate the discourses of art and sexuality—"Your Gaze Hits the Side of My Face"—and they always subvert the meaning of the visual image. She emphasizes the way in which language manipulates, and undermines the assumption of masculine control over language and viewing, through her refusal of completion and her assertion of a position of "otherness."

Like many artists working to extend conceptualism into Postmodernism, Holzer (b. 1950) also stresses art as information. Her move to Manhattan in 1977 challenged her to engage her art with the intense verbal assaults that characterize life on New York streets. She is now
237 best known for her anonymous posters of "Truisms" and "Inflammatory Essays." Originally printed in black italic type on white paper, they later appeared as billboards, on benches, and as computerized moving signs. Holzer's messages seem to offer information, but the "Truisms" are mostly opinions and the "Essays" demands. The topics range from the scientific to the personal and include "thoughts on aging, pain, death, anger, fear, violence, gender, religion, and

356

236 Barbara Kruger
*Untitled (Your Gaze Hits
the Side of My Face)* 1981

237 Jenny Holzer
Selection of Truisms 1982

politics." Although they sound completely familiar, Holzer invents
and polishes them until they assume the authoritative "voice" of mass
culture: "Morals are for little people/ Mostly you should mind your
own business/ A little knowledge goes a long way/ Action causes
more trouble than thought," and others.

These works expose the "anonymous" voice behind the camera or
media language as speaking from and for the patriarchal order. The
work of Cindy Sherman, Sherrie Levine, Louise Lawler, Sarah
Charlesworth, and others uses photographs as a critical means.
Sherman's (b. 1954) work from 1978 reveals gender as an unstable
position. Her photographs challenge the idea that there might be an
innate, unmediated female sexuality by exposing the fiction of a
"real" woman behind the images that Western culture constructs for
our consumption in film and advertising media. In 1978, she began
placing her own body in the conventions of advertising and film
images of women, many of them drawn from the 1950s and 1960s, in
order to act out the psychoanalytic notion of femininity as a
masquerade, that is, as a representation of the masculine desire to fix
the woman in a stable and stabilizing identity. Sherman's work denies
this stability. Although her photographs are always self-portraits,

238

 238 Cindy Sherman *Untitled* 1979

239 Sherrie Levine *After Walker Evans* (1936)

they never reveal anything about Cindy Sherman the person and her image functions only as an object of contemplation for the gazes of others.

Sherrie Levine (b. 1947), on the other hand, has rephotographed, and repainted, canonical works of Modernist art from the photographs of Walker Evans and Edward Weston to the paintings of Kasimir Malevich and Vladimir Tatlin. Rephotographed works, like Walker Evans' *Alli May Burroughs* (1936) which she has exhibited as 239 her own, raise questions about originality and works of art as property in a culture which experiences much art only through its reproduction. Abigail Solomon Godeau and other critics have argued that the difference between a print by Weston or Walker (which may not originally have been printed by the artist anyway), and a print by Levine, is not in any way fundamental or essential.

Levine's work not only contests notions of originality and authorship, it situates those ideas within the premises of patriarchy. Levine does not pretend to be the maker of the original image; nor does she merely emphasize that "originality" in mechanical reproductions is ambiguous. Hers is an act of refusal: refusal of authorship, rejection of notions of self-expression, originality, or subjectivity.

The concept of authorship, protected by copyright like property, and related to the concept of "authority," belongs to a patriarchal society which until recently in most of Western Europe barred women from holding property in their own names. Levine's appropriations situate her work outside property and authorship and undermine the ideology of the artist as the bearer of a privileged subjectivity.

In 1985, the exhibition "Difference: On Representation and Sexuality" brought together the work of a number of British and American artists, including Ray Barrie, Victor Burgin, Hans Haacke, Kelly, Silvia Kolbowski, Kruger, Levine, Yve Lomax, Jeff Wall, and Yates, which deals specifically with the intersection of gender and representation. In her introduction to the catalogue, Kate Linker noted that; "In literature, the visual arts, criticism, and ideological analysis, attention has focused on sexuality as a cultural construction, opposing a perspective based on a natural or 'biological' truth. This exhibition charts this territory in the visual arts. . . . Its thesis—the continuous production of sexual difference—offers possibilities for change, for it suggests that this need not entail reproduction, but rather a revision of our conventional categories of opposition."

Refusing the image of woman as "sign" within the patriarchal order, these artists have chosen to work with an existing repertory of cultural images because, they insist, feminine sexuality is always constituted in representation and as a representation of difference. Kolbowski's work disrupts the conventions by which the gaze structures the female body as an object of desire. She uses fashion photographs because it is here that desire is conventionally displaced from the female body to a product which can be consumed. The 240 *Model Pleasure* project, begun in 1982, consists of ten parts, each composed of a wall-grouping of images from fashion and advertising prints, rephotographed, and reassembled into gridded compositions. Cropped images of women models are juxtaposed with a drawing of a turkey, the leg of which is being carved, a drawing of a foot titled "Charm Anklet," a fashion photograph of a foot wearing a high-heeled shoe, and a text that reads; "There was something she carved/craved; something which cost/cast its spell upon me, while it still remaimed/remained unscene/unseen. . . ." Such puns reinforce the double meaning commonly associated with media imagery: sex and nourishment, craving and consuming, women and meat, product and pleasure. The images that she reproduces are those that, in her words, "not only sell products but also massively establish—for both men and women—our sense of the ideally feminine. . . ."

240 Silvia Kolbowski *The Model Pleasure Series* 1984

241 Marie Yates *The Missing Women* 1982–84 (detail)

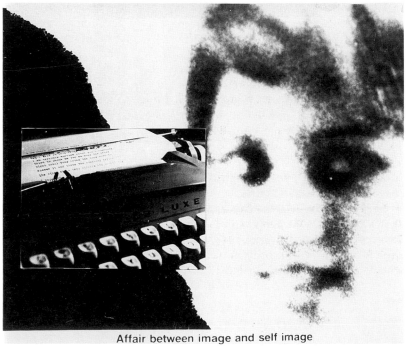

Affair between image and self image

SUPPLICATION

The work of Yves Lomax and Marie Yates investigates the relationship between the so-called enigma of femininity and the "truth" of photographic representation. Parodying psychoanalytic theories of sexual difference, Lomax uses irony to expose their 241 phallocentricity. Yates's *The Missing Women* (1982–84) consists of twenty-five panels of different images, each made up of smaller segments containing visual and verbal signs and fragments which obliquely suggest a soap opera plot. The viewer is invited to construct the identity of a woman who is revealed only by the traces of her social engagements—the family, property rights, legal ceremonies. Yates's photographs and texts force the viewer to consider whose desire is activated by the longing to locate the missing woman and complete the story.

Later works by Martha Rosler (b. 1943) and Kelly also interrogate the ways that women's roles are formed in society. Rosler's conceptual and book works, mail pieces, photographs, performances, and videos deal with motherhood, domesticity, femininity, class, and sexuality. For example, she has analyzed the uses and abuses of food

through works based on anorexia nervosa, food adulteration, TV cooking lessons, waitressing, and restaurant unionizing. Kelly's *Corpus* is the first section of a continuing work, *Interim*, which explores femininity and representation by addressing the issue of aging, the period when the two are thrown into crisis. Articles of female clothing are photographed and juxtaposed with fashion photographs, nineteenth-century images of female hysterics, and a handwritten text tracing women's complex relations to the body, desire, and representation. 242

Treating language as both target and weapon, these and other contemporary artists consciously use it to articulate difference and explore the ways that information is culturally coded. Susan Hiller's (b. 1940) studies in anthropology inform her analysis of the relationship between the art of previous cultures and that of her own. *Fragments*, a multi-sectioned installation first exhibited in England in 1978, combined drawings, charts, photographs, and diagrams with small sherds of pottery by "anonymous" Pueblo Indian potters to point to the differences between cultures, the ways that archeological material has been appropriated by dominant cultural groups, and the role of language in establishing meaning. 243

243 Susan Hiller *Fragments* 1987

The siting of woman as "other" has taken place in a society which has rationalized cultural, as well as sexual, oppression. During the 1970s, feminists pointed to women's shared experiences under patriarchy. Later, awareness that the women's movement reflected the dominant voice of white, middle-class women and recognition of the very real differences that exist among various groups of women led to investigations into more specific forms of oppression and the processes of differentiation which establish race and gender positions.

"Unconscious" and "irrational" are fundamental to the construction of both female and racial otherness; women of color in Britain, the United States, and elsewhere are demanding a combined critique of patriarchy and of imperialism. The controversial "Primitivism and Modern Art" exhibition organized by William Rubin and Kirk Varnedoe at the Museum of Modern Art, New York, in 1984 confirmed Modernism's taste for appropriating otherness by annexing tribal objects to Western desires for artistic innovation.

A series of exhibitions in Britain and the United States during the 1980s considered women's productions within specific cultural contexts. The British Lubaina Himid (b. 1954), in her essay "We Will Be," mapped the range of issues confronting black women artists; "We are making ourselves more visible by making positive images of black women, we are reclaiming history, linking national economics with colonialism, and racism with slavery, starvation, and lynching."

In London, the exhibition "Four Indian Women Artists" at the Indian Artists United Kingdom Gallery in 1981 was followed by "Between Two Cultures" (Barbican Centre, 1982), "Nova Mulher—Contemporary Women Artists Living in Brazil and Europe" (Barbican Centre, 1983), and "Five Black Women" (African Centre, 1983), the first of several exhibitions on the work of black and Afro-Caribbean women. In the United States, "Women of Sweetgrass, Cedar and Sage," curated by Harmony Hammond and Jaune Quick-to-See Smith for the Gallery of the American Indian Community House, New York, in 1985 included paintings, drawings, and handicrafts by Native American women, and "Autobiography: In Her Own Image," a 1988 exhibition of the work of twenty East Coast women of color organized by the painter Howardena Pindell, traveled from New York to California.

Himid and others argued that cultural appropriations must be placed in a dialogue between cultures in order to displace the relationships of dominance/subservience that have used the artefacts

230

364

of non-Western cultures to "prove" the superiority of white culture. Sonia Boyce's (b. 1962) multi-panel *Lay Back, Keep Quiet and Think About What Made Britain So Great* displaces the image of woman to the margin, inserting an iconography of colonialism into the foliate forms of a decorative surface that recalls the cheery domesticity of wallpaper. Himid's painting *Freedom and Change* (1984) and her reworking of Picasso's *Three Musicians* as a mural for a black art center in London challenge the Modernist artist's appropriations of African tribal masks and ceremonial figures. 226

Himid and Boyce are two of the British artists from Afro-Caribbean backgrounds who are committed to exposing the reality behind the distortions that pretend to say what it is like to be black and female in white, male-dominated society. "'Black art,' if this term must be used," argues Rasheed Araeen in the introduction to the catalogue of "The Essential Black Art" exhibition in London in 1988, "is in fact a specific historical development within contemporary art practices and has emerged directly from the joint struggle of Asian, African, and Caribbean people against racism, and the art work itself . . . specifically deals with and expresses a human condition, the condition of Afro-Asian people resulting from . . . a racist society and/ or, in global terms, from western cultural imperialism."

These artists use language as a critical tool. To identify woman as a subject of representation and not as an object of representation is a long and difficult process; to renegotiate cultural paradigms is often perceived as threatening by the dominant cultural group. Appropriating codes which have great social power, deconstructing them to expose their inconsistencies and ideology, using fragments and refusing wholeness, artists reveal the ways that codes of meaning are entrenched in the dominant culture. Some critics suggest that the feminist insistence on the social construction of sexual difference and the role of "woman as sign" is overstated. Others, many of them feminists, argue that the discourses being employed were theorized by men and that deconstruction leads neither to positive social action nor to new visual languages. Contemporary art by women, however, shows that although many goals of the women's movement have not been met—there is still violence against women, discrimination in education and employment, racism, and sexism in daily life—women have formulated complex strategies and practices through which to confront the exclusions of art history, expand theoretical knowledge, and promote social change.

Bibliography and Sources

GENERAL

The first publications on feminist art history were directed toward reestablishing the histories of long-neglected or forgotten women artists and exploring the historical circumstances in which women have worked as artists. See: Elizabeth Ellet, *Women Artists in All Ages and Countries* (New York, 1959); Eleanor Tufts, *Our Hidden Heritage: Five Centuries of Women Artists* (London, 1974); Ann Sutherland Harris and Linda Nochlin, *Women Artists: 1550–1950* (exh. cat., Los Angeles County Museum of Art, December 1976–March 1977); Karen Peterson and J. J. Wilson, *Women Artists: Recognition and Reappraisal, from the Early Middle Ages to the Twentieth Century* (New York, 1976); Donna Bachman and Sherry Piland, *Women Artists: An Historical, Contemporary, and Feminist Bibliography* (Metuchen, N. J., and London, 1978); Elsa Honig Fine, *Women and Art: A History of Women Painters and Sculptors from the Renaissance to the Twentieth Century* (Montclair, N. J., 1978); Germaine Greer, *The Obstacle Race: The Fortunes of Women Painters and Their Work* (New York, 1979); Eleanor Munro, *Originals: American Women Artists* (New York, 1979); Charlotte Rubinstein, *American Women Artists: From Early Indian Times to the Present* (Boston, 1982); *Das Vergorgene Museum: Dokumentation der Kunst von Frauen in Berliner öffentlichen Sammlungen* (Berlin, 1987); Nancy Heller, *Women Artists: An Illustrated History* (New York, 1987). Another group of publications has explored the ideologies of class, race, sex, and power as they have affected both the work of women artists and the representations of women: Roszika Parker and Griselda Pollock, *Old Mistresses: Women, Art and Ideology* (New York and London, 1981); Norma Broude and Mary Garrard, eds, *Feminism and Art History: Questioning the Litany* (New York, 1982); Roszika Parker and Griselda Pollock, eds, *Framing Feminism: Art and the Women's Movements 1970–1985* (London and New York, 1987); Rosemary Betterton, ed., *Looking On: Images of Femininity in the Visual Arts and Media* (London and New York, 1987); Hilary Robinson, ed., *Visibly Female: Feminism and Art Today* (London, 1987); Griselda Pollock, *Vision and Difference: Femininity, Feminism and the Histories of Art* (London and New York, 1988); Linda Nochlin, *Women, Art, and Power and Other Essays* (New York, 1988, London, 1989). Also useful, though not specifically concerned with the fine arts: Kaja Silverman, *The Subject of Semiotics* (New York and Oxford, 1983); Gisela Ecker, ed., *Feminist Aesthetics* (London, 1985); Toril Moi, *Sexual/Textual Politics* (London, 1985); Susan Suleiman, ed., *The Female Body in Western Culture* (Cambridge, 1986); Chris Weedon, *Feminist Practice and Poststructuralist Theory* (Oxford, 1987).

PREFACE

Johann Zoffany: for a fuller discussion of the implications of this painting for feminist art history, see *Old Mistresses*, pp. 87–90. Linda Nochlin first identified Kauffmann's image in "Why Have There Been No Great Women Artists?" in Thomas Hess and Elizabeth Baker, eds, *Art and Sexual Politics* (New York and London 1971), reprinted in *Women, Art, and Power*, pp. 145–78.

The feminist critique of art history: Griselda Pollock, "Vision, Voice and Power: Feminist Art History and Marxism," *Block* (vol. 6, 1982), pp. 6–9, and *passim*; Gloria Orenstein, "Art History," *Signs: Journal of Women in Culture and Society* (vol. 1, no. 2, Winter 1975), pp. 505–25; Lise Vogel, "Fine Arts and Feminism: The Awakening Consciousness," *Feminist Studies* (vol. 11, no. 1, 1974), pp. 3–37; H. Diane Russell, "Review Essay: Art History," *Signs: Journal of Women in Culture and Society* (vol. 5, no. 3, Spring 1980), pp. 473–78; Thalia Gouma-Peterson and Patricia Mathews, "The Feminist Critique of Art History," *The Art Bulletin* (vol. 69, no. 3, September 1987), pp. 326–57; Lisa Tickner, "Feminism and Art History," *Genders* (vol. 3, Fall 1988), pp. 92–128; the quote is on p. 92. Pollock's remark appears in "Feminist Interventions in the Histories of Art: An Introduction," in *Vision and Difference*, p. 17.

Cultural feminism and poststructuralism: insight into the current theoretical impasse is provided by Linda Alcoff, "Cultural Feminism versus Poststructuralism: The Identity Crisis in Feminist Theory," *Signs: Journal of Women in Culture and Society* (vol. 13, no. 3, Spring 1988), pp. 405–36; see also Sherry Ortner, "Is Female to Male as Nature is to Culture?" in Michele Rosaldo and Louise Lamphere, eds, *Women, Culture and Society* (Stanford, 1974). The Kristeva quote is in Alcoff, "Cultural Feminism," p. 418.

Cultural construction of gender: Sherry Ortner and Harriet Whitehead, eds, *Sexual Meanings: The Cultural Construction of Gender and Sexuality* (New York, 1981); Anne Fausto-Sterling, *Myths of Gender: Biological Theories About Women and Men* (New York, 1986).

INTRODUCTION: ART HISTORY AND THE WOMAN ARTIST

Marietta Robusti: her date of birth is listed as early as 1552 in Hans Tietze, *Tintoretto* (London, 1948); the 1560 date proposed by E. Tietze-Conrat, "Marietta, Fille du Tintoret," *Gazette des Beaux-Art* (vol. 12, December 1934), p. 259, is more

likely (the article continues to p. 262). Domenico's probable birth between 1560 and 1562 has also created confusion as both children worked in the Tintoretto workshop. For a good discussion of the situation see P. Rossi, *Iacopo Tintoretto: I Ritratti* (Venice, 1974), pp. 138–39; Ridolfi, *Delle Meraviglie dell'Arte* (vol. 2, Venice, 1648), pp. 78–80; for a discussion of artists and class in the Renaissance see Pollock, "Vision, Voice and Power," pp. 2–21, and Peter Burke, *Culture and Society in Renaissance Italy, 1450–1540* (London, 1972); for a discussion of Domenico's career see Francesco Valcanover, *Tintoretto* (New York, 1985), particularly "The Assistance of the Workshop," p. 49 and *passim*; also, M. Suida, "Clarifications and Identifications of Works by Venetian Painters," *Art Quarterly* (vol. 9, 1946), pp. 288–98; Adolfo Venturi, *Storia dell' arte italiana* (11 vols, Milan, 1901), vol. 9, pp. 684ff; nineteenth-century works on Robusti are discussed in Anna Laura Lepschy, *Tintoretto Observed: A Documentary Survey of Critical Reactions from the Sixteenth to the Twentieth Century* (Ravenna, 1983), pp. 83–84; *The Obstacle Race*, pp. 136–40 and *Women Artists: 1550–1950*, p. 137, discuss the acquisition problem.

Judith Leyster: Cornelis Hofstede de Groot, "Judith Leyster," *Jahrbuch der Koniglich preussischen Kunstsammlungen* (vol. 14, 1893), pp. 190–98; Juliane Harms, "Judith Leyster, ihr Leben und ihr Werk," *Oud-Holland* (vol. 44, 1927), pp. 88–96, 112–26, 145–54, 221–42, 275–79; I am grateful to Frima Fox Hofrichter, who is currently preparing a *catalogue raisonée* of Leyster's work, for her assistance in sorting out the Leyster/Hals attributions; James Laver, "Women Painters," *Saturday Book* (vol. 24, 1964), p. 19.

The "Davids": Charles Sterling, "A Fine 'David' Reattributed," *The Metropolitan Museum of Art Bulletin* (vol. 9, no. 5, 1951), pp. 121–32; Georges Wildenstein, "Un Tableau attribué à David et rendu à Mme. Davin-Mirvault: 'Le Portrait du Violiniste Bruni' (Frick Collection)," *Gazette des Beaux-Arts* (vol. 59, 1962), pp. 93–98; Amy Fine, "Césarine Davin-Mirvault: *Portrait of Bruni* and Other Works by a Student of David," *Woman's Art Journal* (vol. 4, Spring/Summer 1983), pp. 15–20; Andrew Kagan, "A Fogg 'David' Reattributed to Madame Adélaide Labille-Guiard," *Fogg Art Museum Acquisitions, 1969–1970* (Cambridge, 1971), pp. 31–40; *The Metropolitan Museum of Art Bulletin* (vol. 13, 1918), p. 59.

Albrecht Dürer: *Albrecht Dürers Tagenbuch der Reise in die Niederlande* (Leipzig, 1884), p. 85.

Women, art and ideology: the fullest exploration of these issues is in *Old*

Mistresses, in particular ch. 1; the issue is also taken up by Nochlin, "Women, Art, and Power," in *Women, Art, and Power*, pp. 1–36. The nineteenth-century commentary is cited in Griselda Pollock, "Women, Art and Ideology: Questions for Feminist Art Historians," *Woman's Art Journal* (vol. 4, Spring/Summer 1983), pp. 39–47; this is a shorter version of "Vision, Voice and Power," pp. 2–21. For the construction of femininity and its relationship to needlework traditions see Roszika Parker, *The Subversive Stitch: Embroidery and the Making of the Feminine* (London, 1984).

Giorgio Vasari: Giorgio Vasari, *Le Vite de' piu eccellenti pittori scultori e architettori italiani, da Cimabue insino ai tempi nostri . . .* (Florence, 1568); T. S. R. Boase, *Giorgio Vasari: The Man and the Book* (Princeton, 1979).

Women artists in antiquity: Natalie Kampen, "Hellenistic Artists: Female," *Archeologia Classica* (vol. 27, 1975), pp. 9–17.

Humanism and women: Diane Bornstein, "Distaves and Dames: Renaissance Treatises For and About Women," *Scholars Facsimiles and Reprints* (Delmar, N.Y., 1978); Margaret L. King, "Book-Lined Cells: Women and Humanism in the Early Italian Renaissance," and Paul Kristeller, "Learned Women of Early Modern Italy: Humanists and University Scholars," in P. Labalme, ed., *Beyond Their Sex: Learned Women of the European Past* (New York and London, 1984).

Boccaccio: Boccaccio's remarks are cited in *Women Artists: 1550–1950*, p. 23.

Christine de Pisan: Susan Groag Bell, "Christine de Pizan (1364–1430): Humanism and the Problem of a Studious Woman," *Feminist Studies* (vol. 3, nos 3–4, 1976), pp. 173–84.

Seventeenth-century commentaries: *Delle Meraviglie dell'Arte*; Carlo Cesare Malvasia, *Felsina Pittrice* (2 vols, Bologna, 1678), vol. 2, p. 454; Karel van Mander, *Het Schilder Boeck* (Haarlem, 1604); Joachim van Sandrart, *Teutsche Academie der Bau-Bild- und Malerei-Kunste* (Nuremberg, 1675–79).

Eighteenth-century commentaries: Arnold Houbraken, *De Groote Schouburgh* (The Hague, 1718–21); G. Lairesse, *Het Groot Schilderboeck* (Amsterdam, 1707), p. 335; Jean Starobinski, *The Invention of Liberty, 1700–1789* (Geneva, 1964), p. 22; for Rousseau see Ch. 5 below; women and the Enlightenment are discussed by Abby Kleinbaum, "Women in the Age of Light," in Renate Bridenthal and Claudia Koonz, eds, *Becoming Visible: Women in European History* (Boston, 1977); Richardson's letter and Paston's remarks are quoted in *The Subversive Stitch*, pp. 110–46; *Old Mistresses*, pp. 7–12, discuss the application of these stereotypes to eighteenth-century women artists; Denis Diderot, *Salons; texte établi et présenté par J. Seznec et G. Adhémar* (Oxford, 1957–1967). The critique of

femininity and make-up is the subject of Jacqueline Lichtenstein's "Making Up Representation," in *Representations* (vol. 20, Fall 1987), pp. 77–86.

Nineteenth-century commentaries: Léon Legrange, "Du rang des femmes dans l'art," *Gazette des Beaux-Arts* (1860), pp. 30–43; Victorian and Edwardian rewriting of art history is discussed in Lisa Tickner, "Pankhurst, Modersohn-Becker and the Obstacle Race," *Block* (vol. 2, 1980), pp. 24–40; for a discussion of critical responses to the work of women Impressionists and the Huysmans quote see Tamar Garb, *Women Impressionists* (New York, 1986), p. 15.

Anna Jameson: Adele M. Holcomb, "Anna Jameson: The First Professional English Art Historian," *Art History* (vol. 6, no. 2, June 1983), pp. 171–87. Jameson's evaluation is in *Visits and Sketches at Home and Abroad* (London, 1939), vol. 2, p. 133.

1 THE MIDDLE AGES

Women in medieval life: David Herlihy, *Women in Medieval Society* (Houston, 1971); "Varieties of Womanhood in the Middle Ages," S. Bell, ed., *Women from the Greeks to the French Revolution* (Stanford, 1973) pp. 118–80; Frances and Joseph Gies, *Women in the Middle Ages* (New York, 1978); Shulamith Shahar, *The Fourth Estate: A History of Women in the Middle Ages*, trans. C. Galai (London and New York, 1983); Margaret Miles, *Image as Insight: Visual Understanding in Western Christianity and Secular Culture* (Boston, 1985); Penny Gold, *The Lady and the Virgin: Image, Attitude, and Experience in Twelfth-Century France* (Chicago, 1985); Margaret Labarge, *Women in Medieval Life* (London, 1986); Labalme, ed., *Beyond Their Sex: Learned Women of the European Past*.

Michel Foucault's discussion of subjectivity and power is in "The Subject and Power," reprinted in Brian Wallis, ed., *Art After Modernism: Rethinking Representation* (New York and Boston, 1984); the quote is on p. 421.

Monastic women: Lina Eckenstein, *Women Under Monasticism* (Cambridge, 1896); "Nunneries as the Medieval Alternative to Marriage" in Bell, *Women from the Greeks to the French Revolution*, pp. 96–117; Christine Fell, *Women in Anglo-Saxon England* (Oxford, 1984); Boniface's letter is on p. 113; women illuminators are discussed in Dorothy Miner, "Anastaise and Her Sisters: Women Artists of the Middle Ages" (Baltimore, The Walters Art Gallery, 1974); Annemarie Weyl Carr, "Women Artists in the Middle Ages," *Feminist Art Journal* (vol. 5, 1976), pp. 5–9.

Ende: see Miner on the Gerona Apocalypse and "Anastaise and Her Sisters;" Georgiana Goddard King, "Divagations on the Beatus," *Art Studies* (vol. 8, part 1, 1930), pp. 3–55.

Bayeux Tapestry: *The Bayeux Tapestry*, introduction and commentary by David M.

Wilson (London, 1985); *The Subversive Stitch*, p. 28.

Ottonian Germany: political and monastic alliances are discussed by Peter Dronke, *Women Writers of the Middle Ages: A Critical Study of Texts from Perpetua to Marguerite Porete* (Cambridge, 1984), p. 55.

Herrad of Landsberg: A. Straub and G. Keller, eds, *Herrade de Landsberg, Hortus Deliciarum* (Strasbourg, 1879–99); G. Camès, *Allégories et Symboles dans le Hortus Deliciarum* (Leyden, 1971).

Hildegard of Bingen: Barbara Newman, *Sister of Wisdom: St. Hildegard's Theology of the Feminine* (Berkeley, 1987); the chapter on Hildegard in *Women Writers of the Middle Ages* summarizes her writings; the illuminations are discussed in Hans Fegers, "Die Bilder im Scivias der Hildegard von Bingen," *Das Werk des Kunstlers* (vol. 1, 1939), pp. 109–45, see also Charles Singer, *From Magic to Science. Essays on the Scientific Twilight* (London, 1928), pp. 199–239.

Female mystics: Luce Irigaray, "Plato's Hystera," *Speculum of the Other Woman*, trans. G. Gill (Ithaca, 1985), discusses the political and psychoanalytic implications of mystical dialogue; see also Caroline Bynum, "'. . . And Woman His Humanity:' Female Imagery in the Religious Writing of the Later Middle Ages" in C. Bynum, S. Harrell and P. Richman, eds, *Gender and Religion: On the Complexity of Symbols* (Boston, 1986); Caroline Bynum, *Jesus as Mother: Studies in the Spirituality of the High Middle Ages* (Berkeley and Los Angeles, 1982).

Women in medieval towns: Françoise Baron, *Bulletin archéologique du comité des travaux historiques et scientifiques* 4 (1968), pp. 37–121.

The cult of the Virgin Mary: Henry Kraus, "Eve and Mary: Conflicting Images of Medieval Women," *Feminism and Art History*, pp. 79–99.

Opus Anglicanum: its methods of production are described in *The Subversive Stitch*, pp. 40–45.

Secular illumination: Robert Branner, "Manuscript-makers in mid-thirteenth century Paris," *The Art Bulletin* (vol. 48, 1966), p. 65; Millard Meiss, *The Limbourgs and Their Contemporaries* (2 vols, New York, 1974), vol. 1, p. 14.

2 RENAISSANCE FLORENCE AND THE WOMAN ARTIST

Key source books on Renaissance culture: Frederick Antal, *Florentine Painting and Its Social Background* (London, 1947); Joan Kelly-Gadol, "The Unity of The Renaissance: Humanism, Natural Science, and Art" in Charles Carter, ed., *From the Renaissance to the Counter Reformation. Essays in Honor of Garett Mattingly* (New York, 1965); *Culture and Society in Renaissance Italy*; Richard Goldthwaite, *The Building of Renaissance Florence: An Economic and Social*

History (Baltimore and London, 1980); Martin Wackernagel, *The World of the Florentine Renaissance Artist*, trans. A. Luchs (Princeton, 1981).

Renaissance women: Nochlin, "Why Have There Been No Great Women Artists?" in Hess and Baker, *Art and Sexual Politics*; Joan Kelly-Gadol, "Did Women Have a Renaissance?" in Bridenthal and Koonz, *Becoming Visible*; Judith C. Brown, "A Women's Place Was in the Home: Women's Work in Renaissance Tuscany" in M. Ferguson, M. Quilligan, and N. Vickers, eds, *Rewriting the Renaissance: The Discourse of Sexual Difference in Early Modern Europe* (Chicago and London, 1986), pp. 206–26; David Herlihy and Christian Klapisch-Zuber, *Tuscans and Their Families* (New Haven and London, 1978); Ian Maclean, *The Renaissance Notion of Woman* (Cambridge, 1980).

Guilds: Edgecumbe Staley, *The Guilds of Florence* (London, 1906); similar structures of male and female participation have been identified in Florentine confraternities: see Ronald Weissman, *Ritual Brotherhood in Renaissance Florence* (New York, 1982).

Renaissance historiography: N. Streuver, *The Language of History in the Renaissance* (Princeton, 1970); Bruni's remarks on Florence are on p. 105; the Rucellai quote is in Michael Baxandall, *Painting and Experience in Fifteenth-Century Italy* (Oxford and New York, 1972), p. 2.

Alberti: Leon Battista Alberti, "I libri della famiglia" in his *Opere volgari* (Bari, 1960), as *The Family in Renaissance Florence*, trans. Renée Neu Watkins (Columbia, SC, 1969), pp. 115–16; D. K. Hedrick, "The Ideology of Ornament: Alberti and the Erotics of Renaissance Urban Design," *Word and Image* (vol. 3, 1987), pp. 111–37.

Perspective: the implications of illusionism are explored by Norman Bryson, *Vision and Painting: The Logic of the Gaze* (New Haven, 1983); fifteenth-century measurements are discussed in *Painting and Experience in Fifteenth-Century Italy*; Samuel Edgerton, *The Renaissance Rediscovery of Linear Perspective* (New York, 1975); John White, *The Birth and Rebirth of Pictorial Space* (London, 1957).

Embroidery: Florentine painters and embroidery during the fifteenth century are discussed in *The Subversive Stitch*, pp. 79–80.

Household and lineage: F. W. Kent, *Household and Lineage in Renaissance Florence* (Princeton, 1977); Christine Klapisch-Zuber, *Women, Family and Ritual in Renaissance Italy* (Chicago, 1985).

The profile portrait: the basic survey and catalogue is Jean Lipman, "The Florentine Profile Portrait in the Quattrocento," *The Art Bulletin* (vol. 18, no. 1, 1936), pp. 54–102. Traditional views of Renaissance portraiture can be seen in John Pope-Hennessy, *The Portrait in the Renaissance* (Washington, 1966). For a revisionist reading, see Patricia Simons,

"Women in Frames: The Gaze, the Eye, the Profile in Renaissance Portraiture," *History Workshop* (25, Spring 1988), pp. 4–30, and "A Profile Portrait of a Renaissance Woman in the National Gallery of Victoria," *Art Bulletin of Victoria* (vol. 28, 1987), pp. 34–52. The Alberti quotes are in Simons, "Women in Frames," p. 12.

Sofonisba Anguissola: *I Campi e la cultura artistica cremonese del Cinquecento* (exh. cat., Museo Civico, Cremona, 1985); *Women Artists: 1550–1950*, pp. 106–07.

Lucia Anguissola: her *Portrait of Pietro Maria* in *Women Artists: 1550–1950*, pp. 109–10; Flavio Caioli, "Antologia d'Artisti: per Lucia Anguissola," *Paragone* (vol. 277, 1973), pp. 69–73.

Titian: Elizabeth Cropper, "The Beauty of Women: Problems in the Rhetoric of Renaissance Portraiture," in Ferguson, Quilligan, and Vickers, *Rewriting the Renaissance*, pp. 175–90; Erwin Panofsky, *Problems in Titian: Mostly Iconographic* (New York, 1969).

3 THE OTHER RENAISSANCE

Women artists in Bologna: Laura Ragg, *The Women Artists of Bologna* (London, 1907); *The Obstacle Race*, pp. 208–26.

Caterina dei Vigri: Alban Butler, *Lives of the Saints* (London, 1842). Illuminata Bembo is quoted in *The Women Artists of Bologna*, p. 37; accounts of her miracles are in T. Bergamini, *Caterina La Santa: breve storia di Santa Caterina Vigri, 1413–1463* (Rovigo, 1970).

Printing in Bologna: A. Sorbelli, *Storia della stampa in Bologna* (Bologna, 1929); Sorbelli, *Le marche typografiche bolognesi nel secolo XVI* (Milan, 1923).

Properzia de' Rossi: Although de' Rossi was apparently the only Italian Renaissance woman working in marble, the Spanish sculptor, Luisa Roldán (1656–1704), worked as court sculptor to Charles II; *Women and Art*, pp. 8–9.

Emilian painting: *The Age of Correggio and the Carracci: Emilian Painting of the Sixteenth and Seventeenth Centuries* (exh. cat., National Gallery of Art, Washington, D.C., 1986); see also, A.W.A. Boschloo, *Annibale Carracci in Bologna: Visible Reality in Art After the Council of Trent* (The Hague, 1974).

Painting and the Counter Reformation: Marc Fumaroli, *L'Age de L'Eloquence: Rhétorique et 'res litaria' de la Renaissance au Seuil de l'Epoque Classique* (Paris, 1980).

Lavinia Fontana: *The Age of Correggio and the Carracci*, see especially Vera Pietrantonio's discussion of the work, pp. 132–35. See also *Our Hidden Heritage*, pp. 31–34; *Women Artists: 1550–1950*, pp. 111–14; J. Bean and Felice Stampfle, eds, *Drawings from New York Collections I: The Italian Renaissance* (New York, 1965), p. 81; R. Galli, *Lavinia Fontana, pittrice, 1552–1614*

(Imola, 1940); *Felsina Pittrice*, vol. 1, pp. 177–79; Eleanor Tufts, "Ms. Lavinia Fontana from Bologna: A Succesful Sixteenth-Century Portraitist," *Art News* (vol. 73, 1974), pp. 60–64.

Elisabetta Sirani: the Otto Kurz quote is in *Bolognese Drawings in the Royal Library at Windsor Castle* (London, 1955), p. 7; A. Emiliani, "Giovan Andrea ed Elisabetta Sirani" in *Maestri della pittura del seicento emiliano* (exh. cat., Palazzo dell'Archiginnasio, Bologna, 1959), pp. 140–45; A. Manaresi, *Elisabetta Sirani* (Bologna, 1898); *Felsina Pittrice*, vol. 2; *Our Hidden Heritage*, pp. 81–83; E. Edwards, "Elisabetta Sirani," *Art in America* (August, 1929), pp. 242–46. The source for Sirani's *Portia* is pointed out in *Women Artists: 1550–1950*; the theme is also discussed in Ian Donaldson, *The Rapes of Lucretia: A Myth and Its Transformations* (Oxford, 1982); *Old Mistresses*, p. 27, discusses the sadomasochistic element. The Plutarch quote is from "Life of Marcus Brutus," *Lives*, vol. 6, p. 194.

Artists' funerals: C. de Tolnay, *Michelangelo*, vol. 4 (Princeton, 1954), p. 17; Sirani is described in *The Women Artists of Bologna*, pp. 229–36.

Artemisia Gentileschi: R. Ward Bissell, "Artemisia Gentileschi: A New Documented Chronology," *Art Bulletin* (vol. 50, 1968), pp. 153–68; for the discussion of artists' personalities and further information on Tassi see Rudolf and Margaret Wittkower, *Born Under Saturn: The Character and Conduct of Artists* (New York, 1963), pp. 162ff, and *Women Artists: 1550–1950*, pp. 118–24; *The Obstacle Race* has an entire chapter on Gentileschi; *Our Hidden Heritage*, pp. 58–69. A more recent publication is Mary Garrard, *Artemisia Gentileschi: The Female Hero in Italian Baroque Art* (Princeton, 1989). *Susanna and the Elders*: Garrard, "Artemisia and Susanna" in Broude and Garrard, *Feminism and Art History*, pp. 147–71. *Judith Decapitating Holofernes*: see the most Rubens painting is discussed by Frima Fox Hofrichter, "Artemisia Gentileschi's Uffizi *Judith* and a Lost Rubens," *Rutgers Art Review* (vol. 1, 1980), pp. 9–15. *Self-Portrait as the Allegory of Painting*: M. Levey, "Notes on the Royal Collection: II, Artemisia Gentileschi's 'Self-Portrait' at Hampton Court," *Burlington Magazine* (vol. 104, 1962), pp. 79–80; Mary Garrard, "Artemisia Gentileschi's Self-Portrait as the Allegory of Painting," *Art Bulletin* (vol. 62, March 1980), pp. 97–112.

Orazio Gentileschi: R. Spear, *Caravaggio and His Followers* (exh. cat., Cleveland Museum of Art, 1971); R. Longhi, "Gentileschi padre e figlia," *L'Arte* (vol. 19, 1916), pp. 245–314; Alfred Moir, *The Italian Followers of Caravaggio* (Cambridge, Mass., 1967).

4 GENDER AND DOMESTIC GENRE IN NORTHERN EUROPE

Key source books on the north: Ingvar Bergstrom, *Dutch Still-Life Painting in the*

Seventeenth Century (New York, 1956); Jakob Rosenberg, Seymour Slive, and E. H. Ter Kuile, Dutch Art and Architecture, 1600 to 1800 (Middlesex, 1966); Walther Bernt, The Netherlandish Painters of the Seventeenth Century (London, 1970); Svetlana Alpers, The Art of Describing: Dutch Art in the Seventeenth Century (Chicago, 1983); Bob Haak, The Golden Age: Dutch Painters of the Seventeenth Century (New York, 1984); Christopher Brown, Images of a Golden Past (New York, 1984); Simon Schama, The Embarrassment of Riches: An Interpretation of Dutch Culture in the Golden Age (New York, 1987). Major exhibition catalogues: E. de Jongh, Tot Lering en Vermak (Rijksmuseum, Amsterdam, 1976); A. Blankert et al., Gods, Saints and Heroes: Dutch Painting in the Age of Rembrandt (National Gallery of Art, Washington, D. C., 1980); Peter Sutton, Masters of Seventeenth-Century Dutch Genre Painting (Philadelphia Museum of Art, 1984).

Elisabeth Scepens: La Miniature flammande au temps de la cour de Bourgogne (Paris and Brussels, 1927); The Obstacle Race, p. 166.

Caterina van Hemessen: Our Hidden Heritage, pp. 51–53; Osten and Horst Vey, Painting and Sculpture in Germany and the Netherlands: 1500–1600 (Harmondsworth, 1969); Simone Bergmans, "Le problème Jan van Hemessen, monogrammiste de Brunswick," Revue belge d'archéologie et d'histoire de l'art (vol. 24, Antwerp, 1955), pp. 133–57; Bergmans, "Note complémentaire à l'étude des De Hemessen, de van Amstel et du monogrammiste de Brunswick," Revue belge d'archéologie et d'histoire de l'art (vol. 27, Antwerp, 1958), pp. 77–83.

Levina Teerlinc: Women Artists: 1550–1950, pp. 102–04; Our Hidden Heritage, pp. 43–45; Roy Strong, The English Renaissance Miniature (London, 1983), pp. 54–64; Strong, Gloriana: The Portraits of Queen Elizabeth I (London, 1987), pp. 55–57; Erna Auerbach, Tudor Artists (London, 1954), pp. 51–75; Simone Bergmans, "The Miniatures of Levina Teerlinc," Burlington Magazine (vol. 64, January–June 1934), pp. 232–36. For the cult of Elizabeth see Stephen Greenblatt, Renaissance Self-Fashioning: From More to Shakespeare (Chicago and London, 1980); Frances Yates, Astraea: The Imperial Themes in the Sixteenth Century (London and Boston, 1975).

Women and the Reformation: Roland Bainton, Women and the Reformation (Minneapolis, 1971).

Dutch versus Italian Renaissance art: Michelangelo is quoted by Alpers, "Art History and Its Exclusions: The Example of Dutch Art" in Broude and Garrard, Feminism and Art History, p. 194. The Naomi Schor quote is from Reading in Detail: Aesthetics and the Feminine (New York and London, 1987), p. 4.

Anna Maria Schurman: Women and Art, pp. 30–31; The Embarrassment of Riches, pp. 410–12.

Marriage and domesticity: The Embarrassment of Riches, ch. 6. For popular emblems see Jacob Cats, Alle de Werken (Amsterdam, 1659). Cats's Magdeplicht (The Duties of a Maiden) and van Beverwijck's commentary on the female sex are quoted and taken up in The Embarrassment of Riches, p. 400 and pp. 418–20 respectively; Schama, "Wives and Wantons: Versions of Womanhood in Seventeenth-Century Dutch Art," Oxford Art Journal (April, 1980), pp. 5–13; Pieter van Thiel, "Poor Parents, Rich Children and Family Saying Grace: Two Related Aspects of the Iconography of Late Sixteenth- and Seventeenth-Century Dutch Domestic Morality," Semiolus: Netherlands Quarterly for the History of Art (vol 17, 1987), pp. 90–149. The disorderly woman is the subject of Natalie Zemon Davis's important essay "Women on Top," in Society and Culture in Early Modern France (Stanford, 1975).

Cloth production in Leiden and Haarlem: Linda Stone, "From Cloth to Clothing: Depictions of Textile Production and Textiles in Seventeenth-Century Dutch Art," unpublished Ph.D. dissertation (University of California, Berkeley, 1980); the discussion of emblematic literature equating weaving and copulation is on p. 139.

Susanna van Steenwijck-Gaspoel: Stone, "From Cloth to Clothing," p. 69.

Judith Leyster: The Proposition is discussed at length in Frima Fox Hofrichter, "Judith Leyster's Proposition: Between Virtue and Vice" in Broude and Garrard, Feminism and Art History, pp. 173–82.

Gertruid Roghman: The Embarrassment of Riches, p. 417; Linda Stone-Ferrier, Dutch Prints of Daily Life: Mirrors of Life or Masks of Morals? (exh. cat., The Spencer Museum of Art, The University of Kansas, Lawrence, 1983), pp. 59–60; Clifford Ackley, Printmaking in the Age of Rembrandt (exh. cat., Boston Museum of Fine Arts, 1981), p. 166, points out their rarity outside of book illustration.

Vermeer: Lawrence Gowing, Vermeer (London and New York, 1970); Edward Snow, A Study of Vermeer (Berkeley, 1979).

Lacemaking: Mrs. Bury Palliser, History of Lace (London, 1910), pp. 258–60.

Erasmus of Rotterdam: Christian Humanism and the Reformation. Selected Writings of Erasmus (New York, 1987).

Botanical illustration: Wilfred Blunt, The Art of Botanical Illustration (London, 1950); Blunt, Flower Books and Their Illustrators (Cambridge, 1950); Agnes Arber, "From Medieval Herbalism to the Birth of Modern Botany" in Edgar Underwood, ed., Science, Medicine and History: Essays on the evolution of scientific thought and medical practice written in honor of Charles Singer (Oxford, 1953), pp. 317–36; the Brunfels and Cordus quotes are on pp. 322 and 326.

Still-life and flower painting in the north: Edith Greindl, Les Peintres flamands de nature morte (Brussels, 1956); Marie-Louise Hairs, The Flemish Flower Painters in the Seventeenth Century (Brussels, 1985); The Obstacle Race, ch. 12; Charles Sterling, History of European Still-life Painting (Paris, 1959). Important exhibition catalogues include Stilleben in Europa (Westfälisches Landesmuseum für Kunst und Kulturgeschichte, Munster/Baden-Baden, 1979) and E. de Jongh et al., Dutch Still-life Painting (Auckland City Art Gallery, New Zealand, 1983); other women associated with flower painting were Margarethe de Heer (active in the 1650s), Margaretha van Godewijk, and Eltje de Vlieger; for mention of others see The Obstacle Race, pp. 227–49, and W. T. Stearns, The Influence of Leyden on Botany in the Seventeenth and Eighteenth Centuries (Leiden, 1961); the Boerhaave quote is in The Embarrassment of Riches, p. 236.

Clara Peeters: Women Artists: 1550–1950, p. 33, identifies Peeters's game piece as the first dated example of that type; and pp. 131–33; Curt Benedict, "Osias Beert, un peintre oublié de natures mortes," L'Amour de l'art (vol. 19, Paris, 1938), pp. 307–14; Marie-Louise Hairs, "Osias Beert l'Ancien peintre de fleurs," Revue belge d'archéologie et d'histoire de l'art (vol. 20, Antwerp, 1951), pp. 237–51. Other women active in flower painting at the time include Anna Janssens, Maria-Theresia, Anna-Maria, and Francisca-Catharina, the three daughters of the painter Jan Philips van Thielen, and Frans Ykens's niece, Catharina.

Tulipomania: Wilfred Blunt, Tulipomania (Harmondsworth, 1950); N. W. Posthumus, "The Tulip Mania in Holland in the Years 1636 and 1637," Journal of Economic History (vol. 1, Atlanta, 1929), pp. 435–65; Peter Coats, Flowers in History (New York, 1970), pp. 195–209.

Maria Merian: Women Artists: 1550–1950, pp. 153–55; The Art of Botanical Illustration, pp. 127–29; Jan Gerrit van Gelder, Dutch Drawings and Prints (New York, 1959); Gertrude Lendorff, Maria Sibylla Merian, 1647–1717, ihr Leben und ihr Werk (Basel, 1955); Merian, Metamorphosis Insectorum Surinamensium (Amsterdam, 1705); Merian, Erucarum ortus alimentum et parodoxa metamorphosis, in qua origo, pabulum, transformatio, nec non tempus, locus et proprietater erucarum vermium, papilionum, phaelaenarum, muscarum, aliorumque, hujusmodi exsanguinium animalculorum exhibenter . . . (Amsterdam, 1717); "A Surinam Portfolio," Natural History (December 1962), pp. 28–41; the Goethe quote is on p. 32.

Maria van Oosterwyck: Women Artists: 1550–1950, pp. 145–46; Homan Potterton, Dutch Seventeenth- and Eighteenth-Century Paintings in the National Gallery of Ireland (Dublin, 1986), nos 125 and 126; The Golden Age, p. 454.

Rachel Ruysch: Women Artists: 1550–1950, pp. 158–60; Our Hidden Heritage, pp. 99–101; Colonel M. H. Grant, Rachel Ruysch 1664–1750 (Leigh-on-Sea, Essex, 1956); R. Renraw, "The Art of Rachel Ruysch," Connoisseur (London, 1933), pp. 397–99.

5 AMATEURS AND ACADEMICS: A NEW IDEOLOGY OF FEMININITY IN FRANCE AND ENGLAND

Key source books on the eighteenth century: Edmond and Jules de Goncourt, *The Woman of the Eighteenth Century*, trans. J. LeClerq and R. Roeder (London, 1928, first publ. 1862); Michael Levy, *Rococo to Revolution* (New York and Washington, 1966); Robert Rosenblum, *Transformations in Late Eighteenth-Century Art* (Princeton, 1967); Derek Jarrett, *England in the Age of Hogarth* (London, 1974); Hugh Honour, *Neo-Classicism* (Harmondsworth, 1977); Michael Fried, *Absorption and Theatricality: Painting and Beholder in the Age of Diderot* (Berkeley and Los Angeles, 1980); Thomas Crow, *Painters and Public Life in Eighteenth-Century Paris* (New Haven, 1985); Albert Boime, *Art in an Age of Revolution: 1750–1800* (Chicago and London, 1987); Jean Starobinski et al, *Diderot et l'Art de Boucher à David* (exh. cat., Hôtel de la Monnaie, Paris, 1985).

Académie Royale: Octave Fidière, *Les Femmes Artistes à l'Académie Royale de Peinture et de Sculpture* (Paris, 1885); James Henry Rubin, *Eighteenth-Century French Life-Drawing* (exh. cat., Princeton University, 1977).

Rosalba Carriera: Vittorio Malamani, *Rosalba Carriera* (Bergamo, 1910); Gabrielle Gatto, "Per la Cronologia di Rosalba Carriera," *Arte Veneta* (Venice, 1971); *Women and Art*, pp. 20–22; *Our Hidden Heritage*, pp. 107–10; Bernardina Sani, *Rosalba Carriera* (Turin, 1989). Carriera's remark about Louis XV is quoted in *The Woman's Art Show, 1550–1970*, p. 14.

Pastel: Robert Graf, *Das Pastell im 18. Jahrhundert: Zur Vergegenwartigung eines Mediums* (Munich, 1982).

Antoine Watteau: *Watteau* (exh. cat., National Gallery of Art, Washington, D. C., 1984).

The Crozat circle artists are discussed in *Painters and Public Life*, pp. 39–40.

Sophie Chéron: *Women and Art*, p. 44; *The Obstacle Race*, pp. 72–74.

The salonières: Joan Landes, *Women and the Public Sphere in the Age of the French Revolution* (Ithaca, N.Y., 1988); Vera Lee, *The Reign of Women in Eighteenth-Century France* (Cambridge, Mass., 1975).

Marie Loir: *Women Artists: 1550–1950*, pp. 167–68; P. Lafond, "Alexis Loir-Marianne Loir," *Réunion des Sociétés des Beaux-Arts des Départements* (Paris, 1892).

François Boucher: *François Boucher, 1703–1770* (exh. cat., The Metropolitan Museum of Art, New York, 1986).

The Enlightenment: Abby Kleinbaum, "Women in the Age of Light" in Bridenthal and Koonz, *Becoming Visible*, pp. 217–35; David Williams, "The Politics of Feminism in the French Enlightenment"

in Peter Hughes and David Williams, eds, *The Varied Pattern: Studies in the Eighteenth Century* (Toronto, 1971), pp. 338–48; Arthur Wilson, "'Treated Like Imbecile Children'" (Diderot): The Enlightenment and the Status of Women" in Paul Fritz and Richard Morton, eds, *Woman in the Eighteenth Century and Other Essays* (Toronto and Sarasota, 1976), pp. 89–104; Samia Spencer, ed., *French Women and the Age of Enlightenment* (Bloomington, 1984); Baron d'Holbach is quoted in Susan Okin, *Women in Western Political Thought* (Princeton, 1979) pp. 103–04.

Jean-Jacques Rousseau: Joel Schwarz, *The Sexual Politics of Jean-Jacques Rousseau* (Chicago, 1984); R. L. Archer, ed., *Jean-Jacques Rousseau: His Educational Theories Selected from Emile, Julie and Other Writings* (Woodbury, N.Y., 1964); *Women in Western Political Thought*, pp. 99–196. His remark about women and genius is quoted in Carol Duncan, "Happy Mothers and Other New Ideas in Eighteenth-Century French Art" in Broude and Garrard, *Feminism and Art History*, p. 213; his comments on women and needlework are quoted in *The Subversive Stitch*, p. 124.

The amateur tradition is discussed in *The Obstacle Race*, pp. 280–91.

Mary Delaney: *The Obstacle Race*, p. 291.

Anne Seymour Damer: *Women and Art*, pp. 76–77.

Catherine Read: Victoria Manners, "Catherine Read: the 'English Rosalba,'" *Connoisseur* (London, December 1931), pp. 376–86; *Women and Art*, p. 71. The Abbé Grant's comment on Read and history painting is in Manners, "Catherine Read," p. 380.

Académie de Saint-Luc: for a discussion of women in this academy see *Women Artists: 1550–1950*, pp. 36–38; and J. Guiffrey, "Histoire de l'Académie de Saint-Luc," *Archives de l'art français* (Paris, 1925).

Angelica Kauffmann: *Angelica Kauffmann und ihre Zeitgenossen* (exh. cat., Vorarlberger Landesmuseum, Bregenz, 1968); *Women and Art*, pp. 72–75; *Our Hidden Heritage*, pp. 117–21; *Women Artists: 1550–1950*, pp. 174–78; Victoria Manners and G. C. Williamson, *Angelica Kauffmann, R. A.: Her Life and Her Works* (London, 1924); Dorothy Moulton Mayer, *Angelica Kauffmann, R. A.: 1741–1807* (Gerrards Cross, Buckinghamshire, 1972); Robert Rosenblum, "The Origin of Painting: A Problem in the Iconography of Romantic Classicism," *Art Bulletin* (New York, December 1957) pp. 279–90; Pindar is quoted in Adeline Hartcup, *Angelica: The Portrait of an Eighteenth-Century Artist* (London, 1954), p. 133.

Eighteenth-century aesthetic theories: Louis Hautecoeur, "Le Sentimentalisme dans la peinture française de Greuze à David," *Gazette des Beaux-Arts* (Lausanne, 1909), pp. 159–76 and pp. 269–86; see also *Painters and Public Life*. Diderot's attack on

Boucher is quoted in *Absorption and Theatricality*, p. 40.

The cult of happy mothers: the pioneering article on this subject remains Carol Duncan's "Happy Mothers and Other New Ideas," pp. 202–19. A more recent discussion can be found in D. G. Charlton, *New Images of the Natural in France* (Cambridge, 1984), pp. 135–77. Margaret Darrow, "French Noblewomen and the New Domesticity, 1750–1850," *Feminist Studies* (vol. 5, Baltimore, Spring 1979), pp. 41–65, suggests that in the late eighteenth century noblewomen by the score repudiated their traditional "careers" as court ladies and *salonières* in favor of roles as wives and mothers.

Anna Vallayer-Coster: M. Roland-Michel, *Anne Vallayer-Coster: 1744–1818* (Paris, 1970); Roland-Michel, "A propos d'un tableau retrouvé de Vallayer-Coster," *Bulletin de la Société de l'Histoire de l'Art Français* (1965), pp. 185–90; *Women Artists: 1550–1950*, pp. 179–84; *Women and Art*, p. 45.

Adélaïde Labille-Guïard: Anne Marie Passez, *Adélaïde Labille-Guïard* (Paris, 1973); Roger Portalis, "Adélaïde Labille-Guïard," *Gazette des Beaux-Arts* (Paris, 1901), pp. 352–67; Portalis, *Adélaïde Labille-Guïard* (Paris, 1902); *Women Artists: 1550–1950*, pp. 185–87; *Women and Art*, pp. 45–48. *Portrait of Madame Adélaïde:* Jean Cailleux, "Portrait of Madame Adélaïde of France, Daughter of Louis XV," *Burlington Magazine* (vol. 3, March 1969), supp. i–vi.

Elisabeth Vigée-Lebrun: David Robb, ed., *Elisabeth-Louise Vigée-Lebrun* (exh. cat., Kimball Art Museum, Fort Worth, 1982); *Women and Art*, pp. 48–51; *Women Artists: 1550–1950*, pp. 190–94; *Our Hidden Heritage*, pp. 127–32; Edgar Munhall, "Vigée Le Brun's Marie Antoinette: The Beauty of the Head That Rolled," *Art News* (vol. 82, January 1983), pp. 106–08; Brooks Adams, "Privileged Portraits: Vigée Le Brun," *Art in America* (vol. 70, November 1982), pp. 75–80; Vigée-Lebrun, *Memoires*, trans. L. Strachey (New York, 1903). *Portrait of Marie Antoinette with Her Children:* the most complete discussion is in Joseph Baillio, "Marie-Antoinette et ses enfants par Mme. Vigée LeBrun," *Gazette des Beaux-Arts* (vol. 97, March 1981), pp. 34–41, and (vol. 97, May 1981), pp. 52–60; the criticism in *Mémoires Secrètes* is quoted on p. 40. Jean Cailleux, "Royal Portraits of Madame Vigée-LeBrun and Mme. Labille-Guïard," *Burlington Magazine* (March 1969), pp. 1–6, discusses the two portraits exhibited in 1787.

Marguérite Gérard: *Women Artists: 1550–1950*, pp. 197–200; *Women and Art*, pp. 51–52; Jeanne Doin, "Marguérite Gérard (1761–1837)," *Gazette des Beaux-Arts* (Lausanne, 1912), pp. 429–52.

Women and the French Revolution: Thomas Crow, "The *Oath of the Horatii*: Painting and pre-Revolutionary Radicalism in France," *Art History* (vol. 1, December 1978), pp. 424–71; *The Age of Revolution: French Painting 1774–1830* (exh. cat., The Metropolitan Museum of Art, New York,

1975); Scott Lyle, "The Second Sex (September, 1793)," *Journal of Modern History* (March 1955), pp. 14–26; Ruth Graham, "Rousseau's Sexism Revolutionized" in Fritz and Morton, *Woman in the Eighteenth Century*, pp. 127–39; Elizabeth Raca, "The Women's Rights Movement in the French Revolution," *Science and Society* (Spring 1952), pp. 151–74; Olwen Hufton, "Women in Revolution 1789–1796," *Past and Present* (November 1971), pp. 90–108.

Mary Wollstonecraft's important response to the ideology of the subordination of women developed by French writers is discussed by Cora Kaplan, "Wild Nights: Pleasure/Sexuality/Feminism" in *Formations of Pleasure* (London, 1983), pp. 15–33.

Women artists after the Revolution: the work of individual artists is catalogued in *Women Artists: 1550–1950*, pp. 24–30; statistics about women's Salon participation are on p. 46.

6 SEX, CLASS, AND POWER IN VICTORIAN ENGLAND

Key source books on the nineteenth century: Jeffrey Weeks, *Sex, Politics and Society* (London, 1981); Peter Gay, *The Education of the Senses: Victoria to Freud* (New York, 1984); T. J. Clark, *The Painting of Modern Life: Paris in the Art of Manet and His Followers* (Princeton, 1984); H. W. Janson and Robert Rosenblum, *Nineteenth-Century Art* (New York, 1984); Kenneth Bendiner, *An Introduction to Victorian Painting* (New Haven and London, 1985).

Women in the nineteenth century: Charlotte Elizabeth Yeldham, *Women Artists in Nineteenth-Century England and France* (New York and London, 1984); Nancy F. Cott, *The Bonds of Womanhood: "Women's Sphere" in New England, 1780–1835* (New Haven and London, 1977); Carroll Smith-Rosenberg, *Disorderly Conduct: Visions of Gender in Nineteenth-Century America* (New York, 1985); Deborah Cherry, *Painting Women: Victorian Women Artists* (exh. cat., Rochdale Art Gallery, Lancashire, ed., Eleanor Tufts, *American Women Artists: 1830–1930* (exh. cat., The National Museum of Women in the Arts, Washington, D.C., 1987); Elaine Showalter, *The Female Malady: Women, Madness and English Culture, 1830–1980* (New York, 1985); *Representations: Special Issue on Sexuality and the Social Body in the Nineteenth Century* (Berkeley, Spring 1986); Catherine Gallogher and Thomas Laqueur, eds, *Nineteenth-Century American Women Artists* (exh. cat., Whitney Museum of American Art, New York, 1976); Ellen Moers, *Literary Women* (New York, 1963); Pamela Gerrish Nunn, ed., *Canvassing. Recollections by Six Victorian Women Artists* (London, 1986); Joan N. Burstein, *Victorian Education and the Ideal of Womanhood* (New Brunswick, 1984); Barbara Taylor, *Eve and the New Jerusalem: Socialism and Feminism in the Nineteenth Century* (London, 1983); Susan Casteras, *Visions of Victorian*

Womanhood in English Art (London and Toronto, 1987); Lynda Nead, *Myths of Sexuality: Representations of Women in Victorian Britain* (Oxford, 1988); Deborah Cherry and Griselda Pollock, "Woman as Sign in Pre-Raphaelite Literature: A Study of the Representation of Elizabeth Siddall," *Art History* (vol. 7, June 1984), pp. 206–27; Pamela Gerrish Nunn, *Victorian Women Artists* (London, 1987); Jan Marsh and Gerrish Nunn, *Women Artists and the Pre-Raphaelite Movement* (London, 1989). The letter to the Board of Directors of the Pennsylvania Academy is in the Collection of the Archives of the Pennsylvania Academy of the Fine Arts, Philadelphia.

The cult of True Womanhood: Carroll Smith-Rosenberg, "The Female World of Love and Ritual," *Disorderly Conduct*, pp. 53–76; for the Victorian enshrinement of women in the home see *Visions of Victorian Womanhood*, p. 50.

Women exhibitors in Great Britain 1840–1900: *Painting Women*; see also *Canvassing*. For the Society of Female Artists and the Langham Place Circle see *Painting Women*, pp. 8–9. The quote about "woman's power" is in *Visions of Victorian Womanhood*, p. 50. The *Englishwoman's Review* is quoted in *Painting Women*, p. 10.

Barbara Bodichon: *The Woman's Art Show*, p. 51; *Women and Art*, p. 66.

Edith and Jessica Hayllar: Christopher Wood, "The Artistic Family Hayllar," *Connoisseur* (April 1974, part 1; May 1974, part 2); two other sisters, Mary and Kate, also painted.

Clementina, Lady Hawarden: Graham Ovenden, ed., *Clementina, Lady Hawarden* (London and New York, 1974).

Hannah Culwick: Liz Stanley, ed., *The Diaries of Hannah Culwick: Victorian Maidservant*, (London, 1984).

Rebecca Solomon: *The Woman's Art Show*, p. 63; Pamela Gerrish Nunn, "Rebecca Solomon," in *The Solomon Family of Painters* (exh. cat., Geffrye Museum, London 1985).

Emily Osborn: *Women Artists: 1550–1950*, p. 228; *The Woman's Art Show*, p. 60; James Dafforne, "British Artists: Their Style and Character, No. LXXV—Emily Mary Osborn," *Art Journal* (vol. 26, London, 1864), pp. 261–63.

Prostitution: the comment in the *Westminster Review* is quoted in *Visions of Victorian Womanhood*, p. 131; representations of prostitution are the subject of *Myths of Sexuality*.

Rosa Bonheur: *Our Hidden Heritage*, pp. 147–57; *Women Artists: 1550–1950*, pp. 223–25; Theodore Stanton, ed., *Reminiscences of Rosa Bonheur* (New York, 1976; reprint of London 1910 edn); Dore Ashton and Denise Browne Hare, *Rosa Bonheur: A Life and a Legend* (New York, 1981); Rosa Bonheur, "Fragments of My Autobiography," *Magazine of Art* (vol. 26,

1902), pp. 531–36; Anna Klumpke, *Rosa Bonheur, sa vie, son oeuvre* (Paris, 1908); Albert Boime, "The Case of Rosa Bonheur: Why Should a Woman Want to be More Like a Man?," *Art History* (vol. 4, December 1981), pp. 384–409; Rosalia Shriver, *Rosa Bonheur* (Philadelphia, 1982); the *Daily News* quote is reprinted in Ms. F. Lepelle De Bois-Gallais, *Memoir of Mademoiselle Rosa Bonheur*, trans. J. Parry (New York, 1857), pp. 45–47.

Women and the antivivisection movement: Coral Lansbury, *The Old Brown Dog: Women, Workers and Vivisection* (Madison, 1985); James Turner, *Reckoning With the Beast: Animals, Pain and Humanity in the Victorian Mind* (Baltimore, 1980). Elizabeth Blackwell and the comparisons drawn between women and animals are discussed in *The Old Brown Dog*; the Pansy quote is on p. 198.

Elizabeth Thompson (Lady Butler): *Women Artists: 1550–1950*, pp. 249–50; Paul Usherwood and Jenny Spencer-Smith, eds, *Lady Butler, Battle Artist 1846–1933* (exh. cat. National Army Museum, London, 1987); Matthew Lalumia, "Lady Elizabeth Thompson Butler in the 1870s," *Woman's Art Journal* (vol. 4, Spring/Summer 1983), pp. 9–14; critical responses are quoted in *Lady Butler*, p. 36; Ruskin's evaluation in "Academy Notes, 1875" is in E. T. Cook and A. Wedderburn, eds, *The Works of John Ruskin*, vol. 14 (London, 1904), pp. 308–09; for a more general discussion of Ruskin and women artists see Pamela Gerrish Nunn, "Ruskin's Patronage of Women Artists," *Woman's Art Journal* (vol. 2, Fall 1981/Winter 1982), pp. 8–13; responses to Thompson's nomination for Royal Academy membership are quoted in *Lady Butler*, p. 39. Anna Lea Merritt's comments on Thompson are quoted in *The Woman's Art Show*, p. 58.

Henrietta Ward: Pamela Gerrish Nunn, "The Case History of a Woman Artist: Hennrietta Ward," *Art History* (vol. 1, September 1978), pp. 293–308.

7 TOWARD UTOPIA: MORAL REFORM AND AMERICAN ART IN THE NINETEENTH CENTURY

Eighteenth- and early nineteenth-century women artists, including Eunice Pinney, are discussed in *American Women Artists*; see also *Nineteenth-Century American Women Artists*. For the relationship between needlework and political organizing in America see Pat Ferrero, Elaine Hedges, and Julie Silber, *Hearts and Hands: The Influence of Women and Quilts on American Society* (San Francisco, 1987); the Sarah Grimké quotes are on p. 72.

Lilly Martin Spencer: *Lilly Martin Spencer, 1822–1902: The Joys of Sentiment*, introduction by R. Bolton-Smith and W. H. Truettner (exh. cat., National Collection of Fine Arts, Washington, D. C., 1973); Spencer's letter to her mother is quoted in *Women and Art*, p. 105.

Studying art abroad: May Alcott,

Studying Art Abroad (Boston, 1879); *The Journal of Marie Bashkirtseff*, introduction by Roszika Parker and Griselda Pollock (new edn, London, 1985). Harriet Hosmer's letter is quoted in Phoebe Hanaford, *Women of the Century* (Boston, 1877), p. 269; Mary Cassatt's remark is quoted in Nancy Hale, *Mary Cassatt: A Biography of the Great American Painter* (New York, 1975), p. 165; Griselda Pollock, "American Women Artists of the Nineteenth Century, Part 2, Female Expatriots: Two Case Studies," paper presented at the Women's Studies Conference, University of Edinburgh, 1977.

The White Marmorean Flock: the term was first used by Henry James in *William Wetmore Story and His Friends From Letters, Diaries and Memories* (2 vols, New York, 1957; first publ. 1903); Margaret Farrand Thorp, "The White Marmorean Flock," *New England Quarterly* (June 1959), pp. 147–69; William Gerdts, *The White Marmorean Flock: Nineteenth-Century American Women Neoclassical Sculptors* (exh. cat., Vassar College Art Gallery, Poughkeepsie, N.Y., 1972); Wayne Craven, *Sculpture in America* (New York, 1968). Hosmer's letter to Crow is quoted in Cornelia Carr, ed., *Harriet Hosmer: Letters and Memories* (New York, 1912), p. 15. H. M., "Lady Artists in Europe," *Art Journal* (vol. 5, London, March 1866), p. 177.

Women's networks of personal relationships are the subject of Carroll Smith-Rosenberg, "The Female World of Love and Ritual: Relations Between Women in Nineteenth-Century America," in *Disorderly Conduct*, pp. 53–76. Thomas Crawford's attack on Hosmer's conduct is quoted in Jane Mayo Roos, "Another Look at Henry James and the 'White Mamorean Flock,'" *Woman's Art Journal* (vol. 4, Spring/Summer 1983), p. 32.

Harriet Hosmer: Joseph Leach, "Harriet Hosmer: Feminist in Bronze and Marble," *Feminist Art Journal* (vol. 5, Summer 1976), pp. 9–13; Alessandra Comini, "Who Ever Heard of a Woman Sculptor? Harriet Hosmer, Elisabet Ney, and the Nineteenth-Century Dialogue with the Three-Dimensional," in Tufts, *American Women Artists: 1830–1930*, pp. 17–25; Harriet Hosmer; Alicia Faxon, "Images of Women in the Sculpture of Harriet Hosmer," *Woman's Art Journal* (vol. 2, Spring/Summer 1981), pp. 25–29; Barbara S. Groseclos, "Harriet Hosmer's Tomb to Judith Falconnet: Death and the Maiden," *American Art Journal* (Spring 1980), pp. 78–79; Susan Waller, "The Artist, the Writer, and the Queen: Hosmer, Jameson, and Zenobia," *Woman's Art Journal* (vol. 4, Spring/Summer 1983), pp. 22–27. For Jameson on Zenobia, see Introduction above.

Charlotte Cushman: Clara Erskine Clement, *Charlotte Cushman* (Boston, 1882); Emma Stebbins, ed., *Charlotte Cushman: Her Letters and Memories of Her Life* (Boston, 1879); Joseph Leach, *Bright Particular Star: The Life and Times of Charlotte Cushman* (New Haven, 1970).

Nathaniel Hawthorne's remarks on

women authors are quoted in Martha Saxton, *Louisa May Alcott: A Modern Biography of Louisa May Alcott* (Boston, 1970), p. 238; Hosmer's response to *The Marble Faun* is in *Harriet Hosmer*, p. 156.

Anne Whitney: unless otherwise specified, quotations by Anne Whitney are from her unpublished letters, quoted by permission of Wellesley College Library; Elizabeth Rogers Payne, *Anne Whitney: Nineteenth-Century Sculptor and Liberal*, unpublished manuscript, Wellesley College Library; Payne, "Anne Whitney: Sculptures; Art and Social Justice," *Massachusetts Review* (vol. 12, Spring 1971), pp. 245–60; Payne, "Anne Whitney, Sculptor," *Art Quarterly* (vol. 25, Autumn 1962), pp. 244–61.

Edmonia Lewis: Lynda Roscoe Hartigan, *Sharing Traditions: Five Black Artists in Nineteenth-Century America* (exh. cat., National Museum of American Art, Washington, D.C., 1985); Jeffrey Blodgett, "John Mercer Langston and the Case of Edmonia Lewis: Oberlin, 1862," *The Journal of Negro History* (vol. 53, July 1968), pp. 201–18; Lewis's description of Hagar is quoted in *Bright Particular Star*, p. 335.

Vinnie Ream Hoxie: Joan A. Lemp, "Vinnie Ream and Abraham Lincoln," *Woman's Art Journal* (vol. 6, Fall 1985/Winter 1986), pp. 24–29; see p. 27 for Hosmer's response.

8 SEPARATE BUT UNEQUAL: WOMAN'S SPHERE AND THE NEW ART

The Philadelphia Centennial Exposition: Wanda M. Corn, "Women Building History," in *American Women Artists: 1830–1930*, pp. 26–34; Judith Paine, "The Women's Pavilion of 1876," *Feminist Art Journal* (Winter 1975–1976), pp. 5–12; Elizabeth Cady Stanton's response is quoted on p. 11.

The Pennsylvania Academy of the Fine Arts: *The Pennsylvania Academy and Its Women 1850–1920* (exh. cat., Pennsylvania Academy of the Fine Arts, Philadelphia, 1973), essay by Christine Jones Huber.

Susan MacDowell Eakins: *Thomas Eakins, Susan MacDowell Eakins, Elizabeth MacDowell Kenton* (exh. cat., North Cross School, Roanoke, Virginia, 1977); Louise Lippincott, "Thomas Eakins in the Academy," *In This Academy* (Washington, D.C., 1976); *Susan MacDowell Eakins: 1851–1938* (exh. cat., The Pennsylvania Academy of the Fine Arts, Philadelphia, 1973), essays by Seymour Adelman and Susan Casteras.

May Alcott: Caroline Ticknor, *May Alcott: A Memoir* (Boston, 1927); Alcott's description of Cassatt is on p. 152; see also Sarah Elbert, *A Hunger for Home: Louisa May Alcott and Little Women* (Philadelphia, 1984); Nina Auerbach, *Communities of Women: An Idea in Fiction* (Cambridge, Mass., 1978).

Women and Impressionism: Eunice Lipton, *Looking Into Degas: Uneasy Images*

of Women and Modern Life (Berkeley, Los Angeles, and London, 1986); Tamar Garb, *Women Impressionists* (Oxford, 1986); Charles Moffett et al., *The New Painting: Impressionism 1874–1886* (Oxford, 1986); John Rewald, *The History of Impressionism* (New York, 1973); Theresa Ann Gronberg, "Femmes de Brasserie," *Art History* (vol. 7, September 1984), pp. 329–44; Norma Broude, "Degas's 'Misogyny'" in Broude and Garrard, *Feminism and Art History*, pp. 247–69; Griselda Pollock, "Modernity and the Spaces of Femininity," *Vision and Difference*, pp. 50–90.

Mary Cassatt: Griselda Pollock, *Mary Cassatt* (New York, 1980); Adelyn Breeskin, *The Graphic Work of Mary Cassatt: A Catalogue Raisonné* (New York, 1948); Breeskin, *Mary Cassatt: A Catalogue Raisonné of Paintings, Watercolors and Drawings* (Washington, D.C. 1970); Nancy Hale, *Mary Cassatt* (New York, 1975); John D. Kysela, "Mary Cassatt's Mystery Mural and the World's Fair of 1893," *Art Quarterly* (vol. 19, 1966), pp. 129–45; F. Sweet, *Miss Mary Cassatt: Impressionist from Pennsylvania* (Norman, Ok., 1966); Susan Fillin-Yeh, "Mary Cassatt's Images of Women," *Art Journal* (vol. 35, Summer 1976), pp. 359–63; Cassatt's remarks about painting are quoted in Pollock, *Mary Cassatt*, p. 9.

Berthe Morisot: *Berthe Morisot: Impressionist* (exh. cat., The National Gallery of Art, Washington, D.C., 1987), essays by Charles F. Stuckey and William P. Scott; Kathleen Adler and Tamar Garb, *Berthe Morisot* (Ithaca, N.Y., 1987); Mme. Morisot and Edmé are quoted in Denis Rouart, ed., *The Correspondence of Berthe Morisot* (New York, 1957), p. 35; M. L. Bataille and G. Wildenstein, *Berthe Morisot: Catalogue des peintures, pastels et aquarelles* (Paris, 1961); Leila Kinney, "Genre: A Social Contract?," *Art Journal* (vol. 46, Winter 1987), pp. 267–77; Linda Nochlin, "Morisot's *Wet Nurse*: The Construction of Work and Leisure in Impressionist Painting," *Women, Art, and Power*, pp. 37–56; Renoir's remarks about professional women are in *Renoir* (exh. cat., The Museum of Fine Arts, Boston, 1987), p. 15.

Eva Gonzales: François Mathey, *Six femme peintres* (Paris, 1931); *Salons de la Vie Moderne: Catalogue des peintures et pastels de Eva Gonzales* (Paris, 1885).

The Arts and Crafts Movement: Anthea Callen, *Women Artists of the Arts and Crafts Movement 1870–1914* (New York, 1979); Isabelle Anscombe, *A Woman's Touch: Women in Design from 1860 to the Present* (London, 1984); Anscombe and Charlotte Gere, *Arts and Crafts in Britain and America* (New York, 1978); *The Subversive Stitch*; Candace Wheeler is quoted in *A Woman's Touch*, p. 36.

Art pottery: Paul Evans, *Art Pottery of the United States: An Encyclopedia of Producers and Their Marks* (New York, 1974).

World's Columbian Exposition: Jeanne Madeline Weimann, *The Fair Women: The Story of the Woman's Building, World's*

Columbian Exposition, Chicago 1893 (Chicago, 1981).

9 MODERNISM, ABSTRACTION, AND THE NEW WOMAN

Baudelaire, "The Painter of Modern Life" (1863), reprinted in Francis Frascina and Charles Harrison, eds, *Modern Art and Modernism: A Critical Anthology* (New York, 1982), p. 23; Exter is quoted in I. Yasinskaya, *Revolutionary Textile Design: Russia in the 1920s and 1930s*, introduction by John Bowlt (New York, 1983).

Wassily Kandinsky: Peg Weiss, *Kandinsky in Munich: The Formative Jugendstil Years* (Princeton, 1979) contains much valuable information about Kandinsky and Jugendstil; see especially ch. 10 on the relationship between ornament and abstraction; Kandinsky's remarks are quoted on p. 107.

Gabriele Münter: *Women Artists: 1550–1950*, pp. 281–82; *Women and Art*, pp. 160–62; Shulamith Behr, *Women Expressionists* (New York, 1988); Anne Mochon, *Gabriele Münter: Between Munich and Murnau* (Cambridge and Princeton, 1980); Edouard Roditi, "Interview With Gabriele Münter," *Arts* (vol. 34, January 1960), pp. 36–41; J. Eichner, *Kandinsky und Gabriele Münter von Ursprungen modernen Kunst* (Munich, 1957); L. Erlanger, "Gabriele Münter: A Lesser Life?," *Feminist Art Journal* (Winter 1974–1975), pp. 11–13.

Vanessa Bell: Frances Spalding, *Vanessa Bell* (New Haven and London, 1983); *Vanessa Bell: A Memorial Exhibition of Paintings* (exh. cat., Arts Council Gallery, London, 1964), introduction by Ronald Pickvance.

Omega Workshops: Isabelle Anscombe, *Omega and After: Bloomsbury and the Decorative Arts* (London, 1981); Simon Watney, "The Connoisseur as Gourmet: The Aesthetics of Roger Fry and Clive Bell" in *Formations of Pleasure* (London, 1983), pp. 66–83; Virginia Woolf's response to Omega dressmaking is quoted in Spalding, *Vanessa Bell*, p. 142.

Sonia Delaunay: *Women and Art*, pp. 169–71; *Sonia Delaunay: A Retrospective* (exh. cat., Albright-Knox Art Gallery, Buffalo, 1980), essays by Sherry A. Buckberrough, contains extensive bib.; the Delteil poem is quoted here; R. Delaunay's comment is on p. 21; Cendrars's response to Delaunay's dress designs is on p. 38; Crevel's description of the Delaunay apartment is on p. 56; Clare Rendell, "Sonia Delaunay and the Expanding Definition of Art," *Woman's Art Journal* (vol. 4, Spring/Summer 1983), pp. 35–38.

Futurist costume: Pontus Hulten, ed., *Futurism and Futurisms* (London, 1987); Enrico Crispolti, *Il futurismo e la moda: Balla e gli altri* (Venice, 1987), discusses *The Antineutral Dress*; the Balla quote is on p. 11; Futurism and antifeminism is discussed in Fanette Roche-Pezard, *L'Aventure Futuriste (1908–1916)* (Paris, 1983), pp. 141–45.

The Russian avant-garde: *Women Artists: 1550–1950*, pp. 62; *Women and Art*, pp. 162–69; Stephanie Barron and Maurice Tuchman, *The Avant-Garde in Russia, 1910–1930: New Perspectives* (exh. cat., Los Angeles County Museum of Art, 1980); Christina Lodder, *Russian Constructivism* (New Haven and London, 1983); Popova's "painterly architectonics" is discussed on p. 45; Productivism is discussed on pp. 75–76; the Stepanova quote is on p. 147; *Künstlerinnen der russischen Avantgarde (Women Artists of the Russian Avant-Garde): 1910–1930* (exh. cat., Galerie Gmurzynska, Cologne, 1979); Camilla Gray, *The Russian Experiment in Art: 1863–1922* (revised and enlarged edn, London and New York, 1986); Susan P. Compton, "Alexandra Exter and the Dynamic Stage," *Art in America* (vol. 62, September/October 1974), pp. 100–02; Alison Hilton, "When the Renaissance Came to Russia," *Art News* (vol. 70, December 1971), pp. 34–39, 56–62; *Russian Avant-Garde: 1908–1922* (exh. cat., Leonard Hutton Galleries, New York, 1971); Margit Rowell and Angelica Rudenstine, eds, *Art of the Avant-Garde in Russia: Selections from the George Costakis Collection* (exh. cat., Solomon R. Guggenheim Museum, New York, 1981); Leonard Folgarait, "Art State Class: Avant-Garde Art Production and the Russian Revolution," *Arts Magazine* (vol. 60, December 1985), pp. 69–75.

Sophie Taeuber-Arp and Jean Arp: *Arp: 1886–1966* (exh. cat., Minneapolis Institute of Arts, 1986), curated by Jane Hancock and Stephanie Poley; Arp is quoted in *Arp: On My Way, Poetry and Essays 1912–1947* (New York, 1948), p. 40; *Sophie Taeuber-Arp* (exh. cat., The Museum of Modern Art, New York, 1981), essay by Caroline Lanchner; the Taeuber-Arp quote is on p. 9; *Sophie Taeuber-Arp* (exh. cat., Musée National d'Art Moderne, Paris, 1964).

Hannah Höch: *Women Artists: 1550–1950*, pp. 307–09; *Hannah Höch: Collagen aus den Jahren 1916–1971* (exh. cat., Akademie der Kunste, Berlin, 1971); *Hannah Höch, collages, peintures, aquarelles, gouaches, dessins* (exh. cat., Musée National d'Art Moderne, Paris, and Nationalgalerie, Berlin, 1976); *Hannah Höch: Fotomontagen, Gemälde, Aquarelle* (exh. cat., Kunsthalle, Tubingen, 1980), essays by Peter Krieger, Suzanne Pagé and Hanne Bergius; Dawn Ades, *Photomontage* (London and New York, rev. and enlarged edn 1986); Sally Stein, "The Composite Photographic Image and the Composition of Consumer Ideology," *Art Journal* (vol. 41, Spring 1981), pp. 39–45.

Romaine Brooks: *Women Artists: 1550–1950*, pp. 268–270; *Women and Art*, pp. 189–91; Adelyn D. Breeskin, *Romaine Brooks* (Washington, D.C., 1986); Meryl Secrest, *Between Me and Life: A Biography of Romaine Brooks* (New York, 1974); for the women modernists in Paris in the early twentieth century see Shari Benstock, *Women of the Left Bank: Paris, 1900–1940* (Austin, 1986); Brooks's portraits are discussed on pp. 304–06; the remark about Brooks's portrayal of women is on p. 305.

Consumerism and women: Stuart Ewen,

Captains of Consciousness: Advertising and the Social Roots of Consumer Culture (New York, 1976).

The New Woman: Renate Bridenthal, Atina Grossman, and Marion Kaplan, eds, *When Biology Became Destiny: Women in Weimar and Nazi Germany* (New York, 1984); Lisa Tickner, *The Spectacle of Women: Imagery of the Suffrage Campaign 1907–14* (Chicago, 1988); Elizabeth Wilson, *Adorned in Dreams: Fashion and Modernity* (London, 1985); Kenneth W. Wheeler and Virginia Lee Lussier, *Women, the Arts, and the 1920s in Paris and New York* (New Brunswick, N.J., and London, 1982).

10 THE INDEPENDENTS

Key source books on feminism and Modernism: *Vision and Difference*; *Women, Art and Power*; Juliet Mitchell, *Women: The Longest Revolution* (New York, 1966, rev. edn, 1988); Fred Orton and Griselda Pollock, "Avant-Gardes and Partisans Reviewed," *Art History* (vol. 3, September 1981), pp. 305–27.

Sexualizing creativity: the Renoir quotes are in John House, "Renoir's World" in *Renoir* (exh. cat., Hayward Gallery, London, 1985), p. 16; Picasso's quote is in John Golding, "The Real Picasso," *New York Review of Books* (vol. 35, July 21, 1988), p. 22. Carol Duncan, "Domination and Virility in Vanguard Painting," reprinted in Broude and Garrard, *Feminism and Art History*, pp. 293–314; the quote is on p. 311; see also Alessandra Comini, "Gender or Genius? The Women Artists of German Expressionism," *ibid.*, pp. 271–92.

Suzanne Valadon: *Women Artists: 1550–1950*, pp. 259–61; *Our Hidden Heritage*, pp. 169–72; Jeanine Warnod, *Suzanne Valadon* (New York, 1981); the Dorival quote is on p. 88; Nesto Jacometti, *Suzanne Valadon* (Geneva, 1947); Bernard Dorival, *Suzanne Valadon* (exh. cat., Musée National d'Art Moderne, Paris, 1967); Paul Petrides, *L'Oeuvre complet de Suzanne Valadon* (Paris, 1971); Rosemary Betterton, "How Do Women Look? The Female Nude in the Work of Suzanne Valadon" in *Looking On*, pp. 217–34.

Feminist literature on spectatorship: key articles, including Laura Mulvey's influential "Visual Pleasure and Narrative Cinema," are reprinted in *Looking On*.

The cult of fecundity: Wendy Slatkin, "Maternity and Sexuality in the 1890s," *Woman's Art Journal* (vol. 1, Spring/Summer 1980), pp. 13–19; the Zola quote is on p. 15. For Gauguin's representations of Tahitian women see Josephine Withers, "Perspectives on the Art of Gauguin: For Women, It's Sexual Colonialism," *The Washington Post* (July 3, 1988).

Paula Modersohn-Becker: *Women Artists: 1550–1950*, pp. 273–80; *Our Hidden Heritage*, pp. 188–97; *Paula Modersohn-Becker: zum hundertsten Geburtstag* (exh. cat., Kunsthalle, Bremen, 1976); Ellen C. Oppler, "Paula Modersohn-Becker: Some

Facts and Legends," *Art Journal* (vol. 35, Summer 1976), pp. 364–69; Gustav Pauli, *Paula Modersohn-Becker* (Leipzig, 1919, rev. edn, 1934); Otto Stelzer, *Paula Modersohn-Becker* (Berlin, 1958); *Paula Modersohn-Becker, Zeichnungen, Pastelle, Bildentwurfe* (exh. cat., Kunstverein in Hamburg, 1976); Martha Davidson, "Paula Modersohn-Becker: Struggle Between Life and Art," *Feminist Art Journal* (Winter 1973–1974), pp. 1–5; Alfred Werner, "Paula Modersohn-Becker: A Short, Creative Life," *American Artist* (vol. 37, June 1973), pp. 16–23; Günter Busch and Liselotte von Reinken, eds, *Paula Modersohn-Becker: The Letters and Journals* (New York, 1983); the quote about Frau Meyer is on p. 120; a useful discussion of the feminist implications of Modersohn-Becker's paintings of women is in Tickner, "Pankhurst, Modersohn-Becker and the Obstacle Race," pp. 24–39; Gillian Perry, *Paula Modersohn-Becker: Her Life and Work* (New York and London, 1979); the "Volkish" movement is discussed by Michael Jacobs, *The Good and Simple Life: Artist Colonies in Europe and America* (Oxford, 1985).

Woman and nature: the literature is extensive; for example, Sherry Ortner, "Is Female to Male as Nature is to Culture?" in Rosaldo and Lamphere, *Women, Culture and Society*, pp. 67–87. Mary Daly, Adrienne Rich, and Susan Griffin have been influential proponents of an essentialist or cultural feminist position; for a more recent critique of innate gender differences see the references under Anne Fausto-Sterling, and Sherry Ortner and Harriet Whitehead in the Preface above; Marcia Pointon, "Interior Portraits: Women, Physiology and the Male Artist," *Feminist Review* (no. 22, Spring 1986), pp. 5–22, points out that the correlation between woman and nature is fundamental in nineteenth-century thinking. Scheffler is quoted in *Women Expressionists*, p. 8.

Käthe Kollwitz: *Women Artists: 1550–1950*, pp. 263–65; Nochlin's remarks about Kollwitz are quoted in Tickner, "Pankhurst, Modersohn-Becker and the Obstacle Race," p. 34; Hans Kollwitz, ed., *Diaries and Letters of Käthe Kollwitz* (Chicago, 1955); A. von der Becke, *Käthe Kollwitz: Handzeichnungen und graphische Seltenheiten, eine Austellung zum 100. Geburtstag* (Munich, 1967); Martha Kearns, *Käthe Kollwitz: Woman and Artist* (New York, 1976); Otto Nagel, *Käthe Kollwitz* (New York 1963); Howard Devree, "Käthe Kollwitz," *Magazine of Art* (vol. 32, September 1939), pp. 512–17.

Gwen John: *Women Artists: 1550–1950*, pp. 271–72; *Our Hidden Heritage*, pp. 199–204; Cecily Langdale, *Gwen John* (London, 1987); John McEwen, "A Room of Her Own," *Art in America* (vol. 74, June 1986), pp. 111–14; Augustus John, "Gwendolen John," *Burlington Magazine* (vol. 81, October 1942), pp. 236–38; *Gwen John: A Retrospective Exhibition* (Davis and Long Company, New York 1975), introduction by Cecily Langdale; Langdale and David Jenkins, *Gwen John: An Interior Life* (New York, 1986); Mary Taubman, *Gwen John*

(London, 1985). The identification of Rodin's sexuality with his creativity is a *leitmotif* in the Rodin literature; for example, Bernard Champigneulle, *Rodin* (New York and Toronto, 1967); the quote is on p. 151.

Camille Claudel: *Camille Claudel* (exh. cat., the National Museum of Women in the Arts, Washington, D.C., 1987), essay by Reine-Marie Paris; Paris, *Camille Claudel: The Life of Camille Claudel, Rodin's Muse and Mistress*, trans. L. Tuck (New York, 1988).

Marie Laurencin: *Women Artists: 1550–1950*, pp. 295–96; Roger Allard, *Marie Laurencin* (Paris, 1921); Guillaume Apollinaire, *Apollinaire on Art: Essays and Reviews, 1902–1918* (New York, 1972); Jean-Emile Laboureur, "Les estampes de Marie Laurencin," *L'Art d'aujourd'hui* (vol. 1, Autumn/Winter 1924), pp. 17–21; Renée Sandell, "Marie Laurencin: Cubist Muse or More?," *Woman's Art Journal* (vol. 1, Spring/Summer 1980), pp. 23–27; the Apollinaire quotes are on p. 24.

Florine Stettheimer: *Women Artists: 1550–1950*, pp. 266–67; Parker Tyler, *Florine Stettheimer: A Life in Art* (New York, 1963); Linda Nochlin, "Florine Stettheimer: Rococo Subversive" in *Women, Art, and Power*, pp. 109–35; Pamela Wye, "Florine Stettheimer: Eccentric Power, Invisible Tradition," *M/E/A/N/I/N/G* (vol. 3, May 1988), pp. 3–12.

Georgia O'Keeffe: *Women Artists: 1550–1950*, pp. 300–06; *Georgia O'Keeffe* (exh. cat., The Metropolitan Museum of Art, New York, 1988); *Georgia O'Keeffe* (exh. cat., The Whitney Museum of American Art, New York, 1970), cat. by Lloyd Goodrich and Doris Bry; Katherine Hoffman, *An Enduring Spirit: The Art of Georgia O'Keeffe* (London, 1984); Laurie Lisle, *Portrait of an Artist* (New York, 1980); the quotes are reprinted in Lisle, pp. 119–55.

Emily Carr: Paula Blanchard, *The Life of Emily Carr* (Seattle, 1987); Emily Carr, *Growing Pains: The Autobiography of Emily Carr* (Toronto, 1946); Maria Tippett, *Emily Carr: A Biography* (Oxford, 1979); Edythe Scheider, *Emily Carr: The Untold Story* (Seattle, 1978); Doris Shadbolt, *Emily Carr* (Vancouver, 1975); Shadbolt, *The Art of Emily Carr* (Vancouver, 1988).

Barbara Hepworth: Barbara Hepworth, *A Pictorial Autobiography* (New York, 1970); A. M. Hammacher, *The Sculpture of Barbara Hepworth* (New York, 1986); the Stokes comments are on p. 68.

Women and Surrealism: Whitney Chadwick, *Women Artists and the Surrealist Movement* (London and Boston, 1985); more recent sources include Mary Ann Caws, "Ladies Shot and Painted: Female Embodiment in Surrealist Art" in Suleiman, *The Female Body in Western Culture*; Erika Billeter and Jose Pierre, *La Femme et le Surréalisme* (exh. cat., Musée du Cantonal, Lausanne, 1987); Janet Kaplan, *Unexpected Journeys: The Art and Life of*

Remedios Varo (New York, 1988); Carrington's writings have been re-issued, *The House of Fear* and *The Seventh Horse* (London, 1989).

11 IN AND OUT OF THE MAINSTREAM

The Great Depression: K. A. Marling and H. Harrison, *7 American Women: The Depression Decade* (exh. cat., Vassar College Art Gallery, Poughkeepsie, N.Y., 1976); Caroline Bird, *The Invisible Scar* (New York, 1966); Cindy Nemser, *Art Talk* (New York, 1975) contains valuable interviews with artists.

Irene Rice Pereira: *Our Hidden Heritage*, pp. 233–38; Judith K. Van Wagner, "I. Rice Pereira: Vision Superceding Style," *Woman's Art Journal* (vol. 1, no. 1, Spring/Summer 1980), pp. 33–38.

Abstract Expressionism: *Abstract Expressionism: The Formative Years* (exh. cat., Herbert F. Johnson Museum of Art, Cornell University, Ithaca, N.Y., 1978), essays by Robert Carlton Hobbs and Gail Levin; Ann Gibson, "The Rhetoric of Abstract Expressionism" in Michael Auping, *Abstract Expressionism: The Critical Developments* (exh. cat., Albright-Knox Art Gallery, Buffalo, 1987); Irving Sandler, *The Triumph of American Painting* (New York, 1970); Schapiro's and Krasner's comments on the Club and the Cedar Bar are discussed in *Originals*, p. 275.

Lee Krasner: *Lee Krasner: A Retrospective* (exh. cat., Museum of Modern Art, New York, 1983), essay by Barbara Rose; the quote about Krasner's hybrid images is on p. 114; Ellen G. Landau, "Lee Krasner's Past Continuous," *Art News* (vol. 83, no. 2, February 1984), pp. 68–76; *Krasner and Pollock: A Working Relationship* (exh. cat., Gray Art Gallery, New York, 1981), essay by Barbara Rose; Anne Wagner, "Lee Krasner as L. K.," *Representations* (vol. 25, Winter 1989), pp. 42–57; the comments about women and writing, including the Gauthier quote, are cited in Elaine Marks and Isabelle de Courtivron, *New French Feminisms: An Anthology* (New York, 1981), p. 162; Cixous's remarks are on p. 251. Hofmann's response to women's painting is quoted in *Originals*, p. 108.

Dorothy Dehner: *Dorothy Dehner and David Smith: Their Decades of Search and Fulfillment* (exh. cat., the Jane Voorhees Zimmerli Art Museum, Rutgers University, New Brunswick, N.J., 1984), essay by Joan Marter.

Louise Bourgeois: *Louise Bourgeois* (exh. cat., The Museum of Modern Art, New York, 1983), essay by Deborah Wye; the quotation about her paintings is on p. 17; the critic's response to her late 1960s sculpture is on p. 27.

Joan Mitchell. *Joan Mitchell* (exh. cat., Herbert F. Johnson Museum of Art, Cornell University, Ithaca, N.Y.), essay by Judith Bernstock; John Ashbery, "An Expressionist in Paris," *Art News* (vol. 64, April 1965), pp. 44ff.

Grace Hartigan: Ann Schoenfeld, "Grace Hartigan in the Early 1950s: Some Sources, Influences, and the Avant-Garde," *Arts Magazine* (vol. 59, no. 11, September 1985), pp. 84–88; *Hartigan: Thirty Years of Painting, 1950–1980* (exh. cat, Fort Wayne Museum of Art, Fort Wayne, Indiana, 1981).

Elaine De Kooning: Lawrence Campbell, "Elaine De Kooning: Portraits in a New York Scene," *Art News* (vol. 62, April 1963), pp. 38–39; "Ten Portraitists—Interviews/Statements," *Art in America* (vol. 63, January–February 1975), pp. 35–36; Rose Slivka, "Elaine De Kooning: The Bacchus Paintings," *Arts Magazine* (vol. 57, October 1982), pp. 66–69.

Helen Frankenthaler: *Helen Frankenthaler: Paintings* (exh. cat., Corcoran Gallery of Art, Washington, D. C., 1975); Carl Belz, *Frankenthaler: the 1950s* (exh. cat., Rose Art Museum, Brandeis University, Waltham, Ma., 1981); the critical designation of her work as "feminine" is by B. Friedman, see *Originals*, p. 217.

Ethel Schwabacher: *Ethel Schwabacher: A Retrospective Exhibition* (exh. cat., Jane Voorhees Zimmerli Art Museum, Rutgers University, New Brunswick, N.J., 1987), essays by Greta Berman and Mona Hadler.

Louise Nevelson: Laurie Wilson, *Louise Nevelson: Iconography and Sources* (Outstanding Dissertations in the Fine Arts, series 5, New York, 1981); "Nevelson on Nevelson," *Art News* (vol. 71, November 1972), pp. 67–73; critical response to Nevelson's first exhibition is quoted in *Women and Art*, p. 201; the Kramer quote is in *Originals*, p. 141.

Bridget Riley: Bryan Roberts, "Bridget Riley: Color as Image," *Art in America* (vol. 63, March/April 1975), pp. 69–71; her response to feminism is in *Art and Sexual Politics*, pp. 82–83.

Marisol: Grace Glueck, "It's Not Pop, It's Not Op—It's Marisol," *New York Times Magazine* (March 7, 1965), pp. 34–35; Lawrence Campbell, "Marisol's Magic Mixtures," *Art News* (vol. 63, March 1964), pp. 38–41; Roberta Bernstein, "Marisol's Self-Portraits: The Dream and the Dreamer," *Arts Magazine* (vol. 59, March 1985), pp. 86–88.

Nikki de Saint Phalle: *Fantastic Vision: Works by Nikki de Saint Phalle* (exh. cat., Nassau County Museum of Art, Roslyn, N.Y., 1988); *Nikki de Saint Phalle: Retrospective Exhibition* (exh. cat., Musée National d'Art Moderne, Centre Georges Pompidou, Paris, 1980).

American art of the 1960s: Sidra Stich, *Made in USA* (exh. cat., The University Art Museum, Berkeley, 1987).

Eva Hesse: Lucy Lippard, *Eva Hesse* (New York, 1976); *Eva Hesse: A Memorial Exhibition* (exh. cat., Solomon R. Guggenheim Museum, New York, 1973); the quote is in Lippard, *Eva Hesse*, p. 24.

Faith Ringgold: *Faith Ringgold: Change:*

Painted Story Quilts (exh. cat., Bernice Steinbaum Gallery, New York, 1987), essays by Moira Roth and Thalia Gouma-Peterson; Michele Wallace, ed., *Faith Ringgold: Twenty Years of Painting, Sculpture and Performance* (exh. cat. The Studio Museum in Harlem, New York, 1984); for an account of the black art politics of the 1960s see Mary Schmidt Campbell, ed., *Tradition and Conflict: Images of a Turbulent Decade, 1963–1973* (exh. cat., The Studio Museum in Harlem, New York, 1985).

Betye Saar: Cindy Nemser, "Conversation with Betye Saar," *Feminist Art Journal* (winter 1975–76), pp. 19–24; *Betye Saar* (exh. cat., Museum of Contemporary Art, Los Angeles, 1984).

Art of the 1970s: Corinne Robins, *The Pluralist Era: American Art, 1968–1981* (New York, 1984); Wendy Beckett, *Contemporary Women Artists* (New York, 1988); *Europe in the Seventies: Aspects of Recent Art* (exh. cat., The Art Institute of Chicago, 1977); Edward Lucie-Smith, *Art in the Seventies* (Ithaca, N.Y., 1980).

Feminism and art in the 1970s: Arlene Raven, Cassandra Langer, and Joanna Fruch, *Feminist Art Criticism: An Anthology* (Ann Arbor, 1988); Lucy Lippard, *From the Center: Feminist Essays on Women's Art* (New York, 1976); *The New Culture: Women Artists of the Seventies* (exh. cat., Turman Gallery, Indiana State University, Terre Haute, 1984); *Framing Feminism*. The Whitney Museum officials are quoted by Grace Glueck, *The New York Times*, December 12, 1970.

Alice Neel: Patricia Hills, *Alice Neel* (New York, 1983); Linda Nochlin, "Some Women Realists: Painters of the Figure," *Arts Magazine* (vol. 48, May 1974), pp. 29–33.

Isabel Bishop: *Women Artists: 1550–1950*, pp. 325–26; Karl Lunde, *Isabel Bishop* (New York, 1975); Sheldon Reich, *Isabel Bishop Retrospective* (University of Arizona Museum of Art, Tucson, 1974).

The first feminist art programs: Judy Chicago, *Through the Flower: My Struggle as a Woman Artist* (New York, 1977); *Womanhouse* (exh. cat., Los Angeles, 1973); Paula Harper, "The First Feminist Art Program: A View from the 1980s," *Signs: Journal of Women in Culture and Society* (vol. 10, no. 4, Summer 1985), pp. 762–81.

Women and Performance: Moira Roth, ed., *The Amazing Decade: Women and Performance Art in America, 1970–1980* (Los Angeles, 1983); Eleanor Antin, *Being Antinova* (Los Angeles, 1983); Kim Levin, *Angel of Mercy* (exh. cat., Museum of Contemporary Art, La Jolla, Ca., 1977); RoseLee Goldberg, *Performance: Live Art 1909 to the Present* (London and New York, 1979, rev. and enlarged as *Performance Art: From Futurism to the Present*, 1988); the Berger quote is in *Ways of Seeing* (London, 1972), p. 46.

Female imagery: for a critique of feminist imagery see Judith Barry and Sandy

Flitterman-Lewis, "Textual Strategies: The Politics of Art-Making," reprinted in *Feminist Art Criticism*, pp. 87–97; Joan Semmel and April Kingsley, "Sexual Imagery in Women's Art," *Woman's Art Journal* (vol. 1, Spring/Summer 1980, pp. 1–6; Lucy Lippard, "Quite Contrary: Body, Nature, Ritual in Women's Art," *Chrysalis* (no. 2, 1977), pp. 31–47; Lisa Tickner, "The Body Politic: Female Sexuality and Women Artists Since 1970," *Art History* (vol. 1, June 1978), pp. 236–51; Lippard, "The Pains and Pleasures of Rebirth: European and American Women's Body Art," reprinted in *From the Center*, pp. 121–39; Lawrence Alloway, "Women's Art in the 70s," reprinted in Judy Loeb, ed., *Feminist Collage: Educating Women in the Visual Arts* (New York and London, 1979); Susan Griffin, *Women and Nature: The Roaring Inside Her* (New York, 1978); Lippard's list of female characteristics is in "Prefaces to Catalogues of Women's Exhibitions (three parts)," in *From the Center*, p. 49.

Female spirituality: Gloria Feman Orenstein, "The Reemergence of the Archetype of the Great Goddess in Art," *Heresies*, special no. devoted to the Great Goddess (New York, 1982); Carol P. Christ, "Why Women Need the Goddess: Phenomenological, Psychological, and Political Reflections," *Heresies* (vol. 2, no. 1, Spring 1978), pp. 8–13; *Seven Cycles: Public Rituals*. Mary Beth Edelson (New York, 1980), introduction by Lucy Lippard; *Ana Mendieta: A Retrospective* (exh. cat., The New Museum of Contemporary Art, New York, 1987).

Nancy Spero: *Nancy Spero* (exh. cat., Institute of Contemporary Art, London, 1987), essays by Lisa Tickner and Jon Bird; Desa Philippi, "The Conjuncture of Race and Gender in Anthropology and Art History; a Critical Study of Nancy Spero's Work," *Third Text* (no. 1, Autumn 1987), pp. 34–54.

May Stevens: *Ordinary Extraordinary* (exh. cat., Kenyon College, Gambier, Ohio, 1988); *Ordinary Extraordinary, A Summation 1977–1984* (exh. cat., Boston University Art Gallery, 1984), texts by Patricia Hills, Donald Kuspit et al.

Joan Snyder: Sally Webster, "Joan Snyder, Fury and Fugue: Politics of the Inside," *Feminist Art Journal* (vol. 5, Summer 1976), pp. 5–8; *Joan Snyder: Seven Years of Work* (exh. cat., Roy L. Neuberger Museum, Purchase, N.Y., 1978).

Lynda Benglis: "Interview; Lynda Benglis," *Ocular: The Directory of Information and Opportunities for the Visual Arts* (Summer Quarter, New York, 1979), pp. 30–43.

Fiber art: *American Fiber Art: A New Definition* (exh. cat., University of Houston, 1980), essays by Lawrence Alloway and Jane Vander Lee; Mildred Constantine and Jack Lenor Larsen, *Beyond Craft: The Art Fabric* (New York, 1972); Katherine Howe-Echt, "Questions of Style: Contemporary

Trends in the Fiber Arts," *Fiberarts* (March/April 1980), pp. 38–43.

Magdalena Abakanowicz: *Magdalena Abakanowicz* (exh. cat., Museum of Contemporary Art, Chicago, 1982); *Abakanowicz Retrospective* (exh. cat., Galerie Alice Pauli, Lausanne, 1979).

Pattern and Decoration: *The Pluralist Era*, pp. 131–54; Janet Kardon, *The Decorative Impulse* (exh. cat., Institute of Contemporary Art, University of Pennsylvania, Pa., 1979); John Perrault, "Issues in Pattern Painting, *Artforum* (vol. 16, no. 3, November 1977), pp. 32–36; Amy Goldin, "Patterns, Grids and Painting," *Artforum* (vol. 13, no. 11, September 1975), pp. 50–54; Jeff Perrone, "Approaching the Decorative," *Artforum* (vol. 15, December 1976), pp. 26–30; Norma Broude, "Miriam Schapiro and 'Femmage:' Reflections on the Conflict Between Decoration and Abstraction in Twentieth-Century Art" in Broude and Garrard, *Feminism and Art History*, pp. 314–29; Judith Bettelheim, "Pattern Painting: The New Decorative, A California Perspective," *Images and Issues* (Los Angeles, March/April 1983), pp. 323–36; Patricia Stewart, "High Decoration in Low Relief," *Art in America* (vol. 68, no. 2, February 1980), pp. 97–101.

Miriam Schapiro: *Miriam Schapiro: Femmages 1971–1985* (exh. cat., Brentwood Gallery, St. Louis, Miss., 1985); Thalia Gouma-Peterson, ed., *Miriam Schapiro: A Retrospective, 1953–1980* (exh. cat., The College of Wooster, Ohio, 1980).

Jackie Winsor: *Jackie Winsor* (exh. cat., The Museum of Modern Art, New York, 1979); Lucy Lippard, "Jackie Winsor," reprinted in *From the Center*, p. 202.

Earthworks: Ted Castle, "Nancy Holt, Siteseer," *Art in America* (vol. 70, March 1982), pp. 84–91; see also Lucy Lippard, *Overlay: Contemporary Art and the Art of Prehistory* (New York, 1983); *The Pluralist Era*.

Women and "New Image" painting: "Pat Steir: Seeing Through the Eyes of Others," *Art News* (vol. 84, November 1985), pp. 81–88; Tony Godfrey, *The New Image* (Oxford, 1986); Phyllis Freeman, ed., *New Art* (New York, 1984).

Hanne Darboven: Johannes Cladders and Hanne Darboven, eds., *Hanne Darboven* (exh. cat., Venice Biennale, 1982); Margarethe Jochimsen, *Hanne Darboven: Wende '80'* (Bonn, 1982).

Jennifer Bartlett: Marge Goldwater, Roberta Smith, and Calvin Tomkins, *Jennifer Bartlett* (New York, 1985).

Gillian Ayres: Tim Hilton, *Gillian Ayres* (exh. cat., Arts Council of Great Britain, London, 1983); *Gillian Ayres* (exh. cat., Serpentine Gallery, London, 1984).

Pat Steir: *Pat Steir* (exh. cat., The Tate Gallery, London, 1988).

Las Mujeres Muralistas: *American Women Artists: From Early Indian Times to the Present*, pp. 430–34.

Judy Baca: Carrie Rickey, "The Writing on the Wall," *Art in America* (vol. 69, no. 5, May 1981), pp. 54–57; Kay Mills, "The Great Wall of Los Angeles," *Ms. Magazine* (October 1981, New York), pp. 56–58; *The Big Picture: Murals of Los Angeles* (London and Boston, 1988); commentaries by Stanley Young.

Suzanne Lacy: Moira Roth, "Suzanne Lacy: Social Reformer and Witch," *The Drama Review: A Journal of Performance Studies* (vol. 32, Cambridge, Mass., Spring 1988), pp. 42–60.

Judy Chicago and *The Dinner Party:* Jan Butterfield, "Guess Who's Coming to Dinner? An Interview with Judy Chicago," *Mother Jones* (January 1979), pp. 20–24; "Judy Chicago: In Conversation with Ruth Iskin," *Visual Dialogue* (vol. 2, March–May 1978), pp. 14–18; Lucy Lippard, "Judy Chicago's 'Dinner Party,'" *Art in America* (vol. 68, no. 4, April 1980), pp. 115–26; Carol Snyder, "Reading the Language of *The Dinner Party*," *Woman's Art Journal* (vol. 1, Fall 1980/Winter 1981), pp. 30–34; Susan Havens Caldwell, "Experiencing *The Dinner Party*," *Woman's Art Journal* (vol. 1, Fall 1980/Winter 1981), pp. 35–36; Lauren Rabinovitz, "Issues of Feminist Aesthetics: Judy Chicago and Joyce Wieland," *Woman's Art Journal* (vol. 1, Fall 1980/Winter 1981), pp. 38–41; Tamar Garb, "Engaging Embroidery" (a review of *The Subversive Stitch*), *Art History* (vol. 9, 1986), p. 132; Carrie Rickey, "Judy Chicago: The Dinner Party" and Karin Woodley, "The Inner Sanctum: The Dinner Party" in *Visibly Female*, pp. 94–99.

A POSTMODERN POSTSCRIPT

General sources: Brian Wallis, ed., *Art After Modernism: Rethinking Representation* (New York, 1984); Sandy Nairne, *State of the Art: Ideas and Images in the 1980s* (London, 1987); E. Ann Kaplan, ed., *Postmodernism and Its Discontents: Theories, Practices* (London and New York, 1988); statistics about the exclusion of women from Neoexpressionist exhibitions are in Carrie Rickey, "Why Women Don't Express Themselves," *The Village Voice* (November 2, 1982).

Guerrilla Girls: Josephine Withers, "The Guerrilla Girls," *Feminist Studies* (vol. 14, Summer 1988), pp. 285–300.

Postmodernism and Feminism: Craig Owens, "The Discourse of Others: Feminists and Postmodernism" in Hal Foster, ed., *The Anti-Aesthetic: Essays on Postmodern Culture* (Port Townsend, Washington, 1983), pp. 57–82; Abigail Solomon-Godeau, "Winning the Game When the Rules Have Been Changed: Art Photography and Postmodernism," *Screen* (vol. 25, November–December 1984), pp. 88–102; Kate Linker, "Eluding Definition," *Artforum* (December 1984), pp. 61–67; Linker, "Representation and Sexuality" in

Wallis, *Art After Modernism*, pp. 391–416; Rosa Lee, "Resisting Amnesia: Feminism, Painting and Postmodernism," *Feminist Review* (no. 26, Summer 1987), pp. 5–28. For Poststructuralism see Preface above.

Gender and difference: *Difference: On Representation and Sexuality* (exh. cat., The New Museum of Contemporary Art, New York, 1985), guest curators Kate Linker and Jane Weinstock; essays by Craig Owens, Lisa Tickner, Jacqueline Rose, Peter Wollen, and Jane Weinstock; Constance Penley, "'A Certain Refusal of Difference:' Feminist Film Theory," reprinted in Wallis, *Art After Modernism*, pp. 375–90; Linker, "Representation and Sexuality," *Art in America* (vol. 73, no. 4, April 1985), pp. 190–99; Michele Barrett, "The Concept of Difference," *Feminist Review* (no. 26, Summer 1987), pp. 29–41; Nancy Chodorow, *The Reproduction of Mothering: Psychoanalysis and the Sociology of Gender* (Berkeley, 1978); Griselda Pollock, "Screening the Seventies: Sexuality and Representation in Feminist Practice—a Brechtian Perspective" in *Vision and Difference*; *Framing Feminism*; Linker, "Eluding Definition;" Hester Eisenstein and Alice Jardine, *The Future of Difference* (New Brunswick, 1985); Mary Kelly, "Desiring Images/Imaging Desire," *Wedge* (no. 6, Winter 1984), pp. 5–17.

Women artists and the media: *A Different Climate* (exh. cat., Städtische Kunsthalle, Düsseldorf, 1986).

Alexis Hunter: C. Osborne, "Alexis Hunter," *Artscribe* (no. 45, February–April 1984), pp. 48–50; A. Johnson, "Alexis Hunter," *Art New Zealand* (no. 24, Winter 1982), pp. 46–47; J. Fisher, "Alexis Hunter," *Artforum* (vol. 21, March 1983), pp. 81–82.

Therese Oulton: Sarah Kent, "An Interview with Therese Oulton," *Flash Art* (no. 127, April 1986), pp. 40–44; Wendy Beckett, *Contemporary Women Artists*.

Rosemary Trockel: Jutta Koether, "Interview with Rosemary Trockel," *Flash Art* (no. 134, May 1987), pp. 40–42; Dan Cameron, "In the Realm of the Hyper-Abstract," *Arts Magazine* (vol. 61, November 1986), pp. 36–40.

Mary Kelly: Mary Kelly, *Post-Partum Document* (London, 1985); Margaret Iverson, *The Bride Stripped Bare by her Own Desire: Reading Mary Kelly's Post-Partum Document*," *Discourse* (vol. 4, Winter 1981–1982, Berkeley), pp. 75–88; "No Essential Femininity: A Conversation Between Mary Kelly and Paul Smith," *Parachute* (no. 2, Montreal, Spring 1982), pp. 31–35; Mary Kelly, *Interim* (exh. cat., The Fruitmarket Gallery, Edinburgh, 1986).

Feminism and psychoanalysis: Juliet Mitchell, *Psychoanalysis and Feminism* (Harmondsworth, 1974); Jacqueline Rose, *Sexuality in the Field of Vision* (London, 1986); Joan Riviere, "Womanliness as Masquerade," reprinted in Victor Burgin, James Donald and Cora Kaplan, eds,

Formations of Fantasy (London and New York, 1986), pp. 35–44; Sarah Kofman, *The Enigma of Woman: Woman in Freud's Writings*, trans. Catherine Porter (Ithaca, N.Y., 1985); Janet Sayers, *Sexual Contradictions: Psychology, Psychoanalysis, and Feminism* (London and New York, 1986); Jane Gallop, *The Daughter's Seduction: Feminism and Psychoanalysis* (Ithaca, N.Y., 1982); Mitchell and Rose, eds., *Feminine Sexuality: Jacques Lacan and the Ecole Freudienne* (London, 1982).

Barbara Kruger: Carol Squiers, "Barbara Kruger," *Art News* (vol. 86, February 1987), pp. 77–85; Craig Owens, "The Medusa Effect or, The Specular Ruse," *Art in America* (vol. 72, no. 1, January 1984), pp. 97–105; *Barbara Kruger* (exh. cat., National Art Gallery, Wellington, New Zealand, 1988).

Jenny Holzer: Jeanne Siegel, "Jenny Holzer's Language Games," *Arts Magazine* (vol. 60, December 1985), pp. 64–68; Hal Foster, "Subversive Signs," *Art in America* (vol. 70, no. 11, November 1982), pp. 88–92.

Cindy Sherman: *Cindy Sherman* (exh. cat., Whitney Museum of American Art, New

York, 1987), essays by Peter Schjeldahl and Lisa Phillips.

Sherrie Levine: Paul Taylor, "Sherrie Levine," *Flash Art* (no. 135, Summer 1987), pp. 55–58; Gerald Marzorati, "Art in the (Re)Making," *Art News* (vol. 85, May 1986), pp. 91–98.

Silvia Kolbowski: Therese Lichtenstein, "Silvia Kolbowski," *Arts Magazine* (vol. 59, Summer 1985), p. 12, for the quote also; Joan Copjec, "In Lieu of Essence: An Exposition, a Photographic Work by Silvia Kolbowski," *Block* (vol. 7, 1982), pp. 27–31.

Susan Hiller: *Susan Hiller* (exh. cat., Institute of Contemporary Art, London, 1987), essay by Lucy Lippard.

Cultural imperialism: James Clifford, "Histories of the Tribal and the Modern," *Art in America* (vol. 58, no. 4, April 1985), pp. 164–76; the quote is on p. 167; Hal Foster, ed., *Discussions in Contemporary Culture* (no. 1, Seattle, 1987).

Native American women: Ruth Bass, "Jaune Quick-to-See Smith," *Art News*

(vol. 83, no. 3, March 1984), p. 124; Rolf Brock Schmidt, "Mediator Between Two Cultures: A Portrait of the American Artist, Jaune Quick-to-See Smith," *Der Tages-spiegel* (Berlin, December 4, 1983); *Second Western States Exhibition: The 38th Corcoran Biennial Exhibition of American Painting* (exh. cat., Corcoran Gallery of Art, Washington, D.C., 1985); *Women of Sweetgrass, Cedar and Sage* (exh. cat., Gallery of the American Indian Community House, New York, 1985), curated by Harmony Hammond and Jaune Quick-to-See Smith.

Lubaina Himid: Lubaina Himid, "We Will Be" in Rosemary Betterton, *Looking on*, pp. 259–66; the quote is on p. 261.

Sonia Boyce: *Sonia Boyce* (exh. cat., AIR Gallery, London, 1986); the Araeen quote is from *The Essential Black Art* (exh. cat., Chisenhale Gallery, London, 1988), p. 5. See also *State of the Art*, pp. 205–46.

Against deconstruction: Gisela Breitling, "Speech, Silence and the Discourse of Art" in Ecker, *Feminist Aesthetics*, pp. 162–74; Jacqueline Morreau and Catherine Elwes, *Women's Images of Men* (London, 1985).

List of Illustrations

Museum of Fine Arts, Boston. Maria Hopkins Fund. **121** *Mother and Child* c. 1905. Oil on canvas 92.1 × 73.7 (36¼ × 29). National Gallery of Art, Washington, D.C. Chester Dale Collection. **122** *Woman in Black at the Opera* 1880. Oil on canvas 80 × 64.8 (31½ × 25½). Museum of Fine Arts, Boston, The Hayden Collection

CHARPENTIER Constance Marie (attributed to) **7** *Portrait of Mademoiselle Charlotte du Val d'Ognes* c. 1801. Oil on canvas 161.3 × 128.6 (63½ × 50⅝). The Metropolitan Museum of Art, Bequest of Isaac D. Fletcher, 1917. Mr and Mrs Isaac D. Fletcher Collection

CHICAGO Judy **202** "Virginia," *The Resurrection Triptych* 1973. Sprayed acrylic on canvas 152.4 × 152.4 (60 × 60). Courtesy the Artist. **131** 1463 × 1463 × 1463 (576 × 576 × 576) Multimedia installation. Courtesy the Artist.

CLAUDEL Camille **165** *Auguste Rodin* 1892. Bronze 40.6 × 25.4 × 28.6 (16 × 10 × 11¼). Musée du Petit Palais, Paris

DAMER Anne Seymour **67** *The Countess of Derby* c. 1789. Marble 59.7 (23½) h. The National Portrait Gallery, London

DARBOVEN Hanne **220** *24 Gesänge-B Form* 1974. Ink on paper mounted in frames with glass, 48 panels of 125.5 × 30 (49⅜ × 11¾), arranged 2 by 24, and 72 panels of 42.5 × 78.9 (16¾ × 31), arranged 12 by 6. Stedelijk Museum, Amsterdam

DAVID Jacques-Louis **82** *The Oath of the Horatii* 1785. Oil on canvas 330 × 425 (129⅞ × 167¼). Musée du Louvre, Paris. Photo Giraudon

DAVIN-MIRVAULT Césarine **6** *Portrait of Antonio Bruni* 1804. Oil on canvas 129.2 × 95.8 (50⅞ × 37¾). The Frick Collection, New York

DEHNER Dorothy **184** *Scaffold* 1983. Fabricated Cor-ten steel, 243.8 (96) h. Twining Gallery, New York

DELANEY Mary **66** *Flower collage*, 1774–88. Mixed media 334 × 228 (131⅕ × 89¾). British Museum, Department of Prints and Drawings

DELAUNAY Sonia **139** *Couverture* 1911. Appliqué 109 × 81 (43 × 31⅞). Musée National d'Art Moderne, Paris. **142** *Simultaneous Contrasts* 1912. Oil on canvas 45.5 × 55 (18 × 21⅝). Musée National d'Art Moderne, Paris. **144** Costume for *Cléopâtre* with Chernichova in the title-role, 1918. **150** Page from *Sonia Delaunay, ses peintures, ses objets, ses tissus simultanés* 1925. Bibliothèque Nationale, Paris. **153** Appliquéd coat design. Watercolor 32 × 23 (12½ × 9). Bibliothèque Nationale, Paris

DEVERELL Walter **92** *A Pet* 1852–53. Oil on canvas 83.8 × 57.1 (33 × 22½). Tate Gallery, London

DUPARC Françoise **65** *Woman Knitting* late eighteenth century. Oil on canvas 77.8 × 63.5 (30⅝ × 25). Musée des Beaux-Arts, Marseille

EAKINS Susan McDowell **115** *Portrait of Thomas Eakins* 1899. Oil on canvas 127 × 101.6 (50 × 40). Philadelphia Museum of Art, Gift of Charles Bregler

EXTER Alexandra **143** *Composition* 1914. Oil on canvas 91 × 72 (35⅞ × 28⅜). Costakis Collection. **152** Costume design for a woman for *La Fille d'Hélios* 1922. Gouache 49.5 × 64.1 (19½ × 25¼). Theater Collection, The New York Public Library

at Lincoln Center. Gift of Simon Lissim, Dobbs Ferry

FAULKNER Kate **123** Wallpaper design for Morris and Company, after 1885. By Courtesy of the Trustees of the Victoria and Albert Museum, London

FINI Leonor **176** *Sphinx Regina* 1946. Oil on canvas 60 × 81 (23⅝ × 32). Private collection

FLACK Audrey **211** *Leonardo's Lady* 1974. Oil over synthetic polymer paint on canvas 188 × 203.2 (74 × 80). The Museum of Modern Art, New York. Purchased with the aid of Funds from the National Endowment for the Arts and an anonymous donor

FOLEY Margaret **108** *William Cullen Bryant* 1867. Marble relief in medallion 47.6 (18¾) diam. Mead Art Museum, Amherst College

FONTANA Lavinia **33** *Birth of the Virgin* 1580s. Chiesa della Trinità, Bologna. Photo Alinari. **39** *Consecration to the Virgin* 1599. Oil on canvas 280 × 186 (110¼ × 74¼). Musée des Beaux-Arts, Marseille

FRANCESCHINI Marcantonio **31** *S. Caterina Vigri* seventeenth century. Cooper-Hewitt Museum, Smithsonian Institution, National Museum of Design, New York

FRANKENTHALER Helen *Mountains and Sea* 1952. Oil on canvas 220 × 297.8 (86⅜ × 117¼). Collection the Artist on extended loan to the National Gallery of Art, Washington, D.C.

GENTILESCHI Artemisia **40** *Judith Decapitating Holofernes* c. 1618. Oil on canvas 169 × 162 (70⅜ × 67¾). Uffizi Gallery, Florence. Photo Scala. **41** *Self-portrait as the Allegory of Painting* 1630s. Oil on canvas 96.5 × 73.7 (38 × 29). Reproduced by Gracious Permission of Her Majesty The Queen. **43** *Susanna and the Elders* 1610. Oil on canvas 170 × 121 (67 × 47⅝). Schonborn Collection, Pommersfelden. Photo Marburg. **45** *Judith with her Maidservant* c. 1618. Oil on canvas 116 × 93 (45⅞ × 36⅝). Pitti Palace, Florence. Photo Alinari

GENTILESCHI Orazio **44** *Judith and her Maidservant* c. 1610–12. Oil on canvas 133.4 × 156.8 (52½ × 61¾). Wadsworth Atheneum, Hartford. Ella Gallup Sumner and Mary Catlin Sumner Collection

GERARD Marguérite **77** *Portrait of the Architect Ledoux and his Family* c. 1787–90. Oil on wood 30.5 × 24.1 (12 × 9½). The Baltimore Museum of Art, The May Frick Jacobs Collection

GHIRLANDAIO Domenico **24** *Giovanna Tornabuoni née Albizzi* 1488. Oil on poplar 77 × 49 (30⅜ × 19¼). Thyssen-Bornemisza Foundation, Lugano

GONCHAROVA Natalia **140** *Rayonist Garden: Park* c. 1912–13. Oil on canvas 140.7 × 87.3 (55⅜ × 34⅜). Art Gallery of Ontario, Toronto. Gift of Sam and Ayala Zacks, 1970

GONZALES Eva **118** *Pink Morning* 1874. Pastel 90 × 72 (35½ × 28½). Musée du Louvre, Cabinet des Dessins. Photo Réunion des musées nationaux

GUERRILLA GIRLS **231** Poster, c. 1987. Offset lithograph 43.2 × 56 (17 × 22).

HARTIGAN Grace **188** *Persian Jacket* 1952. Oil on canvas 146 × 121.9 (57½ × 48). The Museum of Modern Art, New York. Gift of George Poindexter

HAWARDEN Clementina, Lady

87 Photograph of a model, 1860s. By Courtesy of the Trustees of the Victoria and Albert Museum, London

HAYDEN Sophie **129** Woman's Building at the World's Columbian Exposition, 1893. Photograph. The Art Institute of Chicago. Ryerson Archives Special Collection

HAYLLAR Edith **85** *Feeding the Swans* 1889. Oil on canvas 91.5 × 71 (36 × 28). Private collection. Photo Courtesy Sotheby's, London

HEMESSEN Caterina van **46** *Portrait of a Man* c. 1550. Oil on oak 36.2 × 29.2 (14¼ × 11½). National Gallery, London

HEPWORTH Barbara **174** *Two Forms* 1934. Grey alabaster, 16.5 (6½) h., base 43.2 × 17.8 × 3.2 (17 × 7 × 1¼). Private collection

HESSE Eva **193** *Hang Up* 1966. Acrylic on cloth over wood and steel 182.9 × 213.4 × 198.1 (72 × 84 × 80). The Art Institute of Chicago. Gift of Arthur Keating and Mr and Mrs Edward Morris by exchange, 1988. **194** *Accession II* 1967. Galvanized steel and plastic extrusion 78.1 × 78.1 × 78.1 (30¾ × 30¾ × 30¾). Private collection

HILLER Susan **243** *Fragments* 1987 (detail). Installation consisting of 178 gouache drawings, A3; 8 gouache drawings, A3; 210 potsherds; 5 monochrome charts and diagrams, A4; 10 monochrome charts and diagrams, A3; 12 handwritten or typed texts in polythene bags, 15.2 × 20.3 (6 × 8). Courtesy the Artist

HÖCH Hannah **145** *DADA-Dance* 1919–21. Collage 32 × 23 (12⅝ × 9). Photo courtesy Galleria Schwarz, Milan

HOLZER Jenny **237** *Selection of Truisms* 1982. Spectacolor board, Times Square, New York. Sponsored by the Public Art Fund Inc. Courtesy Barbara Gladstone Gallery, New York. Photo Lisa Kahane

HOSMER Harriet **106** *Beatrice Cenci* 1857. Marble 43.8 × 104.7 × 43.1 (17⅛ × 41⅛ × 17). St. Louis Mercantile Library. **107** *Zenobia in Chains* 1859. Marble 124.5 (49) h. Wadsworth Atheneum, Hartford. Gift of Mrs Josephine M. J. Dodge

HOXIE Vinnie Ream **111** *Abraham Lincoln* 1871. Marble 210.8 (83) h. Architect of the Capitol, United States Capitol Art Collection

HUNTER Alexis **233** *Considering Theory* 1982. Acrylic on paper 96 × 76.2 (26 × 30). Collection of Mr. S. Grimberg, Dallas, Texas

JOHN Gwen **163** *A Corner of the Artist's Room, Paris* 1907–09. Oil on canvas 31.7 × 26.7 (12½ × 10½). Sheffield City Art Galleries. **165** *Young Woman Holding a Black Cat* c. 1914–15. Oil on canvas 45.7 × 29.5 (18 × 11⅝). Tate Gallery, London

JOHNSON Frances Benjamin **132** *Self-portrait* c. 1896. Photograph. The Library of Congress, Washington, D.C.

KAHLO Frida **166** *The Broken Column* 1944. Oil on masonite 40 × 31 (15¾ × 12¼). Collection of Dolores Olmedo, Mexico City. Photo Dr Salomon Grimberg

KANDINSKY Wassily **134** Dress design for Gabriele Münter, c. 1904. Pencil. Städtische Galerie im Lenbachhaus, Munich

KAUFFMANN Angelica **70** *Zeuxis Selecting Models for His Picture of Helen of*

379

Index